Total Digital Photography:
The Shoot to Print
Workflow Handbook

Total Digital Photography: The Shoot to Print Workflow Handbook

Serge Timacheff and David Karlins

WILEY

Wiley Publishing, Inc.

Total Digital Photography: The Shoot to Print Workflow Handbook

Published by
Wiley Publishing, Inc.
111 River Street
Hoboken, N.J. 07030-5774
www.wiley.com

Copyright © 2005 by Wiley Publishing, Inc., Indianapolis, Indiana

Published simultaneously in Canada

ISBN: 0-7645-6952-X

Manufactured in the United States of America

10 9 8 7 6 5 4 3 2 1

1K/SQ/RQ/QU/IN

For general information on our other products and services or to obtain technical support, please contact our Customer Care Department within the U.S. at (800) 762-2974, outside the U.S. at (317) 572-3993 or fax (317) 572-4002.

Wiley also publishes its books in a variety of electronic formats. Some content that appears in print may not be available in electronic books.

Library of Congress Cataloging-in-Publication Data: 2004107914

WILEY

To Donna Kattchee, for your ongoing support of our commitment to photography and how it continues to change our lives so dramatically. A parent, partner, and friend, you are in our hearts forever.

Credits

Acquisitions Editor
Michael Roney

Project Editor
Cricket Krengel

Technical Editor
Ron Rockwell

Copy Editor
Elizabeth Kuball

Editorial Manager
Robyn Siesky

Vice President & Publisher
Barry Pruett

**Vice President & Group
Executive Publisher**
Richard Swadley

Project Coordinator
Maridee Ennis

Graphic and Layout Technicians
Jonelle Burns
Amanda Carter
Sean Decker
Brian Drumm
Carrie Foster
Lauren Goddard
Jennifer Heleine
Heather Pope
Heather Ryan
Ron Terry

Quality Control Technicians
John Greenough
Brain Walls

Proofreading and Indexing
Joanne Keaton
Ty Koontz

Book Designer
Melissa Auciello-Brogan

Cover Design
Anthony Bunyan

Special Help
Maureen Spears

Preface

The inevitable is upon us: The vast majority of professional and "enthusiast" photographers worldwide are considering shifting to digital from film, or have already done so. Major legacy film companies such as Fuji and Kodak are reorganizing their businesses to allow for a dramatic decline in demand for what made them global brands and to build and leverage their businesses in the digital arena. Virtually all service bureaus and labs today process digital files and are gearing up for digital processing to increase dramatically.

Nonetheless, it's common to find photographers who see the digital shift as a daunting undertaking. Although most digital cameras — especially the higher-end models — operate very similarly to film cameras, it's after the shoot that the most challenging endeavor looms large: transferring images to and managing them on a computer.

Digital photography offers real advantages over film. To get the most from this new mode of photography and to operate a digital studio, every successful photographer must acquire new skill sets that don't always relate directly to their training or experience. Computer networking, installing and maintaining software, database management, digital graphic design, data backup and storage, operating environments, image editing, e-commerce, and color calibration of equipment all present steep learning curves in the process of what has come to be called *digital photography workflow*.

Although infinitely more complex, the photographer's world is equally opportunistic. A much larger number of digital images can be managed affordably and quickly, accessed faster, and presented to clients and other interested parties more dramatically than film images. Images can reach clients anywhere in the world in seconds, and they can be sold online around the clock. A photographer can build a reputation more easily now than ever before, and enthusiasts who previously only toyed with the thought of going pro are now realizing their dreams.

I began my photography career at the age of 18 in 1978, working to put myself through college as a photojournalist at a small community newspaper with a Canon AE-1. Every day, I would come in to the darkroom, roll out the Kodak Tri-X Pan film (the black-and-white marvel used universally by photojournalists for decades) that I needed for the day in reloadable 35mm canisters, and head out on my assignments to create the next day's cover photo. I would return a few hours later, process and develop the film, print the best shots, and present them to the editor. That was photography workflow, in a nutshell, as it has taken place for more than 100 years.

As a busy international high-tech executive with an avid interest in photography and a history of working professionally, I always took my camera on business trips around the world. Selling the work at local shows or galleries, and occasionally working on-assignment for magazines, I took photos mostly in slide film on 6 continents and more than 40 countries. I enjoyed the exhilaration and thrill of shooting in markets in India and Thailand, the streets of Morocco and Brazil, and the countryside of France and Germany.

Responsible for corporate communications for Logitech in the early 1990s, I was involved in the launch of "FotoMan," arguably the first consumer digital camera. Although a novelty at the time, lacking high

resolution or serious photography capability, it was clear there was a seed of something big in the works. The term *megapixel* hadn't been coined, Photoshop was something used for scanned images, and the Internet was a university tool. But, as a lifelong photographer, I could tell the world was on to something.

Shortly before September 11, 2001, changed the world, I was working in management for a design firm in Seattle, responsible for brand development. One of the jobs the agency had taken was the "Pigs on Parade" project sponsored by the Pike Place Market Foundation — placing more than 100 large Fiberglass pigs around the city, each decorated elaborately and intricately by artists. At the last minute, the agency needed a photographer to shoot the Pigs on Parade wall calendar. That moment changed my life: I let the agency know I could shoot the calendar, and off I went. And, although the calendar was very successful and some of my images appeared in ads in the *New York Times,* among other places, the agency hit hard times with the one-two punch of the bursting of the Internet bubble and then 9/11. At that time, my wife, Amy, and I decided to begin Tiger Mountain Photo and pursue building our own business.

Over the last few years, we've done just that, and it's taken some interesting direction. As an avid competitive fencer, I decided to apply my skills to the sport. Fencing is not well understood by the average American, nor has it been depicted on television or in photographs — at least in the U.S. — very well, in spite of being a very fast-growing sport. I found that I was able to produce images that expressed the excitement, passion, and drama of the sport in a way that was new to its constituents and to those unfamiliar with it. In January 2003, I was invited to a tournament in Lapland, in Northern Finland, to fence and photograph the only tournament north of the Arctic Circle. Leica, the German camera company, also offered use of their cameras to photograph the Aurora Borealis, which is so amazingly visible in that region. Unbeknownst to me, the president of the International Fencing Federation (FIE), Mr. Rene Roch, was also invited to the tournament, and I was given the opportunity to display my work and express my vision.

At the end of the tournament, Mr. Roch personally invited me to be the official FIE photographer for the Olympic Games for fencing, and for major competitions worldwide — the first of which was to take place eight months later in Havana, Cuba. One of the specific reasons I was offered this role, in addition to my work, was that digital photography was a necessity for being able to quickly and efficiently take sufficient photos at a major fencing competition. Lasting 9 or 10 days, with 18 or more events including competition, medal ceremonies, FIE receptions, "environmental" shots, and multiple other photo opportunities, it's easy to take literally thousands of photos in little more than a week at a big fencing championship. In Cuba, for example, I took 7,000 digital photos in nine days.

Being able to process that many images in film would be expensive and unwieldy — possible, but difficult. Only in the last few years has the world enjoyed cameras capable of shooting a fast sport such as fencing, and, today, such cameras are commonplace. Sports photographers at major world championships with high news value — such as Wimbledon, the Super Bowl, the soccer World Cup, the Indianapolis 500, or the Kentucky Derby — must get photos to editors not within days or hours, but within minutes. Some go so far as to transmit images wirelessly from their camera to a computer where an assistant processes the image and gets it to an editor where it is placed online for the world to see.

This has become the order of the day: processing a large number of high-resolution images quickly from the camera to their destination, enhanced for optimal sales and presentation. Whether a studio shooting a product and giving the client images on-site, a wedding photographer showing shots of the ceremony at the reception, or simply a proud parent getting the images of a child's birthday party to grandparents across the country on the same day, the world has come to expect both immediacy and quality in photographs.

A number of relatively simple software tools for the prosumer and amateur photographer exist today, allowing images to be edited simply and quickly. However, at the higher-level enthusiast and professional levels, Adobe Photoshop overwhelmingly dominates image editing. Because its price makes it inaccessible to many. Scaled-down versions of Photoshop, such as Photoshop Elements, which often ships bundled with digital cameras, whets the consumers' appetites, but lacks the higher-end features necessary to make a real photography business able to manage workflow effectively.

Issues of image archival, color calibration, and e-commerce all add to the mix, further complicating and increasing the price of building a digital studio. As a result, the tools required to create a fully operational digital studio go well beyond simply getting a digital camera and a computer.

Digital photography workflow, however, is also far more than software and hardware and the ability to use it. The real key to successfully getting photographs from being acquired to being delivered is understanding and leveraging how workflow comprises key stages and, perhaps even more importantly, how to transition between those stages. Taking the photograph; getting it onto the computer; processing it so it can be archived, accessed, and edited; and getting it into a deliverable state, whether on-disk, online, or on paper, are all essential parts of workflow that must be not only addressed but mastered by the pro and enthusiast photographer.

The digital photography workflow is not that much different, but at the same time altogether changed, from the scenario I described earlier of my work as a photojournalist out shooting film: Prepare to take the photos, get them back to the studio, process, edit (in film, that means cropping, burning, and dodging using an enlarger), print, and deliver them. These components are true of virtually all types of photography, from studio to sports, photojournalism to events.

This is the crux of what I've had to deal with in transitioning from 100 percent film to 100 percent digital, and the experience this book endeavors to share with you, the photographer facing the challenge of optimizing the transition to and management of a digital studio and the associated workflow.

Dozens, if not hundreds, of software digital-photography tools and plug-ins, hundreds of digital cameras and printers, and myriad online services are dedicated to digital photography. I don't intend to analyze all of them or, with a few exceptions, to make recommendations as to which is best or worst. Nor do I plan to explain every trick and feature of Photoshop in minute detail. There are plenty of books and information on the Web that do just that. Instead, this is about how to really put together a deployable workflow configuration suited to your chosen camera, computer, software, and other digital-studio parts and pieces, and apply it to the type of photography you want to pursue.

My collaborator and coauthor on this book, David Karlins, brings a wealth of experience in graphic design, digital imaging, and photo printing technology. David is the author of the *PC Magazine Guide to Printing Great Digital Photos* (published by Wiley), along with books on graphic design and Web design. In order to provide a format that allows me to share personal insights, opinions, and experiences from the trenches, this book is written in the singular first person. But David's imprint is found throughout the book.

Throughout the book, I've included a number of photos I've taken over the last few years, most of which were shot digitally and a few that were converted to digital from film. I hope you enjoy these photographs and happen to find a few morsels of inspiration from them. I've been fortunate enough to see and shoot some of the most amazing things the world has to offer, from waterfalls in Brazil to the Olympic Games in Greece, the Aurora in the Finnish arctic to Bulgarian beggars. It's a privilege to share these images and thoughts with you and use them as examples of how to better make digital workflow work for you.

About the Authors

Serge Timacheff is a professional photographer and writer. He is also author of four books, photographer for the International Fencing Federation, and partner with Tiger Mountain Photo. His work appears worldwide. He lives in the Pacific Northwest.

David Karlins teaches and writes about graphic and interactive design, and digital printing. His recent books include *Build Your Own Web Site*, *How to Do Everything with Adobe Illustrator CS*, and *The PC Magazine Guide to Printing Great Digital Photos*. Visit David's Web site at www.davidkarlins.com.

Acknowledgments

This book has been the result of many people who lent their guidance, expertise, support, and constructive criticism. We'd first like to thank Mike Roney, Wiley senior acquisitions editor, for initiating, enabling, and guiding this project. Thanks also to Ron Rockwell for his thought-provoking technical edits. Cricket Krengel, project editor, continued to be a bright inspiration and supporter even as we headed into the author review stage.

Amy Timacheff deserves the typical spousal recognition and appreciation for putting up with the intensity and commitment required of a book project. However, because she's also an accomplished photographer, she's been an invaluable expert, sounding board, and sanity check on what we've written.

Thank you to Rene Roch, president of the International Fencing Federation (FIE), for taking the time to hear and see my vision of how photography can help further the recognition and popularity of the sport throughout the world. Thank you, also, to Jochen Faerber and Nathalie Rodriguez of the FIE for your friendship and support for my work at world championships and the Olympic Games.

Our deep appreciation goes out to associates, contacts, friends, and family, especially:

+ Kevin Mar for everything that involves fencing and photography

+ Jo & Duane Rorberg for your partnership, friendship, and shared passion for photography

+ David Fugate and Matt Wagner, our literary agents at Waterside Productions

+ Rob Calem, for your words of wisdom, friendship, and expertise in consumer electronics and technology

+ Carlton Osborne, Mike Kapul, and Chris Hooks at Printroom.com

+ All my friends at the United States Fencing Association and our big fencing family, especially Philip Daly, Michael Marx, Evan Ranes, Paul Soter, Bob and Suzanne Marx, Sue and Tony d'Agnese, Carl Borack, Michael Massik, Cindy Bent, Jan Bade, Marja-Liisa Someroja, Maarit Rajamäki, and Meg Galipault

+ Dana Rasmussen at Glazer's Camera in Seattle

+ Harry Haugen and David Perry for friendship, support, and vast knowledge of photography

+ Tatyana and Alexander for your love and support

+ Dave Taylor, Portraiture, Candids, and Event Photography for advice on digital storage and backups

Contents at a Glance

Contents

Setting Up for Digital Photography Workflow

1

What Is Digital Photography Workflow?

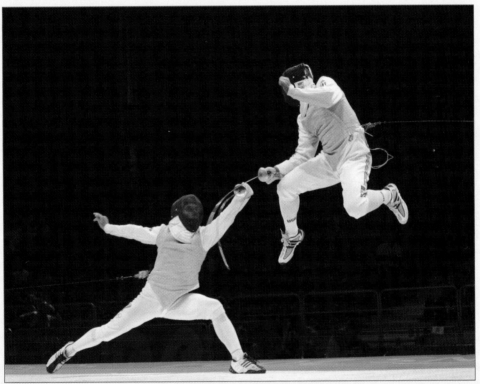

U.S. fencer Jonathan Tiomkin soars above Russian opponent Renal Ganeev in the bronze-medal bout of the men's team foil competition at the Athens Olympic Games. Taken with a Canon EOS–1D Mark II at ISO 500, f/2.8, 1/500 second, and 70mm focal length.

The world has gone digital, and photography isn't exempt. If you're a film photographer, you're confronting the fact that, in a few years, film, as we know it today, may be a thing of the past. If you've already begun to make the transition from film to digital photography, you're undoubtedly finding the transition a bit stressful.

Digital photography has many things in common with traditional film photography, not the least of which is that it all starts with good photos! You'll find the path of taking, working with, and printing digital photos runs parallel to the process you use when working with traditional film, but there are many pitfalls (and opportunities) that are quite different. In this chapter, I introduce you to the basic process of digital photography, and you begin your journey to a rational, creative, enjoyable, productive digital photography workflow. In this chapter, we explore several aspects of digital, including how to make sure it works, how to integrate photography with computers, the workflow, and how to use that workflow in marketing your work.

Why Digital?

In the early days of word processing, some writers fought the changeover from the manual typewriter to digital for years before finally succumbing to the inevitable. Although a few writers today still work on the old machines, and some, such as legal fiction author Scott Turow, purportedly still write by hand, the overwhelming majority of writers find using computer technology to be a boon, not a hindrance.

In a similar way, photographers are finding, and will find, that digital photography opens up tremendous opportunities. Film won't completely go away, at least in the short term. As a film photographer, you've most likely come to love certain types of films and their qualities of granularity, color saturation, contrast, and tolerance for varying light conditions. It's only natural that you'll resist the changes that must take place to be able to replicate your well-established techniques for creating your own style of images in a digital format. I frequently encounter film photographers who claim that film quality exceeds, and will always exceed, digital photographs.

Digital photography, however, is infinitely more controllable than film, and certainly more immediate. Whereas film photographers had to take Polaroid images in the studio to check lighting, with digital photography the image appears on the back of the camera or the computer instantly. For many photographers who have primarily experienced digital and weren't educated in film, it's hard to understand how anyone could rely on a format with such limited feedback, lacking the ability to instantly review and change what's been photographed. Although this, perhaps, is part of the "art" of film photography, the benefits and control of the digital format extend far beyond film.

One of the most profound developments in digital photography is the ability to produce, easily acquire, and edit in what's called the RAW camera format (technically, it's not really even a format the way JPEG or TIFF are, but rather it is the "raw" camera image—literally). This image represents precisely what the camera saw, and can be adjusted dramatically to change the exposure. I believe the RAW format is the very best format capable of convincing even the most diehard film photographer of digital's benefits, providing instantaneous control of the image as the camera and photographer saw it, without any distortion, chemical intervention, or digital alteration. And this is all before images have been filtered in Photoshop or otherwise manipulated. Furthermore, the RAW format allows more tolerance in exposure settings, unlike JPEG images and, again, much more like film-based photography.

Working from scanned photos

If you're a film photographer who has scanned your negatives or slides, you'll find pure digital photography better because you aren't dealing with the limitations and second-generation quality of a scanned image. Unless you're having your film scanned at a service bureau (which can be pricey), scanning it yourself is extremely time-consuming and persnickety.

Scanning film basically amounts to the worst of both worlds: dealing with the delay in receiving images from the lab, and then still having to scan them into second-generation quality (or having to work with second-generation scans from the lab, which have varying degrees of quality and you, as photographer, have only limited control over).

Still, part of the digital studio is understanding how to convert a negative or slide into a digital format, either using your own equipment or a service bureau. It's a good idea to have a good scanner in your studio so you can work with old images and any negatives you or your clients may have. However, planning to do all your digital photography by scanning film-based images isn't a viable alternative to using a digital camera.

Pixelation

Is it real or is it Memorex? Today's higher-end cameras exceed equivalent film-camera quality. For example, the Canon 10D, a 6.3 megapixel "semiprofessional" camera, can produce better images more easily than the Canon EOS3, which shoots 35mm film. The area where the Canon 10D interprets the information, called a CMOS chip (on some cameras, it's a CCD), is similar in size to that of a 35mm frame, and tiny sensors receive tiny points of light (6.3 million, to be exact) into a digital image. By zooming in on a digital photo using an image-editing package, you can actually see each point of light and its value.

This pixelation is what very often bothers film photographers — the fact that you can actually break down the image into little bits and bytes instead of a fluid dispersion of colors and shapes, as shown in Figures 1-1 and 1-2. It takes some of the magic of photography away, relegating it to just another digital structure and hardly a work of art. Yet this is the same thing that has happened for eons in the printing process, whether creating a high-quality coffee-table photo book or a newspaper photo. Under a magnifying glass, little dots of color appear and the photograph, it turns out, is merely an optical illusion of combining millions of tiny objects into one big image.

Figure 1-1: A high-resolution digital image photographed with the Canon 10D, and then cropped to 4 x 3 inches at 300 dpi (1,200 x 900 pixels)

Pixels and Megapixels

In the course of this book, I explore the implications and techniques for managing image resolution. But, for now, a few quick definitions: A *pixel* refers to the smallest digital dot produced by an individual photodiode or photosite on a camera sensor used to record image data; it is also the smallest unit of a digital image acquired with a scanner or other imaging device (scanners use CCDs, just like many digital cameras). On-screen resolution is often referred to as ppi (pixels per inch), while print resolution is usually referred to as dpi (dots per inch),

The degree of resolution of a digital photo is dependent on the camera having, and using, sufficient photodiodes to capture enough pixels of data to reproduce the image with a high resolution. Camera image capacity is measured in *megapixels*—thousands of pixels. For example, a 6.3-megapixel camera produces 6.3 million pixels of information.

Figure 1-2: A close-up of the eye in the same photograph, showing the pixelation squares that make up the image. This image has been cropped to 4-x-3 inches at 20 dpi (80 x 60 pixels).

In digital photography, some of the same problems in film-based photography, such as increased granularity in images shot at a higher ISO setting. But, in digital you can more easily control and diminish these problems using various software tools.

Using the RAW format and Photoshop CS, image exposure can actually be adjusted after the image has been taken—a near miracle if you've ever shot what you thought was a great image, but the exposure wasn't set just right. Or, imagine being able to edit a bride's wedding-dress details with perfect detail from an image that originally had the bride's face and rest of the scene exposed perfectly, but her very-white dress overexposed. With the after-the-shoot control provided with the RAW format, especially, virtually any part of an image can be controlled and adjusted with a high degree of precision. Exposures can be corrected extensively. And, while it's still not a substitute for a good basic exposure and composition, this is digital at its best.

A Gonzo Photo Journey: Digital and Film

I was still shooting some film until late 2003, when I took a Canon EOS3 (35mm film) and a Canon 10D (6.3 megapixel digital) to the World Fencing Championships in Havana, Cuba. As the official photographer for the International Fencing Federation, I travel to world championships including the Summer Olympic Games to get close to some of the best athletes and most exciting fencing action on the planet, and Havana was no disappointment. The photo in Figure 1-3 was taken at the competition.

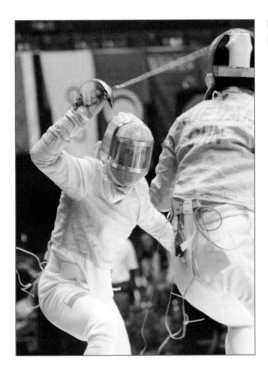

Figure 1-3: The World Fencing Championships, Havana, 2003

Understanding the Difference between SLR and Point-and-Shoot

There are fundamentally two types of digital cameras: SLR (single-lens reflex) and point-and-shoot. SLRs are almost always higher-end, although there are consumer, semipro, and professional versions available; point-and-shoot cameras are always considered consumer products.

With an SLR camera, the photographer looks through an optical viewfinder that uses a mirror system to look through the actual lens at his or her subject. When the shutter release is pushed, the mirror pops up for a split second to expose the camera's digital sensor. Most SLR cameras allow interchangeable lenses to be mounted and used. Digital SLRs also operate much as a conventional film camera does, allowing the photographer to manually set f-stops and exposure times.

In point-and-shoot cameras (most consumer cameras), the photographer looks either at an LCD screen showing a video image of the subject or through a small offset viewfinder that allows the photographer to see what the camera is seeing. Point-and-shoot cameras have one lens, some that zoom mechanically and others that zoom digitally. Unlike a film SLR, point-and-shoot cameras operate primarily in an automated fashion, with lots of presets for varying conditions, but no real manual settings.

I needed both cameras to capture a wide range of shots. In addition to photos I took of the event, I had the opportunity to capture some great photos ranging from the car in Figure 1-4, to people on the streets, such as the man in Figure 1-5.

It might be helpful to walk through why I took both of these cameras. My film camera, the Canon EOS3, has a power drive capable of shooting seven frames per second, while the digital Canon 10D only takes three frames per second. For some events, I needed the faster speed. (I now have switched to the Canon 1D Mark II, a much faster camera offering even higher megapixel capabilities, which was unavailable at that time.) The 10D is a workhorse that allowed me to take a large number of digital photos efficiently and to choose RAW or JPEG formats in up to 6.3-megapixel sizes.

Both the digital and film cameras use the same attachments and lenses, although the size of the image seen through the viewfinder in the digital camera is smaller than that of the film camera.

Figure 1-4: Classic car in Havana, Cuba

Figure 1-5: On the street, Havana

Relying on digital

My trip to Cuba, however, is what ultimately made me decide to sell my Canon EOS3 and become a 100 percent digital studio. Why? As it turns out, I was able to shoot all photos digitally with the exception of three rolls of two events. And those events could probably have been shot digitally.

Taking film in and out of Cuba was a hassle, even with a photojournalist's license from the U.S. Treasury Department allowing me to travel there and photograph the event. It meant having airport security hand-check the film, because I refuse to put any film through an X-ray machine anywhere, and especially in third-world countries.

The digital scans of the film I obtained were lackluster, but without the proper amount of time to scan the images myself, I ended up having to digitally edit rather heavily a couple of the best film-based shots scanned by the pro lab, such as the one in Figure 1-6.

I'd been convinced at this point that digital was for me, but I wasn't sure there was a camera that would meet all my needs. However, Canon announced in February 2004, that it would soon ship a new camera that shoots 8.2 megapixel images at 8½ frames per second, up to 40 frames without stopping. It is a camera equally capable in the studio or in the field, rugged enough for a photojournalist, but with the quality required by higher-end wedding photographers. This was the answer to my needs — and the signal that film, for me, had ended.

A Note About Canon, Nikon, and All the Rest

Most professional photographers settle on one brand of equipment for their primary camera gear; obviously, I use Canon. In the sports, event, and journalism world, Canon and Nikon predominate and are constantly battling to outdo the other in features and capabilities. In the portrait and wedding markets, they are popular, but Fuji, Kodak, and other brands of digital cameras are also popular. I've shot Canon, Olympus, and Mamiya cameras throughout my career, but I now use Canon exclusively—in part, because I have so much invested in Canon-specific lenses, but also because I like the consistency of operation and interface.

As you transition to digital, make sure to evaluate your options and choose a camera based on your needs and what brand you feel most comfortable operating. It is likely that you already have a brand you prefer and have invested in—and switching to digital means you will, no doubt, choose to continue shooting with your favorite brand.

Figure 1-6: A high-speed fencing photograph taken using film and then scanned at a lab

Moving on . . .

It was not without a few pangs that my trusty film camera sold on eBay and I shipped it off to its new owner. The camera had performed flawlessly and served me well, but I hadn't used it in nearly six months. And when I did use the camera, it wasn't actually taking the photos that took more time or effort, but what took place afterward—the workflow of getting images to where they needed to be in a timely manner with high-quality results.

If you're a photo enthusiast and you want to be able to work with your images quickly, or you're a pro who needs to get images to clients as quickly as possible, you know how useful digital technology is. This requires, however, a certain process of taking, preparing, storing, editing, printing (in some cases), and delivering the images to their ultimate destination—and this is where digital benefits reign. Furthermore, most clients today want digital photography—brides want digital slideshows, clients want digital proofs, and photography shows want submissions on disk.

From Image Capture to Image Display: Ensuring It All Works

The digital camera world is divided into two major segments today—one for consumers/amateurs (the point-and-shoot crowd) and one for professionals and semiprofessionals/enthusiasts, who generally use SLR (single-lens reflex) models.

When it comes to digital photography workflow, it doesn't matter if you're shooting an SLR or a point-and-shoot—you'll still need to take a good photo, download it, process it, and print or distribute it. Professional workflow certainly involves more at all levels; however, everyone with a digital camera of any type gets involved in workflow at some level.

Viewfinders

Digital viewfinders, common in less-expensive point-and-shoot consumer digital cameras, rely on some form of liquid crystal display (LCD) to display a little TV-like image of the subject—you may have seen people framing photos with the camera held in front of them at arm's length. LCDs do have some advantages over optical viewfinders in film cameras—they allow you to view other photos and provide a sharp, accurate image.

With single-lens reflex (SLR) cameras, you capture an image with a lens that reflects light through a prism and onto the optical viewfinder. Therefore, the optical viewfinder shows the same image that will be captured by the camera. While high-end, professional SLR digital cameras do have LCDs like the point-and-shoot variety have, they are not viewfinders, but viewing screens for images already taken.

Digital viewfinders aren't a particularly accurate or good way of framing an image, and any professional photographer forced to use one to take a snapshot will bristle at having to frame an image without a true optical viewfinder. Further, they require substantial battery power, particularly when it's necessary to generate an image strong enough to see in bright light.

Digital zooms: Amplifying bad quality

Consumer point-and-shoot cameras lacking high-quality lenses sometimes offer the feature known as *digital zooming,* which allows the camera to create the effect of a telephoto lens without the glass to support it.

Sound like a compromise? That's right. The camera is simply taking a smaller segment of the image it's seeing, showing you that blown-up area, and then recording that as the image. It doesn't use more megapixels; in fact, it's a subset of the full-size image and, therefore, a smaller resolution. Figures 1-7, 1-8, and 1-9 show three photos: the first without zooming-in on the subject, the second using a mechanical/optical zoom, and the third with a digital zoom.

Figure 1-7: A photographic scene that would look much better with the main subject amplified. Most of the greenery is superfluous.

If all you have is a digital zoom and you can't get any closer to your image, shooting the full-size image is just as good as zooming in. You can crop and enlarge the image in your image-editing package later and get the same, and possibly even better, results.

If at all possible, use yourself to zoom if all you have is a digital zoom — getting closer to your subject will yield a better-quality image because it will more fully use the available pixels the camera has to offer. Of course, if that means jumping off the train at the San Diego Wild Animal Park, it's probably not advisable.

Figure 1-8: Standing at the same location, using a zoom lens to *optically* amplify the subject. This still allows the camera to use the same resolution as with the full scene. Note how the clarity and resolution of the photo is the same as in Figure 1-7.

Whereas with a point-and-shoot digital camera you're restricted to the capabilities of the one lens, SLRs are typified by the ability to use multiple lenses. Because they're meant to be used like film cameras, looking through the viewfinder to frame and focus the subject, as well as to see settings such as exposure, bracketing, number of exposures, as well as digital features such as the amount of images remaining in the buffer after one or more has been shot (for example, on a Canon 10D, you can shoot up to nine images in a row, after which you can't take photographs until at least one of the images has been downloaded internally to the flash card).

Flash Cards

A flash or memory card is a small card with recordable media that is placed into the camera to record images; some of the most-common types of cards are CompactFlash, SmartMedia, and Sony MemoryStick, but there are many others.

When you take a photo, the camera records the image into its own memory before it is transferred to the flash card. The amount of memory the camera has and how many images it can hold when photographs are taken in quick succession is referred to as a buffer. The size of the buffer is important, but how many photos your camera buffer can actually hold depends on various factors, such as the size of the image (in megapixels).

Figure 1-9: Also standing at the same location, using a digital-zoom feature that merely crops the photograph and makes the same image *appear* larger. However, note here how the resolution of the image and its corresponding clarity has been compromised.

The bridge between camera and computer

For consumers, image capture is simply taking snapshots and then downloading them to the computer using the CompactFlash, Memory Stick, or SmartMedia card, or a direct connection to the computer. For professionals, taking the photograph may involve much more setup work with lighting, experimenting with shots, connecting lighting equipment, and adjusting the camera's white balance to suit the light in the shot. For both, however, the moment digital photography workflow begins in earnest is when the image is transferred from the camera to the computer.

This simple bridge point between camera and computer — very often, a CompactFlash card — is a critical point of difference between digital and film. It also points to the importance and potential fragility of workflow because physically removing the card from the camera and transferring it to a computer or other device is certainly one of the weakest links in the digital chain. Interrupting downloading images, losing or corrupting a CompactFlash card, or running out of power can all be potentially catastrophic.

Note One alternative to this is to directly connect the camera via a USB or FireWire cable to the computer, an option with many cameras. In this way, the memory card simply remains in the camera.

There are several points where components of digital photography bridge with one another. Understanding, identifying, and controlling workflow's critical junctures is essential in successfully producing quality digital photography. The stages of digital photography workflow are distinct, yet closely integrated.

If you're a reasonably experienced photographer, you're probably very comfortable with the first two stages, even to the point of reviewing images directly on a digital camera. In fact, the old Polaroid days may seem very happily long gone. However, many legacy film photographers find their challenges begin

after the images are transferred to the computer, which is the point where traditional film workflow and digital workflow diverge significantly.

Cross-Reference If you are interested in how black and white photography works when using digital, visit Stage 7 for a detailed explanation.

Digital processing

Just as when film reaches the lab, when the digital image reaches the computer, it begins its journey of being processed. This includes ensuring the image is identified properly, protected from copyright infringement, edited properly for its ultimate use, and archived in a manner that is safe and yet accessible.

Although some images will never be printed or used, they may still be batch-processed for storage. Other more desirable images will have their originals stored but also copied into versions used for editing.

Digital photography workflow ensures these steps take place and the files are safe, optimized, and ready for use.

A Converged World: Integrating Photography, Computing, and Graphic Design

If you have a digital camera, you know that you've got to be as competent on a personal computer as you are with your camera if your images are to be produced in a quality that's acceptable for your purposes, whether that's for clients, public display, or other purposes. Furthermore, you need a good sense of design if you have clients who want your images to have embellishments, such as text and fonts, shapes, or other graphic features. This experience may be a new one for you.

First, a word of comfort: Don't expect to become an instant networking manager or graphic artist. Not only is it unnecessary, it will be a distraction from photography, which is where your passion lies or where you make your money. If you're creating a digital studio with multiple computers, you may be able to simply connect them all with small-business or home-computing networking software and hardware. Both the Mac and PC operating systems allow different systems to be networked using an inexpensive hub and some cables or a wireless system.

However, that part of the process can be daunting to the uninitiated, and for those who are quite tech-savvy it will be time-consuming at the very least. Having a local computer service that offers small-business consulting recommend hardware and software, and set up the system, is well worth the cost. You'll find the money to be well-spent and the system will be up and running much faster, meaning you'll be able to spend more time behind the viewfinder. Depending upon the complexity of your system, you may be able to color-calibrate your monitors, add or remove systems, or work with backup systems without help; having your system based upon a well-established network infrastructure, however, is invaluable. Easy to use, wizard-driven calibration software bundled with highly accurate calibration tools enables you to fine-tune color display on your monitor without any technical expertise.

Cross-Reference For a full exploration of calibrating your monitor with hardware/software packages like Monaco EZcolor system or ColorVision's SpyderPRO, see Stage 5

As for graphic design, at a simple level most photographers have no problem adding text to an image to highlight an event or a date. However, when it comes to actually creatively altering images with multiple borders and design elements, as well as using the many features of today's photography packages, doing

the graphic design yourself can be a recipe for the creation of some very poor-quality images, indeed. Graphic design is not something that a software package creates automatically, although some photo packages include pre-designed templates with borders and other features. Most often, the photographer must add his or her own graphic embellishments.

Once again, this can be a huge distraction for very little potential gain. A photographer's time in Photoshop or other image-editing packages is much better spent learning features that will allow images to be edited to remove red-eye, altering unwanted parts of an image, or properly editing contrast, sharpness, color, and brightness.

The Economics of Digital Photography

The transition to digital photography clearly includes a financial element. In the course of this book, we discuss your options for components like cameras, computers, software, and printing. But here, let us alert you to some relevant business issues.

Probably the first and most significant issue for anyone who's already using film cameras and equipment, and who probably has at least some computer hardware and software, is how to transition in the most effective and yet economical way to digital. Unless you have the capital funds to simply convert your entire studio in one fell swoop, you'll want to prioritize the equipment you need against what you'd like to have but don't necessarily need immediately. Furthermore, you'll want to determine how to jettison the equipment you have that you won't need anymore — meaning film cameras, lenses, darkroom equipment, and any accessories you won't need with digital.

Computer equipment

Don't be too quick to get rid of older computer equipment because you think you'll need the latest high-powered system. For sure, you'll need a fast system with lots of memory — at least a Pentium 4 system with 768MB of RAM (you can run it on less, but it'll cost you in speed). But computers that are a few years old can very easily be used to manage images as well as your day-to-day business needs such as accounting, scheduling, e-mail, and client management.

Camera systems

For some camera systems, such as Canon's EOS series, the lenses that work with 35mm cameras also work with digital cameras, which can literally save you thousands of dollars. Even many of the after-market lens brands, such as those manufactured by Tamron, also work equally well with film and digital. However, check with the manufacturer or your local pro camera store to ensure the compatibility, because some of the aftermarket brands are releasing lenses optimized for digital. Older models with the same focal features have not worked as well with digital in focusing accuracy and speed, in addition to presenting other problems.

Unless you're doing high-end studio photography for advertising agencies or other purposes requiring very high-resolution images that are greatly enlarged, don't assume that you'll need double-digit (10+) megapixel camera systems, at least not right away. You'll be much better off buying two cameras, one as a backup and one as a primary, in the 6 to 10 megapixel range instead. The new Canon 1D Mark II or Nikon D2H, for example, offer images that are more than sufficient for the vast majority of average studio, wedding, event, journalism/magazine, and sports purposes.

How Much RAM Do I Have?

Before you add random-access memory (RAM), you'll need to know how much your computer has. If you're using the Windows operating system, open the Control Panel and double-click System. Under the General tab, at the bottom of the window you'll see the manufacturer information for your computer, along with the type of processor it has, how fast that processor is, and how many megabytes (MB) or gigabytes (GB) of RAM you have.

To check the physical RAM on a Mac, select the icon on your hard drive that contains your Mac OS boot volume. Go to the Apple menu (top left corner of the screen) and select About This Computer (System 9 and earlier), or About This Mac (OS X). The System Profiler also reports RAM by slot, size, type, and speed. To add memory chips to a Mac, Apple recommends taking the computer to a dealer, but the computer's instruction manual has detailed steps to add RAM yourself. Older Macs require RAM chips to be installed in pairs, but newer models don't have that restriction.

You can determine the amount of RAM in Windows XP by choosing Start ⇨ My Computer, and clicking on the View System Information link. This opens the System Properties dialog box. RAM is displayed in the General tab of the dialog box. In OS X, look in System Profile, and then click on Memory. You'll see how many slots are used and what's in them: MB size, type, and speed.

If you intend to upgrade your RAM yourself, you'll need to know the maximum amount of RAM your computer can support. You can find this out by checking your computer specifications in your manual or on the manufacturer's Web site, where it lists information for your specific model. You'll also want to know what type of RAM to buy; there are different kinds for various brands and models of computers.

Because of their long 35mm history, you may find switching to a Canon or Nikon a conceptual challenge, at least, if you're accustomed to shooting medium-format film in cameras such as Mamiya, Hasselblad, or Pentax. Furthermore, these camera companies are offering high-end digital studio cameras, as well, with high-end capabilities and features meant to retain their long-standing photographer clients who are converting to digital. Although this is a viable business solution for photographers who are really doing high-end work, the average pro photographer or enthusiast will find that the new high-end Canon, Kodak, Fuji, and Nikon digital cameras are out-classing the medium-format brands offering digital conversion paths (see Figure 1-10). This, of course, is a business decision for any photographer, and there's something to be said for consistency of operational interface among cameras, but very often the cost considerations and equivalent quality factors will outweigh transitional adaptation to a new interface design.

The business of digital photography primarily involves the effective integration of computers into the studio concept. Although computers were used in some cases extensively with film-based photography, they were nonetheless a semi-optional element and lab and other solutions were always available to compensate. Digital photography as a business requires the use of computer systems including printers, the Web, and image editing and management tools. Photographers who learn how to effectively integrate these into a business-oriented workflow will find they have an advantage over studios that are struggling to make the change or that are less computer-savvy.

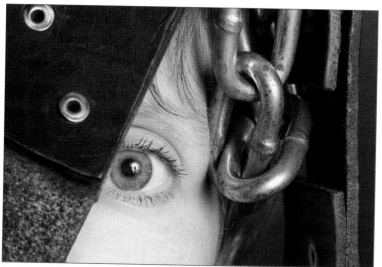

Figure 1-10: This image, a 6.3 megapixel image shot with a Canon 10D, shows a variety of color, reflective, and textural elements, such as metal, leather, skin, eyes, and other features that test a camera's ability to accurately reproduce a subject.

Implementing digital into your workflow

If you have limited experience with computers, or you're intimidated by them (don't worry, you're not alone), consider bringing on an intern from a local college who is into computers and photography. This worked well for our studio, where my wife and business partner, Amy, had only limited experience with computers and had studied photography with a classical studio/wedding film photographer who was fantastic in lighting, portraiture, and cameras but who lacked extensive digital background. And, although I was experienced with computers and technology as well as photography, I simply lacked the time (and, admittedly, the spousal patience) to train her in how to use computers and applications such as ACDSee and Photoshop, in spite of her enthusiasm and ability to learn quickly. Instead, a local community college had an especially strong photography department, and we met with the professor there who spread the word that we were looking for interns. As a result, we've had several computer-savvy college students who were instrumental in helping our studio convert to 100 percent digital.

There is a conceptual threshold to be crossed in any new pursuit, including the business of digital photography. Understanding how the day-to-day operation of the studio — including scheduling, photo sessions, production, and fulfillment — work are essential and must become second nature to the successful photographer, not something that must be relearned each time it's addressed. To master the workflow of digital photography in business, you must be comfortable operating in the photography as well as the computer modes and be equally resourceful and self-sufficient in either.

Making the decision to be completely digital turned into a business asset for me, because it was clear to our studio that there was a complete integration required between computers and cameras, and we had to understand how to ensure seamless operation. Workflow that began and ended in digital simply made sense and required less effort — to say nothing of time spent with labs for processing and image fulfillment. As we developed an increasing understanding of the integration between the camera, computer, and Web, it became evident that certain digital services optimized for photography were available that we hadn't fully considered as a film-based studio. For example, we began using Printroom.com (www.printroom.com), one of the largest professional online photography services providing hosted online storefronts where we could display galleries of our clients' images and where they could purchase and fulfill orders. This would have been very challenging with film, because every image would have had to be converted to digital format before it could be presented to clients. Furthermore, with a number of dynamic galleries online, our work was much more visible and presentable to a wider variety of potential business and individual clients than it otherwise would have been with a basic Web site and gallery of our best images.

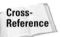

Cross-Reference

For more information on the type of service Printroom.com offers, see Stage 9.

Studio-Management Software and Digital Photography

Ultimately, a studio must be managed with tools adapted to that business. There are a number of ways to accomplish this, ranging from home-grown to commercial, studio-specific software solutions. Many studios today use a combination of Microsoft Outlook for e-mail and scheduling, Best Software ACT! for managing client contacts, Microsoft Excel for budgeting, and Intuit QuickBooks for tracking expenses and accounting. Using local small-business consulting firms to set up accounting and management tools like this can work quite well and provides a way for the average photographer to better manage a business.

However, this may not be the easiest solution or the most cost-effective. Photography is a specialized business, and, like a dental practice or a law firm, unique business activities and practices make using generic business-management tools cumbersome and time-consuming. SuccessWare (www.successware.net), which is dedicated photography-studio-management software, was designed specifically with the professional photographer in mind. It provides studio client contact management, accounting, appointment/shoot scheduling, planning, and forecasting, all in a turnkey application that supports everything from a small one- or two-person studio all the way to a large operation. Photo One is another similar application, available from Granite Bear (www.granitebear.com), which integrates with Microsoft Word and Intuit QuickBooks.

These applications, as well as others, tout themselves as workflow software, although obviously not for image editing or image archival/storage. However, it is noteworthy that they distinctly consider themselves part of the workflow process, and that they address the business side of digital (and film) photography and what is involved in getting a photograph from the studio to a client. These applications certainly aid in helping the photographer organize and operate his or her business, allowing more time for working with subjects, clients, and images.

As for managing our office and administration, we found that computer-based studio-management software from photography-specific services such as SuccessWare, although available for film- or digital-based studios, were optimized for the digital photography world and suited us well. Although I have not included studio management, scheduling, accounting, and the like in the digital photography workflow process per se, it definitely has a place in the working life of the photographer and is critical to its success.

A Digital Photography Workflow Diagram

I've mentioned a number of aspects of the digital photography workflow, but let me summarize the process. Broadly, digital photography workflow divides into several logical stages: preparing for and taking the photographs; transferring, organizing, and archiving images on a computer (and an accompanying network); editing and enhancing the images for optimal display, client needs, presentation, and distribution; and distributing and displaying images and fulfilling image orders. Some of these stages may take place in tandem, especially if there is a team of studio staff working together on a photo assignment. At a more granular level, there are several primary components making up digital photography workflow:

✦ Preparation of cameras, computer, and digital studio — whether in the field, on location, or in the studio

✦ Execution of the photo shoot (taking the photos, reviewing them, and making adjustments)

✦ Transference of images to the computer

✦ Image review, identification, and organization

✦ Processing digital photographs

✦ Digital-image storage and backup

✦ Creative and custom image enhancement and optimization

✦ Image output (online and in print)

✦ Image display and distribution

The flowchart diagram in Figure 1-11, which shows an overview of the digital photography workflow process and key decision points, should be helpful to your understanding.

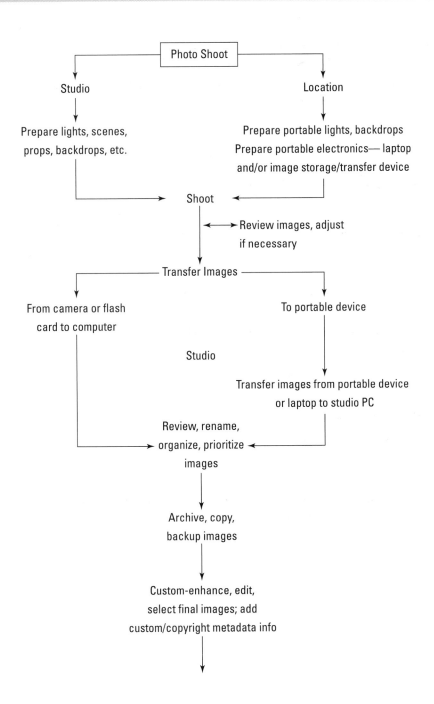

Figure 1-11: Workflow involves key, interdependent stages that flow in a linear fashion for individual photos, but the photographer addresses a variety of the stages throughout the day.

Using Workflow as a Marketing Tool

I've found that digital photography workflow, properly managed and explained, can be a very important marketing tool. As a form of what professional consultants call *best practices,* it provides a type of assurance for clients, business partners, and other key business contacts that your studio operates according to an accepted methodology and set of processes to ensure quality, service, and efficiency. Furthermore, it enables you to train new photographers and studio staff in a consistent way that streamlines your efforts to get them up to speed and helps them be successful quickly.

Often clients perceive photography to be a simple process, and they fail to understand the amount of work and detail in producing and fulfilling professional-quality work. ("All you have to do is take the picture and then print it on the computer, right?")

When pitching new business, your focus on workflow practices can be articulated to educate and inform potential clients—commercial or individual—about photography and what is involved in the images they want you to create. This, then, translates into their understanding more about what you do and what's behind your rates and fees. They further understand that there's a reason photography is a *profession,* and that simply owning a digital camera and a computer isn't sufficient to produce professional images.

Although most people likely won't want to have a complete explanation of how the workflow is involved in running your studio, telling them "We use a well-defined practice of digital photography workflow in our studio that allows us to efficiently take and process professional images from the studio to the digital lab, and then to a professional print for you" gives them confidence in your abilities and professionalism. In your marketing materials, such as collateral, Web site, and presentations, you can include brief descriptions and phrases about your workflow practices that will add to the professionalism of your studio.

Summary

The workflow concept applies to all forms of photography, providing a tried-and-true method and activity path for creating, processing, and fulfilling images. Consumers, semipros, and professional photographers all employ elements of workflow in their endeavors, whether they're aware of it or not, which is all the more reason why identifying the clear tasks involved and how to effectively transition among them is so useful. In digital photography, workflow is even more important because of the numerous variables involved in processing images on a computer. With the tremendous variety of software applications and Web tools for image acquisition, editing, storage, archiving, presentation, distribution, and fulfillment, every image could conceivably be processed differently than another—a very inefficient and time-consuming prospect. Even within specific applications, such as Photoshop or ACDSee, images can be acquired, processed, and stored differently due to the robust nature of these products.

Digital photography workflow provides virtually any photographer with a method and standard set of best practices to ensure each image is treated optimally. This way, there's a consistent method for doing things, results are more replicable, and your work is more easily accessible and secure. You get to spend more time taking photographs and working with the images you or your clients really need the most.

✦ ✦ ✦

2 The Digital Camera: From Pre- to Post-Pixel

This prominent statue standing guard over the Helsinki, Finland train station is a dramatic example of twentieth-century European architecture. This shot was taken with an Olympus E-20P at ISO 80, f/2.8, 1/250 second, and 22mm focal length.

A skilled musician's instrument is so tightly integrated with the performer that she doesn't have to think about anything but the music — the technicalities of the keys, valves, or strings become deeply integrated. Likewise, the skilled photographer has honed his skills and practice enough that he "plays" his camera, the image-transfer process, and computer processing, including editing images in an application such a Photoshop.

Certainly, the number of tools, settings, and features that must be used with a camera and computer greatly exceed that of a musical instrument. Nonetheless, the more consistently and fully integrated the camera and computer, the more the photographer can focus on producing images instead of files — which is the fundamental reason why digital workflow is becoming the standard in the professional photography world.

All types of hardware choices affect the digital studio. Ensuring these not only work together effectively but also optimize the effects they produce is essential in yielding successful and powerful images.

In this chapter, I explain how to select and set up a wide range of equipment required for your digital photography workflow, including:

✦ Cameras and lenses

✦ Storage media

✦ Lighting

✦ Computers

✦ Scanners

✦ Printers

✦ Color-management devices

Tip You can use the preceding as a checklist when getting started with the creation of your own digital studio. All of these topics are addressed over the course of the book.

Consumer versus Professional Digital Cameras

How an image is viewed and framed is perhaps the most obvious difference separating professional from consumer photography, although the world is changing rapidly. Professional digital SLR cameras universally operate like film cameras, primarily featuring through-the-lens viewing, allowing the photographer to look through a viewfinder at the subject. Point-and-shoot cameras, although sometimes offering a simple viewfinder (although not through-the-lens), also typically allow the photographer to look at a low-resolution LCD video image of what she's about to shoot.

If you're not a professional but you're shooting lots of photos — more than a hundred in a day, for example — you're much better off purchasing a prosumer SLR camera. Framing multiple images using an LCD screen is very tiring, and achieving good image quality is difficult. A number of semiprofessional cameras today offer high-end SLR features at near-consumer prices, and these cameras are by far superior to the point-and-shoot models. As much as possible, I recommend that anyone with an even moderate interest in photography purchase a digital SLR.

Note A prosumer is a consumer with a higher-level interest in a given area who typically spends more on a camera than other pure consumers. Prosumers often become professionals, at least on a part-time basis.

The feature trap

Many of the less-professional cameras can lure buyers with lots of whiz-bang features that seem like they'll enhance the photography experience.

Caution The more automation your camera has, the less control you have over the photo and the more likely your photo is to be of lesser quality. In the amount of time it takes to master the features by trudging through the camera's manual, you could have learned some basic photography principles and applied them to a more basic, but more controllable, camera.

High-end cameras aren't loaded with automated features — they focus on high-quality capabilities instead, such as a wide range of ISO settings, for example, that allow the camera to take good-quality photos in diverse lighting situations.

The Canon 10D is a prosumer camera primarily because it offers some automated features — such as pre-sets for various photography situations like sports, night shots, and the like — but, although I use a 10D, I never use those settings. Essentially, the camera companies produced professional cameras such as the 10D and added prosumer features to widen the potential audience. Although thousands of professional photographers use these cameras, they typically use a fraction of the automatic features, if any. In photographing fencing, for example, I shoot in a completely manual mode — manual aperture, shutter speed, and even focus. Shooting manually gives me total control of the image I'm taking, and I can make changes as the conditions, lighting, and situations change, as opposed to relying on the camera to correctly adapt to the situation — which it invariably gets wrong more often than I do!

Every major camera company offers a confusing selection of products, including high-megapixel, feature-laden point-and-shoot models, prosumer SLRs that leave you wondering what might have been compromised, and high-end cameras that seem too simple to warrant the price.

For the serious photography hobbyist who wants to take good photos, but probably won't be selling too many of them, get the best SLR you can for your money — the ability to control the image manually is a much better "non-feature" than any whiz-bang option you'll get in a point-and-shoot model. Video, for example, doesn't mean much to most serious photographers, but is added on to lower-end cameras making them seem more versatile.

If a point-and-shoot camera lets you control the photograph manually — at least to a degree, meaning it might give you the option of setting your shutter speed and aperture manually, focusing and framing through an optical viewfinder (as opposed to an LCD screen) and provides an optical, not a digital, zoom — then it's worth considering. Otherwise, if you're at all serious about producing anything more than a snapshot, keep looking.

The myth of the megapixel

Comparing megapixels is a common game among digital camera owners. Megapixels seem to be the defining factor for consumers when they're determining the quality of a camera. In truth, there's more to digital photography than the megapixel.

What's a *megapixel,* anyway? Think of a photo as being divided into a matrix of millions of points of light, each with a different value. These points of light relate to the number of points that are physically on the CMOS (Complementary Metal Oxide Silicon chip) or CCD (Charge-Coupled Device), which is the sensor inside the camera — like film — that absorbs light and converts it into an image.

For example, a 6.3 megapixel camera, when taking photos at maximum size, generates images that are 2,048 x 3,072 pixels. Think of those two numbers (2,048 and 3,072) as the two sides of a matrix, and, remembering a bit of junior-high math, multiply the two numbers to find the total number of pixels: 6,291,456, which is rounded to 6.3 megapixels (a *megapixel* is equal to 1 million pixels).

For a 6.3 megapixel camera, 6.3 is the maximum number of pixels it will produce. Every image that is cropped loses those pixels and becomes smaller depending on what is cut out when it's cropped. It cannot be made larger, although there are some software packages, such as Lizardtech's Genuine Fractals, that through very complex and sophisticated algorithms can allow some images to be enlarged to significantly larger sizes with surprisingly little loss of quality.

Certain image file formats offer more digital information for optimizing, editing, and printing an image. TIFF files, for example, can include more data than a JPEG file. However, because the JPEG file format is more compressible and the images are smaller, it remains a more popular file format.

A camera that records in at least TIFF, and preferably RAW format, will make the most use of the megapixel capabilities and provide the most detail. The RAW format is the unedited, uncompressed, and unprocessed image the camera sees; therefore, it offers the most pure way to see an image as it was shot at the full size of all the camera's capabilities. However, these images must be saved in a conventional format using a program that interprets them (for example, Photoshop CS includes a RAW file converter) into an optimal format, such as TIFF, that can handle the full set of information.

Tip Remember that once you save an image as TIFF, the image can also be saved as a JPEG or other file, but often it must be converted into a lower-information mode. This involves changing it from 16-bit to 8-bit mode, which is simple to do in Photoshop.

I photographed the homeless woman in Figure 2-1 on the streets of Plovdiv, Bulgaria, which hosted the 2004 Junior World Fencing Championships. The woman would come out onto the street every morning outside our hotel when we were walking to the fencing venue, and the character of her face and the story it seemed to tell was too much for me to resist, so I took some time one morning to photograph her. The photograph was shot in the RAW setting, which is the full resolution the camera offers — 6.3 megapixels.

Cross-Reference Shooting in RAW and JPEG settings is covered more fully in Stage 1.

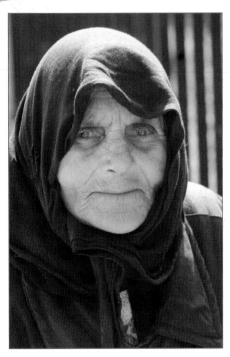

Figure 2-1: Photo shot in RAW format to be saved as a TIFF

Megapixels, size, and resolution

Megapixels can be confusing, so let me explain it further. How do 6.3 megapixels relate to an image's size and resolution? In Photoshop, for example, when you choose Image ⇨ Resize ⇨ Image Size, the Image Size window appears, giving you two sets of information — pixel dimensions and document size — as shown in Figure 2-2.

An image's resolution is a very relative thing, which is what makes it a bit challenging to understand. Resolution is how "fine" the image looks at various sizes. It's measured in dots per inch (dpi). The dots are the same as pixels, so resolution is also sometimes referred to as pixels per inch (ppi). If you don't have very many dots per inch and you make the image too large, it gets a "jaggy" look — especially in print. Images on the Web usually have a lower resolution — usually 72 dpi — so when they're printed, they don't look very good. The lower-resolution images you find on the Web have a two-fold purpose: Because they are smaller, they load faster onto computer screens; they also are, by default, less likely to be copied and used without permission because they will look jaggy if enlarged and printed.

Figure 2-2: The Photoshop Image Size window, showing pixel dimensions and document size for a 6.3 megapixel photograph.

There is a relationship between pixels and image size. In general, image size is constrained by the number of pixels. If the same number of pixels that display properly in an 8 x 10 photo are expanded to a poster sized photo, the resolution, and thus the quality of the photo will degrade.

While increasing the size of an image (assuming the same number of pixels) degrades image quality, decreasing the size of an image (while retaining the same number of pixels) does not hurt image quality. An 11 x 17 image at 180 dpi is a high-resolution image; if you resize the image to a smaller size, and increase the dpi accordingly (which Photoshop and other programs will do for you automatically), the image will lose no image data. However, compressing the same amount of data into a smaller image produces its own forms of distortion, caused by packing together too many pixels. Resampling reduces the extra data and removes distortion, but a resampled image loses data and cannot be re-enlarged to the original size. All this emphasizes the general rule of not editing the original file of your photo, but instead archiving it safely while editing a copy.

Cross-Reference For a more in-depth discussion of resizing and ratios, see Stage 7.

Web images are constrained by the resolution available in monitors (approximately 72 to 100 dpi) and the bandwidth (download time) necessary to transmit large image files over the Internet. The reason the 72 dpi images you see on the Web look so bad when you try to enlarge and print them as 8 x 10s, for example, is that they are sized to be very small, just a few inches high, and when you combine low resolution with a physically small image, it won't look good if you blow it up larger.

So, it's relatively easy to reduce the size of a photo without reducing resolution or quality. Increasing an image reduces resolution, but sometimes that's okay. For example, if you have, a 600 dpi image that's 4 x 6 inches, you can blow it up significantly and still end up with a resolution of 180 dpi, which is acceptable for many professional photos.

When you increase the size of a photo, image-editing software such as Photoshop allow you to add pixels using various options. Obviously, these additional pixels must be interpolated by the software — a process referred to as resampling. The default resampling technique used by Photoshop to generate additional pixels for color photos is called Bicubic, which is best for all-around resampling of most images with the least degradation or mutation. Two other methods you can choose, Nearest Neighbor and Bicubic Smoother, are optional resampling methods that can be found under the Image Size options on the Photoshop Image menu.

Bicubic often has the smoothest results, but can take longer than other methods. Bicubic Smoother is best used for enlarging photos, and Bicubic Sharper is best for making them smaller although it can make things look a little *too* crisp at times. The Bilinear option is used to work at a mid-level quality level and is less useful, generally speaking. Nearest Neighbor is fastest but the least accurate; it's better for images where you want to keep sharp, hard edges and produce a small file size. Watch out for "jaggy" results when using this method, however.

What does this mean? Simply, let's say you have a 180 dpi image at 11 x 17 and you make it bigger — you enlarge it to 20 x 30 inches, for example. Although the software will help keep the image looking pretty good, you're beginning to lose quality, because the application has to fill in what it thinks the photo should look like in the empty spaces you've created by making it bigger than the best-quality resolution. Photoshop is good at accommodating this kind of artificially intelligent enlargement, but generally speaking you're limited in how large you can go before the image begins to suffer in quality.

What About Inkjet Printer Resolution Numbers?

As you process this discussion about image resolution, you might be wondering about the relatively astronomical resolutions associated with photo quality ink jet printers. If your photo will be printed on a 3600 dpi inkjet (or some other resolution in that range), this does *not* mean you need to capture or save your image with a resolution anywhere near that number. The very high dpi values advertised with photo quality inkjet printers allow those printers to *dither* (combine) *many* pixels to produce more exact color reproduction than lower resolution printers. To take the 3600 dpi example, if you print a 180 dpi photo file on a 3600 dpi printer, that printer can dither up to 20 different inkjet droplets to fine-tune the perceived color of the image pixel.

Image quality: Measure twice, cut once

Digital photographs can be altered more effectively the first time they're edited than they can in subsequent edits. When editing an image—especially if you're attempting to make it bigger than its native resolution—it's best to always work with the original photograph instead of a second (or subsequent) generation of an image.

Note Most digital image formats are *lossy,* which means they use compression algorithms to reduce file size by eliminating "extra" data in the file. Each time the file is resaved, the compression process removes more data from the file, reducing the accuracy with which the image is reproduced. The TIFF format allows for saving with no compression, and is a lossless format (no data is lost during saves).

There's no real magic about megapixels; they only relate to the specific size and resolution that a digital camera is capable of photographing. So why is it, then, that the image quality from one 5 megapixel camera can be so different from another?

This relates to a number of factors that all affect how the camera sees and processes an image, generally referred to as pre-pixel and post-pixel stages. In other words, some things that make a photo look good or bad happen before the camera has seen the image, and other factors that affect the image quality happen after the image has been seen by the camera.

The factors that affect an image's quality *before* the camera sees the image, in the pre-pixel stage, are the following:

✦ Lens(es)

✦ Shutter

The factors that affect an image's quality *after* the camera sees the image, in the post-pixel stage, are the following:

✦ Type of light-sensing technology (CMOS versus CCD)

✦ Light sensitivity (ISO)

✦ Quality of electronic image processing and noise filtration

✦ File format (TIFF, JPEG, or RAW)

Depth of Field

Digital cameras, just like film cameras, are affected by the "triangle" of photography that makes each image what it is: how fast the shutter opens and closes (shutter speed, measured in fractions of a second); how wide the lens aperture opens to allow in light (measured in f-stops, such as 2.8 or 5.6); and the sensitivity of the light-absorbing media (measured in ISO, such as ISO 400 or ISO 800). This triangle is the same for the digital or film camera — the only real difference is what kind of media is absorbing light (film or an array of digital light sensors).

This triangle concept, especially shutter speed and aperture settings, create what is called depth of field. *Depth of field* is the area in focus that the camera "sees" to take the photo. For example, a narrow-depth-of-field shot is where you might see a person's head in a crowd and all else in front or behind the person is blurry. In a typical wide-depth-of-field shot, the entire scene is focused, such as when photographing a large group of high-school students layered on a set of bleachers. In the following figure, for example, you see only a specific part of the image in focus — the hands and the weightlifting dumbbell. The athlete's arm and chest are farther away and, because the depth-of-field is narrow, they are out of focus.

Some digital cameras offer automatic depth-of-field settings that calculate and assist in taking optimal photographs for various subjects and scenes. However, simply bearing in mind that a wide aperture opening (for example, 2.8 or 3.5) will result in a narrow depth of field, and a narrow aperture opening (for example, 16 or 22) will result in a wide depth of field generally suffices as a general rule to guide most focusing scenarios.

Where this becomes challenging is if you're using a digital camera's auto-focus capabilities. You must be extremely careful about where the auto-focus is "looking" as your subject changes. Especially in narrow-depth-of-field photos, you can easily take a photo that is focused on something just in front of or behind the subject, resulting in a *soft* (out-of-focus) image. If you want to use at least a semiautomatic setting, but you want to control depth of field, use the aperture-priority setting on your camera and set it according to the type of image you want to create.

In Photoshop or other digital-imaging packages, you can edit an image's depth of field. Here's a quick-and-dirty way to make a narrow-depth-of-field image out of one that is completely focused: Select the background or part of the image you don't want focused. Use the software application's "blur" tool to make the background look out of focus.

Point-and-shoot cameras have notoriously poor pre-pixel quality, with small lenses allowing only limited quality and diversity for the images they capture. The range of their apertures is narrow, and they typically have a difficult time taking very-narrow-depth-of-field shots that require a wide aperture — the lenses are optimized to get a large portion of the image in focus, not the reverse. These cameras also have limited shutter capabilities, lacking the ability to take very fast or very slow photographs, which means that the light and the environment have to be illuminated as well as possible.

Small lenses and poor-quality shutters have always made the difference between high-end and low-end cameras. Professional-level glass lenses have more physical components and better-quality optics. Large lenses allow more light, and may offer features such as motion stabilization, alterable distance optimization (changing how the lens sees things either closer or farther away), and the ability to keep the same wide aperture at any focal length. For example, a zoom lens that can operate at f2.8 from 70mm to 200mm is an expensive technological tool, but invaluable to photographers who need to be able to shoot in lower-light conditions.

A shutter has to operate perfectly, and higher-end cameras have shutters that can either stay open indefinitely or open and close in as fast as 1/8000 of a second or more. To be able to do this, more precise mechanics and technology are required, which cost more. Further, a camera for sports shooters or photojournalists must be able to withstand the rigors of the field, and "ruggedization" of any type equates to higher cost.

Pre-pixel, post-pixel

As a photographer, when you transfer images to the computer from your camera, you've taken the most significant step that differentiates digital from film photography. Until that moment, photography isn't all that different to the person taking the photos, with a few notable exceptions (such as the ability to review images on the camera). You still deal with exposure, lighting, lenses, focusing, flashes, depth of field, and other common photographic concepts.

The digital studio is affected by non-digital devices, as well. Good lighting, for example, is a critical component of photography that makes an impact on image quality long after it has been transferred to the computer — yet it's simply a standard part of basic photography. A well-lighted subject can make digital photo editing far easier, less expensive, and much more modifiable. Similarly, optimizing depth of field — while something that can be digitally faked with complex Photoshop layering techniques — is a basic photographic concept that can make for vastly different images.

If you've ever shopped in an audiophile store and taken a close look at high-end receivers, tuners, and amplifiers, perhaps you've noticed one of the more obvious differences between these astonishingly expensive devices and mainstream consumer stereo equipment: the remarkable simplicity and lack of features on the high-end equipment. Digital cameras, being yet another electronic device striving to produce quality output have fallen prey to the same marketing tactics and ploys that have been selling mid-range stereos for several decades. Yet, when you read an advertisement or promotion on the mid-range consumer products, they sound as if they have more high-end features than a product five times their price. Common business principles apply: Dazzle uneducated consumers in the showroom, catalogs, and magazine ads with techno-whiz features the consumers are unlikely to understand fully but that sound so impressive and intelligent that the product practically sells itself and convinces the buyers they're getting incredible quality at an unbelievable price.

What's in a Pixel?

The word *pixel* is actually short for picture element, which more accurately describes what it really is: Technically, a pixel is a component of a digital image, not a physical part of your camera. As photographers, we often refer to pixels, x-megapixels, and megapixels as if they were hardware; they're not. The light-receiving components of your camera's sensors are called photodiodes or photosites, and they produce pixel information. However, because much of the time we're speaking in general terms, we frequently generalize and use term pixel loosely.

Pre-pixel hype

For digital cameras, the hype is concentrated on the pre-pixel stage of photography, and in the addition of non-photographic features to sell customers on ease of use and a broad set of camera capabilities. For example, let's examine the text of a recent ad for a higher-end SLR consumer camera. The list of features the ad was praising included the following:

✦ Anti-shake technology, so no tripod was necessary

✦ 8.0 megapixels

✦ 7x optical, 2x digital zoom GT APO lens

✦ 3-D predictive focus control with subject tracking capability

✦ VGA electronic viewfinder offering 922,000 pixel TFT with 100% visibility

But what do all the features mean to the buyer? Let's analyze how this ad dupes the unwary aspiring photographer into a buying frenzy:

✦ **Anti-shake technology:** This feature exists in many other cameras, such as the sophisticated image stabilization technology in Canon lenses. What the consumer probably doesn't know is that it's really only useful in photos shot in low light at less than $\frac{1}{60}$ of a second. And, as far as a tripod goes, pros don't always shoot with tripods. Most images won't blur if you're using a flash or shooting at even a moderate speed. Realistically, most people can effectively hold a camera steady at $\frac{1}{60}$ of a second.

✦ **8.0 megapixels:** The number of megapixels doesn't improve the image quality, just the resolution and size. So a whopping 8.0 megapixels means the camera is taking in more information, not improving on it.

✦ **7x optical, 2x digital zoom GT APO lens:** I've already discussed why digital zooms are pretty useless. (What a "GT APO lens" is, I'm sure has some technical definition, but I don't know what it is and neither will most buyers.) The acronyms get confusing as to what's a brand name meant to sound snazzy and what's an actual term. It won't help inform the consumer, but it sounds cool.

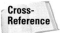 **Cross-Reference** For more information on digital zooms, see Chapter 1.

✦ **3-D predictive focus control and subject tracking:** Okay, it focuses quickly. Great. What in the world is "3-D predictive focus control"? What is "subject tracking"? Will the camera lock in and follow a specific element of a scene? Will it reduce shutter-lag? Again, exciting words that fail to accurately inform a buyer — it sounds like an F-16 fighter jet more than a digital camera.

✦ **"VGA electronic viewfinder offering 922,000 pixel TFT with 100% visibility:** I cannot imagine what would make an electronic viewfinder better than looking through a conventional lens at the actual image the camera is seeing. The big number, the use of the word *pixel,* the cryptic TFT acronym, and the use of "100% visibility" tell me nothing except they've thrown technology features and names at something that worked well without it before.

In addition, this particular ad featured two photos meant to illustrate anti-shake on and anti-shake off. At ½-inch wide each, the photos in the ad are not detectably different, even when viewed under a photographer's *loupe* (a magnifying device used for looking at slides and negatives); hopefully, the camera produces better results than the ad represents. Anti-shake technology is extremely sophisticated and deserves better treatment than this ad provides; consumers today are very perceptive, surprisingly technical, and like to read useful and well-presented information.

I don't single out this ad to criticize a particular camera as I'm sure the camera produces good photos, is well made, is easy to use, and represents this name-brand consumer camera company very well. However, what is clear is that these types of ads hyping fancy sounding features don't actually improve photography and can actually fool and confuse consumers into thinking the camera is more professional than it is.

Notice especially that these features almost all focus on the *pre-pixel* side of the camera—where the consumer notices most of the operation. It says very little, if anything, about what happens in the camera after the image passes across the sensor to the post-pixel stage, which is where quality technology is the most important. Instead, it pushes technology at the viewfinder, lens, and focus side, where most professional photographers operate cameras in digital exactly as they do in film. No pro photographer will easily give up looking through glass at a subject for a VGA screen.

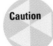

Caution If a feature sounds good but has no real merit, be suspicious—especially at the pre-pixel stage. In photography, just like stereo equipment, never, ever give up quality for features.

Is An SLR Too Much For You?

I'm clearly biased toward the quality, capabilities, versatility, and simplicity of an SLR-type digital camera. However, this isn't to say that you can't get decent photographs from a point-and-shoot camera. You can. But it's going to operate differently, in some cases more like a video camera than a still camera, and you will most likely be giving up some control of manual settings in exchange for automatic, camera-measured exposures. If this is what you have in mind, you'll want to consider a few things when making the purchase:

✦ **How good are the optics?** Chances are if a camera company, not a computer company, manufactures the camera, the glass will be better. Canon, Nikon, Olympus, Minolta, and other camera companies are often the best choices for this type of camera.

✦ **Do you at least have some manual control over the camera?** For example, can you set the ISO, shutter speed, or aperture?

✦ **Can you look through an optical viewfinder instead of at an LCD screen?** Is the viewfinder actually big enough that you can really frame a photo effectively?

✦ **How does the camera "feel" to you?** Is it ergonomically comfortable?

✦ **Does it have an option for other lenses?** If it is a fixed lens camera, is the zoom only digital or is it optical? Optical is, by far, preferable. Some systems also combine a digital/optical combination that lets you zoom optically to the maximum point, and then increase it digitally.

Choosing Lenses

Professional cameras feature interchangeable lenses, with literally dozens or even hundreds of lenses available from the manufacturer and after-market lens vendors. When you combine these lenses with highly sophisticated shutter systems that can operate equally well at ⅛,₀₀₀ of a second and being open manually as long as the photographer likes (a "bulb" setting), the pre-pixel quality soars to great heights. This kind of range of control over how the camera operates to produce an exposure in radically diverse light and environments provides tremendous control over the image before it ever converts to a digital format. Furthermore, the pro cameras offer features such as digital *plungers*, which allow the camera to be operated with a remote cable shutter release that prevents the camera from being jostled during a long exposure (typically when it's mounted on a tripod).

Tip

As much as possible, shoot photographs in as low an ISO setting as possible to reduce noise. If you're taking photographs without a tripod, this means dropping your shutter speed below ⅟₆₀ of a second. However, you may need to increase it to prevent the image from being blurred. In a studio, for example, where lights can be controlled, you can easily take photos at ISO 100, 200, or 400, all of which will yield images without visible digital noise. Likewise, at an indoor event, using a flash will help a camera be able to take good photos without having to operate at a higher ISO.

If you're in the market for a digital camera and you haven't used an SLR before, be aware that your largest investment may very well be in the lenses. Every photographer needs a variety of lenses for different purposes, or a single lens (on less expensive, consumer cameras) that achieves as many of these types of optical effects as possible:

✦ **Wide angle:** A short-focal-length lens for taking in a wide scene, such as a landscape or a large group of people

✦ **Portrait/normal/general-purpose:** For a wide variety of photography representing the world "as it is." A primary lens for most photographers, often with a wider aperture (for example, F2.0 or larger) than other lenses.

✦ **Telephoto:** A long-focus lens for seeing things far away; great for narrow-depth-of-field, distant close-up photographs such as sports

SLR Lenses Designed for Digital Cameras

A few camera manufacturers now develop and sell lenses optimized for digital cameras. There is a theory among some photography manufacturers — Olympus in particular — that pixels will more accurately reflect an image if the light hitting them is as perpendicular (as close to 90 degrees) as possible, and than any deviation from this will result in a less accurate image because the pixel is not fully "illuminated." Schneider, the manufacturer of large-format digital cameras, also subscribes to this theory. However, most of the major mainstream digital-camera companies, such as Canon and Nikon, do not express this as an issue for their cameras. Their lenses are interchangeable and work equally well, they claim. Depending upon the size of the CCD or CMOS, unless it is a 1:1 size match for 35mm film (few cameras offer this; the Canon EOS 1DS is one of the few), the image will appear different looking through the same lens with a film or digital body. For example, if you look through a Canon EOS3 35mm film camera and any lens it supports, the image in the viewfinder will appear much larger than through the same lens on a Canon 10D because the digital camera's sensor is smaller than a 35mm film frame.

✦ **Macro:** For extreme close-ups such as flowers (some different types of lenses include a macro capability)

✦ **Zoom:** A variable-focal-length lens that ranges from wide-angle to telephoto, allowing the photographer to change the lens's optics by turning a ring on the outside of the lens body

This book doesn't delve deeply into lenses or optics, primarily because there are many general photography books that provide ample information about them, and the performance of digital and film cameras are mostly the same when it comes to lenses. Suffice it to say that, in addition to the basic lenses listed in this section, there are numerous types of specialty lenses and lens attachments worth investigating for a wide variety of photographic purposes. Typically, acquiring lenses is a costly endeavor, especially for those lenses featuring specialized capabilities such as image stabilization, long focal length with a wide aperture (for example, a 300mm lens with F2.8), or other lens-specific features. Also, camera manufacturers such as Canon and Nikon offer multiple levels of lenses with similar features, but very different durability and reliability.

Many types of *physical* lens attachments exist for photographers, such as *lens hoods* (to prevent stray light from interfering with a photo) and *lens converters* (which multiply the magnification of a lens so that it has a longer telephoto capability). There are also a wide variety of lens filters available that can greatly enhance the pre-pixel photography experience: soft-focus, starburst, polarizing, and spot, which focus or color on a specific part of the field of view. These high-quality glass rings are screw-mounted to your camera's lens. These can save you from spending lots of time adding software effects in Photoshop later.. Always put a haze or skylight filter over a lens you use in the field to protect it from dust as well as breakage. A wide variety of colored filters are available, although they're much more useful for film because colors are so easily altered — both subtracted and added — in Photoshop. The filter used in the digital candlelight photo shown in Figure 2-3 was a four-point starburst filter.

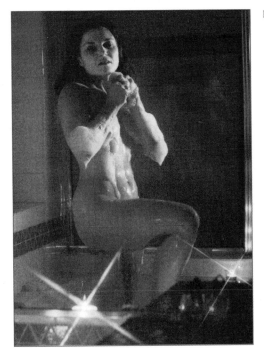

Figure 2-3: Using a four-point starburst filter

Post-Pixel Considerations

When you take a digital picture, the image hits the CMOS or CCD, it's processed through your camera's "optic nerve" to be converted into a specific file format, and then stored on the media your camera uses (for example, CompactFlash, Memory Stick, or SmartMedia). This is the post-pixel stage, where everything is now digital. The quality of the image at this point is subject to several factors, including the digital and technical quality of the camera, the digital settings applied to the camera by the photographer (such as ISO), and how the image is processed after it is transferred to the computer.

CMOS versus CCD

Digital cameras absorb light and images on a small plate that uses either of two types of technology: a CCD (charge-coupled device) or a CMOS (complementary metal oxide semiconductor), both which refer to the type of chip. CCDs and CMOS chips do the same thing on the surface: Through an array of light-sensitive points, representing pixels, they interpret an image as a matrix of tiny spots of light that, together, make up an image.

Many of the higher-end professional cameras today use CMOS chips, but doing so is, overall, a more expensive way to process images because CMOS chips produce more digital noise that must be filtered and processed by high-end, costly computer technology. However, the images CMOS chips produce are more controllable and are of higher quality. If you're shooting larger-format RAW files, in particular, CMOS is the way to go.

CCDs have been around longer than CMOS chips and are very reliable, but they tend to be less effective at very high resolutions for 5-megapixel cameras and beyond.

ISO settings

If you're using your camera in the fully automatic setting, it will choose your ISO for you — a dangerous proposition in low-lighting conditions. You're better off using the semiautomatic setting, where you can specify the ISO and then decide if you need a flash or not. Some cameras, such as the Canon 10D, can be set to not go to their highest ISO setting, which helps prevent the camera in a fully automatic mode from setting itself to produce very noisy images.

Higher-end cameras offer ISO settings — 3200 or higher — which can take photos in very low light but, like film, produce lots of distortion in the form of digital *noise* (known as *granularity* in a film camera). Noise appears like small spots of sand-like color that prevent the image from being smooth.

Figure 2-4 was taken with a long exposure and a high ISO setting. The first photo was shot with a Leica 35mm film camera at F5.6 for about 25 seconds with a very-high-ISO film, Fuji Press 1600. Notice the small spots on the image, typical of a photograph shot at a high ISO setting with sensitive film. Figure 2-5 is a digital photograph shot on an Olympus E-20 on the same night. It, too, shows a high degree of digital noise because it was shot on its highest ISO setting (which isn't all that high — only 320 — but a long exposure also increases the noise).

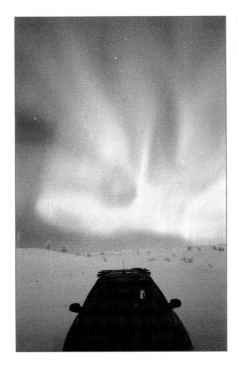

Figure 2-4: A mid-winter photograph of the Aurora Borealis shot with a Leica film camera exhibits the typical spots of a high ISO setting.

Because the Olympus E-20P, a semiprofessional digital camera, was limited to an ISO of 320, the exposure was set for F5.6 at 45 seconds. However, notice how the digital noise tends to occur more with a variety of colors, and the film image is simply a decrease in image quality with more-pronounced and visible "grains" of consistent color. While there's a lot of digital noise in the image, it can, to a degree, be minimized using various software applications such as nik Dfine.

Some digital cameras handle digital noise better than others, due to more sophisticated internal processing. CMOS tends to generate a little more noise than CCD, but the higher-end cameras account for that and process out the noise before the image ever hits the storage media.

Digital image formats

Another post-pixel issue is the type of file format you choose your camera to record. Most commonly, digital cameras shoot in JPEG format, although it has its definite limitations; higher-end cameras will also shoot in a lossless format such as TIFF and RAW, the latter of which is the way the camera really sees an image.

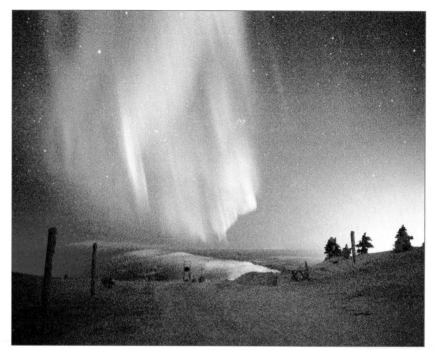

Figure 2-5: A mid-winter photography of the Aurora Borealis shot with a digital SLR also exhibits the spots (digital noise) typical of a high ISO setting.

RAW format

Many pro photographers today shoot images in RAW format, which really isn't a format at all but simply a digital recording of the image exactly as it was recorded on the CMOS or CCD. The advantage of this is that RAW offers the most accurate and, consequently, the most controllable image possible.

Many wedding photographers, for example, love the RAW format because of the age-old problem they encounter of having a photograph of a bride in which her face and the scene around her are perfectly exposed, but her white dress is totally overexposed. Using the RAW format, photographers can more easily edit images to bring out details in the dress and still have an overall exposure that is perfect. Figure 2-6 illustrates this challenge.

RAW files, when opened in Photoshop, are saved in a common format such as TIFF, which retains the lossless and detailed format. Image files are not saved in a RAW format after being opened in Photoshop or other applications (although there is a Photoshop RAW format, but that is a different format used to transfer images between applications and computer platforms).

JPEG format

JPEG files have become the most popular and common file types used by digital cameras because of their ability to be compressed easily, their color quality and focal precision, and their relatively small size compared with other formats such as TIFF. However, JPEG files are primarily a lossy format and they will lose quality as they are saved and otherwise changed over time. Good for general-purpose photography, they are limited in professional application.

Figure 2-6: RAW image files allow better control over variations in color and texture.

Because RAW files can be a bit cumbersome and tricky to process, as well as time-consuming, some higher-end cameras allow images to be processed simultaneously with RAW and JPEG. Just be sure to use storage media with plenty of room, because this takes up lots of space!

TIFF format

TIFF files are sometimes used in digital cameras, and their quality is very good, but they tend to be large and file size is not reduced substantially with many TIFF compression options. Often, professional printing companies and graphic designers like using TIFF files because it's a lossless format that keeps an image very stable in terms of quality over saves and other treatments, and they're more forgiving when it comes to color and tonal adjustments than JPEGs. JPEG files, however, are by far more common as a digital image standard for the average prosumer photographer.

All the post-pixel factors — ISO, file format, digital filtration, and the type of image-acquisition sensors (CCD or CMOS) — directly affect the type and quality of image produced in the camera before the image ever is transferred to the computer. Some of these factors, such as the quality of the digital filtering or whether the camera uses a CCD or a CMOS chip, are not alterable. But other factors, such as ISO or file format, can be controlled. At the post-pixel stage, the photographer has, perhaps unwittingly, begun to directly engage in digital photography workflow and to control the photographic process to create images of superior quality.

Storage Media

Three of the more common types of proprietary memory cards—CompactFlash, SmartMedia, and Memory Stick—battled for the photography business for several years, and CompactFlash won. Durable, able to withstand the rigors of field photography, relatively inexpensive, and widely available, CompactFlash cards are the universal default for storing images on digital cameras.

Other alternative types of memory cards exist as well, and most are attempts at space-saving in smaller point-and-shoot cameras. These cards are typically tiny, with very limited memory and even more limited commercial availability, and they may only work in a minority of cameras. You need to have a really great reason for buying a camera if it doesn't have at least one of the three storage media types mentioned here because using a nonstandard card can be a real pain.

SmartMedia cards are the second most common type, after CompactFlash. At least for now, SmartMedia cards are readily available at decent pricing. Although many portable storage devices, such as the ImageTank or the Delkin PicturePAD, can easily read the SmartMedia card, the support for it is becoming less common. Sony's Memory Sticks are even less common, although Sony computers and some others include a Memory Stick reader/port as a standard feature.

The problem is that, although Sony digital cameras support the Memory Stick, it has fallen short of widespread support from other manufacturers. CompactFlash is the safest and surest bet; a wide variety of card sizes and brands are available today, some at remarkably low prices.

 Note I almost exclusively use CompactFlash cards, and they are the most common card accepted by high-end digital SLRs. They also tend to be the most durable. Unless specified otherwise, when I refer to memory or flash cards in this book, I specifically mean a CompactFlash card.

Write speed and digital cameras

Like a compact disc, the cards have different write-speeds, a real consideration depending on the type of photography you're doing. In the post-pixel stage of acquiring an image, a digital camera must convert the image to a file type and then store it on the card. The size of the image, the amount of light (or lack thereof), and the ISO all play a role in the time it takes to process and store an image. Add to this the amount of time it takes the camera to convert the basic image data into a recognizable file format (for example, JPEG), and then the file must be physically recorded onto the flash card.

The *write speed* is how fast the file is recorded. Cards are rated to different speeds and usually marketed accordingly (for example, 4x, 16x, 40x, and so on). Typically, the faster the card is able to store photos or data, the more expensive the card is. A number of very-high-speed cards have been developed (with equally high price tags) for photographers who need cards to load images quickly. In fact, a CompactFlash technology known as *WA cards* (for Write Acceleration) are available that increase write speed—but be aware that these only work with cameras that support WA (Canon, for example, does not; Nikon does).

How to kill a flash card

You may notice that when you take a photo, it takes the camera a little time to process the image—typically evidenced by a red light blinking as it processes. This indicates that the camera is writing the photo to the card.

X-rays and Your Memory Card

In the mid-1990s, I participated in a 20-country photo shoot, traveling to 5 continents with more than 1,000 rolls of film. At the security gate of literally every airport, I had to beg, plead, or threaten (that last one didn't work very well) to get security officials to hand-check our film. Although most of the film was considered safe for X-rays, I was putting it through so many X-ray machines over the six-week shoot that I was risking a cumulative effect of exposing the film to radiation. Many of the officials wanted to look individually at each roll, which was time-consuming, to say the least. One of the nicest things about digital photography is that flash cards are completely X-ray safe (and you don't need 1,000 of them!). It's a myth that X-rays damage flash cards.

The first and easiest way to kill a perfectly good CompactFlash card is to take it out of the camera while the image is processing. It's so easy to do — get in a hurry when you know you need to put a new card in the camera because you're running out of space, snap that last shot, and yank out the card. After you've put the card in the computer card reader, the card appears corrupted — and then you panic. It happens all the time.

There are a number of stories about CompactFlash cards and their durability, such as the photographer who put one through the wash and, after being dried (in the dryer, of course), the card not only worked perfectly, but still had the images on it. There are stories of extreme cold and heat, scuba diving incidents, and numerous others where CompactFlash has endured the test. Despite its seeming indestructibility, removing it during processing remains the best way to destroy it (short of fire, acid, or giving it to a 10-year-old boy).

Caution When the camera is turned off, if it is still in the midst of writing to a card, the camera will force itself to remain on long enough to download the image. Turn off the camera to remove or insert a flash card, and *don't remove the card until processing is completed!*

If disaster does strike your memory card, such as by interrupting the write-to-card process, there are several useful flash card recovery products available. Some of the higher-end cards include recovery software with them (it's loaded onto the card when it's purchased or available on the manufacturer's Web sites). You can find recovery software at various retail and free-download sites. Although not a 100 percent surefire bet, attempting to recover and repair a card is worth the effort.

Tip Keep flash cards and card readers clean — a nasty piece of dust that happens to interfere with the minute pins that transfer data can cause the card to fail. Most photo-supply stores offer flash-card cleaners that allow the pins and pin ports to be made dust-free.

Keep It Clean: Digital Cameras and Dust

Digital cameras, just like film cameras, are sensitive to dust and every precaution should be taken in the studio and the field to prevent dirt from spoiling a photograph. Although images can be edited later to remove spots, this takes time, and a particularly dirty camera can actually expose and/or focus images incorrectly.

Some cameras are better than others in keeping dirt, moisture, sand, and other foreign matter from getting inside. Cameras optimized for photojournalism, for example, like the Canon 1D and 1D Mark II or the Nikon DH1, have multiple tight seals throughout the cameras to prevent anything from entering. Semipro cameras are less effective at staying clean, and consumer cameras — with the exception of ones specifically made to be weatherproof — will not hold up well at all to foul conditions.

I recently read a report from a photojournalist covering the conflict in Iraq who was shooting digital images. He had to wrap his camera in gaffer's tape and clean the sensor every day just to keep out all the dust and sand.

Cameras with changeable lenses, however, are more prone to dirt infestation than point-and-shoot models, simply because you have to open the camera to change lenses. Changing lenses is the most common way dirt gets into a camera, under the mirror, and, worst of all, onto the CMOS or CCD. Changing lenses with the camera turned on, although very common for sports and other fast-shooting photographers, increases the chances of dirt getting in the camera: With the camera running, the electric charge operating it tends to create a dust-magnet effect. Whenever you can, turn off the camera to change lenses, and change lenses in as dust- and dirt-free an environment as possible.

In film cameras, dirt can get onto the *pressure plate,* which keeps the film flat for even exposures, causing a tiny scratch line on the film as it advances. With digital cameras, the CCD or CMOS is fixed and does not move at all, so a spot of dirt stays in its spot until something moves it. Dirt appears in the digital images as grayish, shadowlike spots.

How do you know if the dirt is on your CMOS or CCD?

 ✦ If the spot appears consistently in the same location from photo to photo

 ✦ If the spot remains when lenses are changed

If either of these is true of your images, then you must clean your CMOS or CCD, which can be tricky and potentially damaging to your camera if you're not careful. The CMOS or CCD (shown in Figure 2-7) is the most sensitive part of the camera, filled with millions of tiny dots, each of which has an important role in acquiring perfect images. Any scratch, fingerprint, oil, or anything else on its surface can cause the camera to have to be professionally cleaned or repaired — an expensive and time-consuming proposition.

Consult your camera manual to determine how to clean the sensors (or however the process is described in your specific manual). Typically, there is an option on the camera's LCD menu that allows you to force the shutter to open and the mirror to go up, exposing the CCD or CMOS.

Caution Clean the CMOS or CCD in a moisture- and dust-free environment. If you're in the field and cannot get to a clean location, then do not attempt to fix the dirt particle — deal with it in Photoshop and clean the camera when you're in a safe place. Dealing with a slightly dirty lens is better than potentially making the problem worse.

Normally, you'll be able to see a tiny spot of dust on the surface, which is what you'll need to clean. Using a bulb-blower, blow a tiny bit of air at the sensor to move the dirt particle. Usually, this is all it takes, and you've eliminated the spot.

Caution Under no circumstances should you touch the sensor with *anything,* nor should you use an aerosol-type air sprayer — these can spray a chemical onto the CMOS or CCD that will permanently damage it. Do not attempt to remove dirt using a brush, tweezers, or anything else that might touch the surface.

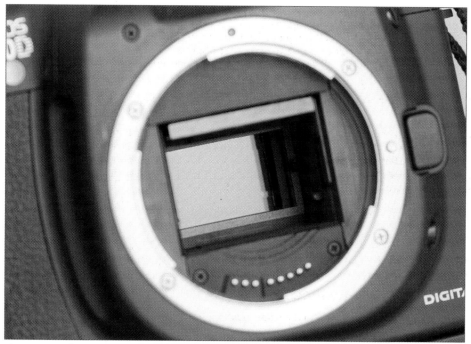

Figure 2-7: The CMOS in a Canon 10D

If the dirt particle will not come off, you'll need to have the camera serviced professionally. Pro camera stores sell CMOS and CCD cleaning kits, but they can be expensive and should only be used if you can't remove the particle with a soft puff of air.

While in Cuba on assignment, I had a little free time after shooting for days in a dusty, dirty sports hall. When reviewing the images I took later, I realized my camera had developed several spots on the CMOS. I knew these were CMOS spots and not dirt on the lens because they were consistent from photo to photo, no matter which lens I used.

Lighting Digital Photos

Although lighting digital photography subjects and scenes is similar to lighting it for film, there are a few distinct issues you should think about. The principles of good lighting for portraiture, products, groups, glamour/fashion, and the like apply to the digital format just as for film, and this book is not intended to teach lighting techniques in depth.

The good news about digital is that any photographer can see the results of his lighting instantly, even before the image is transferred to the computer. Although LCD screens on digital cameras aren't particularly good for checking fine detail, such as focus or exact color, you can very easily check lighting for shadows and general features. With film, professional photographers used a secondary *back* to the camera that would shoot Polaroid photos so they could preview their images — which is time-consuming,

expensive, and cumbersome. To use a "back," you actually have to remove the film cartridge from the back of the camera (high-end medium- and large-format cameras are made to allow this) and replace it with the Polaroid back; after you've completed the previewing of the Polaroid images, you take it off and replace the film cartridge on the camera. Polaroid backs aren't available for just any camera, so this practice is largely limited to high-level professional photography.

The limitations of LCD previewing

The downside and pitfall of the digital LCD preview screen is that it can lure you into an artificial sense of security about photos, distracting from focusing on well-composed and technically accurate photography. Looking at every photo after you shoot can be addictive, which further steers you away from the subject and the flowing momentum of a shoot. What used to be reserved for later review has now become an instantaneous form of gratuitous feedback that prevents photographers from engaging in dialogs with their subjects and producing more powerful images.

Further, incorrectly setting the LCD screen can yield an on-computer image that looks vastly different from the way it did when previewed. Falling prey to the temptation of showing a client the photo of herself in the LCD screen that was just shot is absolute madness. For any number of reasons, including but not limited to color, composition, lighting, and focus, it's simply bad professional practice to show photographs to clients and non-photo staff until they're ready to be presented properly.

Lighting challenges

For particularly difficult lighting situations, or photo shoots where detailed lighting will differ throughout the photograph (such as a bride's dress contrasted with her face and a background), shooting in RAW format will help mitigate lighting that wasn't perfect. Further, software tools such as nik Dfine can further help to enhance and fine-tune images that need lighting adjusted at the post-pixel stage.

> **Cross-Reference**
> For a discussion of using RAW (which technically is not a format) to archive digital photo files, see Stage 10. The nik Dfine plug in is described in more detail in Stage 5.

With film, the temperature of a light directly affects how the image appears. For example, using common daylight film indoors without a flash, illuminated by household light bulbs, causes white to appear orange-brown and causes cold colors, such as blue, to darken. This type of light is referred to as *Tungsten light,* which has a temperature of 3,200 Kelvin, and professional photographers use special tungsten-rated film to handle this difference from daylight or other light.

The same effect will occur with digital cameras if the light-temperature rating (typically known as *white-balance*) has been set manually and is incorrectly used for the light being exposed. Professional and semiprofessional cameras feature several ways to handle light appropriately:

✦ An automatic white-balance (AWB) setting that is often quite good at determining the correct camera setting for the light the camera "sees."

✦ Preset lighting options for different types of light—fluorescent, household bulbs, flash, sunlight, and the like.

✦ Completely manual light-temperature settings, where you set the specific Kelvin temperature. Typically, this is based upon knowing the light temperature of a scene and subject based on measurements taken with a *colorimeter,* an expensive and specialized light sensor.

Test first

Testing your scene and subject to find the lighting that works the very best is important. Shooting test shots and previewing them on a computer, not just on the LCD screen, is the best approach of all. When shooting fencing, I'm often in difficult lighting situations. Flashes are prohibited in the sport because they can distract the athletes and referees and even be potentially dangerous. As a result, I'm always looking at what the lighting situation is presenting and adjusting my camera accordingly. In the preliminary competition hall for the 2003 World Championships in Havana, Cuba, for example, there was a mix of standard light bulbs, natural sunlight coming through windows and skylights (and a few holes in the ceiling), and mercury lights such as the type typical in gymnasiums everywhere.

Each of these types of light has dramatically different light temperatures, so the effect created was lighting chaos, requiring constant attention to how the fencers were being illuminated. At first, I tried using specific settings, such as one optimized for the mercury lights (usually the fluorescent setting). But this inevitably posed a problem because, as I became wrapped up in shooting the action at various spots, I would forget to change it to a different setting if, say, sunlight was pouring onto the fencing strip, resulting in an incorrectly lighted photo requiring adjustment in Photoshop. On subsequent days of the championships, I shifted to using the AWB, which worked remarkably well, because it changed its own lighting response according to what it saw in each image. Occasionally, it would get the lighting wrong, but for the most part it did very well.

Most often, you'll be able to determine the light in a situation and set your camera accordingly. Whenever possible, set the lighting semiautomatically (using a preset) and *always* test how it's coming out.

Dealing with flicker

The flicker rate of some types of light can also cause a problem in digital photography, creating a dark band across the image. This is a bigger problem than simply an off color due to light temperature, and it's a very difficult effect to repair at any post-pixel stage. Although flicker can happen with various types of lighting, one of the more common occurrences of an obvious and problematic flicker happens when photographing a TV screen. This is due to the screen refreshing 30 times per second (other rates apply in some countries), which means that anything photographed at $\frac{1}{30}$ of a second or faster will most likely have a band across the screen. The best solution, although not always the most practical, is to photograph the scene at $\frac{1}{15}$ of a second or slower.

Fixing exposure in the digital studio

It has been said that digital photography is less forgiving than film-based photography when it comes to exposure and light, and that a film photo can be off by an f-stop or a bit more and be exposed nicely, but that in digital it will just be off. Although this is generally true, film lacks the amount of post-pixel options the digital studio enjoys, which are amplified even more when shooting RAW files, where the image exposure can be adjusted infinitely in the process of opening it in Photoshop.

In Figures 2-8 and 2-9, I'm opening a RAW file in Photoshop, with two settings adjusted. In the first, the image appears as it did when opened. In the second, the image has been adjusted to add warmth and to change the exposure.

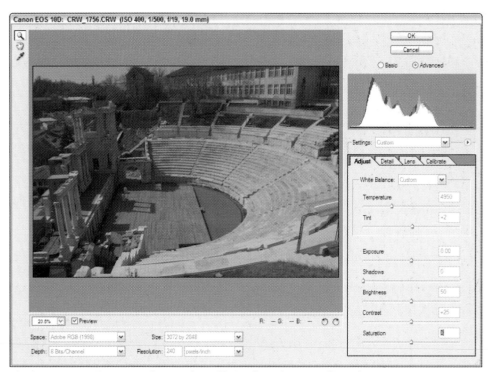

Figure 2-8: Opening a RAW-format photo file in Photoshop, unadjusted

There are so many effects that can be applied to customize, repair, alter, and creatively enhance digital images using products like Photoshop, Corel Painter, and any number of other add-in and plug-in tools that it would take an encyclopedia of books to cover them adequately. In the software sections of this book, we discuss some of the common problems and enhancements, but you should fully explore and understand the amazing relationship between lighting and digital photography by applying your film knowledge to the digital medium to establish a baseline of operation. Then, as it is necessary, apply changes to correct images accordingly.

Cross-Reference

A number of creative image-editing filters and methods are covered in more detail in Stage 7.

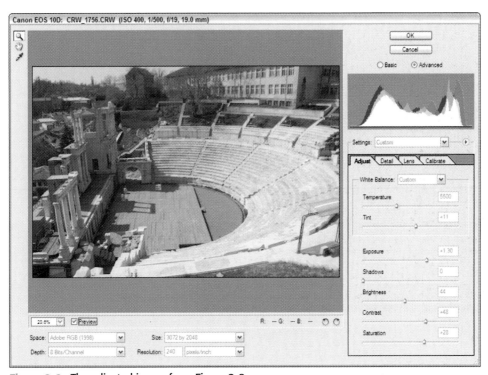

Figure 2-9: The adjusted image from Figure 2-8

Computers, Printers, and Color Correction

Processing the vast amount of digital data stored in a high-quality photo file requires a fast and powerful computer. If you'll be printing your own proofs before sending your photos to a professional digital photo lab, you'll need a high-quality photo printer. And to accurately *soft-proof* (testing your photos on your monitor before printing), you'll want to institute a color-correction routine to synchronize your monitor display with standardized printer profiles.

Processing your data

In this chapter, and throughout this book, the types of internal and external storage devices you can use to store all this data are discussed. Here, I briefly note the basic requirements you need in order to process all this data in your computer.

The critical elements of your computer's ability to process all the pixels in your photos are processing speed and random-access memory (RAM). The processing speed, measured in gigahertz (GHz), is important, but the processors included in desktop and laptop computers made in the last few years, in the 3 GHz range and more, are generally sufficient to handle your digital-photo editing requirements.

On the other hand, you'll want to bulk up the RAM in almost any off-the-shelf computer you purchase. RAM is measured in megabytes (MB) or gigabytes (GB). A suggested minimum of 1GB is optimal for running Photoshop smoothly and printing high-resolution photos.

Correcting the color

As you soft-proof your images on your monitor, you'll want to ensure that the colors you see match a set of standardized color values referred to as the International Color Consortium (ICC) profile specification. ICC profile allows you to view and edit color in your photos. Then when you send your photos to your own printer or to a professional online storefront and print lab, such as Printroom.com (www.printroom.com), the colors you see will match the colors in your print.

Calibration tools allow you to digitally measure (and correct) the colors on your monitor. The SpyderPRO calibration system works on cathode ray tube (CRT) monitors, and even on laptop screens and liquid crystal display (LCD) flat screens. It works with both Macs and PCs.

With SpyderPro, or any calibration system, you place a monitor calibration device — basically a small color sensor — on your monitor while the software that comes with the device displays colors that are read by the color sensor. As the colors are read by the sensor, the software corrects the display on your monitor.

Calibration with a device/software set like SpyderPRO allows you to obtain a much better correlation between what you see on your monitor and your resulting prints.

Proofing photos with your own printer

ICC profiles not only provide a standard to measure (and correct) your monitor display, they're also associated with printers and scanners, ensuring that the entire flow from display to print uses objectively defined color values to maintain consistency.

Better photo-quality printers come with ICC profiles built into the install drivers, so that your operating system will display a set of print options when you send a photo to the printer from Photoshop, or any image editing or display software. These profiles range from minimalist (one profile for all paper and ink options) to complex (a dozen or more options depending on paper and ink).

 Cross-Reference Obtaining quality prints, including using ICC profiles, is discussed in depth in Stage 8.

 Note For a detailed exploration of monitor calibration and printer profiling, see *PC Magazine Guide to Printing Great Digital Photos* by David Karlins (published by Wiley).

Summary

Photography workflow changes fundamentally in digital versus film photography at the post-pixel stage and beyond. Digital cameras combine the mechanics and controls of conventional film cameras, but replace film with digital technology. Where this transition takes place is on the camera's sensor known as the CMOS or CCD, depending upon the type of camera. It is at this point that traditional photography and digital photography meet and diverge.

A fundamental tenet of understanding digital photography is to know the difference between pre-pixel and post-pixel controls, features, and techniques. Pre-pixel operation of a camera is largely similar to how a film camera operates, with exposure, ISO, lens operation, shutter speed, aperture size, composition, and focus. Once the image reaches the sensor, however, it is converted by photodiodes into an array of pixels, which is where the digital photograph truly begins.

The post-pixel aspect of digital photography is where activity takes place after the image has been shot. It includes downloading, processing, and editing the image before it is printed or distributed.

Working with computers, technology, and digital images is a fact of life for the digital photographer, but so is understanding how to operate and maintain the camera in the pre-pixel mode. For every advantage digital photography offers — and it truly opens a new world of photography far beyond what anyone imagined even ten years ago — it generates more for the photographer to learn, understand, and master.

✦ ✦ ✦

3
Software: Digital Workflow's Red Thread

The midday Cuban sun and the front of this classic automobile create a wonderful juxtaposition between an evenly shaded and curved surface (the hood) and the ornament. It was taken with a Canon 10D at ISO 200, f/10, 1/350 second, and 135mm focal length.

Whatever type of digital camera you own, and no matter what type of images you photograph, digital images must ultimately be "processed" through a series of software applications that get them to their intended audiences — whether on paper or online. The key to effectively accomplishing this task lies in selecting the best product for each stage of software workflow, and ensuring there is smooth transition between the stages — from image acquisition to editing to distribution and presentation. Further, there is software used in tandem with image-based programs, such as the application(s) you'll need to manage your photography business.

This chapter isn't a primer or tutorial on how to use these applications individually, nor is it an analysis of features. Further, the concepts presented here apply to both Mac- and PC-based applications (although screen images are taken in Windows XP). In this chapter, I emphasize the importance of being able to quickly process images with the proper applications suited to your digital studio, work habits, photography style, and business to ensure your images are sold and displayed in the most successful manner possible — resulting in optimal revenue, visibility, and client/audience satisfaction.

Digital Photo Processing

Digital photo processing is taking the untouched, original digital image from when it is first transferred to the computer and "processing" it to be stored, archived, optimized, prepared for client needs, edited and enhanced, displayed, and printed. Many things can — and some must — happen to a single image.

First and most importantly, the image must be stored in a safe place where it won't be altered, edited, or inadvertently erased. This *protected original* can be copied, but it's best to copy it only once and create a *working original* from which the other images are copied and created. The protected original should be stored wherever you can protect it best: on a safe hard drive, on a CD or DVD that is filed in a protective case, or on a RAID drive.

Note A RAID system is a set of drives that work together to create a large amount of storage. The drives automatically back each other up so that they are swappable and work together for optimal efficiency, scalability, and access. RAID (which stands for *redundant array of independent discs*) systems are very reliable and perhaps the best way to store lots of vital information. They usually require a board that's inserted in your computer, the RAID hardware shell that holds the drives, and the drives themselves. Although the entire configuration is a bit pricey, your images are very secure when stored in this manner.

The working original can be placed on the drive where you're storing your photo project, and should be named to indicate it's a copy (for example, if the protected original is `smithwedding.jpg`, name the working original `smithwedding-w.jpg`, or something similar so there's no way you'll confuse the two). The working original is very much like the protected original in that you have no intentions of altering this image — only to make copies of it and edit them.

The *enhanced original* is an edited version of the working original. This image will not be edited other than to make the original image look as good as possible in terms of the exposure, contrast, brightness, color balance, digital noise, and other corrections. Use this version of the image for all purposes where the actual photo needs to be printed or displayed; you'll want to name this something unique, as well, such as `smithwedding-we.jpg`.

Other copies of the working original can be used, then, as copies that are edited in other ways: turned into black-and-white or sepia, filtered with creative treatments, having text added or other Photoshop layers, and so on. These are image edits, and should be named accordingly — usually with something to identify what treatment has taken place. For example, if the image was converted into a grayscale image and then had a Photoshop Charcoal filter applied, call it something like `smithwedding-charedit.jpg`. Figure 3-1 shows the many ways in which a single image may be used.

This, then, creates a set of photos that you can use for output in a variety of ways. You may need to print the image, put it onto the Web for display, record it to a CD to be given to a lab for printing or to a customer to keep, place it into an online fulfillment service such as Ofoto.com or Printroom.com, or prepare the image to be projected in a digital slide show. Whatever the output, you'll be dealing with either the enhanced original or the edits that will be altered to suit the kind of output that's taking place. That means you may need to resize the image, crop the image, change the resolution of the image, convert the color mode from RGB to grayscale or to CMYK (for print), or convert the image into a different file format, such as from JPEG to TIFF or GIF (common on the Web). Images may also need to be duplicated in thumbnail format for quick views or printing on a *contact sheet* (a print with many thumbnails of the image in a matrix on the sheet for reference, quick review, and quick selection). Finally, images in thumbnail or full-size form may need to be e-mailed, uploaded to a gallery, or placed onto an FTP site for someone else to access.

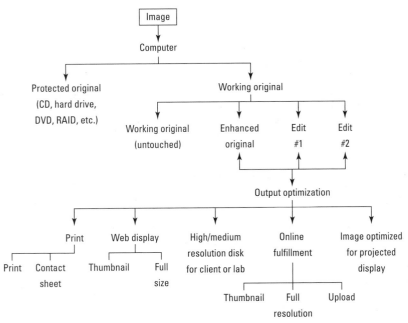

Figure 3-1: Digital photo processing: A single image is used in many ways.

I use a number of different software applications to accomplish all these treatments with the original single image. I use ACDSee to bring the protected original onto the computer, and then save it in my secure location. Then I open the original with Photoshop and immediately choose File ⇨ Save As to copy the file into the working original and save it in my working project subfolder. I'm then ready to make additional copies, as necessary, for the additional edit version and the enhanced original.

After I've done my edits in Photoshop, I need to use burning software to put the image onto a CD, or different Web applications to place it onto an online gallery (such as Microsoft FrontPage or Macromedia Dreamweaver). I use Microsoft PowerPoint for presentations that involve text and information, or ACDSee for simple slide shows (or ACD FotoAngelo for complex ones). I use Printroom.com as an online fulfillment service where I have a digital storefront to sell images; they have a software utility called PSM (Printroom Studio Manager) that I use to automatically convert and upload thumbnails for the Web galleries as well as to store and upload full-sized images they use to print the photos.

So I use all these applications to manage the image, ensure it looks its best and gets where it needs to go, and that it's kept safe and accessible.

Pro Photographers, Time, and Software

As a professional photographer, I find my free time in increasingly short supply. Learning all the new functions in products like Photoshop, working with various issues on the computer (where even a simple problem might take up hours of time), and reviewing all the new software programs and their features to decide what's best for me is overwhelming. Although I'm genuinely excited by the features and software

applications, and I realize that so many incredible new developments are taking place, it's a vast amount of information to take in and integrate.

As a former executive and journalist in the high-tech industry, I'm accustomed to working with software. However, there's way too much information out there for me to absorb easily — it's like being a doctor, keeping up with hundreds of journals every week, and still finding time to treat patients.

I suggest that you, as a professional or enthusiast photographer beginning to build a digital studio, do *not* spend an inordinate amount of time learning every last feature in Photoshop, and, likewise, that you do not overload your computer with too many applications. You simply won't get the most out of them, or else you'll spend all your time there and your photography trade will suffer as a result.

If you're processing lots of basic images and not doing too much creative editing, the vast majority of what you do can be accomplished in ACD Systems ACDSee PowerPack, which includes ACDSee for image management and review; ACD FotoCanvas for image editing; and ACD FotoSlate, a very useful photo printing utility. Although numerous other products are on the market, for the price, reliability, and overall functionality in my studio, I've found that this powerful set of products is tough to beat. You can also add plug-ins (such as RoboEnhancer, which allows images to be batch-processed) and you can specify other image management packages (for example, Photoshop) to automatically start with a specific image from within ACDSee.

At less than $100, I use this suite of products at least as much as I do Photoshop, and it's one-sixth the price. To be sure, Photoshop offers a much broader set of image-editing tools and is more powerful when it comes to editing RAW files (although ACDSee supports them), but if you're a studio processing lots of images with basic editing and enhancement, you'll be hard-pressed to do better.

If you intend to do a lot of creative work with your photography, then it may make sense to jump to Photoshop right away. You can't go wrong with Photoshop overall — the downside is just that it's quite expensive. Other very viable alternatives — especially if you're doing extensive creative work — are the products produced by Corel, including the CorelDRAW Graphics Suite (currently in version 12) along with Corel Painter (which I discuss later in this chapter). Although CorelDRAW is an extensive drawing application, it includes Corel PHOTO-PAINT, a reasonably sophisticated image-editing package fully integrated with the other functions.

All that said, you can begin simply with a full-featured set of image-management products such as what's included in the ACDSee PowerPack, learn its capabilities and limitations, and then decide if Photoshop or Corel is what you really need or if all you need is what you have.

The bottom line is that it's very easy to be lured onto the proverbial rocks by the sirens of the software titans, finding that you've acquired far more software functionality than you're ever going to have the time to learn at a basic level, much less at a productive and proficient one. Further, with too many software features at your beck and call, you'll find yourself tempted to try all types of creative and unique treatments to your photographs that, realistically, probably won't sell more photographs — at least in the short term. Early on, building a solid foundation of high quality, non-creative digital-photo-processing skills will far outweigh the early-stage value of any creative treatments you may want to venture into as you progress in the development of your digital studio.

You might draw a comparison with music. Many musicians may want to jump to improvisational jazz without first building skills in scales, arpeggios, and music theory. However, musicians lacking fundamental training often produce music with less-enduring quality. Likewise, without taking the time to really learn digital photography at both the pre- and post-pixel levels, attempts to be creative often can appear sophomoric. Few photographers are also designers by trade, and this is often reflected in the creative work a photographer attempts using the multitude of design tools available in Photoshop or Corel. Similarly, designers and others — professionals and nonprofessionals — attempting to produce high-quality photography without a basic understanding of composition, exposure, and lighting often produce images that, to the professional photographer's eye, are equally unsophisticated.

Image Management

Image management begins when the photos arrive on the computer. Although most digital cameras from manufacturers such as Canon, Minolta, Fuji, Sony, or Nikon come with software that handle acquisition, as well as some basic tools to manage large numbers of images effectively, you'll need a dedicated image-management tool.

Software applications that manage images generally include a number of key features:

✦ Image acquisition, which provides a way to automatically acquire photos from a digital camera or flash-card reader, rename them (if desired), and store them in a specific subdirectory

✦ Image viewing, including rotation and zooming

✦ Complex image renaming

✦ File conversion, such as from JPEG to TIFF

✦ Image archival, such as creation of a compressed and encrypted storage backup of your photos

✦ Image prioritization, which allows you to flag, number, and eliminate images in a desired order

✦ Image sorting, which allows you to view files by priority, name, file type, or other factors

✦ Metadata tagging, which lets you view information about a digital file, such as how and when it was taken, as well as add your own copyright, informational, and personal data to individual or multiple files

✦ Watermarking, to add permanent personal information to a file to prevent it from being copied or altered

✦ Image-database management, which creates a sortable and selectable database of images based upon factors common to each photo, such as date or category name

✦ Simple image editing and/or automatic plug-ins or integration with a full-featured image package

✦ Printing and output capabilities, such as creation of contact sheets, CD burning, or image processing for optimization on the Web

✦ Batch processing, to automatically resize and rename a large number of images

Some image-management packages have only a partial set of these features; some have more. Although other tools, such as database-management and spreadsheet applications can be used to manage and sort the image files, they lack the ability to work with the files as images; instead, they work with the files simply as data files. If all you want to do is be able to access the files and know where they are, this may suffice; however, most photographers like the ability to work more from a photographic standpoint than a database standpoint.

There are also specialized digital-asset-management packages designed to provide highly sophisticated database, archival, and management capabilities for a large number of files. For example, ImageFolio (www.imagefolio.com) supports multiple users and provides a way to create a massive image database (or other multimedia objects, such as MPEG or MP3 files) with extensive keyword searching, page caching, captioning, and extensive tagging; it even provides the ability to track files by how often they are hit on Web sites — and to sort them accordingly. Although this is far more functionality than a small studio needs, at least in the first few years of operation, it can be a tremendous advantage to a larger or more established business. Of course, at that point, administering and managing the archival process can become a full-time job.

Photoshop Plug-Ins

Photoshop has the most robust set of built-in features and in-the-box plug-ins of any image-management package, period. However, there are Photoshop plug-ins above-and-beyond filters and creative tools that you may want to consider that can integrate and make your image-management life easier. Here are a few to consider, and more can be viewed at www.adobe.com/store/products/plugins as well as www.download.com:

✦ **Genuine Fractals from LizardTech:** Allows you to create resolution-independent images

✦ **Portfolio from Extensis:** Creates a visual database of images

✦ **Suitcase from Extensis:** Lets you preview and set fonts (Yea!)

✦ **The Plugin Site:** A German company dedicated to providing information about and building interesting and useful plug-ins, such as the Plugin Commander, which manages all of your plugins! (www.thepluginsite.com)

A few full-featured photography packages, such as Photoshop, accomplish a significant amount of image-management capabilities, but they'll need special plug-ins for some of the more specialized features, such as watermarking, specialized database and archival operations, among others.

If you have a network in your studio, it's important that your image-management software be able to effectively manage images stored in various locations other than on a single PC. If you have many photos distributed across a network, some of the digital-asset management applications may provide tools you'll find useful, such as multi-user capabilities, system administration, and various controls to limit and permit access, search, and control of files.

Image Editing

When most people think of digital-photography software, they think of image-editing applications, by far the most common photo programs on the market. There are dozens of image software packages, as well as basic image-editing capabilities, embedded into layout, presentation, word processing, desktop publishing, Web design, and other programs.

The undisputed king of the image-editing empire is Adobe Photoshop. The industry standard and default program, few professional photography studios turn to any other program for editing digital photography of any significance. Although other packages are used for specific purposes, Photoshop has the largest following, the most robust set of features, and the most plug-ins and integration with other software applications. If you can afford Photoshop and you're willing to put the effort into learning how it works, you honestly can't go wrong.

Most full-featured image editing packages offer a core of the same basic capabilities. Minimally, you'll want to ensure whatever application you choose offers the following tools:

✦ Image sizing, which allows photos to be resized to various dimensions based on pixels, centimeters, or inches

✦ Image resolution alteration, to increase or decrease a photo's resolution to increase or decrease its size

✦ Cropping, which lets the photographer cut out parts of the photo either by sight or to a specific size

✦ Contrast and brightness adjustment

✦ Gamma correction, which essentially deals with light intensity in an image

✦ Sharpness correction to make an image at least appear that it's more focused

✦ Noise reduction to eliminate or reduce digital graininess from low-light and high-ISO images

✦ Rotation to turn and invert images at preset or manually set degree points

✦ Color-mode conversion, such as the ability to automatically convert an image to grayscale or from RGB to CMYK (which optimizes it for printing)

✦ Color correction, such as emphasizing or de-emphasizing specific colors manually or automatically

✦ Red-eye reduction to automatically or manually repair images

✦ Selection tools, to provide a way to change, cut, fill in, or alter specific areas of an image

Tip Some (but not all) of these features are found in less expensive digital image-editing programs such as Ulead PhotoImpact, Corel PhotoPaint, JASC Paint Shop Pro, and Adobe's stripped down (and much less expensive) version of Photoshop, Photoshop Elements.

Additionally, some packages allow complex and sophisticated image touch-up using tools that heal part of an image by sampling one area of an image and integrating it into another to eliminate or reduce blemishes or other image features.

Sharpness: Magic pill or fool's errand?

As a photographer, you've undoubtedly shot what you thought was a perfect photo, only to find — to your horror and disappointment — that the image was *soft,* or blurry. A blurry image, for example, may look perfect on a digital camera's LCD viewing screen, only to actually be off when viewed on your computer's display. Or you may simply be shooting without reviewing images, and some of your key photos turn out to be off-focus for one reason or another. Perhaps you had the manual focus on and forgot to focus tightly on your subject, or you were using auto-focus and you didn't notice the camera was focusing on something other than what you wanted it to.

Whatever the reason, occasional blurry photos are just a fact of life for all photographers. A sharpening feature in an image-editing application may seem too good to be true — and, very often, it is.

Virtually all image-editing packages offer a sharpen feature of one ilk or another, and some are better than others, without a doubt. Usually, the feature allows you to use a slider tool to dynamically change the sharpness of an image, or you may press a button to increase sharpness incrementally.

Digital sharpening doesn't actually focus your image more; instead, it uses digital enhancement to make the image appear more focused. It accomplishes this by intensifying the edges of high points of pixel contrast in an image, while maintaining, as much as possible, the overall smoothness of the object.

This effect does have a trade-off: The more you sharpen an image, the more digital noise you add to it. If, for example, you reduce digital noise in an image using various noise-reduction tools, you'll notice that the image becomes softer — the reverse of sharpening. Oversharpened images look distorted, very noisy, and artificial, both on-screen and in print. If an image is really soft, it's almost impossible to cover up what has been done; sharpening tools are really best used for jobs where the focus is off by only a relatively small degree. Figures 3-2, 3-3, and 3-4 illustrate the process of managing blurriness.

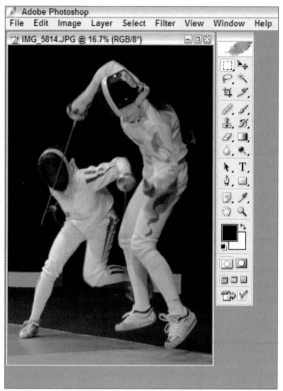

Figure 3-2: A blurry, or *soft,* image as it appears in Photoshop.

Photoshop has several automated sharpening tools, including Sharpen, Sharpen More, and Sharpen Edges. These tools can work for simple and quick sharpening jobs, but for serious sharpening undertakings you're better off using the Unsharp Mask tool.

Note According to the Adobe Photoshop CS Help system, "the name, Unsharp Mask, makes the filter seem like an unintuitive choice for sharpening an image. The term comes from a darkroom technique used in traditional film-based photography. The effect of a sharpened edge can be produced by sandwiching a photographic negative and a slightly blurred and underexposed copy negative in the enlarger. Then the photographic paper is exposed through the sandwiched negatives."

However, using Unsharp Mask too much can simply increase noise in an image to the point of distortion (which can have some interesting artistic effects, but not that of repairing bad focus) as is evident in Figure 3-4. When used correctly, it is a sophisticated sharpening tool and is your best bet for a tough sharpening job. It provides several types of controls for sharpening, such as a dynamic preview with radius, amount, and threshold controls to provide a very dynamic approach to altering an image. If you have an image that's seriously out of focus, discard it or use it for artistic purposes. For example, many blurry images can turn out wonderfully with digital filters applied to them. Experimenting with blurred images can yield highly saleable images — yet another reason not to share photographs with a client before you're really ready to do so.

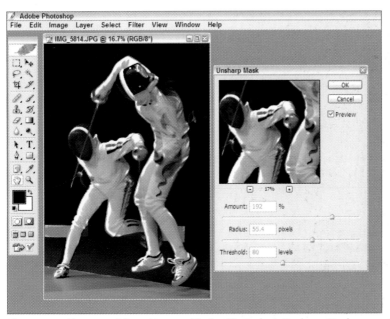

Figure 3-3: The same blurry image with the Photoshop Unsharp Mask feature being applied.

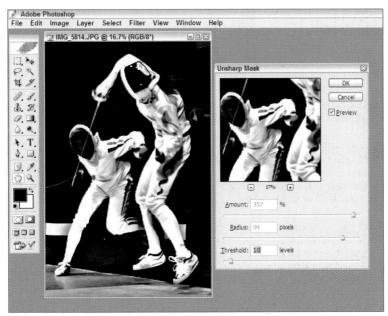

Figure 3-4: The image sharpened too much. Notice the amount of digital noise that occurs with excessive sharpening.

The challenges of Photoshop

High-end image-editing packages are extremely complicated and can take years to master. Photographers and designers use Photoshop, for example, to lay out complex wedding albums with multiple photographs and text that are then sent to album binders to create high-end, flush-mounted coffee-table books for brides. These albums can be sold for $1,000 or more. An image-editing package like Photoshop, rather than a layout or design package, is used for a project of this type because of its superior handling of images and their ultimate output quality, color correctness, and accurate rendition.

Some professional online photography services, which provide a way for professional photographers to display and sell their images in online storefronts, use Photoshop behind the scenes to perform batch and image-editing processes to enhance images. In fact, Printroom offers a unique service combining the services of photographer-selected designers with automated and sophisticated online photo processing to produce the wedding albums described earlier. Image-editing packages at this level go far beyond the basic features of a simple consumer digital-photo tool to provide extremely involved sets of editing features, filters, plug-ins, layers, masking, and other features to manipulate images comprehensively.

Figure 3-5 illustrates one of the hottest new trends in digital wedding photography: a flush-mounted, high-end wedding album, each page of which consists of Photoshop-generated files containing multiple images and text laid out and stored as a single JPEG image. The images can then be printed and published as a high-end, coffee-table book.

Figure 3-5: A flush-mounted wedding album where each page is a collage stored as one JPEG image.
Photo courtesy of Printroom.com; album design by Kamran Zohoori of ZohoDesign.com

If you're considering working with RAW files, make sure your image-editing package not only supports the RAW format, but also can manage and process RAW files efficiently and accurately. Although some of the image-editing packages have scrambled to support RAW files as digital cameras have begun to add them, they don't always work well or quickly. Photoshop CS, as of this writing, is the only image-editing application that truly handles RAW files acceptably in terms of viewing, processing, and manipulating.

For advanced creative work with images, Photoshop can be used to apply a vast array of filters, and many third-party plug-in filters are available to do everything from applying artistic treatment to images to fixing problems such as digital noise, exposure and lighting, and color imbalance. Although many

other applications exist beyond Photoshop, Corel Painter is the most powerful program on the market for applying serious and highly involved artistic effects to digital photographs.

As you can see in Figure 3-6, Corel Painter can turn a digital photograph into a complex work of art.

Figure 3-6: Corel Painter

Image Presentation and Distribution

When you're finished editing an image, you probably have to present it to a client and distribute the image, either in print or online. Digital photographs can be presented in a variety of ways. They can be projected, uploaded into an online gallery, conventionally printed in 4-x-6-inch proof books, distributed as a self-running slide show on a CD or DVD, or shown on a monitor. Whichever method you use, presenting images to clients and audiences is not to be understated as a critical element of digital-photography workflow. A series of photos projected in a 10-foot-wide image with music has immense power to influence, inspire, and emotionally affect an audience receptive to what is being shown. Furthermore, professional-photography organizations have studied and proven that brides and other photo-purchasing clients are more likely to buy more images at larger sizes if they've had photography presented to them professionally, in a large, impressive format or a very clean and navigable online gallery.

Slide shows

Software used for a digital-photography projected presentation includes many different applications — some that are dedicated slide-show packages, and others that include it as a feature, such as Microsoft PowerPoint, ACD FotoAngelo, CRE:8 Multimedia 2.1 (from PresentWare at http://presentware.com), and ACDSee's built-in slide-show capability. The slide shows these products produce are best viewed on a large monitor or, even better, on an LCD projector on a large screen.

I've found that the ACDSee built-in slide show, although simple, convenient, and reliable, is powerful enough to be able to run a presentation of just-shot images very quickly and with a nice basic set of transition effects.

When I photographed the opening ceremonies of the World Fencing Championships in Cuba, we were disappointed that Fidel Castro didn't show up (as rumor had it). However, we were treated to some of the best performers in the country and were allowed to shoot at very close range. At the reception following, everyone wanted to see the photographs and I used ACDSee to present a very quickly produced slide show. It simply involved specifying the folders and subfolders where the images I had photographed were located (it involved first rotating images so that they were right-side-up and getting rid of a few throwaways, but this didn't take long), choosing a few options (such as whether to display filenames, whether to add audio, whether to display images in their full size, and so on), and selecting transition effects, as shown in Figure 3-7.

More full-featured applications (and there are many slide-show and multimedia-presentation software packages available), such as ACD's FotoAngelo, typically involve more time for setup, including choosing images; setting music to the slides; adding complex design, layout, and text effects; and other factors that take time to configure. Although this yields a much better finished product, it takes more time to generate.

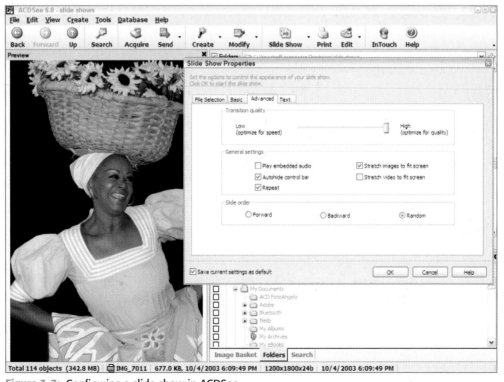

Figure 3-7: Configuring a slide show in ACDSee

One advantage of the more elaborate packages is that you can create a single file packed with your photos that is then stored on a CD or other storage media, sent via e-mail, or loaded onto a Web server. Instead of showing the file to clients, this lets you distribute the slide show to a client or someone else who will run it, complete with music, transitions, and so on. It operates in a self-running mode, so the user doesn't need special software to operate it. Your photos are protected and cannot (in theory, anyway) be extracted or copied. FotoAngelo is specifically made for this purpose and also offers a screen-saver option, which lets you create a Windows screen saver that you can sell and distribute with your images.

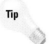

Tip

Be cautious about what music you use with any screen saver or slide show—you may be violating the law. Using it for your own purposes is very different from distributing and especially selling copyrighted music with your images. Use only non-copyrighted, royalty-free music—just to be safe.

Another form of presentation/slide-show software is intended to place the completed presentation onto a DVD or a CD that can run in a DVD player (also known as a VCD). Popular especially with wedding photographers, applications such as Ulead CD & DVD PictureShow (www.ulead.com) create wedding and other DVDs, as shown in Figure 3-8.

Figure 3-8: Configuring a slide show in with Ulead CD & DVD PictureShow

Ulead CD & DVD PictureShow features various simple or basic image-editing and image-management capabilities. The program's best attribute is the ability to create self-running DVD shows. This allows clients to easily view slide shows on their TV sets with a DVD player instead of only being able to watch them on a PC screen.

Conventional proof books

One of the easiest ways to show your work to a client or friend for whom you've shot a large number of photos is the tried-and-true film-photographer method of a proof book—with a digital twist.

You can take the digital images to any lab to be processed as 4-x-6 or 5-x-7 images, and then place your best shots in a presentation flip-style album. With the album, you can include a CD of the images in low-resolution that the client can see on her computer or, even better, a simple slide show in a self-running mode (like the one FotoAngelo produces).

Online galleries

I present much of my work to clients using an online "storefront." Many such storefronts exist, ranging from consumer sites such as Ofoto.com and Snapfish—both of which are optimized for getting snapshots printed and sharing pictures with friends—to specialized professional-photographer online-fulfillment services such as Printroom.com (which is more oriented to selling photos), Pictage (which is primarily oriented toward wedding photographers), and Profotos.com (which is oriented to displaying photography).

Online storefronts are essentially Web-based galleries where another company hosts your images in a format optimized for others to view. You set up the gallery with a look and feel you choose from templates the company provides (or that you create from scratch using Web-design tools), upload your images to specific galleries, and set prices and other features such as image optimization, copy protection, and so forth. Customers go online, see the images you took, select them, and purchase them in any size print they want or as gift items (for example, printed on a coffee mug, T-shirt, mouse pad, and so on).

Figure 3-9 shows a pro photography account-management screen from Printroom.com. Figure 3-10 shows the same gallery, but as seen from a client at the same account.

Although the consumer and pro sites have many similarities in terms of being able to display images, the pro sites differ primarily in that they're designed to sell images and/or market the services of the photographers, not just display photos. I typically tell clients that their images will be uploaded to a personal gallery, which allows them to view their photos from anywhere in the world—and to order photos at prices I set. This means I can sell images to someone in London, Tokyo, or Dallas with equal ease, and I can display literally thousands of images in many galleries and sub-galleries with a huge variety of options and ways to enhance, market, and sell images. Further, some online hosts provide a PC-based (non-Web) utility that allows you to easily process and upload digital images. Printroom.com actually integrates its with Photoshop for easy image editing.

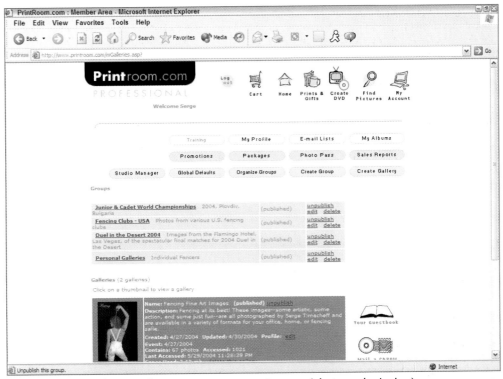

Figure 3-9: A pro photography account management screen (photographer's view)

Most professional-photographer online-fulfillment services require an up-front registration fee and charge a specific amount for sales of your images. Check with the various services to ensure you're getting the best services for your money and that your images can be presented in the best manner possible. As with slide-show software, there are many services from which to choose. Clearly, some services sound like they're absolutely great, but when it comes to services, quality, and responsiveness, they fall short.

Cross-Reference For more details about online fulfillment services, see Stage 9.

Figure 3-10: A gallery as seen by the client

Studio Management

Aside from working with images, studios require specialized management to ensure scheduling, accounting, communication, and networking all operate efficiently. Most studios grow organically, beginning with a few computers that get networked and share software before hitting a growth point where issues such as network administration, software site licenses, advanced accounting practices, shared printing, and database management become a real issue.

However, when these issues become a reality, they can be a harsh reality requiring time, money, and commitment on the part of the entire studio staff. Organizations such as the Professional Photographers of America (PPA) have addressed studio management by offering management consulting specifically for studios, which helps ease the transition.

How does studio management relate to workflow? Although it doesn't specifically affect individual images, part of the photographer's responsibility is to track clients, their assignments, and all communications with them. If a client calls two years after a shoot and wants a photo, you want to be able not only to find the photo but also to know what you charged that person for the shoot and the images, what kind of relationship you had with them, and so on.

SuccessWare (www.successware.net), for example, is a software program dedicated to operating a photography studio. It provides a way for studios to track clients, schedule shoots, manage expenses and revenue, and market to prospective clients (for example, with direct-mail campaigns, advertising, and so on). Although SuccessWare is specifically for photographers, nothing about this software deals with images — it's all about the client.

Other applications exist for photography, and many studios rely on non-photography-specific software, such as Microsoft Excel and other conventional office tools, to run their studios.

The Digital Client Dynamic: How Digital Changes Customer and Subject Interaction

One of the best and, at the same time, potentially worst attributes of digital photography is the ability to review images immediately. The positive factors are relatively obvious: to get instant feedback on how a subject is being exposed, to gauge pre-pixel as well as post-pixel settings, and to be able to quickly review a series of images before they're downloaded and processed. The cons, however, are anything but insignificant. Some photographers find they become addicted to looking at virtually every image they've shot immediately after the image is exposed, which prevents them from focusing fully on their subjects and, in some cases, even causes them to miss a shot that occurs while they're preoccupied with their images.

Including a client in the image-review process can be an even worse liability, however. As a young radio street reporter working for KTRH-AM, a CBS radio affiliate in Houston, Texas, I was taught never to give the microphone to whomever I was interviewing. Reporters who make this mistake relinquish control of the interview to the interviewee, and getting the mike back is anything but an easy task. Likewise, the photographer who engages the subject and/or client in the immediate image-review process has just relinquished at least some control of that image or series of images.

Managing client review

If you allow your client to review your images just after you've shot them, you're immediately putting yourself into a defensive position — the last place you want to be. The image may be perfectly good but still need to be processed and adjusted — a common and normal process for almost any image. Further, the LCD screen on the camera or even a laptop may not show the image at its best. Sometimes, the image may look perfect on the LCD screen and it turns out to be irreparably soft in its final form and must be used with extensive filtering — inevitably, this is the image the client saw on the LCD screen and remembers, but you won't want to show it in its original form.

As a result, you, the photographer, feel compelled to explain why the image looks the way it does, how it will be altered, and so on. The client begins to offer advice and opinion, and the power of presentation has lost all its power to surprise, delight, and sell the client. *Do everything in your power to resist showing off your images to the client until they're ready to be presented.* No matter how good you think the image looks on the LCD or laptop, do whatever you can to put off showing images to clients until *you're* ready to show them.

A pitfall in using fancy technology is it's fun to show off, and many clients love to see it. That said, in certain professional situations, waiting to show your clients the results might be impossible. A micromanaging art director will always want to see images of a model as soon as they're shot to be able to make changes, and some clients will want to sit and review images on the screen with you right after they've

been shot. If you can avoid this, do so. But if you must show them, then work to display the images in the best manner possible. If you can, at least rotate the images and delete (or store elsewhere) ones that you don't want seen. If at all possible, show them on a projection screen as opposed to an LCD or laptop, because the projection screen is more accurate than an LCD, but more forgiving than a close-up computer screen.

Whenever possible, in situations where you need to show images to clients (whenever it occurs), do so with the most preparation and best-quality software and hardware tools you have available. Relegating an important image to back-of-the-camera LCD review is imprudent and downright risky.

Photo volume overflow

One of the clear differences between digital and film photography is the propensity and ease with which photographers produce exponentially more images using digital. It doesn't cost anything—at least in terms of film, developing, and processing—and digital files multiply faster than well-fed germs.

A classical wedding photographer in Seattle, Harry Haugen, who had shot more than 2,000 weddings with film, formally trained my wife, Amy. Because of her training, she inherently understood the frugality of the film-based wedding photographer and the need to shoot a very limited number of well-posed, well-exposed images to ensure the bottom line didn't get out of control. Shooting mostly medium-format, Rembrandt-style portrait photography, Harry had become an expert in producing breathtaking images with an amazingly limited amount of film. Figure 3-11 shows a wedding portrait shot in medium-format film by Harry Haugen.

Figure 3-11: A wedding portrait by Harry Haugen

As a former photojournalist and current sports photographer, I just couldn't bring myself to shoot a limited amount of photos—I was going to shoot what I thought I needed to create beautiful images for the bride, and to hell with the cost of film. Fortunately, however, I quickly began shooting weddings in digital, not film, because (as Amy is quick to remind me) we wouldn't have made a dime of profit. The first all-digital wedding I photographed was with Amy, and over about 10 hours (it was a very long wedding!) I took just over 1,000 photographs while Amy shot just under 400. In the end, however, we had an equal number of shots in the final images delivered to the client, which speaks to Amy's training as well as mine.

A large number of photos from a single event makes for long hours in the studio for which there is little compensatory value. I have since learned to scale down the number of images I take for events such as weddings, but with digital it is absolutely normal for more shots to be taken than with film—a fact of life every photographer must learn to address.

Software to the rescue

Fortunately, the digital good outweighs the bad in terms of wrangling photo herds. Digital photos are more easily managed—especially in groups—than film images, so handling a larger number of shots can be addressed through batch processing in applications such as Photoshop, iView MediaPro, Photoshop Album, or ACDSee. Each application handles these tasks in a variety of ways, ranging from pre-defined and automated management tools (such as renaming, for example), to complex "actions" in Photoshop or ACD RoboEnhancer. Actions allow for complex series of "actions" you perform on an image to be replicated and applied to large numbers of images automatically. Metadata information (see below) can be added to groups of photos at a time, and complex image editing can be applied to lots of photos at once. Further, images being fulfilled through online image services such as Printroom.com can be edited, optimized, and enhanced even after the sale has taken place.

Here are some tips for working with a large number of digital images:

✦ Realize that even though you'll have more photos with digital than with film, you can still take too many shots, which can become a digital-image-processing nightmare.

✦ As soon as possible, group your images logically using metadata tag information and by placing them into labeled sub-folders (for example, for a wedding, you could have *formals*, *ceremony*, *reception*, etc.).

Note
Metadata is information that is image-specific information, such as keywords, copyright information, camera data about how the shot was taken, keywords, and image descriptions. Some of this information is recorded automatically when the shot is taken and some is appended by the photographer.

Cross-Reference
I discuss metadata in more detail in Stage 4.

✦ Some pro cameras allow you to define metadata tags ahead of time using a computer and synching to the camera. This way, all photos shot will contain that additional, custom information on the metadata tag of each image. This helps get you a step ahead in the image processing.

✦ An image-acquisition utility, such as the one that ships with ACDSee, will search and acquire all the images on a flash card and place them in one folder. Otherwise, the camera will place images into groupings of subfolders—which takes more time to extract and organize.

✦ Batch-process whatever you can. For some sets of images, using the auto-level capabilities of Photoshop will suffice; however, exercise caution, because it may alter some photos poorly and you'll have to go back to the original (saved and archived) images, make more copies, and redo them — which defeats the purpose of batch processing! Try using auto-contrast instead of auto-levels and see if it accomplishes the majority of what you need.

✦ Be brutal in your decision-making about images — especially duplicates. You don't need to show a client five nearly identical versions of an image, so pick one that looks best and be done with it.

✦ Limit the use of the multiple-image function on your camera — it's a good thing for car-racing and fast-moving sports, but it's unnecessary for weddings and portraits (okay, if you must, use it for shooting the reception dance or bouquet-throwing).

✦ Remember that a large number of RAW images will take much more time to process than a large number of JPEGs.

✦ Don't be afraid to erase images on your camera before they're downloaded — albeit carefully!

Summary

Choosing the right software for your digital studio is a critical part of setting up a proper system of photography workflow. From acquisition to editing to storing and archiving, correct and efficient digital-image processing can save you many hours of studio time — time better spent taking photos than trying to locate them. One of the best things you can do in building a digital studio is begin conservatively — not creating a software monster filled with features and functions you won't have the time to learn or use, and tempting you away from important activities.

Find a few key applications and use the heck out of them. If you're not doing extensive creative work, a product like the ACDSee PowerPack may be all you need until you master it and make time for the more-detailed capabilities of Adobe Photoshop or Corel Painter. However, you'll find that a couple key applications will be necessary to effectively get an image from the camera to the client — and it's knowing how to properly treat that image along the way and transition it among the applications that will make the difference between getting snagged and getting the job done.

Images must be presented to clients in the best possible manner. Allowing a subject to commandeer the image-viewing process too early can be a big problem and can thwart the opportunity to show off a shoot in a big way. Presentation-software tools can make a photo shoot look bigger than life and can boost sales and client satisfaction if used properly.

Finally, generating more images is easier with digital than it is with film. Get used to this fact, and learn to manage it. Lots of tools for easily processing digital images are at your fingertips, and knowing how to best work with a large number of images so that they look their best, are easy to find and access, and are optimized for their intended audience is important.

✦ ✦ ✦

Following the Digital Photography Workflow

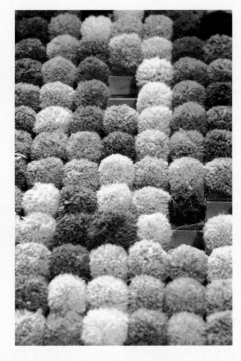

Preparing the Digital Photo Shoot

An image-stabilizing lens is helpful when shooting at night, such as for this scene taken in Austin, Texas. It allowed the shot to be taken with a lower ISO, which meant less digital noise. Taken with a Canon 10D at ISO 200, f/3.5, 1/15 second, and 28mm focal length.

Plotting a foolproof crime and planning the perfect wedding have at least one thing in common: No matter how iron-clad your details for the event are, you'll inevitably miss one or two things — even if you're the world's best wedding planner (or the most accomplished villain). You just can't foresee an event in the future in utter completion.

As with weddings and crimes, planning a photo shoot involves covering as many details as you can, but being prepared for the inevitable crisis: Something breaks, you forget something, you need something you don't have, you're asked to do something you didn't expect, or you have a "human moment" and do something stupid. Understanding how a shoot will be illuminated — either by you or by existing light — is perhaps the greatest factor that will affect your photo shoot preparation.

Preparation in the Field

Digital-photography workflow begins with preparing a photo shoot and accounting for as much as you possibly can—and there's a lot. There's more to a digital shoot than there was to a film photo shoot. (Okay, I admit it: I've officially begun speaking of film in past tense!)

Location and studio shoots both require more than a camera and lights. At the least, in addition to acquiring the images, you need a way to download them and ensure their safety, to back them up, and, in some cases, to copy or even display them on-site. Because the studio is a more controlled and defined environment, pulling off a successful location shoot provides a special kind of challenge that I'll focus on first.

By nature, digital photography is equipment-intensive. With some exceptions, it's also more susceptible to environmental factors such as moisture, heat, and cold. You have to think about batteries and how well they're charged, some kind of a device for accepting flash-card downloads such as a computer or portable drive, as well as access to power outlets. If you're in a foreign country, you may need physical adapters to transform one style of AC plug to a different configuration. And you still have all the other accoutrements of pre-pixel photography: lenses, cameras, lights, cables, and lighting accessories such as reflectors, grids, snoots, and barn doors.

To give you a sense of things, when I recently went to Plovdiv, Bulgaria, to photograph the 2004 Junior/Cadet World Fencing Championships, I knew that in spite of being in the second-largest city in the country, I would probably encounter some challenges. As a result, I doubled-up on some things, but I would say it was more or less typical of a foreign digital-photo shoot for me. I was there for ten days, with nine days of competition, in which I shot environmental images, preliminary competition, quarter- and semifinal and final matches, as well as medal ceremonies, official ceremonies and receptions, and privately commissioned shoots. I took about 10,000 photographs in the time I was there. I knew if something went wrong, I didn't have a good chance of finding parts or replacements for computers or cameras, and I was the only official photographer for the International Fencing Federation there to photograph a world championship.

The major equipment I took included the following (I'm not including things like lens cleaners, lens caps, cell phones, CD-Rs, and so on):

✦ Two Canon digital SLR camera bodies

✦ Extra camera batteries

✦ A battery charger

✦ 70–200mm and 28–135mm Canon image-stabilizing zoom lenses

✦ A 17–85mm Canon zoom lens

✦ A Canon flash with a bounce-card (which helps to deflect the flash for less red-eye and less direct, intense light on the subject)

✦ A backup digital camera (a 5.0-megapixel Olympus with an integrated zoom and separate telephoto and wide-angle attachments)

✦ An ImageTank portable hard drive with its AC power supply/charger

✦ A Toshiba 1700 Satellite laptop with a 17-inch high-resolution screen suitable for showing high-quality images, along with its power supply

✦ Two extra USB cables

- ✦ A PCMCIA/PC Card CompactFlash card reader

- ✦ A USB CompactFlash card reader

- ✦ A flash bracket-mount with cable that allows me to raise the flash higher than if it's just on the hot shoe of the camera (to prevent red-eye and be able to rotate the flash for vertical shots)

- ✦ CompactFlash cards (a mix of 512MB and 1GB cards, plus a 256MB card I kept loaded in the Olympus backup, just in case)

- ✦ About 30 AA batteries (enough to put fresh ones into my flash every day)

- ✦ A mini "slave" strobe light (very portable, inexpensive, and handy) that fires when my flash goes off (see Figure S1-1)

- ✦ A rolling travel case for the gear

- ✦ A fanny pack for moving around while shooting

- ✦ An international power strip

Figure S1-1 was taken in the finals hall in Plovdiv, Bulgaria, at the 2004 Junior/Cadet World Championships — it is a dark venue and flashes were prohibited. In this environment, in an Eastern European country with few easily available western amenities, much less specific camera and computer supplies, you have to be ready to handle any photo situation that comes along. Photography in this kind of environment can be challenging.

Figure S1-1: A dark venue, high-speed action, and no flashes allowed

In addition, you may have to think about backdrops and props, model releases, lights, cables and power, sandbags, flash firing mechanisms, and other parts and pieces. The photo in Figure S1-2, for example, seems very simple. However, in addition to the camera and computer, it required a large soft-box with a light and stand, a secondary light using a grid system (described later in this stage), and all the equipment mentioned in the previous bulleted list. For a backdrop, a black velvet drape was used.

I had to construct the photograph to match the model's personality with my concept for the shoot. This photo also involved setup of several lights, a backdrop, and the camera. In addition, to use the image, I had to obtain a model release from the model.

Figure S1-2: Photo preparation ranges from matching personality and concept to obtaining legal releases.

The Less Tangible Aspects of Digital Workflow

There are obvious reasons why being prepared is so important, such as in shooting wedding ceremonies or major sports events where you have only one shot at an image. You don't want to be running out of batteries or flash-card space when the groom is about to kiss the bride or the champion is about to accept his medal. But there are other, subtler and less tangible aspects of photography workflow that warrant attention.

The very concept of workflow implies a certain momentum to a series of activities. To flow digital information from the camera to the computer to an ultimate form of output requires fluidity of skill and action applied to an image to ensure it is created and processed properly, reaching its ultimate destination looking its very best.

For example, as part of a project shooting a number of fencers for a commercial venture, I took about 500 photos of eight fencers making various moves. To do so, I had to secure a space in a fencing club and ensure I had access to a fencing strip for most of the day. Then I had to make sure I had fencers ready be moved in and out of the shoot at the right time; different fencers were more adept at certain moves, so I paired them together with their most natural opponents. Because they were moving, because I was trying to only capture the fencers and not the environment, and because I couldn't use a backdrop (the space was too large), I used flashes and darkened that area of the club.

I had to keep repositioning the lights to catch the fencers at the right part of their moves, and I had to prepare their weapons so that the blades had the most reflectivity possible (I ended up covering them with white tape). There were three lights—a main light on a high light stand at the far end of the fencing strip, a secondary light with an umbrella reflector, and a simple, small light in the center just to illuminate spots that might not be reached by the two other lights. I had to ensure the lights weren't visible in the shoot and yet position my camera far enough away that I could catch the fencers anywhere appropriate on the strip.

So, a number of obstacles were related to setting up the shoot and ensuring I could keep things flowing and achieve good images for each item on a shot list of more than 40 photos—lights, the logistics of various shots, camera settings that changed depending on lighting changes, ensuring equipment showed up, working to make sure no visible brands appeared on the fencers' clothing (shoes, especially, represented a challenge, and I had to tape over logos and identifiable brand marks), and having a schedule that accommodated what needed to be done as well as the individual fencers' agendas.

Because I thought about these factors ahead of time, I was able to meet the schedule without any problems. I took the time to set up lights and think through what the shots would take, as well as to ensure I had a good schedule mapped out. I also took some test shots early on to find out lighting differences and look for any spots that could be problematic. I didn't think about the reflectivity of the blades beforehand, but because I had done the setup properly before the shoot, I was able to stop and quickly devise a solution for the problem.

Shutter Lag

Less-expensive digital cameras suffer from a trait sometimes known as shutter lag; When you push the shutter release, there's a small (but very annoying) time lag until the image is exposed; the camera has to "think' about the shot before taking it.

Higher-end digital cameras expose immediately with no shutter lag, which is one reason for their high cost. When I'm shooting fencing, for example, I shoot up to 8.5 frames per second for a sport that moves tremendously fast. For any fast sport, it's nearly impossible to catch stop-action photographs with shutter-lag.

If you need or want to shoot some fast shots but your camera tends to lag a bit, you'll need to plot your shot carefully. It requires a bit of anticipation and setting your camera to the most manual setting possible: Often the biggest reason for shutter lag is if the camera must handle all kinds of automatic readings and settings before exposing the shot: focus, such as white balance, exposure, and the like. The more you can set into place before the shot is exposed, the faster the camera can respond—but this means you must set the camera correctly for the shot and then make sure it's exposing correctly. If you've turned off auto-focus, you'll need to make sure you can focus the image correctly manually.

If you are shopping for a camera and you plan to shoot on a regular basis anything that's moving, you'll want to get a camera that capably limits shutter lag. It should be able to shoot at least three or four frames per second, and it should have a sufficient buffer (the amount of images it can store in the camera's internal memory before becoming overloaded and slowing-down) to handle as many shots as you may need to take in a row. This is known as burst rate.

Many of these challenges are found in any photographic workflow, but keep in mind that they are compounded by the requirements of a *digital* shoot. On top of managing the typical non-digital photo shoot workflow, I'm juggling equipment such as my portable hard drive, my 17" laptop for high-quality image preview, all the flash-card readers, and power supplies needed for the digital end of the operation.

Figure S1-3 is from a set of photos taken in a controlled environment, and then this particular image was edited in Photoshop later to add *lens flare* (the light reflections emanating from the fencer's chest) and the text in the image (*fleche* is the term referring to the move being made by the fencer on the left). Notice the tape on the mask, trousers, socks, mask, and shoes that was used to cover logos and names.

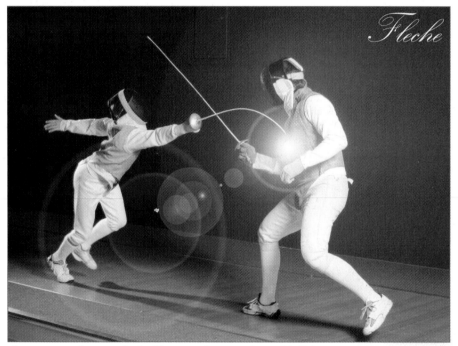

Figure S1-3: Photographed with a complete set of portable lights

In any photo shoot, careful preparation can help avoid major breakdowns, and involves attention to detail, as well as anticipating glitches and major disasters. All this is magnified on a digital shoot given the complex meshing required of digital camera, storage devices, laptop, cables, and power supplies. A missing cord, a power connection that doesn't match local power supplies, or a software glitch can ruin a more fragile, complex digital shoot.

If you're preparing for an in-studio shoot, you have more control over the environment — and small stuff, such as replacing a battery or avoiding frostbite, are relatively easy to control. The field is a much more unpredictable world, involving weather, unavailability of replacement parts and items, terrain, laws, customs, and other surprises.

Equipment Checklist

When preparing for big photo shoots, especially when I go overseas, I use an equipment checklist to ensure I have everything. For every shoot, it's different. In the last year I've shot in Cuba, Lapland (Finland), and Bulgaria — all places where finding even the most basic photography or computer supplies was tough.

In Cuba, finding a simple AA battery meant a taxi ride and two hours away from a shoot. In Lapland, shooting in –50° F (even without the wind chill) resulted in dramatically reduced battery time and the need to protect equipment from temperature differentials of 120° between the outdoors and indoors. In Bulgaria (and Cuba as well), protecting equipment from theft was something to think about ahead of time.

Nothing is more disruptive to the intangible momentum of a photo shoot, as described earlier, than having to stop taking photographs because you need a battery you don't have or even something as simple as making a client wait while on a set while you download a flash card. Have enough on hand that you can quickly change batteries, so that accessories are accessible, and so you can download flash cards while still shooting.

Shooting in a digital studio means equipping the studio with everything you need to accomplish a shoot. You should have an equipment checklist you keep in the studio. Some items, such as batteries, may need to be replenished, while others, such as reflectors or backdrops, may need to go out of the studio on location shoots. In either case, you need to know what's there, what's not, and what needs to be maintained.

To create a checklist, think about what you'll be doing and where you'll be. There are several major subdivisions to checklist categories and equipment considerations. Feel free to copy and use (or adapt) my checklist.

Pre-pixel checklist

When considering the pre-pixel stage, you'll need to think less about the digital aspects of your shoot, and more about conventional photography. What will you need to accomplish the shoot with the best-possible results? Here are a few suggestions:

✦ Camera bodies

✦ Lenses

✦ Camera battery charger

✦ Lights

✦ Light stands

✦ Extra light bulbs (modeling and flash)

✦ Power cables and power boxes (for some lighting systems)

✦ Sync cables (unless you're wireless — but it's still a good idea to have these just in case your wireless capabilities fail)

✦ Flashes

✦ Radio or infrared triggering/firing devices and other automatic lighting tools for flashes

✦ Umbrellas, snoots, barn doors, gels, grids, soft boxes, reflectors, diffusers, and other lighting accessories

Cross-Reference See the Preparing Lighting section later in this chapter for more information on some of these accessories.

✦ Backdrops and backdrop stands

Post-pixel checklist

The post-pixel stage is where the image has passed through the camera's digital sensor and is now digital. So, what are the tools needed to get the image from the camera to its ultimate destination? Consider the following:

✦ Flash cards

✦ Flash-card readers (if necessary)

✦ Portable hard drive, computer, or other device for "receiving" images

✦ Printer

✦ Display device (monitor, LCD projector, and so on)

Accessories and extras

Be prepared for contingencies at photo shoots. When possible, carry extras for parts that may fail, wear out, become damaged, or simply disappear without a trace. If you think you might need something—for example, a model release—take a few along if at all possible. Photographers by nature must be organized pack rats. Here's a list of items you are likely to need:

✦ Lens and camera cleaning items (for example, lens cloths, bulb air-blower, and so on)

✦ Lens hoods to prevent light flare

✦ Flash-card cleaner

✦ Remote camera shutter release

✦ Tripod and/or monopod

✦ Extra lens caps

✦ Lens filters

✦ Devices for viewing images in bright sunlight (such as a camera LCD hood and/or hood for viewing laptop images)

✦ Extra battery charger

✦ Model releases

✦ Printer supplies

✦ Extra USB and/or FireWire cables

✦ CDs for recording images (and a functioning internal or external CD burner)

For portable/location shoots

When shooting on location, you'll want to have tools that will help you protect your gear and adapt to the environment. Unlike a studio, when you're in the field, you have only limited control over your space and you may wish you had any of the following:

✦ Antitheft devices (cables, alarms)

✦ Carrying cases

✦ Flash-card cases

✦ Power strips

✦ AC adapters (for foreign shoots)

✦ Camera case(s)

✦ Desiccant (anti-moisture devices that you keep in your camera and computer bag)

✦ Indelible pens (for example, Sharpie markers)

✦ Notebook

✦ If a commercial shoot, you'll want a copy of your shot list and contract or letter of agreement

✦ If you're working with individual clients or simple commercial shoots, bring a receipt book

Air Travel and Camera Equipment

U.S. security forces don't want you to lock checked baggage, and most airlines will not cover camera equipment for loss or damage in checked luggage. So checking expensive equipment knowing it may very well be opened, examined, and generally treated poorly is disconcerting. However, the size of what you can bring onto the plane is limited—so if you're carrying any lighting equipment, especially, you'll have to check it. Checking light stands, backdrops, and even lights is better than checking cameras or lenses.

This issue is important when traveling in Europe because some European airlines—British Airways, in particular—are very persnickety when it comes to carry-on bags. They only want you to carry one bag, and it should be a small one. In some countries, they'll even weigh your carry-on luggage and charge you extra if you've exceeded their puny limits (this happened to me in Bulgaria, for example, getting onto British Airways).

Traveling in foreign countries to take photos in out-of-the-way locations can present unique and challenging preparation demands.Use your best diplomatic skills to charm the flight crew, because the less baggage you have to check, the better! A shoot in Lapland in the middle of the winter required that I bring three cameras. Additionally, I had to bring some basic lights for portrait shoots, a computer, a tripod, an LCD projector to display images, speakers to play music with the slide show I created while there, extreme cold-weather gear for myself and my equipment, plus my personal gear!

This amounted to a tremendous load to convince the airlines I had to carry on as well as check. Finnair, I must say, was much more accommodating than British Airways, with whom I've had a much tougher time with significantly less equipment. As you can see in next few figures, I had a diverse set of situations and environments to shoot.

Figure S1-4 shows two fencers outside. This was for publicity purposes for the Saresto Open, the tournament that was taking place in Levi, Finland. This was a warmer day — only –38° F. In addition to the cold, the burden of the ski equipment made for a logistical challenge (especially considering one of the fencers had never been on skis!).

Figure S1-4: A quick shoot — the fencers became painfully cold within about two minutes of standing outside wearing only their fencing gear.

Figure S1-5 is a photo of the organizer of the tournament, Maarit Rajamäki. She is an accomplished concert violinist and champion fencer who posed with her instrument, a 500-year-old Amati violin. I had to find a place in the town to take this photograph with only about 30 minutes to set it up, and even less time to take the photo because the violin is so fragile the atmosphere must be constantly monitored for humidity and temperature and it had to be returned quickly to its case.

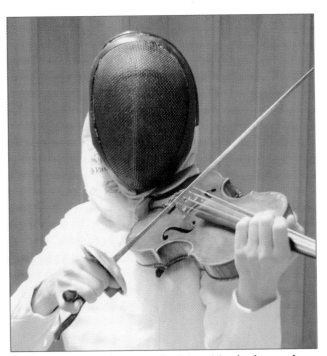

Figure S1-5: Field shoots require improvising backgrounds, lighting, and other factors (here a sliding room divider served as a backdrop).

The Aurora Borealis is shot in darkness, outside. It's moving. You don't know where it will appear. And, the places in the world where it can be seen the best are miserably cold. The shot in Figure S1-6 was taken on a tripod at –42° F at about 2 a.m. The image was exposed for about 35 seconds at F5.6 at ISO 800. Digitally, photographing in the cold is very difficult because severe cold quickly penetrates a camera, reduces battery performance, and can even prevent certain functions from working such as automatic focus. When shooting low-light images, digital cameras generate "noise," as you can see in the figure. This is a similar effect to "grain" from film cameras.

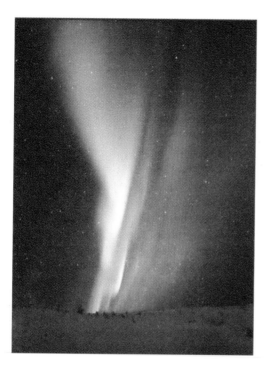

Figure S1-6: The Aurora Borealis is one of the more difficult things to photograph in the world.

Cross-Reference See Stage 2 for more information on ISO and digital noise.

Traveling in harsh weather on outdoor adventure vehicles like a snowmobile with camera equipment makes for a tough shoot. Protecting the equipment, keeping it warm enough that it doesn't fail but cool enough that you don't have to wait too long to be able to take photos in the environment, and still being able to keep from getting frostbitten or ending up in a ditch is a rather harrowing challenge.

In spite of tough setup, sometimes the work of getting all the equipment onto an airplane and getting out into remote locations is well worth the trouble. The blue shade of the sky shown in Figure S1-7 is common in the Arctic winter.

I've had more than one semi-heated discussion with a gate agent about bringing a computer bag and camera backpack on board a trans-European flight. However, the decision almost always comes down to whether the cabin crew of the airline approves — and they almost always do. As diplomatically as you can, always insist on letting the crew decide.

Carry on everything that you can

For location shoots where you'll need to fly, you're going to want to carefully consider what you'll be able to check on the airplane versus what you carry on. Most computer equipment poses no threat from a security standpoint, so the more that you can carry on, the better.

Figure S1-7: White balance, exposure, and ISO have to be set quickly in a harsh environment. This shot was taken at f/5.6 at 1/125 second at ISO 400.

If you can fit your camera and lenses into a computer briefcase or backpack with your laptop, all the better. It may mean checking your empty camera case/backpack along with other less-critical items and reloading your camera bag when you reach your destination, but it may make getting on board much easier and will make your flight much more peaceful. But you still need to be cognizant of carry-on size limitations in the U.S.

Caution

Note this statement from the U.S. Transportation Security Administration's Web site: "You may carry one (1) bag of photographic equipment in addition to one (1) carry-on and one (1) personal item through the screening checkpoint. The additional bag must conform to your air carrier's carry-on restrictions for size and weight. Please confirm your air carrier's restrictions prior to arriving at the airport." (Transportation Security Administration Web site (www.tsa.gov), "Traveling & Consumers: Transporting Special Items — Transporting Film and Photographic Equipment" May 2004).

Checking gear

Different airlines have various (and changing) restrictions for checked luggage, and photography equipment can get heavy pretty fast. For example, United Airlines and many other airlines begin charging for bags in excess of 50 pounds and you're allowed to check two (possibly more if you're a frequent flyer with lots of miles). Southwest Airlines is one of the most liberal, allowing anyone to check three bags up to 70 pounds each before levying a charge.

Cases for digital cameras and accessories abound. In particular, I favor the Pelican cases for checking equipment because they're very weatherproof and shockproof. They have some interesting and unique designs, such as a foam-loaded, box-like case with wheels and an extendable handle. Their prices are very good and it's the best protection for the money I've found.

When checking lights, you'll want to be sure the bulbs are as protected as possible because they're so fragile. Have replacements ready when you need them.

Finally, the good news! With film, x-ray machines in airport security were always a big concern. Not so with flash cards — based on my experience as well as a statement by the U.S. Transportation Security Administration (TSA) putting flash cards through the scanners doesn't create any problem. According to the TSA's Web site, "The screening equipment will not affect digital cameras and electronic image storage cards." However, if you have any concerns about flash cards or other gear, you can always ask for a hand-check; the TSA is usually happy to comply with a physical inspection of equipment.

Averting Digital Disaster

In Cuba, at the 2003 World Fencing Championships, I used an ImageTank to download flash cards to the hard drive. Because I was shooting lots of large-format images quickly, I used two large-capacity (one gigabyte) flash cards. I would fill one up, replace it with a second card, and download the one I had just used up while shooting the other. Shooting large-format images in rapid succession is what you must do to capture the moment and then be able to do enough with the image later. Being able to capture so many images, such as the photo in Figure S1-8, allowed me to select from a large pool of photos from the event.

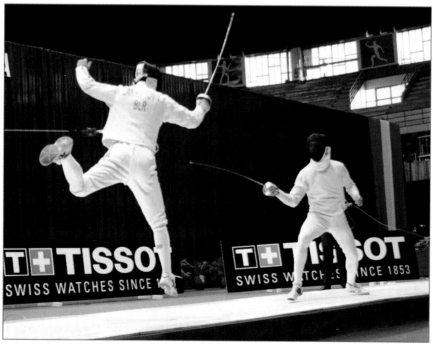

Figure S1-8: Shooting large-format images in rapid succession presents data-transfer challenges for large numbers of photo files.

I formatted the card I placed in the camera, confident that it had been downloaded. However, because the ImageTank has no way to tell what files have specifically been downloaded, every now and then I became mildly paranoid and so I would resave a card. Later, in the hotel, if I had downloaded it twice, I would just delete one set.

Unfortunately, this strategy backfired—on one of the nine nights I repeated this process, I missed a card. Somehow, I accidentally didn't download a card, reinserted it in the camera, and formatted it. Those photos were lost, I learned to my horror several days later when I went looking for a particular image from a medal ceremony on that night. So much for my paranoia.

The moral of this story is to emphasize Murphy's law is in play wherever and whenever you shoot in the field. The more you can do to put your own method or process in place to prevent disaster and stick to your system, the better. Consider the following:

✦ Charge batteries as often as possible, although try to use them up as much as possible and have a fresh one ready (recharging some types of batteries before they are completely discharged can limit their life).

✦ Make sure you place filled flash cards in a separate location from fresh ones. Don't forget which is which!

✦ Consider bringing enough flash cards so that you don't need to empty one and re-use it

✦ Keep an emergency battery and flash card handy, just in case.

✦ If your flash card came with Recovery software, install it on you laptop so you have it with you.

Digital backups

Being ready to make backup files as soon as possible is of critical importance. The sooner you have your digital images stored in at least two separate places, the better. Thinking back to my Cuban experience, if you can afford to have enough flash-card space to cover all the photos in a shoot, not having to erase or format any cards until you're safely in the studio working at your leisure is better. Download them, yes; format or erase them before you have to, *no!*

If you do plan to download cards at a shoot and then erase or format the cards, storing the images in two places rather than just one is best. One of the easier ways in which to do this is to first download cards to a portable hard drive such as the ImageTank or Delkin PicturePAD, and then immediately—or before you break down the shoot—copy the images from the drive to the computer.

Don't put everything in one place

If you're on location, try not to transport the hard drive and the computer together to avert any potential disasters. Don't pack them in the same bag, for sure. If you're shooting a critical event, have someone else transport either the computer or the hard drive and you carry the other one. This strategy may sound a bit over the top, but for very important photos, you can't be too careful. One stolen, dropped, or lost bag with everything in it is all it takes for catastrophe to pay a very unwelcome visit.

When staying at hotels, and after you're off the job, still keep your stored images separate. Place your portable hard drive in your room safe at your hotel, or check it with the front desk—the drives are small enough that they're easier to store in a safe-deposit box than a laptop. For example, when shooting in unknown and sometimes potentially dangerous urban environments, I don't want to be worrying about

too much equipment I really don't need with me, so I try to carry enough CompactFlash cards to shoot what I need, and leave the computer and hard drive at the hotel.

You need to be ready to move files from anything portable to something permanent, whether that's a hard drive, a backup system (for example, a RAID system), CDs, or DVDs — and you have to be diligent about doing so. You always want to have two copies of even moderately important images, keep them separately stored, and have them cataloged and indexed so that you know where and what they are.

Tip One useful option is to compress your image files using a compression utility like WinZip or StuffIt. This reduces file size for transport without degrading image quality. Later, the images can be un-archived and restored to full size for editing. If an Internet connection is available at your hotel, you can use it to upload the compressed files to an online server or storage site, thus avoid subjecting your photos to inspection stations.

In-Studio Preparation

How you set up a studio for digital photography will depend upon whether you plan to have computer equipment permanently in the studio, or you locate it separately. In my opinion, having the computer equipment too close to the actual photography area can be distracting to both the photographer and the subject and limits your ability to control display of the images — if the computer is there, your client will naturally want to see the images right away.

Where you take your photos should be dedicated to just that: acquiring the images. Keeping the area clear so that you can move lights, tripods, people, props, and backdrops is important.For example, Figure S1-9 used a sitting pose on an Egyptian fainting chair with a dark, flowered, hand-painted muslin backdrop. In addition to the digital camera (in this case, a Canon D60), it involved using an assistant to help position props, work with wardrobe, and aid the model; a large soft box with a flash head on a light stand; and the 10-x-20-foot backdrop. In my studio, I always work with various props, chairs, and backdrops for different effects. In some cases, the props are understated or not even seen (for example, in the case of a posing stool); in other cases, the props are an important element of the image.

Studio shoots — especially creative ones — involve lots of experimentation with lighting, backdrops, props, wardrobe, and furniture. Managing these and being able to access and store them quickly to maintain the momentum of the shoot is important.

That said, when you plan how your studio will operate, ensure you have an area dedicated to downloading images where you can safely place and perhaps even store flash cards and whatever it is you're using to acquire the images, such as a portable hard drive or a laptop. You don't want to have to flit off to a separate part of the building (or another place) just to download a card. Generally, I believe using a portable hard drive in the studio is just as handy as it is in the field. I can keep it close to where I'm shooting, download images as I go without disrupting the shoot, and control carefully where and when I download the photos to the computer — where I can view them. If I use the laptop in the studio, inevitably clients and subjects want me to show them the images before I'm ready to do so, which isn't a good idea.

A digital studio, from a purely pre-pixel standpoint (that is, how you set up and position your lights, subject, and camera) is virtually the same as for a film-based operation. You still have the same considerations for lighting and exposure, whether you're shooting a glamour model, a family, or a still-life bowl of fruit.

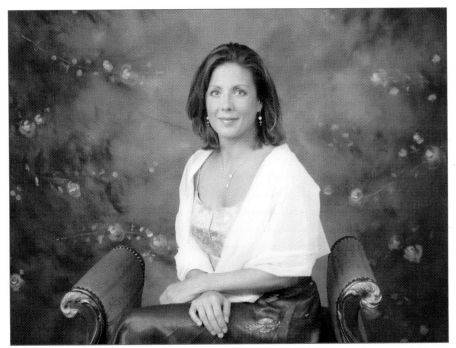

Figure S1-9: A number of props and backdrops were used in a series of images of this model, in addition to three different lights.

This image was photographed by Jo Rorberg, a founding partner of Boudoir Northwest, in the Tiger Mountain Studio.

Higher-end SLR digital cameras operate just like a film camera would in terms of lighting and composition. (The low-end, point-and-shoot digital cameras are very light sensitive and, because of this and their automated operation, you cannot control exposure on them well enough to be able to use them in a studio setting.) Regardless of camera complexity, you must still think about issues such as how to pose a subject, low- and high-key lighting, flashes, and so on.

Note　*Low-key* and *high-key lighting* refer to whether images are primarily dark or light. High-key lighting relies primarily on an abundance of light that wraps a subject — very common in fashion modeling photography, for example — with very little mid-tone or shadowing. Low-key, conversely, involves an emphasis on low-light conditions. There is little tonal highlighting and lots of shadowing. Fine-art nude photography, for example, often employs low-key lighting for dramatic effect.

Preparing lighting

For lighting, I combine traditional umbrella lighting with a large soft-box light that provides excellent high-key coverage and is suitable for a wide variety of portraiture. I add various types of lighting accessories to that, such as small *hair lights* (meant to illuminate behind a subject so the subject's head is

highlighted and doesn't blend into the background), as well as attachments to the lights. To control lighting, I use several very useful add-ons:

✦ **Gels:** Colored transparent sheets of plastic that add spot color to a scene; these are mounted onto a light.

✦ **Snoots:** Cone-like metal attachments to a light that provide a focused spotlight on a scene or subject.

✦ **Soft-boxes**: Large sheets of typically white, light-diffusing material in a fixture attached to a light head, through which the flash or light shines (see Figure S1-10). Soft-boxes come in a variety of shapes and sizes.

✦ **Umbrellas:** Used to reflect indirect light onto a subject, or used to shoot through and diffuse light, similar to a soft-box.

✦ **Grids:** Flat, honeycombed disks that snap into the hood in front of the light to control light on a subject and provide lighting depth without highly defined edges. These are newer and a bit less common, and also come in large soft styles as a combination of a soft-box light with the grid effect (see Figure S1-11). Very light and portable, I often use these for location shoot with lights. Note the honeycomb design to allow a light to be directed in a feathered, spotlight fashion on a subject.

✦ **Barn doors:** An attachment to the front of the light consisting of multiple leaves that can be moved to control where light is being cast on a scene (see Figure S1-12).

Figure S1-10: A soft-box mounted on a Bowens head and a tripod with a boom

Figure S1-11: A 20 percent grid lighting disk mounted in a light

Figure S1-12: A barn door mounted on a light

There are many interesting lighting configurations, tools, and accessories, with a tremendous range in power, lighting control, and price. Because many of my shoots are away from the studio, I tend to buy lights that I can easily transport and that will withstand the rigors of travel combined with frequent setup and teardown. While lighting can be significantly adjusted in the post-pixel stage, especially with RAW files, creating a photograph with good lighting at the outset will help ultimately result in the very best digital shots.

Lighting kits

You'll find that lights, very broadly, are divided into two groups: full systems, or *kits,* as they are commonly called, and stand-alone units you purchase piece-by-piece. Lighting kits are typically more dedicated and work with specific power supplies and connectors.

With stand-alone units, you buy a flash head, which often includes a modeling light, which is often a tungsten light — this is meant to help set up the light so you can see how it will flash, but often it can suffice as the only light you use, especially in low-key lighting when you don't want to use a flash. If you go the stand-alone direction, you'll need to buy light stands, synch cables, and everything else; kits, conversely, come in a wide variety and usually come with just about everything you need to light a studio or other shoot.

Cabling techniques

It's important in setting up a studio to minimize cabling as much as possible, not just with computers, but with lighting also. Instead of synch cables, use infrared or radio firing devices for cameras.

For example, if your flash heads have an infrared receiver, they can be operated in slave mode by placing an infrared device on your camera's hot shoe (where the flash is normally mounted). I like the Paterson Infrared Transmitter, which is inexpensive, very reliable, and operates forever on a couple of AA batteries.

Figure S1-13 shows a Dyna-Lite (www.dynalite.com) Uni400JR flash head in my studio with an infrared receiver. When switched to slave mode (the switch just beneath the infrared receiver), the receiver will pick up any flash that goes off in the studio and force its light to flash at the same instant.

Virtual backdrops

It's Hollywood meets still photography — being able to green-screen subjects onto almost any background imaginable. Virtual backdrops combine an in-studio subject with a scene of anything you can photograph and create as a background. Through a specialized system created by Texas-based Virtual Backgrounds (www.virtualbackgrounds.com), you can project a transparency (slide) photo into what any type of SLR camera sees along with the subject. The system ranges in price depending upon certain options, but can be acquired for about the cost of a professional digital camera.

> **Note** Using a green screen allows you to have a person appear in the scene that is being shot, but the background is virtually non-existent.

Using a sophisticated beam-splitter and projection system along with an extremely reflective backdrop (1,500 times more reflective than a white wall, according to the company), the result is a photo that looks like the subject was physically part of the background. Figure S1-14 shows a diagram of the Virtual Backgrounds photography setup, which can work with almost any camera to create an artificial background behind a subject. Figure S1-15 shows the actual hardware.

Infrared receiver

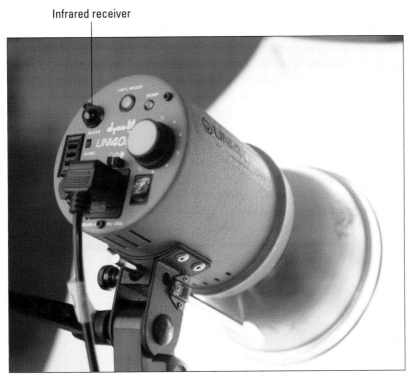

Figure S1-13: The infrared receiver is the small, dark-red dome at the upper-left of the back of the light.

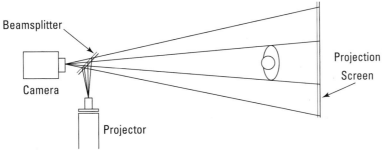

Figure S1-14: A diagram of the Virtual Backgrounds photography setup

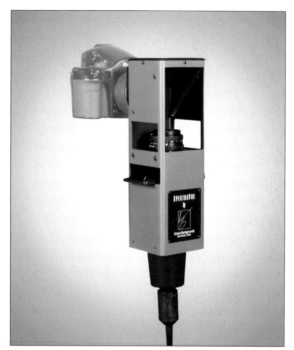

Figure S1-15: The virtual background hardware is capable of working with both digital or film cameras.

The Virtual Backgrounds system is like Photoshop layering, except that it's done at the pre-pixel stage, which means the ultimate result is (at least potentially) even better, because you're beginning the photographic process with an original image you can control before it becomes digital. And, although the system can be used with film as well, digital photography is perfectly suited for this system because reviewing what's just been photographed and then making minor corrections to yield a perfect photo is so easy. Figure S1-16 shows an example of a photograph taken with the Virtual Backgrounds system, combining a subject with a background slide. While it can be used in a variety of ways, in this image the "virtual background" is the out-of-focus area in the center behind the boy; the walls on the sides of the image are actual studio props. It's common for photographers to combine background images — whether real backdrops or virtual — with physical foreground props to make the images look three-dimensional.

One of the more interesting potential uses of the system, says the founder and CEO, Henry Oles, is to use your own photographs as backdrops. "For example, many hotels will not let you shoot a bride in their lobbies," he says. "This way, you can take a photo of the lobby without the bride there, turn it into a transparency, and then superimpose the bride into the lobby using Virtual Backgrounds."

Figure S1-16: A photo taken with the Virtual Backgrounds system
Photo taken by Joseph and Louise Simone, courtesy of Virtual Backgrounds

Organizing studio space

I have my studio organized into three primary areas: the area where I take photographs and set up my scenes combined with some storage area, a small room where I can meet with clients and can set up a laptop or even a portable screen to show images, and a dressing and makeup area. Figure S1-17 shows the layout of the Tiger Mountain Photo studio.

Tiger Mountain Photo studio, though small, is very efficient. With a little innovation, I can make scenes look much larger than the space in which they were photographed. An advantage of digital is that you can work carefully with exposures to enhance the depth of field to make the background more blurred. For example, by being able to immediately review the image, changes can be made easily on-the-fly.

It's important to realize that images can be edited after the fact in Photoshop or other programs, and significantly enhanced. However, the extent to which they can be modified may very well be affected directly by the type of shot you take in the studio. For example, a plain black background will be much easier to remove in an editing application than one with a design or multiple colors or one with props. If you believe you'll be significantly enhancing an image later, or removing the background to use the only the subject as a component or design element in other images or layouts, then the simpler the background, the better.

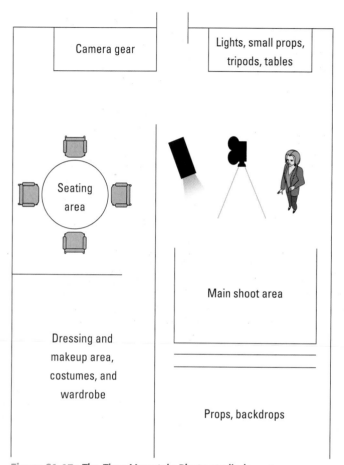

Figure S1-17: The Tiger Mountain Photo studio layout

At Tiger Mountain, we use seamless rolled paper, velvet drapes, or hand-painted muslin backdrops for most of our in-studio work. Because we aren't doing a tremendous amount of studio work, we keep our systems simple and relatively inexpensive. Expensive automated backdrop systems are available to ease working with these large pieces of paper and material, but for now we've opted to put our money into cameras and computers and, as our studio grows (especially physically, because we plan to expand it), we'll add the automated features — this has been one of our transition-to-digital lower priorities. The paper backdrops are good for everyday portraiture, the velvet drapes are good for low-key artistic work, and the muslins are good for creating interesting scenes that add perspective and depth. If you get a good-quality painted muslin, it can look completely different through the camera's eye than it does just sitting in the studio.

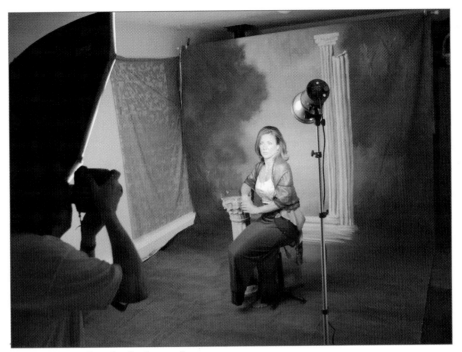

Figure S1-18: Shooting in the studio

Painters who know photography can create a kind of optical illusion in the way they paint the shadows and colors that can give the image amazing qualities. One of my favorite suppliers of these types of high-quality backdrops is Studio Dynamics, based in Paramount, California (`www.studiodynamics.com`). It's their background shown in Figure S1-18.

The Human Factor

If you're doing a studio or location shoot with models or paying clients, you must ensure their comfort and offer wardrobe and makeup options and facilities. I did a boudoir photo session of Jennifer, the model in figure S1-19, in her home on a snowy day in the Pacific Northwest, and, considering she was nine-months pregnant, I had to be certain she was relaxed enough to take a great photo. As it turned out, she ended up being more relaxed than I was, since I thought she'd need to get to the delivery room at any moment.

To create a dreamy winter ambience with Jennifer looking out the window and seemingly into the future about to arrive so soon, I had some specific lighting and environmental challenges to set up the shot. I didn't want her standing too long, and so I quickly set up two modeling lights to give just enough light that I could take a nice photo of her without the bright snow outside causing a backlighting problem. I decided not to use flashes, because it would take more time to measure the effect of their light on the scene.

Because this shoot had such marked contrast between the bright outside and the dark interior, we adjusted the ISO setting on the camera as well as the speed and aperture, accordingly, to experiment quickly with the image. A real advantage of digital is that in difficult light you can alter the ISO from shot-to-shot, as opposed to film where it can only be adjusted roll-to-roll.

I brought her in at the last minute and made sure she didn't have to stand so long that she got too tired or cold, but long enough so that I could take about 20 photos. In order to accomplish this, I had to pay attention to the temperature and her mood as well as the camera and light settings.

Figure S1-19: This shoot required that the model be as comfortable as possible.

You might call it the "geek factor." What many photographers overlook—especially those coming from a computing orientation as opposed to photography—is the human element of working with other team members on the photo shoot and working with clients, models, and subjects. Workflow must integrate adaptability to working with people who may not be familiar with photography or computing, or how they work together, and they may not care—all they may be interested in is looking at and getting some great photos. Many digital photographers become so absorbed in their technology that they fail to develop and cultivate the people skills necessary to work with models or clients to bring out their very best personality in a shoot. They aren't interested in how many megapixels your camera is, how cool the editing or downloading software is, or sifting through 750 photographs with minor differences in lighting. All they want is some great photos, and it's up to you to provide them.

As a photographer, you're in control of the workflow, in terms of equipment as well as your subjects. They look to you as a professional to tell them how to pose and behave in front of the camera. You're the artist, and although they may expect you to work with them to achieve what they want in a photo, ultimately it's all up to you. With digital, there's even more to the equation, because you may also be thinking about the digital treatment — whether that's creative or practical, such as using the subject only with a removed background — that is to come after the shoot.

You also control how the images you take are presented to them, and that will relate to the success of your images. Ensuring a person's comfort in front of a camera and then presenting images to her professionally are essential elements of digital-photography workflow. Digital images are much more presentable than film was — you can post digital images on the Web in a personal gallery or easily display them on computers or projection devices — and, as a result, clients and subjects get much more involved in photography than they did in the mystical, magical days gone by when film was the only option.

Maintaining a professional relationship with clients

With paying clients, you'll also need to be able to take their money and ensure a professional business transaction has taken place in a secure and appropriate environment. Ahead of time, you'll want to work with them in the sales cycle to give them confidence you're right for the job — whether it's a wedding, a company's product, a senior portrait, a corporate event, or a sports team.

Managing your clients' accounts can take considerable time, and you'll also find that clients want to have access to you, as the creative mastermind behind your photography business. If you're their photographer, they want to know you ahead of time and work with you after the shoot — which is where your ability to delegate workflow elements is essential. You need to know the elements of your workflow ahead of a shoot in order to set proper expectations among clients and subjects alike. (I refer to clients and subjects together because they both bond to you as the photographer and as the one who's in control of what ultimately happens to create the best-possible images of or for them.)

Beyond the aspects of the shoot common to all types of photography, such as wardrobe, poses, etc., you'll want to ensure clients who know you're shooting digital understand what that means. Let them know how they'll be viewing their photos and when, if they'll have online access to them, if they'll be getting images on a CD, DVD, or in a slide show, and so on. Use the digital aspects of the shoot as an option-rich advantage that lets them have the best of all worlds.

Managing Business and Time

Most photographers are surprised that the amount of time they spend taking pictures pales in comparison with the time spent on the business of photography and working with clients, subjects, and other people before and after a shoot. There's more than you might think in administrating photography, including accounting, maintaining contact information, scheduling, marketing and sales, and managing a Web site — all of which play into how you manage a professional relationship. This is an unavoidable, necessary part of operating a digital studio and — although not specifically part of workflow as it relates to getting an image from a camera to ultimate output — if you don't have it under at least some control, it will get in the way of photography workflow.

What you'll find is that, at least at some point, doing it all yourself is impossible. You may need to get the help of a family member, an assistant, or an intern. Obviously, if you're already an established studio, you've found this out.

Prepare them for the event and what they can expect:

✦ Tell them what clothes to wear, and which ones to avoid. Because digital photography is particularly susceptible to moiré patterns (an undesirable visual defect of conflicting grids and lines), clients should avoid patterns and stripes, if possible.

✦ Explain how much time the shoot will take.

✦ Establish how many changes of clothing they might have to have.

✦ If they will need makeup, and, for commercial shoots such as executives or glamour shoots of models, determine if there will be a makeup artist ready to work with them.

✦ Explain when they can expect to see their photos.

✦ Identify who will be at the shoot, and what their role(s) will be.

Most people who have not been in a studio or had photos taken very often are a bit nervous and/or awkward at the shoot. Do your best to make them comfortable and expect that the first few images will be throw away shots where they will look stiff or tight. Even if you have the studio or location set up perfectly, take some shots you know you won't use with flashes and lights going, telling the client they are just test shots and there is no need to pose or smile for them. This way, the client can get used to the environment somewhat before you begin your shooting in earnest. Relaxing your client and establishing your shoot and set ahead of time allows you to be more creative. And, the client's photograph will be the best it can be. Best of all, if a client enjoys the time in front of the camera, the photograph will mean more.

You'll want to remind clients that they don't need to worry about looking at their images right away, that the review process will come later. Many subjects will realize you're shooting digital and will want to see things right away, but you'll want to emphasize that all they need to worry about is looking good in front of the camera. This is both a pitfall and advantage of the digital workflow, and maintaining good momentum is essential to producing good photographs. One great thing about digital is being able to shoot lots of shots on one flash card (assuming you're using one with a large-enough capacity) so you don't have to stop to download or change cards.

After the shoot, do your best to follow up with clients in a timely manner. This, however, can mean many things — finding photographers who take a month or more to get wedding photos back to clients is not unusual. I've even heard of portrait photographers who take several months. This, of course, is a throwback to the days of film, where processing and review of those photographs was a time-consuming effort. That said, digital doesn't happen immediately, even though the images are ready to be viewed immediately after shooting. Sometimes building anticipation helps, and you'll want time to review, process, tweak, and perhaps even post images on a Web site before they see your work — so asking clients and subjects to wait a few weeks or more to see photographs is perfectly okay (it can actually serve to increase the perceived value of the photos). If the process seems too easy, they may think it should be cheaper — many clients may feel that way if you're too quick to show what you've done.

 Cross-Reference For full discussion of storing, displaying, and protecting online photos, see Stage 10.

The legal angle

Covering yourself legally in photography — especially for the situations in which you may only have one shot at getting it right, like a wedding — has traditionally been based upon every photographer's greatest fear: that somehow the film would fail. It would be exposed incorrectly, the negatives would be destroyed or lost, or something else catastrophic would happen. In digital, disaster can still strike, such

as inadvertently deleting an image, dropping a portable hard drive, losing a flash card or not downloading it, or accidentally corrupting a card by removing it from the camera while it's processing. Any of these things can destroy images, and can potentially put you into a legal situation with a client.

However, digital photography offers one thing film does not: the ability to see the image the moment you take it. This makes up for a tremendous amount of a photographer's angst over creating a successful photograph and catching the perfect moment. Furthermore, it allows you the ability to see right away if there's a problem with your photo and, potentially, reshoot it. It's better to have the bride throw the bouquet a second time and catch it for eternity in mid-air — believe me, you wouldn't be the first photographer to restage such an event, and the bride, bridesmaids, and guests rarely mind getting a second chance at throwing and catching the flowers!

Twenty years ago, and especially before the e-mail era, photographers commonly required their clients to sign long legalese contracts no matter what kind of shoot. Contracts are still common, especially for large events, such as a big wedding or an extended corporate shoot that involves a lot of people, time, locations, and so on. However, for simple assignments and projects the vast majority of pro photographers today rely on simple, e-mail-based letters of agreement that are much less hassle. Further, clients only spending $500 or $1,000 aren't inclined to want to read and sign long contracts for a relatively quick job — even if it's formal photos for a wedding. They just want to have a sense of what you're going to provide, how long it will take, how much it's going to cost and when they're supposed to pay, and what happens if there's a snag (for example, weather problems, you get sick, and so on). There's no reason all these details can't be addressed either directly in e-mail or in a letter attached to an e-mail. That way, also, you have an electronic paper trail of correspondence with your client. Typically, having the client agree to the terms via e-mail is sufficient to close a deal. The digital world is more complex than one that's simply paper-and-pen, but being able to trace your communication with a client is key to protecting yourself. If you really want to be certain, however, having a signed document is always your best fallback.

Tip Legal documents sent over the Web are best saved in Adobe PDF format, which is created using Adobe Acrobat. This is a purchased application that allows you to create a PDF of files created in virtually any application, such as a Word, Excel, or even Word Pad, and it can be protected from being changed or copied when in PDF form. This is better than simply using the original application file, which could be altered. Clients can open PDF files using the Adobe Acrobat Reader, which is a free and common application available on the Adobe Web site at www.adobe.com.

Here are some legal instruments you'll want to have ready, depending upon the types of shoots you plan to offer:

✦ A basic, plain-language letter of agreement for a shoot that includes the key elements of the event:

- Day and time

- How long you'll be there

- How much you're charging, and how much of a deposit (nonrefundable!) you require

- How much you'll charge if they ask you to stay longer

- Where it will be (studio, church/synagogue, corporate headquarters, and so on)

- What happens if a problem occurs

- What happens in the event of a client-based problem, such as weather preventing the event from taking place, the executive being called away on business, and so on

- What happens in the event of a photographer-based problem, such as breaking your leg the morning of the shoot, your equipment being stolen, and so on

- What happens where there is a cancellation for any reason (typically the deposit is lost, at the very least, depending upon how close the cancellation is to the event)

- What photos they'll get for their event, if they'll be uploaded to an online gallery, and within what general time frame

- Who "owns" the digital image and, if the photographer continues to own them (which is the most common scenario), what "usage rights" the client has purchased and over what period of time.

Note In many personal shoots, such as weddings, bar mitvahs, etc., it's common to simply sell the images to the client and they own them, with perhaps the agreement that the photographer can use the shots for his or her portfolio. High-resolution digital images are given to the client on a disc, and they can print them as they like. Quite often, clients will continue to return to the photographer to provide this service for them even though they've purchased the images.

✦ A complete (as opposed to a shortened) model release for formal, commercial shoots (see the "Model releases" section later in this chapter).

✦ A brief, concise model release to use when in the field.

✦ A wedding contract for larger weddings where you'll be shooting the formals, ceremony, reception, and other events surrounding it, such as the rehearsal dinner or engagement party.

✦ A commercial agreement for significant commercial engagements to shoot products, facilities, annual reports, or numerous locations (a simple letter of agreement over e-mail is sufficient for executive head shots or very limited, simple assignments).

Many paying clients may not really be that excited about having their picture taken and will want to be in and out as fast as possible. This is one thing that both kids and business executives have in common — their agendas aren't likely to include a lot of time for photographers! This means you have to be ready to shoot and not take too many measurements or rearrange the studio or setting before you take the photos; fortunately, with the digital format, it's easy to see how the images are turning out on the spot, which makes for creating good shots quickly. However, be ready ahead of time, and use someone else, such as an assistant, a family member, or anyone willing to sit for a few minutes, to pre-test your lighting, composition, and pose. Then, when your actual client arrives on the scene, you only have to make minor adjustments, check the image and histogram on the LCD, and you can focus better on interacting with the person instead of fooling around with your equipment.

Be ready to work with clients to make the business transaction as smooth and easy as possible. Make it clear ahead of time if you take checks, credit cards, or other forms of payment. Make sure you can provide a receipt, and ensure the client that you'll handle their money and personal financial information with utter professionalism and discretion.

Although taking someone's check may not really be part of digital-photography workflow per se, it can have a direct effect on it because it's something you have to think about that can detract from your concentration on ensuring all your equipment is set up, powered, connected, and working properly.

Model releases

If you're shooting models, or any shot that you may potentially use in print (such as in a magazine arti-cle, book, or other publication) or even on a Web site, getting a model release signed at the time of the shoot is a good idea. Although you can get them later, doing so is more trouble. If you're out and about shooting — even in a foreign country — carry simple model releases you can have someone sign on the spot. If they don't speak English, have someone interpret for you, if possible, so they understand what they're signing (or they won't sign it, most likely!). Having these model releases is essential.

I keep a folder of model releases stored in a safe place in my studio. If I don't have a model release for a person, I don't use the photo — period. Sometimes I've received e-mail authorization from a model to use the image, but this is a relatively weak alternative to having them sign something (though it's technically sufficient for most purposes).

There are situations where you don't need model releases, such as if the person is clearly unidentifiable, if you're a journalist shooting in a public place, or if you're shooting at an event where people have agreed by either participating in or attending the event that, just by being there, it's implied that they have given up any rights to the images being taken.

Tissot, the famous Swiss watch company, is a major sponsor of the FIE (the International Fencing Federation) and world fencing competition. At major events, such as the one in Cuba, taking photographs of fencing and not including Tissot's logo somewhere in the shot is impossible, just because the logo is everywhere. I took the photo in Figure S1-20 in Cuba at the 2003 World Championships, and it was subse-quently chosen by Tissot as the main photo they use in magazine and Web advertising for their support of world-class fencing. And, although I technically own the photograph, because the FIE sponsors and hires me to shoot these events, I allow them to use some photographs as they need to — such as to pro-vide a key sponsor like Tissot with an image they want.

Because this was a big international sports event, no model releases were necessary for the fencers or the referees; their mere participation in a big public sporting event being broadcast live internationally and photographed by numerous entities carries with it the implication of permission to use their image. Tissot is able to use the photo because it was given to them by the FIE, and I gave my permission to the FIE.

A non-sponsor would have a difficult time obtaining a photograph. They would have to negotiate with me or, at least, with the FIE to obtain usage rights of the image. And, just because an athlete may be wearing their shoes, socks, or jacket, or drinking their sports drink, it's not an automatic endorsement of the product, so the company must be careful as to how they represent the image.

The Olympic Games are an extreme example of sponsorship management and control. At the time of this writing, I'm preparing to shoot the 2004 Summer Olympic Games in Athens. As an official photographer with International Olympic Committee (IOC) credentials, I've been advised by the FIE that I should wear no recognizable brands on my clothing (at least not in a big way) and that I may have to place black tape over product brands on things like computers and other equipment. For example, the Toshiba label on my laptop may have to be covered by tape if it's going to be anywhere visible to cameras — video or still. Of course, because I'm shooting Canon cameras, and because they're a major sponsor of the Olympics, that will be no problem.

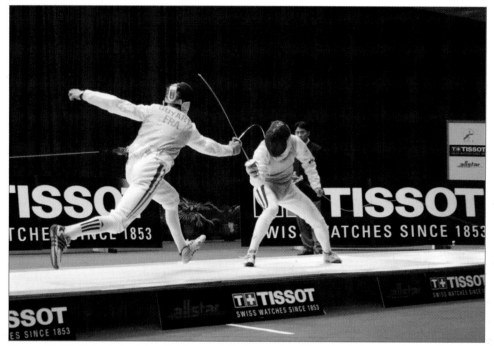

Figure S1-20: This photo, taken in Havana, is being used by Tissot in their magazine and Web advertising.

The legal discussion of model releases, endorsements, and the like is a long one worthy of an entire text unto itself. But, here are just a few tips if you're shooting any models, brands, or people who might end-up in print or on the Web:

✦ If in doubt, have them sign a model release. If they won't sign and you're still in doubt, don't use the image without first consulting your attorney.

✦ Have a basic, short model release for use in the field. People have much less trouble signing a model release that's in plain English and only a few sentences long than they do a five-page legal document.

✦ Use a pen!

✦ If there is to be any nudity in your images, even implied nudity, get a model release that stipulates that the model is over 18 and be specific about the fact that there is nudity involved. You will also need to document at least one form of official, government-issued identification, such as a driver's license or passport. Don't accept anything less, and, if possible, obtain two forms of ID.

✦ Do not sell photographs for advertising purposes that obviously show brands other than the brand of the client who is buying the image. This is especially important for any stock photography shots, if you want them to be purchased by stock libraries.

✦ For any image used in advertising, on your Web site, or other visible location that involves children in the image — meaning subjects under the age of 18 — you will need to obtain a release from the child's parent or guardian.

✦ If people are visible in a photograph that's being used for commercial purposes, if possible get releases from them — even if they happen to be bystanders.

Figure S1-21 shows one of my most popular fencing art shots. Although it doesn't show any visible nudity, it is suggestive nonetheless. For this image, my studio has a model release and a statement that the model is over 18 and there may be nudity involved.

Figure S1-21: While there is only implied nudity here, the model had to sign a release indicating that she was over 18.

Model releases are available for members of different professional organizations, such as the PPA (Professional Photographers of America. You can also find them in a number of photography form books. Most photography stores also have model releases available, sometimes they even come on tablets that are easy to drop into your gear bag.

As a pro or semi-pro photographer, you may not deal with all these factors, but being aware of them and covering yourself as much as possible is important. You never know when one of your shots may become of interest to someone, and if you don't have a release or permission ready to roll, there goes the opportunity.

File Formats: RAW+JPEG=TIFF

When you're preparing for your digital photo shoot, you'll need to determine the file format you'll use for taking photographs. Generally speaking, in professional and semiprofessional photography, that means deciding between RAW and JPEG for shooting, and then deciding if you want to save images in TIFF from either format, which is always preferable and recommended. Some digital cameras also offer TIFF as a file format, but this has become less prevalent because JPEGs are fast, easy, and small, whereas RAW files are very versatile and can be saved in any format of any quality—TIFF included. When shooting a big event with lots of photos, it's unreasonable to shoot every shot in RAW—the files are way too big and it will be take time to process each photo.

However, JPEG files are inferior due to their compression and inherent lossy nature. Every time you "Save As" in JPEG, you lose some information. Ultimately, this manifests itself in (albeit sometimes very minute) image aberrations of color or edge definition. While many photographers use JPEGs all the way to print, the best option when not shooting RAW is to save a JPEG file as a TIFF file in its best-quality setting, which is lossless. That way, whatever happens to the image after it has been saved, is performed in the highest-quality possible. And, while many printers will print JPEG files, most always they will guide you to provide TIFF.

That said, many times JPEG will be sufficient even for professional purposes. Assuming the image has not been resaved too many times, it the degradation is insignificant enough that JPEG is perfectly suitable. Regardless, whenever possible, TIFF is recommended and preferable.

High-end SLR digital cameras allow you to shoot in both JPEG and RAW at the same time, generating multiple files. This allows you to save the JPEGs that are good enough and be done with them quickly, as well as to work in RAW with the images that might require more editing and adjustment. I find this mode very handy, although it eats more CompactFlash card space than I like. But it's really versatile and gives me the best of both worlds—especially when I'm shooting in situations where everything changes from moment to moment.

Figures S1-22 and S1-23 show the exact same image. The camera was set to create both a RAW and a JPEG for each photo taken. Notice the subtle but increased amount of detail in the RAW image (for example, the highlights and individual strands in the model's hair) that isn't present in a JPEG. Having the camera generate both images makes it easy to choose if you want to use an image that needs to be processed quickly (JPEG) or if you want to work more closely with adjusting the exposure and other image elements to repair or improve the image (RAW). Of course, you'll need to gauge what will ultimately be happening to the image—if it's destined for being enlarged significantly, you'll want to start with a RAW file to ensure the most control and versatility. However, shooting both formats simultaneously takes more space on your flash card because you've generated two files, not one.

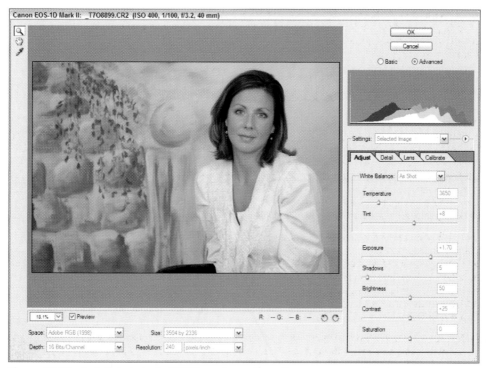

Figure S1-22: A digital photo in RAW format, exactly as the camera saw it.

RAW captures more data and, therefore, more detail than JPEG format. Also, the camera stores the files slightly differently in terms of dimensions, although technically the same size. If you look closely, the RAW image quality is notably finer. If you're taking photos for anything that's going to be enlarged significantly or displayed in a maximum resolution and size (and, of course, if your camera supports it), I suggest shooting in RAW. I don't suggest using this format if you're shooting several hundred photos at a time and then having to process them, unless you have lots of time on your hands to process them individually.

Note　You don't want to be shooting in RAW if you don't have the software that will allow you to process the images effectively and efficiently. Even some software that today touts its ability to process and display RAW images may run horribly slowly. The best option is Photoshop CS if you want to be sure of your ability to manage RAW files—I don't recommend using any other software to process them at this point in the workflow. With higher-end cameras, high-end, professional processing software handles RAW images efficiently; however, most RAW processing utilities bundled with prosumer and semipro cameras won't be as robust and reliable as Photoshop. If RAW isn't an option, then shoot in JPEG and, whenever possible and prudent, and then save and use your images in TIFF format.

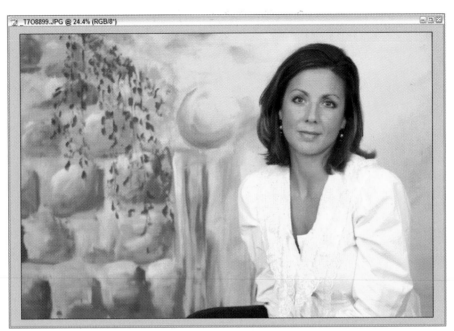

Figures S1-23: The same digital photo from S1-26 in JPEG format; note it looks more adjusted, but this can be deceptive as the JPEG format has done some processing for you rather than you having more control.

Getting Everything Right.... And Having Digital Backup

Shooting in highly forgiving formats, such as RAW, can compensate for images that were perhaps over- or under-exposed or had white-balance problems. The vast amount of data saved to the RAW format allows you to jump into Photoshop and adjust levels, hue, white balance, saturation, lightness, contrast, and other elements. In this way, you can strip away darkness of an underexposed photo, for example. I photographed Figure S1-24 in Havana under non-optimal conditions, including bright sunlight, a very reflective wall, and clothing that contrasted with the woman's very dark skin and eyes, all combined with various shades of gray in the background. Using Photoshop, I was able to compensate by adjusting levels to the photo over-all, and to individual parts of it by lassoing areas, feathering their edges, and adjusting their exposure.

Cross-Reference I'll be returning to ways Photoshop is integrated into the digital photography workflow throughout the book, and focusing on applying effects to images in Stage 7.

That said, a forgiving file format and Photoshop are no substitute for starting with a correctly exposed image. As a result, preparing the digital photo shoot involves both planning for what you know will happen — such as the type of light, what you'll be shooting and what it looks like, what you can meter or not, and so on — and planning for what might happen — such as changes in the weather, having to shoot from a distance instead of close-up, or other contingencies. The old Boy Scout motto "Be prepared," as overused a cliché as it has become, applies in spades with photo shoots.

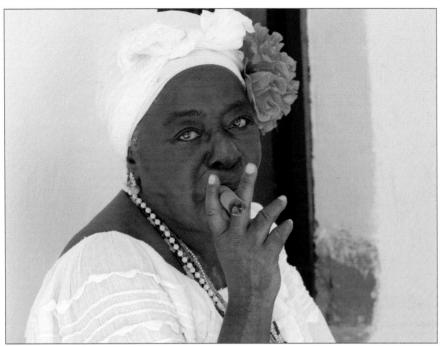

Figure S1-24: This Cuban woman's face was underexposed due to too much bright light being reflected from the bright whites in the image, but it was revived with Photoshop.

Summary

When preparing for a digital photo shoot, you'll want to think about how to separate your photography from your digital photo processing. And a shoot on location versus in the studio will have some very distinct operational and workflow differences.

For setting up your photography shoot, you need to think about lighting, being able to access your equipment, and how you'll efficiently and quickly be able to download images without disrupting the momentum of the shoot. A restless subject or a sinking sunset won't wait for you to admire your work on a computer screen in the midst of a shoot — you're better off downloading images into a portable hard drive and continuing to shoot.

Whether in film or digital, lighting and metering are essential parts of setting up a photo shoot — understanding how it will affect what you're photographing, and then controlling it as much as possible. This is true both for physical lights, such as flashes, and for settings on your camera such as ISO, white balance, and even the type of file format in which you choose to shoot. Yet, digital poses some interesting advantages, such as being able to review images on the spot and make changes accordingly as well as being able to bracket photos, with the camera making adjustments in the exposure to give you a range of exposures automatically.

Finally, choosing file formats is a fundamental and essential component of digital photography workflow. While many cameras shoot in JPEG and it's a common format used by both pro and consumer photographers, it's not especially preferable due to its inherent lossy, compressed format. It's better to save JPEGs as TIFF files, which makes them virtually lossless. If you're doing high-end work, or creating images to be enlarged significantly, you'll want to shoot in RAW format and save the images as TIFF files, as well, for optimal quality.

✦　　✦　　✦

2 The Digital Photo Shoot

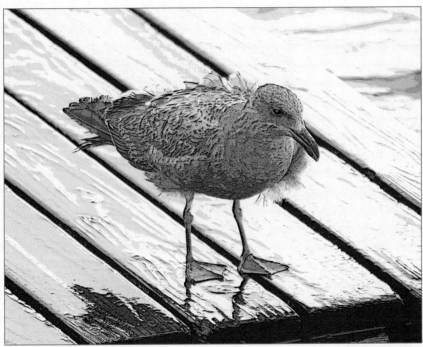

A series of digital filters in Photoshop CS makes this San Francisco seagull looks extra wet and chilly. Taken with a Canon 10D at ISO 100, f/5.6, 1/180 second, and 400mm focal length.

The digital photo shoot is often a mostly pre-pixel world that differs little from film photo shoots. However, there are certain advantages to be leveraged as well as distinct considerations that play directly into the workflow of the digital photographic process. Understanding how to use the new digital tools you now have and integrate them into tried-and-true photography technique is the secret behind effective digital-photography workflow.

I'm reminded of the old TV ad "Is it live, or is it Memorex?" that had people guessing if the music they were hearing was live or recorded. Often, clients can't tell if I'm photographing them with film or digital because my cameras don't look that much different from a 35mm film SLR—clients expect digital to look more futuristic, like something from a science-fiction movie.

In fact, higher-end digital cameras don't look that much different from a film camera, with a few notable exceptions, such as the LCD viewing screen. It's usually the point-and-shoot consumer cameras that look different.

To really produce wonderful photographic images, the digital photo shoot must combine the pre-pixel mechanics of more than a century of camera development, the astounding accomplishments of digital technology, and your own artistic eye and technical aptitude. To obtain the best results, you need to interweave these factors during the digital photo shoot. The digital photo shoot flow, whether in the studio or on location, requires preparation and forethought. This doesn't just mean knowing when to download a card; it also means figuring out where you place and how you access equipment, as well as what to do if something goes wrong.

In a studio, you can set into place a flow that can be used over and over again. For location shoots, you must adapt to various situations indoors and outdoors, and know ahead of time how to handle image transfer, backup, power, and other pesky factors.

Post-Production Fixes — Reality and Myth

It's easy to assume that you can fix imperfections in a digital shoot later, but that's not true. Many film photographers or digital photographers who used to shoot film will tell you that film is far more forgiving than digital images in terms of your ability to adjust the exposure in the processing and printing. Now, with RAW digital images, all bets may be off and the film photography argument has far less merit, because both the coarse and fine levels are equally controllable as those in between.

I've been in situations where I've shot a digital photo that I didn't think was perfect for one reason or another; whether I chose to reshoot the image was a subjective decision. If the problem with the scene involved a very complicated element of the image, such as light, something big in the photo that shouldn't have been there, and the like, I would retake the photo, if possible. If a light shines from the wrong place, for example, and affects exposure on multiple individual faces in a formal shot and streaming across other parts of the scene, I'd start over.

Simple things that don't take too much post-production time aren't a problem. For example, if a power cord from a light is visible in a scene on a black backdrop, that's an easy fix. Taking care of someone blinking in a formal group of ten or so people, as long as I have other photos of the same crowd, is relatively easy. These are things that allow you to keep going because you can deal with them later.

With the Canon 1D Mark II, I shoot formal and especially important images in both JPEG and RAW format (the camera lets you choose RAW plus any size of JPEG) so that if there is some lighting or exposure issue with a photo, I have the option of using RAW but still can process a number of decent shots quickly in JPEG.

In Cuba, during the 2003 World Fencing Championships, I took a large group photo in the hotel lobby of the U.S. fencing delegation (athletes, coaches, trainers, and so on), which had about 40 or so members. After the shoot was complete, I was told that two people who were not officially part of the delegation had snuck into the shot. It was too late to reorganize everyone, so they asked if I could "Photoshop out" the two people.

The fixes for this shot were complicated and would have been essentially impossible in a purely film world. However, it would have been better if I could have just reassembled the group (or had been told ahead of time that there were some intruders!). This speaks to the old saying of "measure twice, cut once" especially when shooting anything that's going to be hard or logistically difficult to replicate.

Shooting on Location

Shooting on location, by definition, means dealing with unique, unpredictable, and often chaotic environments. The challenges for digital photography are compounded by the need to store digital files quickly and safely onto storage devices. And flash cards with photos must be safely cataloged and stashed, along with cameras, lights, and other gear.

Further, the digital photographer on location often relies on at least a field version of a digital darkroom. A laptop sometimes becomes a portable printer, and external hard drives can become the field version of a more extensive setup in the studio.

When I'm at international fencing tournaments, I have access to a pressroom where I can safely leave my computer. However, it's not always convenient to run back and forth from wherever the press room might be, which is why I download images into an intermediate device like an ImageTank. And I don't trust having my computer out in the middle of the tournament, where anything could (and would) happen to it, from spilled drinks to theft. Figure S2-1 shows a photo of the fencing preliminaries in Havana and, as you can see, there's a lot going on. The venue was a relatively chaotic and rough place for staging a photo shoot.

Cross-Reference See Stage 3 for more on the ImageTank.

Figure S2-1: The fencing preliminaries for the 2003 World Fencing Championships

Figure S2-2 shows the finals hall of the same event, which is a completely different facility. You can see the photographers sitting on the concrete floor just to the right of the center of the photo — a bit more orderly than the preliminaries hall, but not exactly convenient or comfortable (and devastating to a dropped piece of equipment). Shooting in the field requires scoping out the location before you begin so that you know how you can most effectively work with your equipment to get the job done and to keep everything safe and as hazard-free as possible. During the shoot, it means being aware of your surroundings and yet being able to focus on your subject matter. On location, you have, at best, only limited control over the environment, so you must adapt your shoot — equipment, workflow, and yourself — to fit the situation.

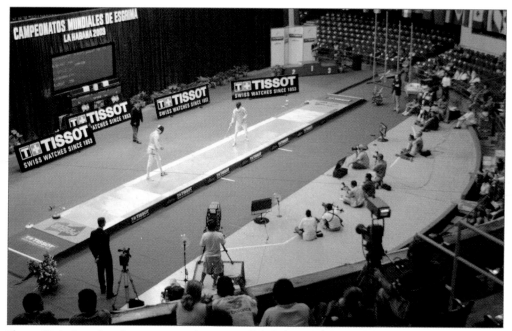

Figure S2-2: Location shoots present dangers to digital photo equipment.

For every tournament, I have to set up a different scenario to my digital-photography workflow. This includes where I take the photos, where I access my computer to back up images, and where I access the Internet if I need to upload images quickly to the Web. For outdoor photo shoots, such as weddings, I need to find a safe place for my computer away from the elements.

To become completely portable, you can carry a portable hard drive in your pack, download as you're walking around, and only use a computer in a completely different area. This strategy works as long as you don't need to review images with too much detail (beyond what you can see on your camera's LCD or on the LCD of a portable device such as the PicturePAD).

The Rule of Threes

The digital world is giving people opportunities to look at each other more than ever before. Internet dating, for example, has taken off as a respectable and bona fide way to meet a mate; companies frequently display their executives' photographs online; and personal Web sites and shared photo sites abound. As a result, the quest to get the right look in a photo is a challenge for both the subject and the photographer—it must reflect the person, the image that individual wants to present (corporate, family, boudoir, or whatever), and be an accurate and appropriate representation. This means using the tried-and-true methods of good photographic composition, but also realizing and leveraging the immediacy of a digital world.

Good composition begins with establishing and devising a plan for a subject's look. To achieve a look, think of the rule of threes. This involves understanding what the three most influential people or groups of people are. Think of your shot from:

✦ The subject's view of him- or herself

✦ Loved ones', co-workers'/clients', or friends' view of the subject

✦ The photographer's view of the subject

I often spend time with my clients to learn about their personalities, interests, other photos they've had taken. I learn what the person likes about himself. Does he like or hate his profile? Does he think he has a good or bad side? What images does he like? What will the photo be used for? Sometimes I have my clients look through books of photographs, the way you would look for a hairstyle in magazines at the beauty shop. I also use a questionnaire that they fill out or I walk them through so I can gain a more complete perspective.

Then I learn what I can about how others see them: "People tell me I'm really funny, but I don't think so." Or, "Everyone likes my hair up, but I hate it," and so on.

Finally, I use my own judgment about people. I have ideas about how people look their best in front of lights and backdrops or on location, and I must reconcile that with the first two factors.

This way, I have an in-depth, rounded perspective of the person, couple, family, or group. It's simple, and it works. It may not be scientific, but it's the side of the photography business where subjective judgment has a higher value than meter readings.

Setting up in the field

If you're going to use a computer while in the field, consider the following:

✦ Locate the computer in an accessible, convenient, safe, and dry place on a steady surface.

✦ If possible, plug the computer into a power source. Often, computers use a low-power mode when running on batteries, which limits your ability to accurately view image quality. That said, having the laptop on high power demands more electricity, so plugging it in is better.

✦ Limit the number of dangling cables. Use a PC-card/PCMCIA-style adapter that accepts flash cards to download images instead of a USB connection.

✦ Have extras of everything available—USB cables, power cables, synch cables for lights, CD-Rs, flash cards, light bulbs for lights, and AA batteries for flashes and other devices. If you can, even bring two portable hard drives just in case one fails or is damaged. On some critical foreign shoots, I've even brought two laptops just in case one goes out for some reason.

I find that the trunk of my car is a useful field studio for my computer if I'm not close to any building. I can download and look at images in semidarkness, I can run a power cable through my back seat to an AC–cigarette lighter outlet, and, when I need to, I can simply close the trunk and it's locked. Also, the equipment is covered (at least in part) by my auto insurance policy. The vast majority of camera thefts involve equipment that's clearly visible in unattended vehicles.

Protecting equipment

To protect your equipment, consider the following tips:

✦ **Flash cards:** Carry your flash cards in one place, and don't vary your method — ever. They are too small, too expensive, and too easy to misplace or lose. Don't just put them into your pocket — lint can get stuck in the small pinhole connections, preventing the card from operating correctly, and possibly damaging your reader. To carry flash cards, I favor the zippered cases that attach to my belt. They're sealed from falling out and aren't going anywhere. If you're going to be in harsh conditions with snow, water, or sand, use the small sealing cases such as the ones made by Pelican.

✦ **Computer:** Use an antitheft device on your computer. Virtually all laptops have a locking slot on the side or back of the chassis that allows you to insert a locking cable and connector, such as that made by Targus. You can then attach the cable to something such as a table and be assured that theft would be, at the very least, difficult. I've felt secure leaving my laptop unattended for hours at a time at a large fencing tournament in this manner.

✦ **Portable devices:** If you carry portable drives on your person, be careful you don't jostle them too much while they're downloading. Even though they're portable, they're still complex devices with lots of moving parts. If you do leave them someplace, make sure they're both secure and in no danger of falling or having something spilled on them.

✦ **CDs and DVDs:** If you record CDs on site, you'll need to have not only enough recordable CDs (or DVDs), but also proper storage and handling tools. Bring a soft-tip, permanent marker to label media disks, as well as a protective case like a Case Logic wallet with protective sleeves for each CD or DVD.

Sources of power

Carry a power strip with you so you can plug in your battery charger, your laptop power, and the power supply for your portable hard drive. Note that some portable hard drives last longer than others on battery power; typically, the more features they have, the more juice they use. Devices like Delkin Devices PicturePad (for Mac) that include LCD viewing screens, take up the most power.

If you're traveling internationally, know ahead of time what type of AC plug you'll need. Power strips in foreign countries can be a problem and you may not find them locally. Power strips are necessary because, if you're staying in a hotel room, you may have only one or maybe two outlets and you may need to charge your laptop, camera batteries, portable hard drive, cell phone, and other power-hungry devices.

I brought a U.S. power strip to Bulgaria, assuming I could just plug my U.S. plugs into it, and plug it into the wall outlet using a local adapter. I had lots of things to charge and my room had only two available outlets (and that was after unplugging the TV). The first night there, I plugged in my cell phone, a two-camera-battery charger, my laptop, and my portable ImageTank hard drive. The minute I tried it, I blew the power in my room and everything went dark.

After the hotel technician finished resetting the fuse for my room (fortunately, I had not blown the entire floor), I resorted to recharging batteries using two outlets. I set my alarm so that I could wake up at 3 a.m. and change devices being charged. So much for the power strip. Figure S2-3 shows a typical small tourist hotel (this one is in London) where you shouldn't expect to find much in the way of power or other digital support.

Figure S2-3: Small (and even some large) hotels in foreign countries won't have lots of AC outlets or other support, so be prepared.

I suggest you buy an international power strip ahead of time and take it with you. Quail Electronics (www.quail.com) offers a nice, high-quality selection of products online or from stores; you can also find travel electronics at TravelOasis (www.traveloasis.com). Both sites offer substantial reference information for the types of plugs and power requirements you'll find in various corners of the globe. These power strips also have surge protection, advisable especially in third-world or lesser-developed countries where an electrical spike could seriously damage your equipment.

Storing files

When you're traveling to location shoots, you need to be sure you've invested in enough flash cards that you can put an entire shoot onto individual cards without having to reformat any. That may mean enough to handle a wedding ceremony, but not the reception, too, or it may mean the entire thing. It depends on your photo shoot's timeline and whether you have the actual time available to carefully download the cards between events.

You don't need to spend $1,000 on a 4GB CompactFlash card when you can buy three 1GB cards for less than $500 with a little price-shopping. You'll have three-fourths as much storage for half the price, and if you happen to lose a card, you're out a lot less money.

When you're shooting in the field, don't always assume the largest file format is the best (of course, this doesn't apply if you're shooting in RAW). If you know that your images are destined for magazines and nothing larger, or will only be placed on the Web, then you can shoot many more images on a flash card if you set the camera at a lower-megapixel setting. For example, at a wedding, you may want to shoot the formals in RAW, the ceremony in large-format JPEGs, and the reception in the second-largest size. This helps your workflow and file management considerably.

Cross-Reference For a full discussion of, and comparison of, RAW files and the JPEG file format for saving digital photos, see Stage 5

Extreme locations and special location challenges

When I prepared to photograph a fencing tournament and the aurora borealis 100 miles north of the Arctic Circle in Lapland, northern Finland, in midwinter, a lot of people gave me advice on what to expect out of film and digital cameras. I spoke with representatives from Olympus, Canon, and Leica, as well as several photographers. Very little of the advice was about how to take photos — most focused on protecting the gear.

One of the more interesting comments was that flying at higher altitudes in the arctic, because of the electromagnetic field generated by the magnetic north pole, could actually cause permanent pixel loss in digital camera CCD and CMOS chips. Certainly, the electromagnetic energy is prevalent — you experience some rather odd performance by electrical and electronic equipment (the fencing scoring equipment, for example, would occasionally score a hit when the fencers were nowhere near each other!). In extreme cold, as well, batteries run down very quickly.

One of the biggest considerations for protecting camera equipment in extreme temperatures is to ensure it's in a sealed bag when you *change* temperatures — such as going indoors from a very cold outside. You want to have your camera in a sealed case or resealable plastic bag, and keep it there until it adjusts to the change, otherwise damaging moisture can — and will — appear on and in the camera.

I use a rolling-style camera equipment bag that I can carry on airplanes; it looks like a carry-on rolling suitcase. I like it because it doesn't look like a camera bag and is less likely to be bothered as a result. I also carry my computer in a backpack-style briefcase that is padded and that I can store under my seat on a plane. When I'm in the field, I switch to a fanny pack to carry most of my things so that they're accessible.

One of the more important things I have in all my bags is called *desiccant.* Perhaps you've opened a piece of new electronic gear before and noticed a little pouch of powder or gel that says "Do not eat"? This substance absorbs moisture and prevents any temperature differentials from affecting the product. For normal location shots, or travel, the use of desiccant might not be essential, but for locations with high levels of moisture (check the weather channel before you travel), proper protection against moisture can make or break a shoot, or your equipment.

Most photo-supply stores carry a large version of desiccant, which comes in a little plastic case that you drop into your camera and computer bags. This absorbs any moisture. When the bag changes color (which means it's lost some of its potency), you simply place it in the microwave for a few minutes and it's recharged. I don't carry equipment without this handy stuff — especially to shoots in humid areas. I recommend you don't, either.

When preparing for a shoot, you must think about not only your equipment, but also the safety of that equipment. You must change lenses and place them into a safe place, and replace the lens caps and covers on them quickly without exposing them to dust. You need to have haze or daylight filters on your lenses, as well, because if you drop a lens, you want an easily replaceable element to break, not the lens itself.

Here are some tips for protecting equipment in extreme location conditions:

- ✦ **Keep everything stored, but still accessible.**

- ✦ **Use resealable plastic bags whenever there's rain, snow, sand, dust, or extreme temperatures.** Keep extras, and use the heavy-duty type of bag that can withstand anything and doesn't rip easily

- ✦ **Get to your shoot location with enough time to scout the area and decide how you will accomplish workflow, and how you'll set up and protect your gear.**

- ✦ **If there's a way to lock bags and cases when you aren't watching them, do so.** Even a simple, cheap lock may be enough of a deterrent to prevent a loss. Don't set equipment near food or drinks, or a spot where people may put down finished drinks or food.

- ✦ **If you use a cable-lock system for your computer, you can loop the cable through the handle on your backpack, a camera strap, or other items in need of protection.**

- ✦ **Use bungee-style cable ties for USB and FireWire cables, power cords, and sync cords.**

- ✦ **Whenever you can, roll your equipment in a wheeled case.** Rolling keeps the equipment closer to the ground and saves your back.

- ✦ **Try as much as possible to keep camera and computer equipment separate, which more closely matches digital-photography workflow.**

Tip

By joining a professional photographer's organization such as the National Press Photographers Association (NPPA, www.nppa.org), Wedding and Portrait Photographers International (WPPI, www.wppinow.com), or the Professional Photographers of America (PPA, www.ppa.com), you can buy affordable insurance for your equipment anywhere in the world, no matter what happens to it (including acts of photographer stupidity!).

Studio Shoots

In Stage 1, I explain various approaches to setting up a digital studio. I argue that it's best to maintain separation between your digital darkroom (the computers, printers, and other equipment used to edit and produce digital photos) and the shooting studio. At my studio, I keep a dedicated area for taking photos that is free of distractions from the photography process.

In a smaller environment, the same results can be achieved (with a bit more work) by moving your computer and other non-shoot-related equipment to the side or out of your studio during a shoot.

Creating the studio atmosphere

With traditional photography, final quality is totally dependent on the shooting environment. Extreme control over lighting, background, and other elements is essential for a successful photo. Digital photography provides some leeway, but digital photography does not transcend the need for a studio shooting

environment that is well organized, technically supportive, and aesthetically pleasing. Digital photography, as much as film photography, requires a studio environment with a good atmosphere—not something you can add later in the digital darkroom! I commonly have music in the studio. People can bring their own or I stream it from the Internet using MusicMatch.com. I offer a variety of refreshments, including wine on occasion (this is especially helpful for boudoir shoots, where the client may be uncomfortable wearing something a little risqué).

For example, Figure S2-4 required three hours of shooting in the studio, during which time I took nearly 250 photographs. This image, technically an artistic nude, was taken using only candlelight made up of a few dozen votive candles positioned strategically around the scene. I stood on a ladder to shoot directly down onto the client. The image was digitally filtered in Photoshop using a series of filters, including Extrude, the most prominent distortive feature, which allows the image to show the client but keep it tasteful and not too revealing. In addition to the soft candlelight, I had music on to keep the atmosphere right to capture the essence of the subject's mood.

Figure S2-4: A photograph illuminated entirely by candlelight and then digitally altered in Photoshop using the Extrude filter.

Although you can also swap backgrounds in Photoshop or another image editor to correct problems with a studio background, there are challenges and risks in such digital photo doctoring. Extensive digital editing to correct mistakes in a shoot adds many, many hours to a project that would not have been necessary if you had spent the time to set up the studio more carefully. Often, digital editing yields a domino effect, where every change leads to a new one.

In short, carefully setting up the studio environment is a major element in producing an excellent photo. The flexibility of a studio, uncluttered with computers and other digital darkroom paraphernalia, provides tremendous flexibility.

Cross-Reference For more information on backgrounds and setting up a studio, see Stage 1.

Studio props

Digital photography makes it possible to not only add backgrounds but props, lighting, and even people to a photo. But, such extensive digital Photoshopping can add hours to a photo project, and demote you from a photographer to digital editor. In other words, the magic of digitalization does not fundamentally alter the challenges of properly setting up, posing, and taking photos in studio.

In my studio, I use a basic set of props, backgrounds, and scenes that I can transform into a broad set of images. While I do some fine-art work that involves creativity and a variety of looks, most of what the studio does to generate revenue involves reusing existing scenes and props. I have certain backdrops I know will work with executives, others with families, couples or individuals, and still others with boudoir clients. The props and scenes are meant to complement the faces and relationships, not to dominate them. Additionally, I have clients and subjects who choose to bring their own props for shoots. For example, a high-school senior might bring a guitar, a couple may bring their dog or virtually anything else that has personal interest and expression.

Figure S2-5 shows some of the props, backgrounds, and backdrops in my studio before they are assembled into a specific scene.

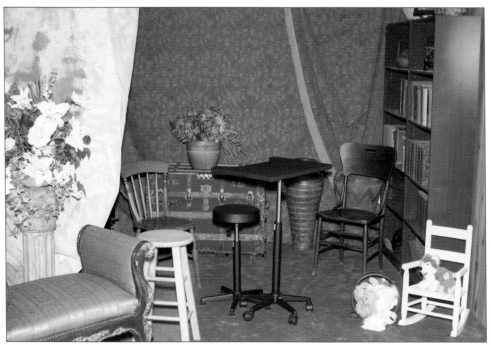

Figure S2-5: A studio needs a variety of looks that can adapt to each subject's personality and interests.

I like to call this aspect of workflow digital adaptability. One of the great things about digital is the immediate versatility you have in shooting indoors, outdoors, or in virtually any lighting condition because you can change ISO settings on an image-by-image basis (as opposed to having to change rolls of film). This allows a more fluid workflow to take place, working with a client in various scenes, moods, and environments. Digital photography workflow has the unique ability to allow the photographer to effectively blend in and adapt to various environments.

Working with studio lighting

Studio lights are designed to work in concert, through synchronization cables, radio signals, or the infrared transmitters/receivers mentioned in Stage 1. When you shoot a photograph, the lights all flash together because you've set them to do so. Lights are switchable so that you can place them into a slave mode (where the light can be triggered by another light or firing device) that allows them to respond to another light being flashed.

You can also use your camera's flash to fire studio lights, either by the flash signaling the other lights to flash via an infrared receiver (when the camera's flash goes off, the individual lights' infrared receiver causes the flash to fire, as long as the flash head has been set to a slave setting) or by a sync cable.

Lighting in a digital studio is very similar to how it's done with film. Where it differs is that settings for light temperature — white-balance — can be made on-the-fly with the digital camera. For example, some studio lights have both modeling lights as well as flash capabilities, and each light has two bulbs — one for the flash and one for the modeling light. If you shoot some images with flashes and others with the modeling light, the temperature, and the resulting images, will feature different colors of the same subject material. A digital camera can adjust the white balance automatically, or you can set it very specifically to respond to and record the change in color temperature to where you want it.

Another advantage of digital photography, especially when it comes to lighting, is the recording of metadata with each image. If there's an image you took where the light was good and you want to use that particular setting again, you can replicate precisely how your camera was set — including ISO, shutter speed, aperture, and even focal length — simply by referring back to the metadata on the image.

The Rule of Thirds

As I've discussed, the best digital images begin with good composition. However, the post-production aspects of photography are equally essential in producing a final product of superior quality. In black-and-white film photography, for example, Ansel Adams' zone system has long been a mainstay high-quality methodology for photographers shooting black-and-white images especially in medium- and large-format film.

A very important, traditional, and yet simple concept for composing a good photograph is the rule of thirds, which involves positioning your subject within something similar to a tic-tac-toe grid. It doesn't always mean positioning a person in the dead-center square, but, rather, understanding the relationship between the components of the image. When you start thinking in threes, composition becomes easier. With digital photography, the rule of thirds sets the stage not only for a well-composed image, but also to create an image that can best be digitally treated during the post-production phase of image editing. Much more can be done with an already good-quality photograph to bring out digital effects than if it must be recomposed, cropped to smaller pixel dimensions, or adjusted to make it acceptable for treatment.

Figures S2-6, S2-7, and S2-8 all show how the rule of thirds works consistently for photographs with very different compositions. The primary content and subject of the photograph does not have to be in the center. And the thirds do not have to always be perfectly even. However, you can almost always divide the image into nine distinct sections, three by three. How you decide to divide the parts and where you place the subject is where artistic judgment comes into play and directly affects the drama and impact of the image.

The thirds allow an image to be framed within itself, but also to create a certain flow that naturally leads the viewer to understand the focal point and subject of the photograph. Furthermore, it allows the photographer to emphasize a use of negative space (areas of apparent unused imagery) that serve to further emphasize the subject and the photo's drama. Dividing images into thirds provides a natural and simple way for the photographer to visually think about an image in a way that helps create a well-composed, meaningful shot. It also helps prevent chaotic, busy images that lead the viewer to nowhere but confusion, which is the all-too-typical mistake a beginning photographer makes when shooting events or sports, where there's a lot going on.

The rule of thirds allows photographers to think in a mode that consistently encourages strong composition to take shape. It helps you to avoid framing an image poorly, including extraneous information, or excluding useful parts of an image. Further, it helps you to naturally learn to frame a subject with proper proportions of negative space, which are the parts of the image that, though not necessarily a direct part of the subject, support it with depth and a contextual framework.

Figure S2-6: While there's color and shape in this image, the bicycle is really the main subject of this photo taken in Cuba.

Figure S2-7: This nighttime image commissioned for a peace march following the 9-11 tragedy makes use of color and shape on the façade of Seattle's Saint James Cathedral as a form of negative space to emphasize the drama of the silhouetted person holding the American flag.

The digital photo shoot can, potentially, be distracting with the temptation to look at the LCD screen, to fiddle with digital settings on the camera (although this can be useful at times), and even to download images and prematurely jump to processing before you've completed the shoot. At least until you've become intimately familiar with the digital medium and fully develop your own style and abilities in this format, it's important to focus on the simple nature of good composition.

Using flash or not

Whether in the studio or the field, a great many photographers detest using camera-mounted flashes unless they absolutely cannot avoid it. Why? Because flashes tend to create unwanted shadows, both on people's faces and on what's behind them. It's tough to predict what they'll illuminate — and what they won't. Shooting a corporate event, wedding reception, or other event in a darkened room or on a dance floor requires supplemental lighting that must travel with the photographer, as opposed to posing some-one in front of lights. In these cases, certainly, a flash cannot be avoided. In the studio, flashes on tripod-mounted lights are common and easy to use; however, combining them with a camera-mounted flash is less desirable.

The on-the-fly abilities of digital cameras to be set at different ISO levels as well as white-balances means you don't have to rely on a flash to make sure you get the perfect exposure. If it means an image will have too much digital noise without the flash, then it may be worth using; however, if you can avoid using the flash and make digital adjustments and review them on the spot, that's preferable.

Figure S2-8: Without the grid, the focus of this image may not be obvious — a world championship fencer waiting for her bout to begin — but the negative space provides additional drama and implies a "beyond" awaiting her.

Higher-end professional digital cameras tend to handle flashes more intelligently, while, on the other end of the spectrum, the "wink" flashes integrated into semipro and lower-level digital cameras work on averages and only should be used in a situation where doing so is unavoidable.

If you can't avoid using a flash, consider the following tips to mute its effects:

✦ **Diffuse the flash.** I often use a diffuser on my flash, such as a boxy, translucent plastic piece that pops over the flash. It works well to prevent the flash from being quite so intense and overpowering.

✦ **Use the "bounce" mode.** Pointing the flash at a ceiling or something other than the subject (where I can) creates enough light to expose the scene but not so much that it blows out the subjects.

✦ **Use bounce cards.** These allow me to point the flash straight up, but they angle reflected light off a white surface at the subject so that less light, but nonetheless good light, reaches the target at which I'm aiming. This allows the light from the flash to hit the subject, but not so directly, no matter where the photographer is shooting.

✦ **Try a fill-in flash.** Using a *fill-in flash,* which is a lower-level flash to fill in light spaces that may be shadowed or darker than the rest of the image, may seem logical and easy in certain circumstances. For example, if there is bright sunlight shining directly from above on subjects, they may get a "raccoon" look, where a shadow is cast just below their eyes.

✦ **Use reflectors.** A fill-in flash is certainly one way of dealing with situations such as when overhead light is causing shadows, but it's not the only, and not always the best, way. I prefer, when possible, to use a reflector. These devices, made of highly reflective material that is stretched taut against a wire frame, are held by an assistant or by using a special reflector stand (see Figure S2-9). These can collapse and fold into a circular, flat size that's easy to store. They reflect light at the subject from a source such as the sun or another light. They come in different colors, such as gold or silver, and, depending on which is used, they can also add color elements to the image. I often use the gold reflector, for example, to add warmth to a face while also filling in light.

Figure S2-9: A Photoflex reflector on a stand

Figures S2-10 through S2-13, for example, were taken with flash and non-flash lighting. I took these at the opening ceremonies of the 2003 World Fencing Championships in Havana. The dancers, who performed at one of the city's flagship theaters, are some of the country's finest performers; they put on a fabulous show and welcome to all the delegations who had just arrived from around the world. Because they allowed us to use a flash while photographing the dancers — something rather unusual — I experimented a little with going back and forth between a high ISO (either 1600 or 3200) with no flash or ISO 800 with a flash (still a reasonably high ISO, but it wouldn't have been enough to catch the action sufficiently).

Figures S2-10: This shot of a winning fencer in Cuba was shot without a flash at 1/250 second at ISO 800 and f/4.5. Because no flash was used, notice how much of the image can be seen clearly and with nice depth. Because of the shutter speed, the image has nice stop-action quality.

Figures S2-11: In this photo of a winning fencer in Bulgaria, the flash was used and photographed at 1/60 second at ISO 400 and f/4.0. At this shutter speed, the image has some blur visible on the teammates' hands, but overall has decent stop-action quality in the fencer's face. However, there's less depth to the image quality because the only part of the image that's clearly illuminated is what the flash hit, and the flash makes shadows more pronounced.

Figures S2-12: With a flash, you're often limited to whatever its light can catch. In this photo from Cuba, the dancer leaping in the foreground catches the brunt of the flash's light, which gives her legs a bit more light than the image needs to be well balanced. However, the flash managed to catch the dancers in mid-air quite nicely. The image was shot at ISO 800 with a shutter speed of 1/90 second at f/11.

Figures S2-13: From the same vantage point as S2-16, a high ISO of 3200 was used, but no flash was fired. As a result, the stage lights provided the complete illumination, creating some interesting lighting of the dancers' dresses and shadows from a variety of angles. The image was shot at 1/125 second at f/6.7.

Note that the higher-ISO images will have more digital noise. But, you can use software such as nik Dfine to remove noise, alter colors, and so on.

Camera settings

Setting your digital camera to shoot with studio lights requires that you use a manual mode because the camera cannot predict what the light will look like when other flashes are going off at the same time the shutter opens. When you just use a flash, it's automatically synchronized with the camera and it knows that its flash is going to fire; this is not so with other lights. So, if you put your digital camera in an automatic or semiautomatic mode and take a picture while firing the flashes, the photo becomes overexposed. As a result, you must manually set your camera to the correct light level when the flashes all go off. With digital cameras, you can do this two ways. The less methodical way is to experiment by taking a photograph, viewing it through the LCD, and then making the corresponding adjustments. Eventually, you'll come up with the right exposure; however, shooting too many shots does not inspire your subject's confidence that you know what you're doing!

A better method is the tried-and-true method of using a light meter — either a dedicated model or the one integrated with your camera. In the studio, however, you meter a scene using incident instead of reflective light. *Reflective light* is the light you measure by pointing your camera or light meter at your subject and measuring the exposure. This is the most common way consumers take photographs. The camera points at the subject, reads the light that "reflects" off all the surfaces, and then sets an averaged exposure corresponding to that light. An *incidental reading* looks at light from the subject's perspective. Instead of pointing your camera or meter at the subject and reading what light is bouncing off, you position your meter at various points around the scene, such as just beside the subject's face or clothing, and then measure the light that shines on it.

In Figure S2-14 you can see a subject being metered in the studio using incidental light. This gives you a much more accurate reading of the light so that you can set your camera properly in a manual mode. When you measure light in this manner, it's best to take several readings in different locations so that you can tell if there are darker or lighter areas. You'll want to make sure you're getting a proper reading for the most important part of the image, such as the subject's face.

That said, if you're off by a bit in a studio-metered shot, and you're shooting in a RAW format, you'd have no problem adjusting the exposure later by an F-stop or two to improve it significantly. I've had situations where the person holding the reflector moved and didn't have the light pointing at the subject, or I ended up shooting farther away than I had originally expected and the shot was a bit dark, and any number of other reasons that I had to address in post-production, digitally. Fortunately, in digital workflow this can be addressed and often remedied, but should not be relied upon to cut corners in setting up lighting and exposures correctly to begin with.

Of course, when you're outside or in a big space, incident light measurements aren't practical. If you're taking a photograph of a mountain landscape, you can't exactly go stand on the mountain and point the meter or your camera at the sun and get an accurate reading, which is the time you'll use reflective metering. Incidental metering is best used in controlled situations where you can become part of the scene with your meter.

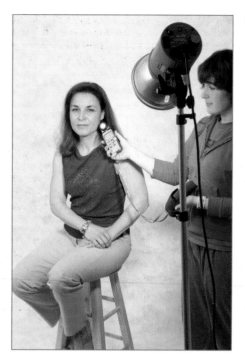

Figure S2-14: Metering a subject in the studio

Measuring light: Handheld meter or camera?

Chances are if you have an SLR-type digital camera, it probably has a rather sophisticated light meter integrated into it. However, having a handheld light meter is a lot more convenient if you're taking lots of measurements. Also, the meter inside your camera is only designed to measure reflective light, not incidental light. The meter in your camera can also be highly subjective based on the focal length of the lens being used.

In a pinch, you can get a very rough measurement of incidental light with your camera by standing beside your subject, pointing the camera at the lights, and then reading your camera's measurement of the light. But this is rather unreliable and may end up only being confusing and frustrating because it is likely to be off by some factor. Further, there's no way you'll be able to measure the light if you fire flashes; the only thing you can measure is any existing light.

Despite the technological advancements of digital cameras, there's absolutely no substitute for a handheld light meter to accurately measure a scene for optimal exposure, especially in the studio. That said, I don't take a light meter with me to events where there is constantly changing and varying light; I rely on the camera, my own photographic judgment, and the feedback from images I've taken to gauge the situation. However, in the studio, I invariably use a light meter. This allows me to measure an entire scene or a very small part of it (known as spot metering). I can adjust different ISO settings on-the-fly, and I can check what light is doing to different f-stops and shutter speeds. I've found the Sekonic meters to be my favorite and the easiest to operate.

Tip The Sekonic site (www.sekonic.com) has some excellent information on metering techniques if you're interested in further study. Sekonic, by the way, is a division of Mamiya America Corporation, makers of high-end cameras.

Light meters can be set to measure light by just hitting the button and seeing what you get or by measuring light as it occurs during a flash. You can set the meter to take its measurement when it "sees" the flash go off, or by attaching a sync cable to the meter and firing the flashes by pressing the meter's trigger. Some of the newest (and, of course, more expensive) models operate by radio signal and do everything wirelessly.

White-Balance, ISO, and File Formats

A successful digital photo shoot requires that your digital camera is set optimally to capture the best image possible. In addition to choosing the right lenses, setting the correct exposure, and composing the image, there are three pre- and post-pixel issues to consider carefully to optimize your photograph's quality: white-balance, ISO, and file format. To review, the pre-pixel aspects of an image are those that take place and affect the image before it has hit the CMOS or CCD sensor and become digital — even if you're making electronic adjustments to the camera, such as white-balance. A post-pixel setting is one that affects the image afterwards — such as file format.

White-balance and ISO settings both relate to the type and amount of light entering the camera, which will vary because it's the environment to which you must adapt, such as outdoors, or it's the situation you've created, such as in a studio. In addition to that, but really unrelated to these other two factors, you'll need to think about the type of file format and quality (such as JPEG small, medium, or large files) you will have your camera store the image in, and ultimately the file format you'll use when you process and publish your photo. All of these directly affect image quality and how your image ultimately can be used and edited.

White-balance

White-balance is a measure of how the camera sees and records color based on light that's being reflected into the lens or sensor. In fact, "white" is a misnomer because cameras are actually calibrated against an 18 percent gray color, rather than white, because the reflection of most of our world is not perfectly white. Gray is a mid-tone and, thus, a better determinant of what the camera is likely to see. You can purchase perfectly colored, 18 percent gray cards from photographic-supply stores, take photographs of them in the light where you intend to shoot, and adjust your camera to that color to obtain a perfect exposure.

Different types of light have different temperatures that result in their having different colors. A candle flame, for example, has different colors at its center than it does at its edges, because the fire has higher heat intensity closer to the wick. Likewise, the light outside in sunlight, inside a room with normal household lamps, inside an office with fluorescent lights, or in a studio with flashes all cast different physical temperatures and, therefore, appear in different colors when photographed the same way.

Understanding exposure and light "temperature" is one of the more challenging topics to explain and understand in photography, which is why point-and-shoot cameras all have settings to take pictures inside, outside, in sunny weather, in cloudy weather, and so on. With digital cameras, you can control temperature remarkably well. Higher-end cameras actually let you set a specific color temperature for an exposure. If you choose an automatic white-balance, the camera interprets the light temperature it sees and sets itself accordingly. Although this works well some of the time, it's not a guarantee, especially in changing light situations.

If what you're photographing is generally more reflective than the mid-tone of 18 percent gray, such as a subject with a pale white complexion, snow, a wedding dress, or fencers, as shown in Figure S2-15, you'll need to make adjustments accordingly to your camera to shoot the scene. The same goes for a dark image — a person with very dark skin, a black car, or a low-key scene.

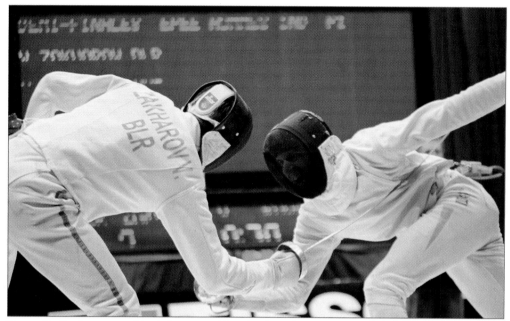

Figure S2-15: Improper white-balance would make these fencer's uniforms look off-color.

Note Low-key lighting emphasizes darkness and shadows, instead of bright, wrap-around light.

The digital camera, in an automatic white-balance mode, tries to compensate an exposure against the mid-tone, meaning that if the subject is very white, it gives less light, and if the subject is very dark, it gives it more. However, this may not be what you want. For example, if you're shooting a snow scene, giving less light actually makes the snow look gray — much to the shock of many skiers who have ended up with very gray images while on vacation with their point-and-shoot digital cameras.

Think of it like driving on ice: If you begin to skid, you steer in the direction of the skid to get out of it. For images where the predominant exposure is lighter or darker than a mid-tone, you need to compensate in that same direction. Where the subject is on the high side of mid-tone, adjust your camera to allow more, not less light. Likewise, if the subject is dark, you want to let less light into the camera. This seemingly counterintuitive method of adjusting a digital camera to compensate for automatic white-balance is illustrated in Figure S2-16.

So, although you may still have your camera set to an automatic white-balance, you're overriding the setting through adjusting the exposure.

You don't want to make big changes — usually one or one and a half f-stop settings are enough in either direction. You should check your exposure before beginning the shoot in earnest, or you'll be spending time in Photoshop adjusting levels, shadows, and highlights!

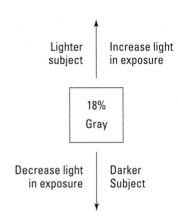

Figure S2-16: Seemingly counterintuitive? Adjusting the digital camera to compensate for automatic white-balance.

Lighter subject | Increase light in exposure

18% Gray

Decrease light in exposure | Darker Subject

Note Photoshop CS's new Shadows/Highlights feature, available under the Image menu, helps tremendously as an alternative to using the levels adjustments. But, it still takes time to fix a poorly exposed image!

For specific lighting situations, such as if you're using flashes (either the one on your camera or studio lights) or outdoors in bright sunlight, your camera most likely has settings related to that type of light. You'll want to try these out and see how they work for you, and how reliably your camera operates this way.

Tip If you adjust your camera to a different white-balance setting by either a preset lighting mode or a specific Kelvin temperature, don't forget to change it back when you're no longer taking photos in that setting! This is the biggest cause of white-balance problems that can result in hours of post-pixel headaches. The same goes for ISO settings: It's hard to get a good exposure if your ISO hasn't been set correctly for a shoot, or if you forgot to match it to the light meter's ISO setting when you took your reading.

Cameras are sensitive, too: ISO settings

I used to buy film based on the quality, color, brand, and ISO rating. The ISO indicates how sensitive the film is to light, and is also referred to as the film speed. Kodak Tri-X Pan film, for example, was the mainstay of journalists for many years. It's a black-and-white 400 ISO, very forgiving negative film, meaning it adapts to many situations of light with great flexibility. However, if you wanted to change ISO from one shot to another, it meant changing film — which is one of the great advantages of how digital cameras handle ISO settings.

Measuring Light with a Colorimeter

If you really want to get technical, and if your camera will handle it, you can use a colorimeter to measure a given lighting scene and then adjust your digital camera's Kelvin degree setting accordingly. I don't suggest this except in the most controlled and measurable situations, and you need to be pretty sure of your lighting, the temperature and how consistent it will remain. For example, if your camera will remain in the studio or will always be taking photos in a predefined setting with lights — such as a school photo set where you always position lights the same way and you trudge student after student through the same scene and exposure — then using this setting is a valid option.

ISO, ASA, or DIN?

You may remember film sensitivity being rated with ASA or, in Europe and some other places, with a DIN rating. ASA stands for the American Standards Association, which, like DIN (Deutsche Industrie Norm), was replaced by the ISO rating. ISO, which stands for International Standardization Organization, is now used worldwide as the prefix to film speed and to refer to speed settings on digital cameras.

With digital, you can choose a different ISO setting for every image on a flash card, if you so choose. This sensitivity setting is based upon a setting in the camera, not the media, as it was with film. With film, there was some flexibility in "pushing" or "pulling" the film to change its ISO, but the changes applied to the entire roll and the lab required special processing instructions.

The ISO settings work the same with a digital camera as they did with film, in that a low ISO number, such as 100 or 200, is for bright light and a high number, like 800 or 1600, is for low-light conditions. Also the higher the ISO and lower the light, the more granular the image appears. This granularity is called *digital noise* in the digital-photography world.

With point-and-shoot digital cameras, changing the automatic light settings for night, for example (almost always represented by a little crescent-moon icon), actually adjusts the camera's ISO to a higher speed, among other things (such as opening the aperture, slowing the shutter speed, and so on). While semiprofessional cameras also offer similar presets, you can also set the ISO manually.

The Canon 10D, for example, offers the little iconic presets for the photographically uninitiated, but you'll almost always get better results, even if you have to experiment a little, by using your own ISO settings. The fully automatic setting will set its own ISO, as it sees fit; usually there's a nearly automatic setting, often called the *program setting,* represented on the camera dial by a *P* that allows you to control the ISO. If you want to shoot in a nearly completely automatic setting, this is a good bet. Anything more manual from there, and you have to set the ISO no matter what.

In general, set your ISO as low as possible to ensure the best image quality. You achieve the finest quality with lower settings. However, if you don't have enough light, you must set the ISO higher. If you set the ISO too low in a lower-light situation, you have to open up the aperture, and you end up with a very-narrow-depth-of-field shot when you didn't really want one. Alternatively, you may have to slow your shutter speed to an unreasonable setting that causes a blurry mage. Low light may also force you to use a flash in a situation where you really didn't need to use one, and I know I'm not alone in the photography community when I say that the more photos you can take without a flash, the better your work is.

If you set the ISO too high, conversely, the images tend toward overexposed or you won't achieve as narrow a depth of field as you were hoping. Furthermore, you may produce the image with too much noise, which causes the image quality to suffer. Figure S2-17 is a low-light night shot of Havana, Cuba. It was taken by setting the camera on the open window ledge of a hotel and exposing the shot for 1.5 seconds at an f-stop of 3.5 with an ISO of 800.

Generally speaking, the ISO ratings in Table S2-1 work for photography. Note that not all digital cameras can be set to the extremes of ISO 50 or ISO 3200. Use the table as a rough guide to ISO settings.

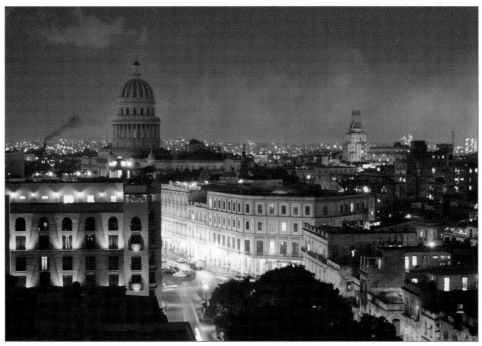

Figure S2-17: A low-light, high ISO, night shot of Havana, Cuba

Table S2-1: **ISO Settings**	
ISO Setting	*Situational Use*
ISO 50 to ISO 400	Sunlight, daylight, longer exposures where you want to limit grain/digital noise, bright high-key studio lights, flash photos
ISO 800 to ISO 1600	Evening and lower-light photos, low-key ambient studio lighting
ISO 3200 or higher	Only the most low-light situations where nothing less will suffice

To contrast the previous figure, Figure S2-18 shows a brightly lit scene shot with an ISO setting of 100.

Tip When shooting night shots with a digital camera, such as stars or the aurora borealis, don't assume you need to set the camera on its highest ISO setting. Doing so only results in extra noise. Take a longer exposure and use a lower ISO to obtain a better photograph.

Figure S2-18: A lower ISO speed lets you expose longer with less noise.

Summary

The digital photo shoot, while technically not that much different from a film-based photo shoot, is the key transfer point between pre- and post-pixel photography. There are many things to think about — lights and camera settings, composition and meter readings, props and scenes, and keeping subjects happy and comfortable. A good photographer develops a shooting style to accommodate these and other factors to produce the best-possible images suitable for digital processing, printing, display, and distribution.

"Measure twice, cut once" applies to digital photography, and just because images can be "fixed" or "Photoshopped" after the fact is no excuse to start with anything less than a good-quality image. Taking enough time to properly set up a scene and focusing on your subject, not your camera, are good skills to develop.

Lighting and metering are essential parts of setting up a photo shoot — including understanding how lighting and metering will affect what you're photographing, and then controlling it as much as possible. This is true both for physical lights, such as flashes, as well as for settings on your camera such as ISO, white-balance, and even the type of file format in which you choose to shoot.

Protecting equipment from damage and theft is essential and part of how you'll design your workflow. Even in a studio, you'll want to know where things are and be able to minimize equipment congestion. Further, you don't want to intermingle camera equipment with computer equipment — the activities are separate in the workflow process, and there's no reason to combine them when you organize your studio or portable digital studio.

✦ ✦ ✦

3 Transferring Digital Images from Camera to Computer

Alcatraz looks close enough to swim to in this telephoto shot taken from San Francisco's Pier 39. A TIFF file brings out nice detail of the many colors and shades of the water and sky. Taken with a Canon 10D at ISO 100, f/8.0, 1/250 second, and 140mm focal length.

Moving images from a camera to a computer represents the critical link that characterizes the digital studio, where a photograph is physically transferred from one primary technology to another. Making this transfer without losing photo quality—or your photos!—is important.

Handing Off: The Critical Transfer from Camera to Computer

Transferring a file from your camera to your computer seems pretty insignificant in the day-to-day operation of digital photography workflow. However, its importance cannot be understated! You've invested tremendous effort (and skill), and perhaps had some good timing and even luck to capture your image. You don't want to blow your picture during this critical transfer process.

In the post-pixel stage (after the image has been exposed and has become a digital photograph) of digital photography workflow, the newly acquired/created digital image must be transferred from the image-capture device (your camera or scanner) to the host computer or a storage device (such as a portable hard drive). Handling your precious image from camera to computer is dependent on two elements: ensuring the integrity of a flash card or cable connection, and how the image is stored and processed after being transferred. Both these factors can have a direct impact on how the image can later be edited and used.

Note An image-capture device, in this case, is a digital camera, but it could also be a scanner, slide reader or other equipment. Scanners are typically directly connected to a computer, so the transfer process is much less prone to accidental data loss.

How image files get to your computer

An image can travel from a camera to a computer in several ways:

✦ From a flash card (like CompactFlash, SmartMedia, or Memory Stick), which is moved or copied to the computer using a flash-card reading device

✦ From an interim storage device or media such as a portable or mini-drive, compact disc, or floppy disk

✦ Directly through a USB or FireWire cable

Flash cards hold image files that have been transferred from the camera. To move files from a flash card to your computer, the card is removed from the camera and inserted into a reader that is attached to the computer's USB or FireWire ports.

Mini-drives, writable CDs and floppy disks can be connected directly to your camera. Images written to these drives are then transferred to your computer simply by inserting them into the appropriate drive in the your computer.

Note There are also flash card readers that plug into the PCMCIA (or PC Card) slot common to laptops.

If your camera has connection ports, the simplest (and safest!) form of file transfer is using a USB or FireWire cable to connect your camera directly to your computer. Software, including that provided by your digital camera manufacturer, manages the transfer of files to your computer's hard drive.

Caution If you're photographing in RAW, not all applications that automatically recognize flash cards and download images will handle the files. For example, with a RAW+JPEG setting, you may find that the application will download the JPEGs but leave the RAW files on the card. In this case, you'll have to copy the files from the card to your hard drive by using the Windows Explorer. Be sure to check ahead of time, so you know if you'll need to download images manually.

When you can't download to a computer . . .

In the field, carrying a computer is not always convenient or safe. How, then, can you download and store large numbers of images? You'll want to use a portable storage or data-recording device, like the ImageTank, the Apacer Disc Steno, or the Delkin eFilm PicturePAD. These devices can temporarily store thousands of high-resolution, native images.

The ImageTank and the Delkin eFilm PicturePAD, are miniature hard drives with anywhere from 20 to 40 gigabytes or more of storage combined with flash-card reader slots (some of the devices support SmartMedia and CompactFlash, others just the latter). The devices automatically read the flash card and allow all the files to be stored in directories with the push of a button. Later, at the computer, you attach the drive to a computer with a USB cable and download the images.

Note The ImageTank is manufactured by Grand-Level Technology Corp. (www.grand-level.com.tw) and distributed in the U.S. by JOBO Fototechnic Inc. (www.jobodigital.com).

Using drives with USB 2.0 support, providing your computer supports, is significantly faster than USB 1.1 when it comes to transferring images from the device to your computer. Note, however, that flash cards themselves don't download at full USB 2.0 speeds (but they're usually faster than USB 1.1). If you don't have USB 2.0 in your computer, I suggest you look into purchasing the upgrade (it involves installing hardware). You'll be amazed at how much faster transferring information becomes between hard drives and other devices and your PC.

Hard drive or disk burner?

Which device—hard drive or disk burner—is right for you? It depends on what you're doing. For example, when I'm at a big fencing championship, I churn through one flash card and have either the PicturePAD or the ImageTank portable hard drive sitting beside me. I insert the flash card, begin its download process, and insert another flash card into the camera to use while the other one is recording. I go back and forth for the full event this way. At the end of the evening, in the pressroom or the hotel, I copy the images from the portable drive to my laptop for viewing. That way, the portable device has then also become a backup drive.

If you have time, burning to a CD can be useful, especially if you intend to give the images to a client or someone else. Products like the Apacer Disc Steno allow multiple flash cards to be burned to one or more discs in a single session, as well as *disc spanning,* which gives you a way to automatically burn multiple discs of large amounts of data. Remember, however, that CDs can be damaged relatively easily, so relying solely on a CD for critical data storage is a bad idea, unless that disc is being stored *very* safely.

Protecting data media

All these devices, though intended for field use, are not unbreakable. They have moving parts, like spinning hard drives, CD spindles, and hardware data readers. Dropping a portable hard drive or CD burner will most likely render it unusable—you'll have to have it professionally serviced and keep your fingers crossed that the data wasn't destroyed. Protect these devices in the field from dirt, moisture, dust, and physical jarring. Keeping them as still as possible while they're operating is especially important.

Keep the device in a protective case (most come with one) and, if you're in especially harsh conditions, place it with its case into a heavy-duty resealable plastic bag. If you're going to be quickly moving the device in and out of very cold and hot environments—such as between the humid, hot outdoors and an

air-conditioned building, or between extreme cold and a heated building—keep the device inside the sealed bag until you're reasonably sure it has completely adapted to the new temperature. This prevents any condensation from affecting the device, which can be very damaging.

Tip Keep flash cards safe when they aren't in use and when physically transferring them between camera and computer. Don't just stick them into your pocket. If you're carrying multiple cards, carry them in a case that, preferably, closes with a zipper to prevent any from inadvertently falling out. If your shooting conditions are especially bad, put them into a watertight/airtight container or a resealable plastic bag as a last resort. I've found that Pelican (www.pelican.com) makes exceptionally reliable products for keeping things dry and safe. Mark the cards with your phone number using a permanent pen in case you happen to lose one.

Viewing photos on storage media

On some portable hard drives, you can check that your images have safely been transferred, something I highly recommend doing if you can take a minute during your photo shoot. Some of the devices simply download and don't include an LCD window to review the files, and the only way you can tell if your images made it is by connecting the device to a computer (where it appears as a supplemental hard drive). When buying a portable drive, choose one where you can see the files after they're downloaded—it will save you angst if you happen not to remember if a specific flash card was downloaded or not.

I find the ability to physically view images on the LCD, although exciting at first, to be of limited value. The PicturePAD can even display RAW files, although it's very slow in processing them and the color representation is poor. I would rather display RAW files on my laptop when in the field. As a quick check for JPEG images, it's occasionally handy, and the ability to view images in a slide-show format on a TV is a fun feature but limited in practical use. Remember that you pay for these features, so if they aren't critical, you're better off purchasing a device with fewer features, a lower cost, and equivalent quality and reliability—which is what you absolutely cannot live without in the field.

Tip Some miniature hard-drive devices, such as the Archos Jukebox, combine other consumer features such as an MP3 player, a video player, and the ability to see the stored images and videos on a tiny LCD screen.

Image Integrity and Data Transfer

Moving data from the camera to the computer needs to take place efficiently, quickly, and securely. If stored such as on a portable hard drive or CD, it must be protected from corruption—a scratched CD or dropped hard drive can have devastating consequences. Optimal workflow occurs when you use the most efficient, streamlined method.

The most secure and fastest way to transfer images between camera and computer is a direct connection, such as a USB or FireWire cable. The flash card stays in the camera, which automatically appears as a virtual hard drive on the computer when it's connected and turned on. This way, there is no danger of damaging a flash card or subjecting the card to a failure in a flash-card reader. As you connect your flash card to your computer, your operating system detects the device and prompts you with download options. Figure S3-1 shows the message that appears.

Figure S3-1: In Windows, a window appears with multiple download options when the PC detects a flash card. If you've installed software that includes a "device reader," such as ACDSee, then it will automatically detect the reader and card.

Several software tools can be used to receive the images on the computer, with a wide range of capabilities; some of these are purchased applications such as ACDSee, but Windows XP and the Mac can also automatically detect devices such as a card reader and card. When a flash-card reader or the direct camera connection is attached to the computer, a window will appear automatically, offering a variety of ways to view, print, or copy the images.

Use Caution When Copying Images!

Be vigilant when you copy images to a computer or portable device using flash cards. A number of pitfalls lurk for the often-hurried photographer.

Although cameras can automatically number the images and put them into numbered subdirectories, leaving the subdirectories numbered is a recipe for trouble. Numbers can easily be confused, misfiled, and even, on occasion, duplicated with a new set of images by the camera. As soon as possible after transferring images to the computer, rename the subfolder and the images using the batch rename feature of your file-management software.

Never remove a flash card from the camera while it's still processing. If a number of photographs have been taken in a row, the camera has likely stored the images in a buffer, and it takes a few seconds to a minute or so for most cameras to store the images onto the flash card. During that time, typically a blinking light on the camera indicates processing is taking place. Removing a flash card during that operation can cause — at the least — corruption of image files or — at the worst — complete corruption of the flash card itself.

Turning off the camera should not affect a card that is still processing. Most cameras are able to finish storing the images onto the card after the camera is switched off, and then shut down completely only after the processing is complete. Note, however, that removing the battery would not have the same effect as removing the card, and could potentially corrupt the card.

Make sure flash-card readers are clean — both the portable kind and the actual flash-card port in the camera. Dust and moisture are the sworn enemies of the flash-card connection, which consists of minute pins that insert into equally small openings in the card. Anything interfering with the connection can cause files to be corrupted or cause it not to work at all.

Managing Images with Windows XP Utilities

Windows XP comes with a Scanner and Camera Wizard that allows you to scan images or bring images directly into your computer from your camera and save the images as TIFF files (or other formats).

Particularly if you don't have large numbers of images to manage, the Scanner and Camera Wizard can be a functional way to bring images into your computer. The Scanner and Camera Wizard also includes features that allow you to view a slideshow using the Windows Picture and Fax Viewer, and print the pictures using the Microsoft Photo Printing Wizard. Of course, you can view images in any folder in your computer using the Windows Explorer; Thumbnail view displays thumbnail images. Note that Windows Explorer is different from Internet Explorer; Windows Explorer can be accessed simply by right clicking on the start button and choosing Explore.

Although useful for snapshots, none of these options is an optimal choice for serious photography workflow. Simply viewing images or printing them doesn't process them in the sense of getting the native images to a secure location and stored so that they can be accessed.

One of the biggest challenges in digital photography is quickly and easily managing, storing, and prioritizing the many images that are produced. After images arrive on the computer, processing them promptly will ensure that their quality and accessibility are optimized.

Setting up, naming, organizing, and cataloging file folders is nobody's favorite part of the digital-photo workflow and is often relegated to interns and other assistant and apprentice photographers. Nevertheless, experienced digital photographers know (and many have learned the hard way) that careful file management is an essential element of the workflow. Luckily, both helpful software tools and time-tested techniques make the process less tedious.

Your camera will have automatically numbered each image and, in some cases, divided the images into smaller, numbered subfolders. You should begin by placing them all in one working subfolder with an easily referenced name and date for the shoot.

Cataloging your files

After your images are safely stored in folders, batch rename the files before doing anything else with them. Image management tools such as ACDSee and the Photoshop CS File Browser allow complex renaming to take place easily and efficiently.

The filenames should include two primary pieces of information: an identifying number for individual images and a name for the image series. One feature I find especially helpful in using ACDSee's automated file acquisition tool is how it gets rid of those pesky extra subfolders cameras love to generate — it will automatically transfer and rename every image on the flash card to the computer and store images into one subfolder you specify.

Metadata batch processing

For managing large number of images, professional and serious enthusiasts use a dedicated software application such as Photoshop CS File Browser or ACDSee. These programs provide complete solutions to image downloading and processing. Adobe's File Browser also allows image metadata to be efficiently customized for a large number of images.

Metadata is the unique subfile of data about an image recorded by the digital camera. It tells when the image was created and by what type of camera, the exposure and focal settings, and even information

such as whether the flash fired. Figure S3-2 shows an example of partial metadata information for an image, as seen in ACDSee.

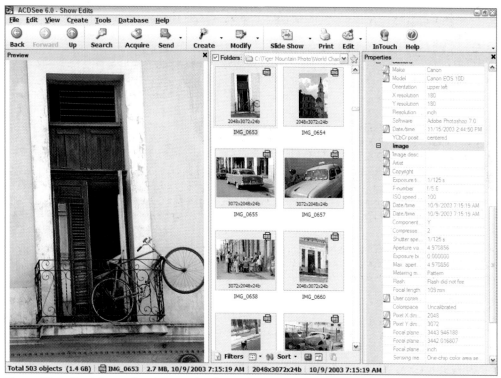

Figure S3-2: Partial metadata information for an image

Metadata is an easy way for a photographer to place embedded copyright, authorship, and image title information for a file. Follow these basic steps to add some types of metadata to groups of images in Photoshop CS File Browser (metadata can also be added individually, image-by-image, if individual image titles are required):

1. **From within the Image Browser, press Ctrl+A to select an entire subfolder of images.**

2. **In the Metadata window of the Image Browser, enter the appropriate data for the images, such as the author name, description, and copyright information, as shown in Figure S3-3.** The metadata you enter will apply to all the selected images. Note how the information relating to all images can be modified, but individual file metadata is not available or changeable in the batch process.

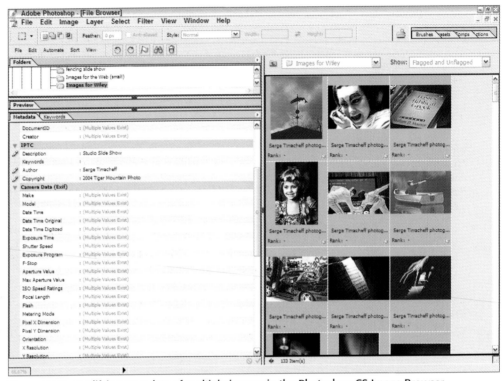

Figure S3-3: Modifying metadata of multiple images in the Photoshop CS Image Browser.

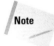

Note Some data, such as the camera data, cannot be modified.

3. **Click Yes to apply the metadata information to all the images selected in the subfolder.** The larger the number of images, the slower the process — several hundred images can take several minutes or longer.

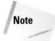

Note The CS File Browser is packaged with recent versions of Photoshop.

Using Image Editors

Many image-editing and image-management tools are on the market, and I don't intend to enter into a comprehensive discussion of them all. I will discuss image transfer and management and emphasize workflow issues, using ACDSee and Photoshop CS, as well as basic Microsoft Windows tools, to describe the process.

These industry-standard products feature everything found in virtually all image packages on the market and more; furthermore, Adobe integrates elements of Photoshop features into consumer versions of its

software (for example, Photoshop Elements). Among the various other packages on the market, you'll see many of the same features named and implemented at least in similar — if not identical — ways among various applications. The features and functionality — not to mention price — of other packages such as Microsoft Digital Image Pro and Corel PHOTO-PAINT will affect what you purchase and use, and there's enough commonality that these workflow descriptions should hit home no matter what software you use.

Managing file versions

Renaming files at this stage is important because, when you have two versions of the same image, with different names, finding and reconciling the two can be a real challenge if one is edited or changed. The unique number the camera produces is helpful, but it potentially poses a risk (albeit a small one), because it cycles through series of numbers and, ultimately, names another image with that same number. Renaming the file from the get-go ensures you have a name you can retain as you back up and then edit the file.

Tip Name files using a convention you create that is consistent, and never rename an edited file the same as the original. For example, I place a simple *e* after the name for a file that has had any basic cropping, auto-leveling, or editing. If I've added a creative effect, such as posterization, I'll include *poster* or simply *p* after the identifying name, or *bw* for black-and-white, and so on.

Immediately store these renamed, original files to a backup storage location, such as a CD, DVD, or hard drive. When possible, use the same subfolder (subdirectory) name as the working folder.

In the working subfolder, review the images and delete ones that are obviously unusable, such as black images, where the flash didn't fire.

Using lossless formats

Using a lossless technique, rotate images that are not correctly displayed. The lossless method, which is available in most better-quality image-management tools, ensures that the image quality and integrity is not compromised when the rotation is applied, and that the computer won't attempt to throw away information it deems unnecessary (it's better for you to determine that, in most cases). Figure S3-4 shows an image ready to be rotated in ACDSee and the various options associated with rotation, such as keeping the original image as is and placing the rotated image into a separate folder, or forcing the rotation to be lossless.

You should note that some photographers believe that virtually anything you do to an image has some type of effect that results in image-quality degradation. Suffice it to say that the fewer changes or alterations to an image — even simply copying it or saving it multiple times — the more it will remain in a pristine state.

Using the lossless method generally works the most reliably on photos with dimensions that are a multiple of 8 or 16, simply because computer data is made up of 8 bits of information, and an image dimension that does not correspond evenly with this will have some information loss (usually in the form of pixel loss on the outer edge of the photo).

If you're using a lower-end image-editing or acquisition tool, you'll want to check to see if it offers lossless rotation before altering any of your images, and original images in particular.

Tip Some digital cameras can automatically rotate images in their LCD viewing window so you don't have to rotate the camera to view your shots. This doesn't affect your original image file quality.

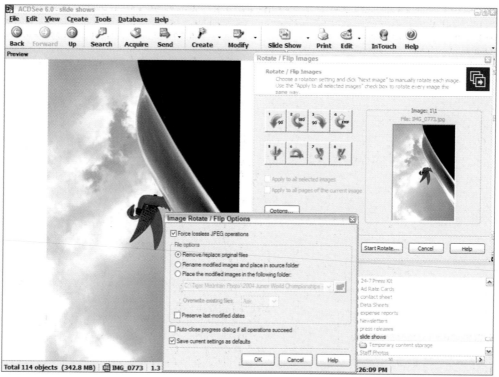

Figure S3-4: Rotating an image without lossless data management can result in a loss of data because the image must be copied and resaved.

Ranking image files

Image-management tools offer features that allow you to rank images, prioritizing the best shots. Rate the images that are obvious best shots, as well as those that are good possibilities, and so on. Although not every image needs to be rated, ranking down to second- or third-best can be accomplished quickly.

To prepare to rank image files, first create a new subfolder that is subordinate to the working subfolder. Into this folder, copy the less desirable and non-prioritized images. This way, the main working folder has the prioritized images where they can be batch edited, reprioritized, and accessed easily and quickly, and the lower-priority images are still located nearby and available if needed.

Caution

Do not rename the lower-priority images! This will prevent you from being able to reference them later, if necessary.

Many cameras provide software that allows images to be downloaded and otherwise edited. For example, Canon includes its ZoomBrowser EX software (shown in Figure S3-5) with most of its cameras, a remarkably powerful application that allows images to be previewed on the flash card and then downloaded, printed, renamed, and superficially managed (for example, to be placed into favorite categories such as family, business, and so on). It shows the image histogram (indicating lighting, contrast, and brightness) and some metadata information.

Figure S3-5: The Canon ZoomBrowser EX utility, which reads flash-card images and displays file information as well as the histogram and metadata information

Flagging images

I often find flagging images to be the fastest way to select, prioritize, and sort images. For example, after big fencing competitions, I typically have anywhere between 7,500 and 12,000 photos to review, which I then organize into subcategories of the various events and then specific shots: medal ceremonies, action, officials, joy, defeat, and so on. Figure S3-6 shows how images in Photoshop can easily be flagged, ready to be sorted and prioritized later. They can also be organized numerically.

For each subfolder, which is typically unique to an event, if I were to review and then rank these files from, say, 1 to 3, it would be incredibly tedious. Instead, in Photoshop or ACDSee, I quickly go through the files and flag images instead of giving them a numerical rating. Later, I sort the images by flag, which moves all the flagged images in each folder to the top. This is a quick and dirty way to reduce the images and be able to view them as a group and then process them.

Figure S3-6: Flagging an image in Photoshop CS

Ranking numerically

If you're going to rank images numerically, the Adobe Photoshop CS File Browser, although much improved over previous versions, is a little more cumbersome than ACDSee. In Photoshop, the easiest way to rank is to click below the image thumbnail, which opens a space where you can insert a rank number. Figure S3-7 shows the Photoshop CS File Browser.

Figure S3-7: Organizing files with Photoshop's file browser

Alternatively, you can right-click and select Rank from the menu list, which then produces a small window where you can manually enter a number. Both of these methods are awkward because they require you to shift between mouse and keyboard. ACDSee, instead, includes an optional-view properties box where you simply click on a number between 1 and 5 (or 0, for no rank) to rank the files. As seen in Figure S3-8, this forces a small number in a colored circle to appear atop the thumbnail—in a different color for each number, which further helps to find different prioritized images later.

Using multiple programs for reviewing and ranking

Normally, when I'm reviewing and ranking images, I have three applications open: Adobe Photoshop CS, ACDSee, and the Microsoft Windows Explorer. For sure, Photoshop and ACDSee have overlapping features, but I find that each does certain things better than the other, such as the ranking/rating example earlier.

Photoshop, for example, is much faster at displaying RAW files and allows me to make a quick adjustment to the image so that I can see if it will be a worthy candidate for the project. In ACDSee, you can see the RAW file in its basic exposure, but it won't let you immediately edit or otherwise alter the image. Further, ACDSee is slower at displaying the RAW images than Photoshop.

Figure S3-8: Prioritizing images in ACDSee using numerical/color identifiers.

I sometimes find it easy to review images in the Windows Explorer window, and to create and manage subfolders there, if only because it's simple and easy to use and the search feature is equally basic. Unfortunately, the Windows Explorer won't display RAW thumbnails.

Another reason to keep multiple applications open is to review a file in one and do preliminary editing in another. Because Photoshop is such a profoundly superior editing tool overall, with so many plug-ins and features, I almost always edit higher-end images in it. The File Browser is a pain to open and close, although, to be fair, it is extremely adept at returning to the point where I left off in the browser after opening and closing an image (a wonderful feature, by the way).

Typically, for all images except for RAW files, I rename, review, rank, and flag images using ACDSee. When I need to edit an image, I click and drag it to Photoshop where I can make a quick edit or save it as another file and do something more significant to it such as turn it into a black-and-white image or apply filters for creative or image-enhancement purposes.

Using ACDSee's Image Basket feature

For faster jobs, where I need to quickly review and edit lots of images requiring basic image enhancement and not destined for magazine covers or other high-end uses, I frequently use a unique and innovative feature in ACDSee called the Image Basket.

The Image Basket acts as a temporary holding bin for images where I can keep track of various images from different folders. The Image Basket lets me print photos with a very nice little print utility and burn a CD of the images. It also allows me to make minor adjustments; for example, I can make a quick adjustment to the exposure using a variety of tools including an image printing tool, an exposure slider, brightness/contrast/gamma, and an autolevels histogram curve tool similar to Photoshop's. It has numerous other editing features as well, such as batch processing and the ability to change JPEG compression factors. Figure S3-9 shows a photo in the Image Basket being adjusted.

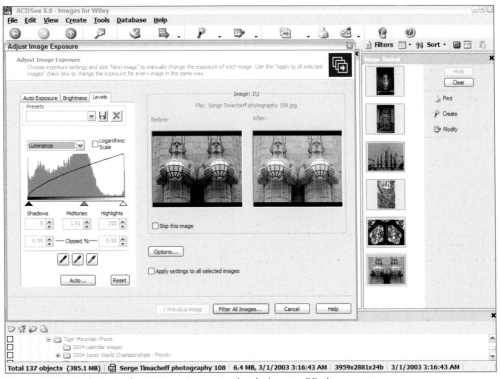

Figure S3-9: A photo in the ACDsee Image Basket being modified.

Summary

Moving images from the camera to the computer, while a seemingly minor part of digital photography workflow, is actually a critical juncture. Moving an image from one device to another has to be done safely using a reliable device, and the software must receive the image in a way that is easy for the photographer to wrangle it into the various formats, copies, archives, and other uses it will take on.

Further, for shooting in the field, it's essential that images be stored properly and safely onto portable image storage devices or recorded onto CDs for transport to the studio.

A variety of applications exist for accepting images on the computer, and several will automatically read your flash card or other device and process them as they're being moved. However, it's also important not to change images before they are correctly processed to avoid any data loss or unnecessary compression that might compromise image integrity. Products such as ACDSee are useful in image acquisition, and, once acquired, they can be edited and managed in that product or others, such as Photoshop. Many digital cameras also come with software suitable for image management, but it's important to ensure the software is robust enough to maintain optimal image quality for professional use.

Once on the computer, images need to be treated appropriately, including recording metadata, reviewing and prioritizing them, and backing up and archiving them. It's essential that all original, untouched images be stored safely in a location where they won't be edited, altered, or touched other than to make working copies.

✦ ✦ ✦

4 Image Review and Organization

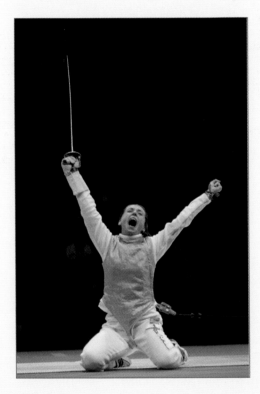

Valentina Vezzali of Italy roars a cheer to a wild crowd of fans after winning the gold medal in women's foil fencing at the Athens Olympic games. Taken with a Canon EOS–1D Mark II at ISO640, f/2.8, 1/500 second, and 110mm focal length.

I sometimes take as many as 1,500 photos a day at big world-championship events, especially because my camera can shoot 8.5 frames per second. Although taking lots of pictures is a great way to get super images, it also requires a substantial amount of elbow grease to select and organize those images so that they're usable, accessible, and identified properly.

In this chapter, you'll look at how to review and organize images — an essential step in digital photography workflow. Even before a shoot, you'll want to work on the type of images you're creating to ensure you won't overload yourself in post-production. Once images are on the computer, they must be processed in terms of reviewing and prioritizing them, naming, image editing, and how to use metadata to ensure you'll be able to archive, reference, and identify images for future use.

Looking at your photos is lots of fun; organizing them is not. The amount of digital images being created every minute of every day worldwide is explosive — and the vast majority of those shots aren't usable. Even pro photographers use far fewer images than they shoot. Consequently, image review and organization isn't optional for photographers, even if it's not the most fun part of the business. The more up-front work you can do to organize photos, and the more you can do to review as you shoot, the better. Before you begin your shoot, think about how you'll review and organize images later. Organization is a necessary evil in digital-photography workflow, so consider how to make the best of it, beginning with what might happen even *before* a shoot in terms of decisions you'll want to consider.

Before the Shoot: Print Sizes and File Formats

TIFF and JPEG files that are too big can choke some of the most robust applications, eat up hard drive space, be difficult to fit onto CDs for distribution or storage, take a long time to upload to an online service, and make e-mail slower than driving with Grandma. However, it's nearly impossible to enlarge images beyond their pixel dimensions without losing information, so not having a photo large enough for its intended purpose is a big problem. There are software solutions to solving this problem, but it's better to plan ahead and capture an image with sufficient pixels for the intended print size, which means thinking about print size in early stages of the workflow.

 Cross-Reference Genuine Fractals is a software program that provides a viable solution for enlarging photos beyond the existing pixels. For a discussion of Genuine Fractals, see Stage 9.

✦ **Always shoot the smallest size you know you'll need.** If you're shooting a professional or semiprofessional SLR, this means you won't take photos at the full megapixel size, especially for events such as school photos, family snapshots, and most sports. People rarely want or need these types of photographs enlarged to much more than an 8-x-10 size, which is achievable with a secondary large or high medium (or even smaller) setting on your camera.

✦ **Set your camera to highest-quality images for enlargements.** If you're shooting a photograph that you know you'll enlarge significantly — a big family portrait, for example — set the camera at its highest setting because there's a good likelihood that your client will place the image on a wall or over a fireplace, and you want it to look its best.

✦ **If your camera supports it, use the RAW format for best-quality shots.** To create the best quality for an enlargement, take the shot in RAW format. This means that the file will be big no matter what. Generally speaking, you use the RAW format for important images where you don't intend to shoot many photos and when you intend to keep the images as snapshots — not only are the files too large, they take more work to process and you can get really bogged down processing lots of RAW files.

Discussing file-management options on a conceptual level is one thing. But consider a case study. Imagine you're the photographer for a wedding shoot. How do you divide up the file size and format load for the event, assuming you're shooting the formals, rehearsal dinner, ceremony, and reception?

You have to make some assumptions: The camera for the following examples can handle up to about 6 megapixels and can shoot in RAW, JPEG in multiple sizes, and RAW+JPEG (generating two files for each shot). For each event component of the wedding, you need to change your camera's settings to suit how you'll review and use the images later.

The rehearsal dinner

Because the rehearsal dinner is the groom's family's event, it's a good opportunity take shots of family members who may get lost in the shuffle at the wedding. However, it's an event, not a formal photo setting, so you'll want a number of impromptu groupings and candid, photojournalistic shots. You may use a flash, as well, depending on the light. It's unlikely that your client will want to enlarge any shots larger than 8-x-10; in my experience, the commonly requested sizes are 4-x-6 and 5-x-7 for the wedding or proof books.

As a result, you'll do just fine with a JPEG setting of medium or secondary (not the largest) large size. This allows you room for several hundred shots on a 1GB flash card — about as many photos as you'll probably take. Hopefully, most of those photos are usable because they're various permutations of family groupings with the bride, groom, and wedding party. You'll most likely upload these shots to an online service, so having them in something that requires the least amount of processing is highly desirable — probably some automatic levels and/or contrast work in an image-editing software, and you're pretty much done. For the best shots, you'll want to convert and save them later as TIFF files, especially if they're destined to be enlarged. You may even get them online that night and be able to let people know the next day at the wedding!

Shooting the formals

As I've discussed, the RAW format is the perfect, information-rich format for shooting a bride and groom where there's a fancy white dress surrounded by skin tones and other darker colors. RAW handles the image the best, giving you the opportunity to display highlights in the dress and still have the faces looking good. Of course, RAW files will be saved and used at TIFF files later, but they'll capture the most information possible at the largest size your camera can produce.

Inform your clients that it will take some time to produce the formal photographs. Wedding clients know the formals take some time (a throwback to film), so you'll have a few weeks (for some photographers, a few months, but I don't recommend waiting that long) to work the images in Photoshop or other applications for optimal presentation. Then, if all goes well and you present your images with enough pizzazz, clients will order enlargements up to 20-x-30 (sometimes even larger), print them on canvas, and mount them in an expensive frame!

You don't need to shoot RAW+JPEG on these images, and you won't need to shoot hundreds of formal shots. You only need two or three shutter clicks for each pose and/or grouping. This yields a manageable amount of files for reviewing and processing. Further, you can count on many more of these images being printed in 8-x-10 and larger sizes.

The ceremony

The wedding ceremony can be tricky, because it's such a mix of people, settings, light, and other factors that can directly affect what you'll do with the photos later. For that reason, you'll want to shoot in RAW+JPEG and use a medium JPEG setting.

This way, you have the best of both worlds. If you take a spectacular photo of the bride and groom kissing at the altar, you can use the RAW shot to edit her dress and the image, and enlarge it to maximum size like a formal shot. If you have candid shots of the happy couple coming down the aisle, of the best man fainting, or of Aunt Bertha's tears of joy, you can quickly process these as JPEGs because they aren't going to make it to a large format. Because you can't really predict everything about the ceremony and

there's the chance for virtually any type of shot, the RAW+JPEG format is the best selection. RAW+JPEG format yields the best of both worlds: image detail as well as ease of access.

The main thing to remember is that you'll take up quite a bit of room on your memory card, so be sure to have extra cards on hand or, even better, a card big enough to handle the entire event. Most wedding ceremonies are relatively short, so it shouldn't be too much trouble.

The reception

Receptions are broken into a couple of different types of photography — the candid groupings similar to the rehearsal dinner, photojournalism shots of dancing and socializing, and the semi-posed shots of the garter, cutting the cake, tossing the bouquet, and other traditional activities. Typically, the reception has very little formality, and seldom are photos made exceptionally large from the event, so you're safe shooting the entire event in a medium or secondary JPEG format. Receptions can go on quite long, so preparing for taking quite a few photos — including a few can't-miss shots, such as tossing the bouquet — is essential. And, for the best shots, as with the rehearsal dinner, you'll save your images in TIFF format for use in enlargements or other edits.

Also, as with the reception, you'll want to take lots of shots and upload a majority of them to an online gallery where guests and other friends and family members virtually anywhere can view the images and buy them.

For some receptions, where there are reasons you can't easily control the lighting — such on a dance floor with multicolored or flashing/spinning lights — for this you have to use a flash, but consider using RAW as a setting because you have better control over adjusting the images later. After the key events, switch back to JPEG for the less-critical shots.

Image Review and Organization

The size and format of your image files are an essential part of preparation for review and organization and can make the difference of hours in your digital photo processing later on. Reviewing and organizing images works more easily if you take a methodical approach. Here are the basic steps you'll want to follow:

1. Logically arrange your photos into one manageable location, such as a subfolder or a main folder with several subfolders organized by topic.

2. Rename your images, but be cautious if you're planning at some point to relate these to archived backups.

3. Standardize on a file naming and storing strategy and stick with it.

4. Apply metadata information to all of your images, including your copyright information, keywords, author information, and so on.

5. Using your organization application, such as ACDSee or the Photoshop File Browser, rank your images either by number or flagging them. You'll probably want to take a couple of passes on each to effectively get a sense of the shots you have.

6. Place your prioritized files into separate folders.

7. Create a contact sheet — either a viewable file or actually print a sheet — for fast reference.

These are key steps; obviously, there could be more (or less), depending on how you're organizing your own digital studio's workflow or what you may or may not need. The essential message in these steps is to create a common, consistent method that works for you to review and organize images, and have everyone in the studio use the same strategy.

Using Software to Organize

Optimizing your file sizes and types helps you prepare to review and organize images, especially when it comes to saving time and memory on your computer. However, there are other factors to consider ahead of time:

✦ **Having images in a manageable location is important.** This means segmenting files into logical categories so that you can easily figure out what you shot and where it is. You can store images optimally for review, organization, and, ultimately, archival and copying.

Cross-Reference

For a full discussion of backup strategies, see Stage 6.

✦ **Different software and hardware storage tools — whether on location or in the studio — store images slightly differently.** For example, ImageTank (specifically, the kind that doesn't let you alter filenames on the device) creates folders and subfolders for each individual memory (flash) card you download to it — even if you download the same card twice. The folders contain your images, in the number sequence your camera created for them.

Many cameras create subfolders into which they store images; some storage devices, such as the ImageTank, do the same thing. This helps to segment them, but can be a bit cryptic. If you use the ACDSee Acquire Wizard and load photos directly from your flash card to a computer, it disregards the pesky camera or device subfolders, which saves time and hassle. You have some options, such as the folders into which the images are stored, which helps you put images where you want them instead of simply being put into camera-generated folders. You can also rename them as they are stored and transferred; however, renaming files can sometimes be a failure-prone operation, so it's safer, and often faster, to rename them once on the computer.

One thing to note, however: If you're working with RAW files, sometimes automatic file readers won't recognize them. If so, you'll need to download them manually.

Caution

Although the option exists to automatically erase files on a memory card while downloading them to the computer, doing so is a dangerous practice. If anything goes wrong with the download — for example, the computer crashes, the battery dies, or the flash card is removed prematurely — you risk losing one or more files. Keep the images on the card at least until after you download them. Optimally, keep them on the card as an extra backup until you've finished your shoot (of course, this means having enough cards or space on a card to hold all the shots you take).

Whatever method you use, you'll need and want to think about where your files are being stored and how you'll get them there. Does your method require a lot of renaming? Do you need to move images around (shifting them among folders)? Whether you plan to review images in Photoshop, ACDSee, or another program, chances are you will primarily browse images using a basic PC or Mac file structure system, so before you begin reviewing, place all images for review in a logical place and structure that meets your organizational needs.

Naming Images on Your Camera

Most semipro and professional digital SLR cameras let you choose how to number your digital images. At a basic level (some cameras offer additional naming options), you can either reset them to zero each time you load a new memory card, or you can make them continuous — continuing a number sequence (usually up to 9,999) regardless of what memory cards you insert or remove. Depending upon how you store your images, and especially for a single shoot with lots of photos, you'll want to use the continuous method so that each photo has a discrete number/name. Otherwise, you may risk confusing files with duplicate names when you change memory cards.

The Photoshop File Browser

I discussed the Photoshop File Browser initially in Stage 3, but only as it relates to downloading files to the computer and doing some initial file review. The Photoshop File Browser is an indispensable tool for reviewing images throughout the image processing part of workflow, and you'll find yourself returning to it again and again.

The Photoshop File Browser has several key components used for reviewing and organizing images: the Thumbnail window, the Preview pane, the Folder view, and metadata and keyword tags. You can open images while the File Browser remains open depending on how you open the image: Select an image in the File Browser and it appears in the thumbnail preview window. Double-click the thumbnail image to open the file, or you can double-click the image in the File Browser list just as easily. The File Browser stays open behind your image. However, if you double-click an image while holding the Option/Alt key down, the File Browser actually closes. You can open multiple images by holding down the Shift, or Control/Command keys as you select additional images. Double-click any one of the selected images and all will open.

Although I find the Photoshop File Browser more tedious to use than ACDSee, it is undeniably powerful. Because I use Photoshop so much for editing images, it has become the most direct line into an image. It lets me bounce between editing and working with the image's organizational information. Also, Photoshop CS — at least as of this writing — is the best way to look at RAW files; the plug-in RAW converter it uses displays files faster than almost any other application (some of the dedicated camera software for RAW files that ships with Canons and Nikons, for example, is fast but not as feature-rich).

One good way to organize images at a rough-cut level is to flag them in Photoshop, as illustrated in Figure S4-1. In the File Browser, with an image selected, click on the Flag icon in the Browser menu. This places a flag at the bottom of the image thumbnail. When you've been through the entire directory of images, you can sort according to the flag, which will place all of the flagged shots at the top so you can view what you've selected as a group.

Here's how to review and organize images with a client at a shoot using Photoshop. This will let you look at images in a thumbnail size with a larger, detailed preview of each image you select. You can even view RAW files this way (which is useful because, once you open a RAW file, you have to work with a dialogue box and save it as a separate file type).

1. **Flag and then sort them accordingly.** Take a first pass through all the files in a folder and flag images you deem great, good, or mediocre. If you'd like to number images, you can do that, as well, using the rank feature, which works in the same way except you have more hierarchical possibilities for your images. Flagging is simpler.

2. **Sort the files using the flag option (or rank if you've used that option).** This places all the flagged files at the top of the thumbnail view. This is available under Sort option on the File Browser menu.

3. **Look over the smaller list of images and un-flag the redundant images or the ones that you can do without by simply clicking on the Flag icon again for each unwanted image (the flag then disappears).**

4. **Place your most-wanted files in a separate folder.**

5. **Assign keywords and metadata to the images.** By selecting one, all, or a group of images, you can assign keywords and metadata to images that will better allow you to search, archive, and process images later. The metadata information can be viewed in the File Browser — it's displayed under the preview — and easily appended.

Cross-Reference

Learn more about metadata in Stage 3.

Note

The more you can accustom yourself to working with keywords and metadata as soon as possible after a shoot, the more efficient your digital-studio workflow will operate. Metadata is covered in more detail later in this chapter.

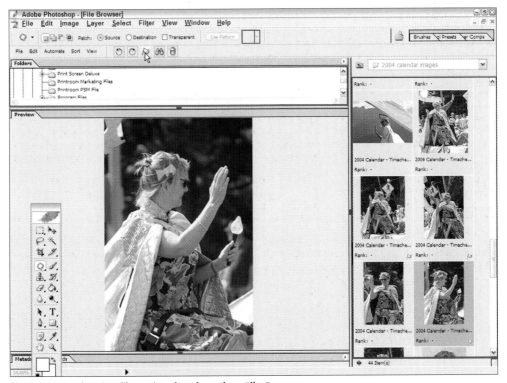

Figure S4-1: Flagging files using the Photoshop File Browser

While you're in the File Browser, you can use certain Photoshop features, such as the Photomerge, Picture Package, Contact Sheet, Web Gallery, or PDF Presentation options, to automate your work. There are also myriad other options for customizing your review work, such as sizing thumbnails, working extensively with metadata, and sorting your images by virtually any factor you can imagine including color profile, file height or width, size, date, copyright, and so on. Figure S4-2 demonstrates Photoshop's Picture Package capability. Let's take a brief look at these different features.

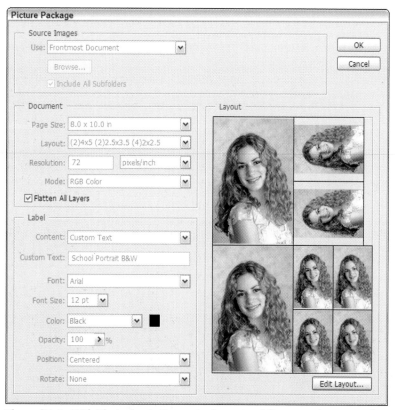

Figure S4-2: With Photoshop's Picture Package capability, many layouts and photo size combinations are available as presets.

Photomerge

Photomerge is a Photoshop command that is similar to what some other image editing applications call stitching. It allows you to combine several images into one. For example, taking four or five photos side-by-side of a mountain landscape and then merging them into one panoramic view. Photomerge allows you to merge images that are either horizontal or vertical.

Picture Package

The Photoshop Picture Package command lets you create combinations of one image into various photo sizes printed onto one page, just like the student portrait packages you used to get in school. There are a variety of sizes and layouts from which to choose, and Photoshop automatically places the images into the different layouts.

Contact sheets

A contact sheet is a single sheet of photographic paper containing a list of thumbnail images. The name comes from film photography, where a strip of negatives was placed directly onto a sheet of photographic paper (hence the term contact), and then the paper was exposed. The negatives were then printed onto the photo paper without enlargement, which allowed multiple images to be shown on one page. In digital photography, this equates to a page of thumbnail images printed onto one sheet of paper, a feature Photoshop CS calls Contact Sheets II, which can be automatically generated. You specify how many images you want on a page, and Photoshop draws images from a given location (such as a sub-folder) and places them onto one or more pages. These pages become individual image files that can be saved and printed.

Web gallery

Photoshop offers a way for you to create automatically a gallery of images you can use on a Web site. By pointing Photoshop to a specific folder of images, it will create a Web page of selectable thumbnail images linking to full-size shots, as well as links so that the site can be navigated. There are a variety of styles available for how the page can look, which you or your Web designer can place into your Web site.

I recommend using the Photoshop File Browser, especially for RAW files and when you need to frequently automate files and jump into editing photos. It's powerful and, assuming you're using Photoshop, you won't find another file review and organization tool that's so closely associated with your primary image-editing application. In Figure S4-3, the camera was set to shoot in RAW+JPEG, so there are two files for each image. The RAW and JPEG thumbnails display side-by-side in the Photoshop File Browser.

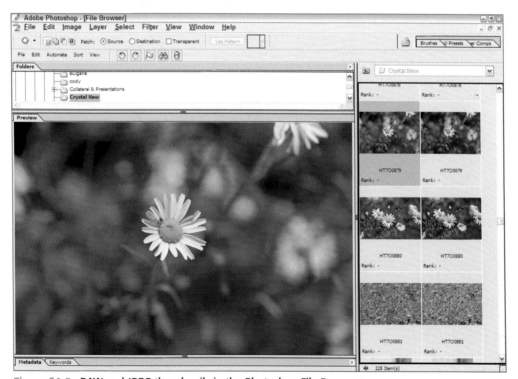

Figure S4-3: RAW and JPEG thumbnails in the Photoshop File Browser

Dedicated image-management applications

As good as the Photoshop File Browser is, it's not for everyone and it's not the perfect answer in every situation. Programs such as ACDSee, which is dedicated to file review and organization of folder-based images on your computer, and iView MediaPro, which is dedicated to review and organization of photos you've assembled into your own image catalog, are both powerful applications designed to manage photos.

Note A catalog is a kind of database of images organized by you.

These applications take a different approach from Photoshop, which is a comprehensive image-editing tool, because they also offer some editing power. Each has its own system for reviewing and organizing images, and you'll want to understand that process in depth to get the most out of the software.

iView

iView's catalog system is very unique and capable, but it takes some practice and familiarity to get the most out of it. It's not so much a way to look at every image you have on your drive, but more of a tool that manages the images you've already chosen to prioritize and keep in a catalog. Many pro photographers swear by iView, and its versatility and power make it easy to see why.

An image is represented in the catalog by a thumbnail, and catalogs can then automatically check for updates of the original image on a specified, frequent or infrequent basis. What this means, however, is that, although the catalog may be on your laptop's hard drive, if the image is located elsewhere — such as on a separate hard drive or network — if you take the laptop somewhere else, the image isn't accessible. iView keeps track of the images, references where they are located (such as on the network, your hard drive, etc.), and generates a thumbnail for each. You have all the same kinds of options you do with other image-management packages, including the following:

✦ **Appending and adding metadata so you can review images according to various factors.** Figure S4-4 shows iView MediaPro displaying metadata for one of the catalog images.

✦ **Working with sets of images in unique ways, ranging from slide shows to highly organized sets of photos optimized and prepped for placing on the Web and organizing batches of files according to a wide variety of criteria.** iView can quickly throw together images for display in a slide show and easily manage (often disparate) groups of images.

I recommend using iView whether you're an aspiring pro photographer or already a pro and when you have the time to really work with it and understand its unique language, especially as it relates to catalogs. Although it's probably not the best package for amateurs or to use when you quickly need to review a large number of images, it is superior in its options and ability to prepare and present images when you've had the time to prepare them in the studio to show to a client or audience. Many photographers who have spent time becoming familiar with the iView method find it to be a good way to organize images straight off of the camera as well as to present them later on.

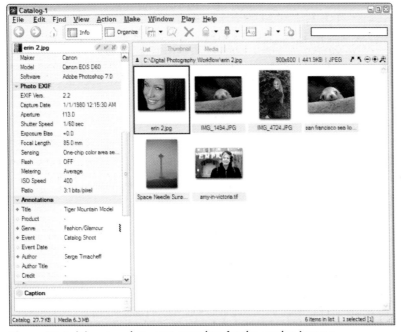

Figure S4-4: iView can show you metadata for the catalog images

ACDSee

ACDSee has fewer high-end features than iView, but for quickly reviewing and organizing photos, it's my all-around favorite application. Rarely do I do a shoot where I don't use it at least once, and I often use it extensively. I can introduce an intern or enthusiast to it at a workshop and have them use it with minimal angst, and it's offered at an amazingly low price, making it affordable for nearly anyone.

The ACDSee interface can be configured to appear many ways—displaying or not displaying features such as metadata, image preview, and folders. It operates more or less like the Photoshop File Browser, so it's easy to use. I think one of my favorite things about ACDSee is the Image Basket, shown in Figure S4-5, which stores temporary images from different file folders in one location, so you can work with them in a variety of ways.

You should be aware of a couple of things when using ACDSee:

✦ **ACDSee is best used with JPEG or TIFF images.** Until ACD Systems comes up with a new version (I'm currently using 6.0), if you're "going RAW" you'll want to use the Photoshop File Browser or iView. While it supports RAW, it's quite slow.

✦ **ACDSee uses a numerical, color-coded method of file ranking**, as opposed to flagging images. You can, however, use the Image Basket as a substitute for flagging, to a degree, and it's very handy when jumping between different sub-folders.

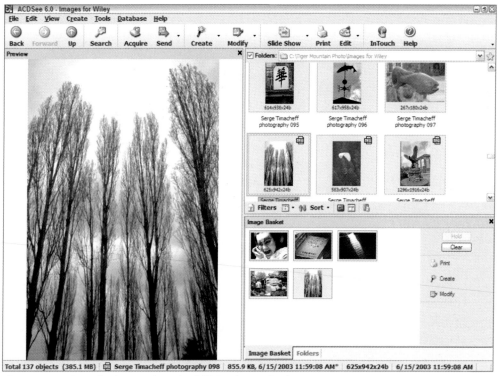

Figure S4-5: Dropping images into the ACDSee Image Basket

When acquiring images from a flash card or directly from a camera, ACDSee's Acquire Wizard works wonders in eliminating the file folders that some cameras create and reorganizing the acquired files into a more rational folder structure. ACDSee provides multiple options for renaming images during the transfer process, but these can be risky if anything goes afoul in the download process.

One thing that ACDSee does really well is to create contact sheets. Creating a contact sheet helps you keep images organized. ACDSee (and most image-organization applications) automates contact-sheet creation with a variety of options. Figure S4-6 shows the contact-sheet options in ACDSee.

There are other dedicated archiving products available, ranging from low-end products like Adobe Photoshop Elements, which includes Adobe Photoshop Album (they used to be separate) — which works well for simple reviewing and organizing, but nothing really complex — to very high-end archival tools. For the enthusiast, semipro, or pro photographer, the products mentioned provide everything to review and organize images effectively. You may have heard something about Corel's product, PHOTO-PAINT, but it is better suited to powerful image editing and enhancement than it is to review or organization.

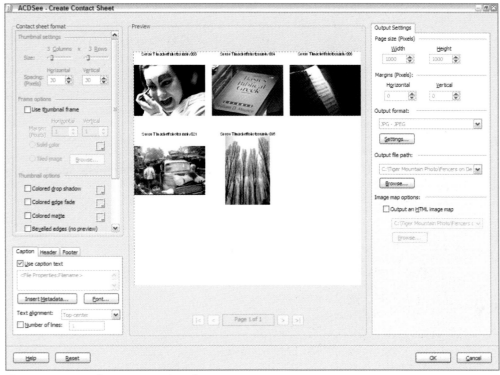

Figure S4-6: Creating a contact sheet in ACDSee

Decisions, decisions: Prioritizing images

As a professional photographer, I used to find prioritizing images very difficult—and very tedious. I absolutely hated to sit down and choose between images. In the days of film, it meant pacing through hundreds of slides or contact sheets of negatives, which was, of course, much worse than using a computer with the ability to rate, rank, and move things around in folders. It meant sitting for hours with paper and a loupe (a magnifying lens used specifically to view slides and negatives).

Digital prioritization, however, carries its own burdens, primarily related to the sheer number of images. Most photographers (I admit it, I'm one of them) tend to shoot more photos in digital than they shoot when they're using film, and so they have more photos to review and select from.

To save yourself time in the selection process, remember the following :

✦ **Know how many photos you'll need.** This is the first step in the selection process. Knowing this helps you come up with natural image combinations among your images to accelerate your decisions. Take a portrait sitting, for example: Are there multiple poses or settings? Are some of the shots of the subject's full body, or just head shots? Is the subject wearing different outfits? Each of

these represents a *grouping* that can segment your photos. You can find the best shot within each grouping, flag it, and then sort your images so that you have the best of each; then you're in a better position to pare down the photos to your final set of images.

✦ Be *brutal* **in your decision-making when selecting and prioritizing photographs.** Don't accept anything less than best. Whether you're shooting sports, for stock, weddings, or anything else, more isn't better. Unless you absolutely have to use a less-than-perfect shot because it's the only one you have of a certain must-have photo, don't use it. With fencing, where I might have 300 photos from 10 minutes of a match, I can quickly select 10 or fewer shots. I know that I won't use the other shots, that clients won't find them interesting, and that I will never use them for anything else. If anyone ever asks for "all the shots" I took of an event, I can show them more, but it's only by special request.

✦ **What happens to the photo, what you promised the client, and what the client expects drives the prioritization of the shots.** If you offer a bride and groom only ten photos of their reception, they'll be disappointed. However, if you make a mother choose between 50 photos of Johnny posing with his soccer ball, she's going to be bored and wonder why you didn't do your job.

✦ **If you are going to be uploading your digital photos at some point—either to an online gallery for sale or an online storage service—organizing and** *prioritizing* **(including getting rid of some of) your images before you upload saves time, space, and even money.** You generally pay for online storage space by the megabyte, and you don't want to tie up your computer and waste storage space with files you should have weeded out earlier in the workflow process. You'll also find that uploading to galleries and online archival servers is much easier if your filenames follow a consistent naming system.

Cross-Reference Storing and archiving digital photos online is returned to in depth in Stage 10.

✦ **Prioritize RAW+JPEG files.** When you shoot in RAW+JPEG, you'll end up with two files for each image on your memory card, and then on your hard drive after they've been copied to your computer. You'll notice that RAW images, in the review stage (such as in the Photoshop File Browser) often don't look quite as good when it comes to color, contrast, and brightness as the JPEG files. The RAW files haven't been adjusted or pre-processed like the JPEGs, so don't be fooled—the RAW files have much more information and will ultimately yield the better photograph. But the JPEG preview is a good way to look at how an image may ultimately look once the RAW file is processed; if you do need to show a client an image at a shoot and you don't have the luxury of processing the images first, then showing the JPEG is often a good way to do it.

✦ **Never edit your own work.** When I worked as a news editor, the office had a rule: *Never edit your own work.* You tend to overlook words and sentences that may have problems because you wrote them. Reviewing, and especially prioritizing images works similarly, and I often have an intern or someone else in my studio review my images. I can specify what it is I'm looking for overall so they know what criteria to use when making decisions. Then I get less involved with remembering the circumstances of each shot, and I can have an objective view of my work.

What's in a Name? Strategies for Renaming Images

The best time to rename photos is as soon as possible after they've been taken. That way, their numerical name—generally the way the camera recorded them—is eliminated early enough that the photos can't get confused with others that may carry the same number. If, for example, you only use the camera-generated numbers and you're searching an entire hard drive for a single image among thousands, it can be confusing as to which image is the right one. This is especially a hazard if you're using multiple

cameras in a studio that all generate the same types of numbers. However, I'm very careful to do virtually *nothing* to a fresh, original file from my camera. Call me paranoid, but I don't want to alter original images in any way, which prevents digital degradation of any type. I store them in a folder that won't be touched other than to copy the images into another folder later. The folder is labeled with the date and the name of the photographic event, and it is backed-up on CD. I then copy either the entire folder or specific images, depending on the project, and create another folder where my working images are stored.

It's the working images that I then rename, but I retain the original file number in the names. Table S4-1 illustrates this file-naming strategy.

Table S4-1: **File Renaming Examples**	
Original Image Filenames	*Working Image Filenames*
HTZO0939	Jones Wedding 001-0939
HTZO6232	Campbell Family Reunion 033-6232
HTZO0002	Acme Executive Retreat 624-0002

Notice how the original file numbers (for example, "0939") relate to key identifying information from the original filenames as they came out of the camera, but I automatically removed the extraneous data as part of the batch processing. Then I added a numerical sequence of my own plus the name of the event. ACDSee and Photoshop both allow me to automatically rename any or all of my images in this manner using various types of templates and terminology indicating original and new file numbers. Then, if I ever need to refer back to the original file, I can find it with minimal difficulty. Figure S4-7 illustrates the process of renaming a series of images in ACDSee, including the original filename with a new number series.

Cross-Reference See Stage 5 for more information on batch commands in various applications.

Caution Experiment with file renaming on a set of extra images where you don't mind if something goes haywire and they're irreversibly renamed to something you don't want. The batch-renaming processes in these applications are sufficiently feature-rich and powerful that if you mistakenly rename files in the wrong way, you won't be able to reverse your steps (not easily, anyway)!

Photoshop offers the least powerful renaming capabilities; iView and ACDSee offer the most, although they operate quite differently. ACDSee's simple renaming interface allows you to apply multiple factors (such as metadata information) to renaming, and iView has numerous features that can be applied to the PC and/or the Mac (for example, you can easily strip out PC-specific file information such as .jpg file extensions).

Tip When saving and renaming files that will be used on different operating systems or computers — such as between Macs and PCs — try to be as simple and brief in your naming as possible to prevent parts of the name being truncated or lost. One of the most frequent OS mismatch issues comes from how Windows and the Mac OSX handle file name extensions. Windows requires file name extensions (such as .JPG, .TIF, and so on) to associate a file with an application, so Mac users have to remember to add file name extensions (and only file name extensions) after the "." in a file name.

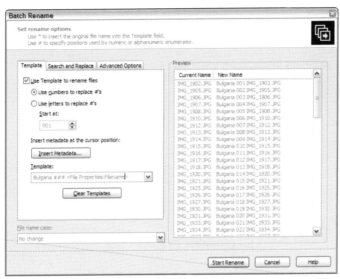

Figure S4-7: Renaming a series of images in ACDSee

Metadata: Use It!

Each digital image generated by a digital camera contains file information known as *metadata.* Whatever use the image will ultimately have, whether it's being published on the Web, e-mailed, or just stored in a database, metadata helps photographers and anyone working with images in a variety of ways:

✦ It provides specific camera data about how the image was taken, by what kind of camera, and how it was exposed

✦ It can be customized to add an image-specific title, copyright information, and who took the photo

✦ It can include certain keywords that help to identify and search for images

Originally developed by the newspaper industry to track digital file information and easily access the thousands of photos the media stocks, Photoshop began using the standard created by the Newspaper Association of America and International Press Telecommunications Council. Stock photo agencies, such as Corbis and Getty Images, require metadata on images to be able to search and identify them. Newspapers and other media organizations also use metadata extensively. Metadata includes a variety of types of information: image description, author, copyrights/credits, image origin, and keywords. Some metadata is alterable; some is not. For example, you cannot alter the information related to what type of camera took the photo, the exposure details, or whether or not the flash was fired. You can change information such as the author of the photo, the date, when and where it was shot, keywords, and copyright information.

Each image-management program, and most image-editing packages allow you to view image metadata and customize it, at least to a degree. Further, the better packages such as the ones I've described in this chapter also allow you to attach common metadata to batches of images, create your own keywords, and sort images accordingly. Figure S4-8 illustrates how descriptive metadata and keywords can be used to find a specific image in Photoshop.

Figure S4-8: Entering descriptive metadata and keywords into Photoshop

Photoshop provides the most robust metadata manipulation and appending options, and I tend to use it the most frequently when working with batches of files. As shown in Figure S4-9, Photoshop segments image metadata into several pages of information, such as "Camera Data 1," one of the less technical metadata information categories.

You can even add a URL for a copyright; for example, I add www.fencingphotos.com to many of my fencing images. In Photoshop, you create a metadata template that contains the specifics you've added, and this can then be batch-appended to groups of files in the Photoshop File Browser. Photoshop uses what's called *XMP* or the *extensible metadata platform,* which allows you to carry information among various Adobe applications (for example, Illustrator) and what they call *publishing workflows.* The information you append to a file's metadata, such as copyright information or document name, then appears as metadata in other applications, as well, such as ACDSee.

Tip Some information is proprietary to the application and won't cross applications. I find it frustrating, for example, that you can add a keyword into an image's metadata in Photoshop, but it won't appear in ACDSee; it does, however, appear in iView MediaPro. So, this is something to check before you begin applying metadata keywords and then opening or working with images in multiple applications.

Metadata is an area of image management that will continue to grow in importance and automation. Most digital files carry far more digital information than anyone really knows what to do with today. This is only sure to grow over time to be manipulated in a variety of archival, review, and management techniques for digital images as applications add metadata capabilities. For example, it would be great if applications could evaluate a series of images and compile a report showing information and statistics about how the images were shot overall, including percentage of flash images; average focal lengths, and exposures. These types of analytical data would help in teaching and understanding photography.

Figure S4-9: Photoshop segments image metadata into several pages of information.

Summary

There are many methods and techniques for organizing and reviewing images, and the more images you produce, the more you need to efficiently work with them in a consistent manner. Digital files are produced in greater quantity than film images, so it's essential to know how to use the right file formats and sizes for the appropriate job, and then to work with them in a manner that optimizes processing and workflow.

Organizing images according to their metadata, name, and other factors makes a big difference when you present them to clients, archive them, and access them for editing. Understanding and applying a basic methodology to this often tedious and less-fun aspect of digital-photography workflow can dramatically affect the amount of work you've created for yourself and how much time you need to spend at the computer screen.

✦　　✦　　✦

5 Processing Digital Photos

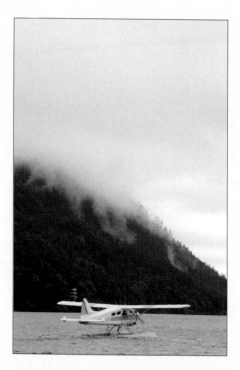

The San Juan Islands, which separate Canada from Washington State at the north end of Puget Sound, are a photographer's paradise. This shot was taken with a Canon 10D at ISO 400, f/4.0, 180 second, and 75mm focal length.

The process of digitizing photos creates tremendous potential for editing photos with Photoshop or another photo-editing software. But digitizing also presents a challenge reminiscent of the biblical Tower of Babel story. Rather than all the different languages, you have cameras, scanners, photo-editing software, monitors, printers, and other elements of the photo-management process that all use different digital measurements and standards to quantify and display color.

You'll process digital photos in the middle of the workflow. Between setting up and carrying out your shoot (at the beginning), and providing finished prints (at the end), processing digital photos involves transferring, storing, and editing the image files.

There are several elements of digital photo processing that run though the entire stage—from file management to final prints. Those elements include making decisions as to which file format to use to maintain photo files, synchronizing printer and monitor color display, and deciding how much money and time to invest in purchasing and learning Photoshop. I'll introduce you to and share some advice on all these preparatory elements in this chapter.

Essential Digital Photo Processing

The key elements of processing photos, after they've been loaded onto the computer, involve readying each image (individually or in a batch mode) for its ultimate destination—storage, output, creative treatment, or display. Digital images rarely appear on your computer perfectly suited for all of these without some work. A couple key areas must be addressed when an image is processed:

✦ **Making the appropriate copies of the image,** including saving the original in an archive, and saving the images to their correct destinations for storage, creative treatment, or optimization editing.

✦ **Working with the images to be optimized or treated creatively,** including sizing/cropping, sharpening, filtering, reducing digital noise, changing the images' brightness and contrast levels, and adjusting the exposure. Particularly if the image was shot in RAW, it must be imported using a RAW photo interpreter (such as the one included in Photoshop CS) and optimized before being edited within Photoshop as a JPEG, TIFF, or other file format.

Organizing image files for processing

The first thing to do is to eyeball your images after renaming them and putting them into one easy-to-access location. You should have placed all the original files onto a CD or hard drive. Remember that you won't be altering or touching those original files other than to make copies with which to work.

I cover file management and archiving in detail in Stage 6. For an in-depth discussion of moving image files from camera to computer, see Stage 3.

In the folder, CD, or hard drive that you've chosen to organize your project, you can use the Photoshop browser or a review application such as ACDSee, to look at the working images to see what you have from a specific project. It's at this point that you can begin the process of flagging or numbering images if you see ones that are especially good—or even ones that are perhaps not such good images but may have potential with some creative and artistic treatment in Corel Painter or using a set of Photoshop filters.

If you have a large number of images, such as from a wedding or event, and you need to make relatively minor corrections to them, such as adjusting the contrast, you can batch-process them using a Photoshop action command or ACD RoboEnhancer (a batch-processing plug-in for ACDSee).

For a more in-depth look at Photoshop, read Stage 7.

Batch processing

Many processing chores are repetitive and boring. For example, if I shoot a hundred photos in a darkened arena, it might be appropriate to apply the same set of editing options in Photoshop to each photo. This is one of the nice aspects of the evolution to digital photo processing: Settings and editing actions can be recorded once and re-used many times.

The Actions window in Photoshop automates processing tasks that can be re-used on multiple photos. Photoshop actions are essentially *macros*, which are recorded keystrokes or mouse selections that can be stored and replayed.

Leveling, which is the process of stripping levels of all or selected colors from a photo, is one of the most widely used features for achieving more clarity, contrast, and better color in photos. Photoshop provides an Auto Levels command that applies leveling settings that help most photos. But auto-leveling is a one-size-fits-all approach to enhancing photos, and effective as it is, auto-leveling can never be as powerful as custom leveling. That doesn't mean I have to custom level all hundred shots taken under the same lighting conditions. Many times it's worth it to define a set of editing features and record them as a Photoshop Action to use in situations like these.

Consider the example of a hundred photos in a darkened arena. When the exposures and lighting are relatively consistent, I can apply the same adjustments to all the images to save time—as well as to make the images highly consistent. This strategy is also good if you need to make all your images one size and resolution, such as all 5-x-7s and 300 dpi.

Recording and using Actions in Photoshop can be a complex process, and I'm mentioning it in passing to make you aware of the kinds of tools available to those who invest the time in learning Photoshop at a fairly advanced level. You can automate a wide variety of editing functions and preset actions that come with Photoshop; you can also record your own actions and apply them to a series of images in a subfolder. An example of the actions that can be included in automated editing functions is shown in Figure S5-1.

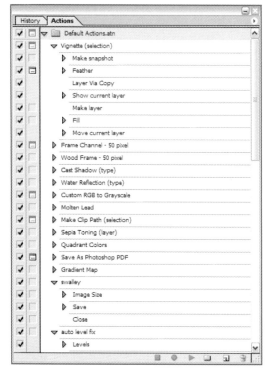

Figure S5-1: Using Photoshop actions to automate editing

RAW files

I'm a big believer in RAW files, especially for situations in which the exposures may be dicey or in which you may need to work with an image destined for greatness. A RAW file contains no in-camera adjustment or filtration to optimize the image — it's exactly the image the camera "saw" and recorded onto its CMOS or CCD sensor. It's more similar to a TIFF file than a JPEG or other format, because TIFF files don't discard any information from what was shot. However, the RAW files aren't filtered or altered inside the camera at a post-pixel level at all, and, although they're larger than JPEG files, they're actually smaller than (uncompressed) TIFF files.

RAW files aren't always an option. Not all cameras offer the ability to capture a RAW file; it tends to be a feature available in higher-end prosumer and professional cameras. Some lower-end professional cameras that offer RAW as an option process the files very slowly. Pro equipment, however, may also offer the ability to record RAW+JPEG for each exposure, meaning the camera records a JPEG *and* a RAW file for each shot. This is because JPEGs are faster to process overall, and the RAW file can be worked with more completely if significant adjustments need to be made to the file (for example, if there's a problem or a bad exposure).

Jo Rorberg, my partner with Boudoir Northwest, handles our administration and business management and is at the same time learning professional digital photography. She worked with me to shoot formal wedding-party group shots before a ceremony, as well as a few candids. Once the formal shots were done, Jo took a few minutes to shoot her own candid shots on her Canon D-60 digital SLR, but she didn't remember to change the settings on the camera from when we adjusted them to the lights we had set up for the formals, which resulted in a badly underexposed photo, as shown in Figure S5-2.

The good news, however, is that her images were exposed in RAW, which meant that a simple slide of the exposure adjustment in the RAW plug-in (which pops up automatically when you open a RAW file in Photoshop CS), as shown in Figure S5-3, produces a photograph that would never have been able to be adjusted as easily in JPEG format. Oftentimes, RAW files can, more than any other type of image, be quickly altered and adjusted as if the camera had taken them with entirely different settings.

You select a RAW image using the Open command in Photoshop or the File Browser; this automatically brings up the RAW plug-in window. When using RAW, in addition to exposure, a number of factors can be adjusted in the plug-in window, such as the image temperature and tint, shadowing, brightness, saturation, sharpness, hue, color balance, and other details. You can even adjust the camera white-balance to compensate for different lighting such as fluorescent, daylight, tungsten, and so on. These settings can be saved and applied to subsequent images as well.

Once you're ready, click OK in the RAW plug-in, and the image opens in Photoshop CS where it can be image-edited as any other image, and saved in a variety of common image formats such as JPEG or TIFF, as well as in the Photoshop (PSD) format.

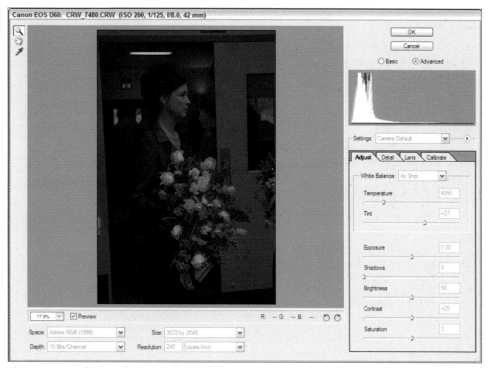

Figure S5-2: What can happen when you forget to readjust manual settings when changing locations

A Little Bit of File-Format Techno Info

I'm not going to get into lots of techno-babble in this book, but you do need to understand a little about the different file formats and their relationships to digital, post-pixel information, and camera operation. RAW files allow a camera to fully leverage its capabilities to take in a maximum amount of digital information. If you have Photoshop, you may have noticed in the Mode section of the Image menu; files can be in 8 bits/channel or 16 bits/channel, which refers to how much total digital information is being processed and stored by the camera sensor chip (CCD or CMOS).

JPEGs can only store 8 bits of information, which means they're less flexible in terms of overall color and quality. Although you aren't likely to see this difference in day-to-day photos, it makes a big difference if the image is to be enlarged significantly, professionally printed, or processed creatively. If you shoot a JPEG file with your camera, for example, and then you open it in Photoshop and select the 16 bits/channel mode, you'll notice that you can no longer store it as a JPEG. By saving to Photoshop RAW (or TIFF) format instead, you can retain all the image data, which is always preferable.

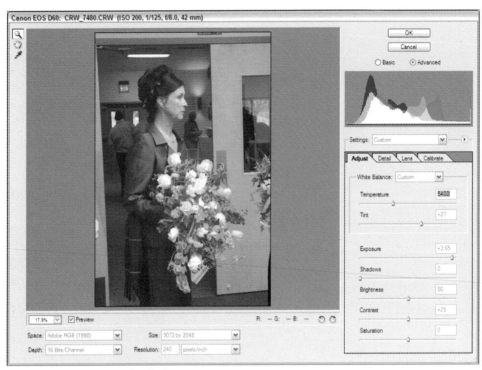

Canon EOS D60: CRW_7480.CRW (ISO 200, 1/125, f/8.0, 42 mm)

Figure S5-3: RAW saves the day!

Because RAW files allow the camera to store more information, when you use the file as a TIFF, PSD, or other file, you take full advantage of the data capabilities and amount of light the file can record. Furthermore, the RAW file format automatically saves additional information to the image metadata about the image exposure information (brightness/contrast, color temperature, and so on). A RAW file, also, unlike a JPEG, is uncompressed—meaning it's larger, but nothing gets lost in translation—which is why it's called a *lossless* format.

So, what's the difference between RAW and JPEG?

More data with RAW

✦ No white-balance has been set, although it records how the camera was set. This means you can change it on-the-fly after-the-shoot in your RAW file settings (which mimic your camera's, such as daylight, Tungsten, fluorescent, cloudy, etc.).

Cross-Reference

For more on white-balance, see Stage 1.

✦ RAW files are uncompressed and, as a result, have absolutely no loss of data at any point during their processing (unlike JPEG images which are immediately compressed on the camera).

✦ RAW files contain as much data as the camera can possibly record for each image.

✦ You can adjust RAW files almost infinitely, even compensating for some pre-pixel mistakes, such as incorrect exposure settings.

✦ Brightness, contrast, and saturation settings are recorded but the image data is not changed or adjusted automatically in the camera at the post-pixel level — that's left up to the user in digital photo processing.

✦ A RAW file is basically like film that has been exposed but not developed. The image is there, but it's up to the photographer to apply different processes and treatments to produce the photograph.

JPEG: File format for the common man

✦ JPEG files are easy to work with, and are much smaller than RAW files. They use less disk space, fewer processing resources, and can be transferred much faster than RAW files.

✦ JPEG files are very common and standard on the Web; for example, many online services will only accept JPEG files for online photography fulfillment.

✦ Virtually all digital cameras will shoot in JPEG mode.

✦ JPEG file quality is often perfectly good for average photography purposes, even at the professional level (it isn't, however, as advisable for fine-art or advertising use). It is acceptable for some magazine and smaller-format publishing purposes. However, it is NOT acceptable by most printers. They want TIFF or EPS — there's almost always a "do not submit JPEGs" clause in their pre-press contracts.

The reason you should look at the world as RAW or JPEG is because this is how the majority of cameras operate, and other file formats — such as PSD or TIFF — can be saved through RAW processing (also with JPEG, but with limited data capabilities). JPEG is the most common format and the easiest to use, but it won't work as well beyond day-to-day processing standards. RAW can be very advantageous in difficult shooting situations and works well for a much wider variety of demanding and high-quality image-production projects, but it's harder to process and requires more hands-on adjustment.

Note For an interesting and very technical analysis of JPEG versus RAW, take a look at the work performed by David Eppstein at UC Irvine. Results of his study can be found at www.ics.uci.edu/~eppstein/pix/rawvsjpg/. There are mixed results for the two formats. While it's clear that RAW files are better for large-format printing, JPEGs aren't all that bad.

Soft-Proofing Standards

Unlike traditional photo developing, you can preview and *soft-proof* (view a pre-print proof in photo-editing software) to see a close approximation of your final print output. Soft-proofing is useful for printing on your own photo-quality inkjet or dye-sublimation printer *and* for previewing photos that will be printed by a service bureau.

As you might imagine, soft-proofing is tremendously useful in the digital-photography workflow. Instead of generating endless test prints on your own printer, or from your service bureau, soft-proofing allows you to roughly preview how your photo will appear in final form. Later in this section, I explain the inherent

and systemic differences between the process of displaying a photo on a monitor and printing a photo; it will become clear that soft-proofing can only approximate the color output of a printer. But a close, accurate approximation is far more useful than a wild guess. And, as you gain experience working from soft-proofed photos, you'll be able to get a good idea of how your final print will look.

Note

Soft-proofing involves editing photo content and color in Photoshop, and then previewing how colors will appear in a selected set of print-output options — including printer, paper type, and ink.

Proof colors can be displayed right in Photoshop's editing mode (as opposed to just previewing a print). Choosing View ➪ Proof colors in Photoshop toggles between Adobe's standard ICC settings and custom ICC profiles for a selected printer.

Understanding Additive and Subtractive Color

Before going further into the process of matching monitor and printer color, you need to understand that printers and monitors produce colors in very different ways. Printers layer inks on top of each other to produce a spectrum of colors. This process is referred to as *subtractive* because, for instance, when cyan is applied on top of yellow, the result is less yellow.

Monitors add colors together to project light and can produce a larger spectrum of color than is possible to create by mixing colors on a printed page, which is *additive* color.

Cross-Reference

For a more detailed examination of how inkjet and dye-sublimation printers combine ink to generate color, see Stage 8.

The range of color available in print is smaller than that visible by eye. The spectrum of color visible on a monitor is wider than that available in print. Darkest purple and deep reds cannot be fully reproduced using techniques that create printed colors. You can't get around this limitation of printing, but you can soft-proof your photos in image-editing software so that you know before you print how your colors will reproduce on photo paper.

Additive RGB color

Monitors mix channels of red, blue and green to produce millions of different colors. Each pixel on your monitor contains a combination of red, blue, and green. Those combinations are quantified with the RGB color system. For example, an RGB setting of Red=0, Blue=225, Green=0 produces green.

Why red, blue, and green? Other colors could have been chosen as the primary colors from which others are generated. Mixing red, blue, and green coincides with how the eye defines colors. Human eyes are made up of receptors that are normally tuned to collect red, blue, and green light. Colors that fall in between red, blue, and green, are generated in your brain by impulses from your eye that mix reds, blues, and greens.

The RGB system matches how your monitor generates color. By choosing the Eyedropper tool in Photoshop, and choosing RGB as your color mode (from the Color palette menu), you can point to any pixel in a photo and determine the mix of red, green, and blue. In Figure S5-4, the green barbell is defined as Red =50, Green=152, Blue=58.

Color palette Color palette menu Eyedropper tool

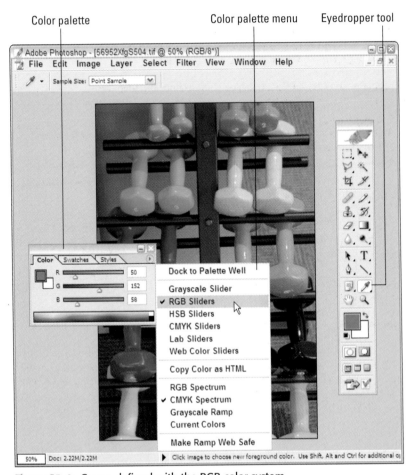

Figure S5-4: Green, defined with the RGB color system

Note Photoshop windows are accessed from the Window menu, and the window menus are activated by clicking on the right-facing triangle in the title bar of the window.

Subtractive CMYK Color

Printers create colors by mixing inks — cyan, magenta, yellow, and black — collectively referred to as CMYK (K is used to represent black, to prevent confusion with blue). Current inkjet photo printers enhance the set of printable colors by adding other cartridges like light cyan, light magenta, or red, green, and blue. But regardless of how many colors are mixed in the print process, generating a much larger set of colors by layering together ink of different colors is still necessary. As noted, each new color takes away a bit of the underlying color, thus the term "subtractive."

Because the RGB and CMYK color systems combine different colors in different ways, the software that drives your printer, and your image-editing software must translate colors from RGB to CMYK as your photo prints. Your printer *drivers* (programs that configure your operating system to work with your printer) and your image-editing software are up to this task. But the process of translating your image from your monitor to your printer will only be as accurate as your monitor calibration and your printer profiling.

I'll break down the process of calibrating your devices and working with ICC profiles next, but the short version is that calibration aligns your monitor display to standardized color values so it can accurately reflect how prints will look. And profiles are files that allow different printer configurations to mesh with the display on your monitor.

Calibrating Monitor and Printer

In order for soft-proofing to be meaningful, your printer and monitor must be profiled. Otherwise, no link exists between color adjustments viewed on your monitor and output from your printer. Monitor calibration can be done by hand (and eye), but more accurate hardware and software kits automate the process and do a much more better job than you can do eyeballing colors on your own.

You can calibrate devices because color is scientifically measurable. Color tones are measured in wavelength nanometers (nm) — a billionth of a meter. The spectrum of visible light runs from about 400 nm (purple) to around 700 nm (red).

Your perception of color in a printed photo is a product of the interaction of light striking the photo. The ink or chemical process used to color the photo imprints paper with properties that absorb and reflect light of various wavelengths. So, color in a photo is actually a product of both the photo itself and the light source used to view the photo. Look at the photo in Figure S5-5, for example — first in the normal light you're using to read this book, and then under a high-intensity light.

In short, how you see color in a photo is a product of light waves, conditioned ink, or chemical processes that give tiny dots in the photo properties that absorb and reflect some of the wave spectrum.

You can calibrate a monitor in two basic ways. The lower-budget but more difficult method is to take a printout sheet of solid red, blue, and green (or cyan, magenta, and yellow) from your printer, and hold it up to your monitor next to a block of a similar color. Then adjust your monitor settings — the controls that are activated by the Menu (or similar) button on your monitor. Needless to say, this approach is a tedious one.

A more efficient and accurate method for monitor calibration is to invest in an automated calibration device that physically measures the colors displayed on your monitor, and corrects them to meet recognized color standards. First, I'll explain the low-budget option, then I'll show you how I use an automated device for highly accurate soft-proofing quality calibration.

Figure S5-5: Perceived color is a product of both ink properties and light source.

Manual calibration

A number of monitor-calibration kits for manual calibration are available for download. Or you can simply make your own by printing color strips (using any graphics program), and using the color and brightness controls on your monitor to synchronize color display. The calibration screen provided by Lunn Fabrics at www.lunnfabrics.com/monitor.htm is shown in Figure S5-6. If you go to their site, you'll tune your red, green, blue, brightness, and contrast settings so the color palette looks the way they tell you it should look.

Printed calibration palettes are also available for you to visually compare a color on your monitor with a printed color. Basically, they help you print swatches of various colors that you then match to your monitor by tweaking your monitor configuration settings (the adjustments are available right on your monitor).

External lighting affects the way colors look on the monitor, so before manually calibrating your monitor, follow instructions that accompany the calibration palette to determine how much external light to allow in the room. If those instructions call for matching typical lighting, color-temperature settings for monitors are available from the manufacturer, and photography stores sell lights that match that setting.

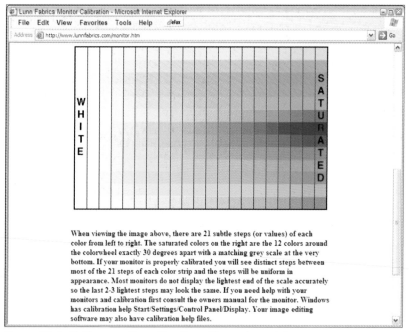

Figure S5-6: Setting monitor calibration with a color palette

Manual techniques for printer-monitor calibration work, and they're better than nothing. But calibrating by eye is more subjective than automated, digital calibration systems, and the manual method works only for a specific combination of printer and monitor (and paper, ink, and so on) configuration that you test. A better option is to use an automated calibration system based on the ICC standard.

Automated calibration

Automated monitor-calibration and printer-profiling tools allow you to configure and document your monitor and printer profiles digitally. Automated monitor-calibration devices attach to your monitor and precisely measure the color on your screen when a color is projected from a file. The calibration software then adjusts your monitor to conform to standardized ICC settings.

Many printers come with printer profiles, and several image-editing programs can embed the printer profile to display your photo more or less as it will print. For an even higher level of accuracy, you can improve the accuracy of your software-to-computer color connection by using a printer calibration and profile system. These systems provide a palette of colors for you to print, and then scan that palette with a scanner produced by your printer, and compare the output to the screen display. These calibration and profiling hardware and software systems use the data they measure to generate custom ICC files that you can use with Photoshop, Paint Shop Pro, PhotoImpact, and other photo-editing software.

Note For specific menu options to configure a variety of photo-editing software packages with printer ICC profiles, see the "Configuring photo editors to recognize ICC profiles" section later in this chapter.

Do *Real* Digital-Photo Studios Use LCD Monitors?

The newest generation of calibration devices work on either a cathode ray tube (CRT) monitor or a liquid crystal display (LCD) monitor. LCDs make for convenient flat screens for desktop computers, and they're used on all laptop computers. But they're still widely shunned by serious digital photographers. That may be changing, however. Several factors have emerged to make soft-proofing on an LCD more attractive:

✦ LCD color technology has improved.

✦ The tradeoff in space between a thin-panel LCD and a 20-inch-deep CRT makes an LCD monitor a plus in a crowded digital-photo studio.

✦ Quality calibration tools work accurately with LCD displays.

✦ A calibrated laptop monitor allows on-the-fly image editing for gonzo photographers.

That said, many photographers say there is no substitute for the color display of CRTs. One professional photographer likened his CRT to his beloved tube-amplifier. For now, CRTs are the consensus choice.

Both the MonacoEZcolor system and the ColorVision package combine automatic detection and adjustment tools for your monitor with tools that test and adjust your printer profiles. The ColorVision system includes the SpyderPRO monitor-calibration system, and the PrintFIX printer-calibration/profiling tool. The MonacoEZcolor system is similar to the ColorVision package in features and price (both are available for around $300), but the ColorVision package includes a dedicated micro-scanner for profiling printers whereas the MonacoEZcolor system requires a separate scanner.

Calibrating with SpyderPRO

The SpyderPRO monitor calibration system works for Windows 98, 98SE, ME, 2000, and XP, as well as for Mac OS 9.x and OS X. I've calibrated both Windows XP systems and Macs with equally hassle-free and accurate results.

The amount and type of light shining on an object affects the display of colors. Before you start your calibration process, turn off desk lamps, close blinds, and try to create an environment free of any lighting that would distort how the calibration device detects color on your monitor. With SpyderPRO, or any calibration system, launching the software prompts you to affix the monitor-calibration device to your monitor; the prompt from SpyderPRO is displayed in Figure S5-7.

Calibration devices affix to CRT screens with suction cups, as shown in Figure S5-8. Suction cups won't apply to the membrane surface of an LCD monitor, so calibration devices used on LCD screens come with small hangers that simply allow the calibration device to hang down over the top of the monitor or screen.

After installing the software that comes with your calibration system and affixing the calibration device, sit back and let the calibration system do its thing. And, after calibrating, your monitor will display color synchronized with printers and other devices (such as scanners) that use ICC profiles.

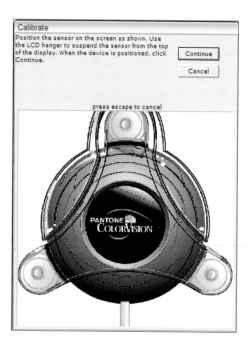

Figure S5-7: Calibration software shows you where to affix the calibration device on your monitor.

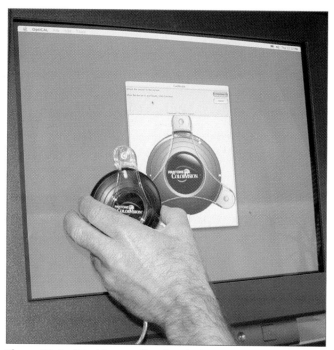

Figure S5-8: Attaching a calibration device to a CRT screen

Creating and Using ICC Profiles

In 1993, at the dawn of the digital-color era, Apple Computer initiated the forerunner of the International Color Consortium (ICC), the organization that sets color standards used by manufacturers of monitors, printers, scanners, and software.

When devices are equipped with ICC profiles, image-editing software, such as Adobe Photoshop, can preview your photo based on your specific printer and paper type; your image-editing software projects how your print will look based on the ICC profile of your printer.

ICC profiles translate color

Most major printer manufacturers include ICC profiling information with the printer drivers and software that come with your printer. You'll find ICC profiles at printer manufacturer Web sites, but the profiles are installed automatically when you install the driver software that shipped with your printer.

Service bureaus provide downloadable ICC profiles, as well as instructions on how to install them, so you can preview your photos on screen before you print them. Accurate soft-proofing saves time and frustration — prints match monitor display. It also saves money as the ink and paper for a large quality print is expensive.

Configuring photo editors to recognize ICC profiles

A wide range of photo editing software recognizes ICC profiles for soft-proofing. Although the emphasis in this book is on Photoshop, other photo-editing software also supports soft-proofing using ICC profiles.

In Photoshop, choose View ➪ Proof Setup to open the Proof Setup dialog box. From the Profile list in the Proof Setup dialog box, choose your printer.

In Photoshop Elements, choose File ➪ Print Preview. In the Print Preview dialog box, click the Show More Options check box to access more preview choices. In the Output drop-down list, choose Color Management. The Profile drop-down list is now accessible. Choose your printer from the Profile drop-down list.

To use a printer profile in Jasc Paint Shop Pro, choose File ➪ Preferences ➪ Color Management. The Color Management dialog box opens. Select the Enable Color Management check box to activate the Color Management dialog box. Select the profile for your printer.

If you're using Ulead PhotoImpact, choose File ➪ Preferences ➪ Color Management. The Color Management dialog box opens. Select the Enable Color Management check box to activate the Color Management dialog box. Select a profile for your printer.

As you can see, regardless of what image-editing software you use, choosing your printer's ICC profile is similar in each of them. So, even if your specific software's instructions aren't listed here, this information should be helpful in finding and selecting the correct profile in whichever software you use.

There are several sources for ICC printer profiles. Most photo printers ship with many different ICC profiles, one for each combination of paper (or other printable media), ink, and printer setting. Manufacturers offer additional profiles at their Web sites. Private developers make and sell specialized profiles that match specific configurations. For example, manufacturers of high-quality photo printing papers like Moab Paper, Atkinson, Crane Museo, Legion Paper, Ilford, and Arches Infinity provide free profiles at www.inkjetgoodies.com.

Although many preconfigured ICC profile files are available, there is an almost infinite set of possible (and, therefore, needed) profiles for any printer or paper. As you might guess, printer manufacturers tend to make available profiles that support its set of paper and print media (like transparencies, printable CDs and DVDs, and so on). However, if you're printing on paper distributed by one manufacturer using a printer from another manufacturer, you're not likely to find a custom profile. You can guess that Canon's glossy high-end photo paper will configure similarly to Epson's high-end glossy photo paper — and chances are the two will treat ink in a similar fashion — but if you really want to configure a specific paper and printer setup, you'll want to create a custom printer profile for that paper.

Creating precise printer profiles with PrintFIX

Custom printer profiling tools configure the way colors display in your image-editing software for any printer-paper combination. They do this by scanning a printed sample page, comparing the print results to the on-screen display, and adjusting the display to match the printer output.

Caution
The PrintFIX system requires Photoshop. To produce the test file requires Photoshop. After you create precise profiles for your printer, you can use those files with any image-editing software that supports ICC profiles (like PhotoImpact, CorelDRAW, or Corel PHOTO-PAINT).

PrintFIX software installs as an automated plug-in in Photoshop. The wizard is activated in Photoshop and identifies your printer and paper combination, as shown in Figure S5-9. PrintFIX generates a custom color palette to test the selected printer.

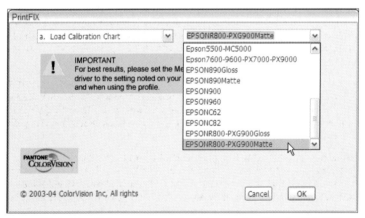

Figure S5-9: Identifying a paper and printer combination for PrintFIX

The test pattern is printed in Photoshop, and then scanned by the dedicated micro-scanner that comes with the package. The image is scanned back into Photoshop, where it is compared to the original file. This process is nicely documented for Mac and PC users in the materials you get with the ColorVision suite, or you can download documentation from their Web site.

Soft-Proofing with Printer Profiles

You might obtain a printer profile from your printer manufacturer, download a file from your paper supplier, or create a profile yourself using a configuration package. If you're sending print files to a service bureau, they should provide you with ICC profiles that you can install and use to attune your Photoshop display to match final print output.

In combination with a calibrated monitor, printer profiles provide fairly accurate color matching and take some, but not all, of the guesswork out of soft-proofing colors.

After the scanned image is compared to the original file, PrintFIX generates an accurate ICC file for the tested printer-paper configuration. This file, saved with an ICM filename extension (ICM is the filename extension of an ICC profile), can be saved to a common library folder and shared by other image editors (besides Photoshop). In OS X, that path is `Users/your user name/Library/ColorSync/Profiles`. In Windows XP, the path is `C:/Windows/system32/spool/drivers/color`.

Digital Imaging Software

I reference Photoshop often, and use it as a working example throughout this book in a variety of photo-processing tasks. Photoshop has become the de facto industry standard in digital photography, the standard against which other digital-photography-application developers set their sights to meet or exceed in quality, performance, features, and functionality. In addition to being able to control colors, calibration, and output better than any other digital-imaging tool, Photoshop offers arguably the widest and most robust set of tools and capabilities a digital photographer can use. But it comes at a price—both in dollars and in a relatively steep learning curve.

I've already mentioned how products like ACDSee and ACD FotoCanvas, Microsoft Digital Image Pro, and Corel PHOTO-PAINT accomplish some—or even many—of the things Photoshop does more simply, and at a much lower price. Also, Adobe's consumer digital-imaging product Photoshop Elements (which is more for simple archiving and online sharing), provides basic editing tools at a more automated and significantly lower price than the full version of Photoshop.

Most of these Photoshop alternatives, perhaps with the exception of Corel products, tend to be consumer or prosumer packages and are easier to learn and use. Corel's DRAW and PHOTO-PAINT suite is marketed for professional illustrators and photographers, and has a feature set roughly equivalent to Photoshop (and Illustrator), but with an interface and personality that are quite different than that in Adobe Products.

Consumer-oriented photo-editing software tends to feature more automated processes, such as the ability to fix red-eye, touch up blemishes, sharpen, and adjust lighting and brightness/contrast. In Photoshop, all these tasks can be accomplished, but doing it is typically more difficult and requires more in-depth understanding of the application (if for no other reason than there are so many options and adjustments that can and must be made). It's something like taking photographs with a point-and-shoot camera that has fully automatic settings, as opposed to shooting an SLR in a completely manual mode.

There are many consumer digital-photography editing applications available. These applications, such as Microsoft Digital Image Pro shown in Figure S5-10, feature basic touch-up capabilities that are simple to understand, access, and operate, although not as powerful and broadly capable as Photoshop. However, if you are not yet ready to invest in Photoshop, the consumer applications are a good starting point.

Figure S5-10: Microsoft Digital Image Pro

Photoshop: Ultimate power

Most digital-photography applications on the market feature a subset of Photoshop tools and a limited or automated set of capabilities. For example, Photoshop's complex array of touch-up tools, such as the Clone Stamp tool, Color Replacement tool, Patch tool, and Healing Brush are unrivaled in their ability to apply extremely complex effects to an image.

Most photographers using Photoshop for photo touch-up interweave the capabilities and functions of these tools, jumping between them numerous times when working with an individual photograph. Fully understanding how the tools work, why they do what they do, and how to optimize their adjustments and features to achieve professionally edited images takes time, practice, and training. For example, Photoshop's Healing Brush has the ability to instantly fix blemishes, spots, and other undesirable elements of a photograph, as shown in Figure S5-11. The adjustments for the Healing Brush, however, are complex, comprehensive, and take understanding and practice to master.

Other photo-editing packages on the market offer touch-up tools, but nowhere as powerful or complex as that of Photoshop's. You may find that a lower-end application is insufficient as you grow in your abilities in digital photo processing. If that's the case, you'll want to make sure you don't just install Photoshop and expect to immediately create perfect photos and fix any problem.

Figure S5-11: Photoshop's Healing Brush: A number of adjustments and controls make for great versatility in post-production touch-up.

Allow yourself enough time to at least come up-to-speed at a basic level before you commit yourself to a time-sensitive project! A number of excellent books and training aids are available for Photoshop, as well as both online and live workshops; pursuing one or more of these is a good idea.

Note

While I have not undertaken to duplicate or recommend any of the hundreds of fine Photoshop books available, I do address the role of Photoshop in the digital photography workflow throughout the book. Chapter 1 includes many references to how Photoshop fits into the workflow. Chapter 2 is sprinkled with notes on the relationship between your digital camera output and Photoshop. Chapter 3 integrates discussion of Photoshop into an exploration of the whole workflow. The various stages of this book all reference and incorporate the use of Photoshop.

One notable feature that separates Photoshop from other simpler digital-image packages is its use of layering in processing images. Layering is also used in its sister graphic-arts application, Adobe Illustrator. The layering concept, although simple, often seems confusing to first-time Photoshop users. However, it's extremely useful and powerful in creating images where you've added text, effects and other images to a photo. And, even better, this allows you to make tremendous changes to an image in stages but be able to go back and alter or delete intermediate steps.

Although this book is not intended to teach Photoshop, understanding what layering is and how it works is important. Essentially, layers provide the ability to work on individual parts of an image without affecting other parts of it. Think of an image as several image files stacked on top of one another, with the potential to be merged, blended, or dissolved as you like.

At a simple level, you may have a basic photo, on top of which you place text, such as a title for the photo. This text is another layer, and isn't an integrated part of the basic photo. You might then add a special-effects layer, and maybe even yet another area of text. Each of these — the basic photo, the two sets of text, and the special effects — is a layer and, as such, is a discrete element of the image. Figure S5-12 shows adding an Adjustment layer in Photoshop. Adding layers provides a powerful and complex method for editing images that is completely alterable and reversible.

Figure S5-12: Creating a layer in Photoshop

Many Photoshop users make any and all changes to images using layers, to give them ultimate control over an image and so that they can reverse anything they've done quickly and easily. Later, when you're ready to finish your photo with its editing, you can flatten the image and save it as a JPEG, TIFF, or other file — which takes the layers and merges (flattens) them all into one image. You can also save your layers and edits, without flattening the file, in the Photoshop PSD format, which will always let you come back and edit whatever you've done.

Although you can easily and quickly create a simple layer — such as text — in Photoshop, the layering concept can be complex and difficult to master at a high level, but well worth the effort in terms of the ultimate power and control it provides in being able to do virtually anything to an image. Layering, probably above any other feature, is what makes Photoshop so different from and so much more powerful than any other digital-imaging product on the market today.

Plug-ins: Added features, power, and capabilities

A *plug-in* is a mini-application or type of functionality that can be installed to run with another software package. For example, Quantum Mechanic from Camera Bits (www.camerabits.com) and nik Dfine (www.nikmultimedia.com) are plug-ins for Photoshop that allow you to remove digital noise, adjust color, and alter other lighting factors in an image. You purchase and install Dfine and other plug-in applications just like any other full-fledged software package — online or from a CD. Where the difference comes is that the plug-in application installs itself into the host application — in this case, Photoshop — where it appears as a menu item. The plug-in cannot run in a stand-alone mode.

Figure S5-13 illustrates nik Dfine 1.0, a powerful and sophisticated Photoshop plug-in, that provides noise reducing and lighting/color-control capabilities. You can even purchase optional camera-specific modules for it, which allow you to specifically load defined optimization capabilities not only for one type of camera, but also for different ISO settings.

Figure S5-13: nik Dfine 1.0, a Photoshop plug-in, provides more noise reducing and lighting/color controls than are found in Photoshop itself.

You can find plug-in applications at software stores or online, especially on Web sites offering numerous software applications for downloading, such as www.download.com. Adobe also features an online plug-in store featuring a wide variety of applications from different developers (go to www.adobe.com). ACD Systems also offers plug-ins available at its Web site (www.acdsystems.com), as does Microsoft for Digital Image Pro (www.microsoft.com). And although there are plug-ins for other digital-imaging packages, the greatest number are written for Photoshop because it is such a standard.

Often companies will write plug-ins for their own software packages as for-sale upgrades, such as RoboEnhancer for ACDSee, which gives the application more batch-processing capabilities (the native ability to batch-process is another advantage of Photoshop over other digital-imaging packages). In fact, most of the Photoshop filters that come with the program are actually plug-ins.

Tip You can look at the Help menu and click on About Plug-ins, to see all the plug-ins in Photoshop.

In Figure S5-14, I'm creating a batch-command sequence for images using the ACDSee plug-in RoboEnhancer, sold by ACD Systems. As you can see in this example, plug-ins can get quite sophisticated and full-featured; this is one way that less-expensive applications such as ACDSee add professional-level functionality to their basic applications.

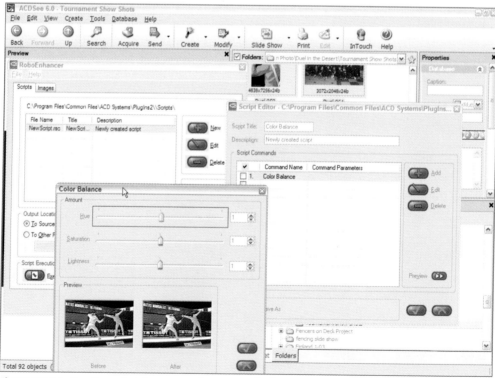

Figure S5-14: Creating a batch-command sequence for images using ACDSee's RoboEnhancer

Summary

In between the photo shoot at the beginning of the workflow, editing, and finally printing, lies a transitional part of the workflow process. In this chapter, I've focused on elements necessary to prepare to edit and print photos.

Here, you've previewed file management and organization issues that you'll return to throughout the remainder of this book. I've also explained the value of monitor calibration and printer profiles to facilitate accurate and efficient soft-proofing of photos before printing.

The more work you put into planning and implementing a coherent file management strategy, and the more carefully you calibrate your monitor and use correct printer profiles, the smoother the rest of the digital process will flow.

✦ ✦ ✦

6 Storage and Backup of Digital Images

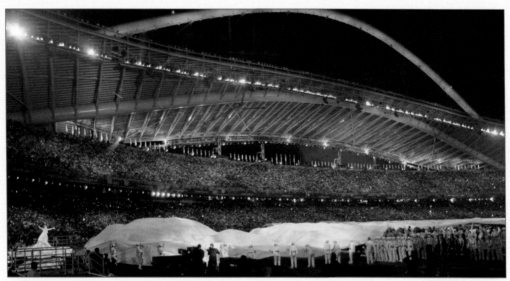

A mythical goddess (portrayed by Icelandic singer Björk) spreads her gown across the athletes of the world at the opening ceremony of the Olympic Games in Athens, Greece. Taken with a Canon EOS–1D Mark II at ISO 1000, f/3.5, 1/50 second, and 19mm focal length.

When hooked up to a lie detector, placed in a confession booth, and doped up with truth serum, many photographers will admit that we have no coherent, consistent system for organizing and safely backing up our folders of digital photos. And yet, assessing what backup system is appropriate for your needs, and implementing it can save you an unimaginable amount of stress, trauma, and loss of irreplaceable photo files.

How might calamity strike? Perhaps a hard drive becomes corrupted or crashes, with irretrievable loss of files. Your system might be stolen. Files might become corrupted. You might accidentally save over or delete digital photos, or a folder that contains them. You might be rear-ended traveling from a photo

shoot (with your laptop and storage device in the trunk). A virus might attack your system. And don't forget mundane threats to your digital photo files like dropping your laptop as you rush to shove it back in its case after passing through a security check to catch a flight. For all these reasons, it's *really* worth taking time to:

✦ Survey available backup strategies and technologies

✦ Assess your own needs, and settle on a consistent backup approach

✦ Execute your backup routine (often a painless and automatic scheduled process)

Backup Media

Backup media is increasingly large, convenient, and cheap. The unwieldy tape drives of yesteryear were supplanted by zip drives, then by readable, and read-write CDs, and in a few years faster DVDs will supplant CDs. In July of 2004, Bill Gates proclaimed that DVDs would be obsolete in ten years or less.

But that's a few years away. Today, a quick-writing CD-R remains the most widely used media for photo backup. CDs can be burned anywhere from two to twelve times faster than a DVD; as a result, if you don't mind changing discs, you can finish the job that much faster.

While storage devices evolve, photo files are expanding, almost exponentially, in size. With the emergence of RAW files (which vary as to how much larger they are than the JPEG files your camera produces, depending upon how your camera's post-pixel technology compresses the files), and technology that facilitates capturing huge numbers of images quickly, backup demands continue to grow as well.

Note While in general, JPEG files are smaller than RAW files, JPEG image sizes depend on a number of factors: How many megapixels are captured by your camera, how your camera compresses them, the size you select (large, medium, small), and so on), RAW files, conversely, are close to the maximum megapixel capability of your camera.

The third element in all this is the development of cheap, fast connections between storage devices and computers (or cameras). The combination of FireWire or USB 2.0 connections, and large-capacity external hard drives has made multiple external hard drives a convenient and increasingly frugal option for backing up an entire catalog of photo files.

CD/DVD

Available everywhere, reliable, and cheap, 700 MB CDs are a widely used and fine option for basic digital-photo backup. While the number of digital photos that can be stored on a CD obviously depends on the file size (which is a product of image size, resolution, compression, format, and so on), in general you can store hundreds of JPEG files on a CD, and something like a thousand large digital photos on a DVD.

Read only versus rewritable media

I prefer to use CD-R (write-once) disks, for a number of reasons. CD-R media can be written to but not re-written to (or erased). For backup purposes, I consider that a plus—it eliminates the possibility of accidentally overwriting or deleting files, and CD-Rs tend seem to record more reliably on more types of CD burners. More costly CD-RW media can be overwritten, but given the low cost of CR-Rs, and all the bad things that can happen when backup photos are overwritten, why use them for backup? Plus, read-only CDs are a fraction of the cost of rewritable CDs.

Emerging as a replacement for CDs, DVDs store 9GB gigabytes of data (on two sides, about half that on one side). Backing up to DVDs is faster, and DVDs hold more than ten times as many photos as CDs. Like CDs, DVDs come in writable, or re-writable types. If you are using a DVD like a hard drive, for ongoing backup, a rewritable DVD can be an acceptable backup medium. However, there are limits to how many times a rewritable DVD can be written to (about 1,000 times).

Tip Both CD and DVD RW media allow you to overwrite an existing file, which poses a danger of accidentally destroying original image file. Rewrite software generally warns you when you are rewriting a file, and prompts you with options (including changing file name or canceling the overwrite).

Labeling CDs and DVDs

If you rely on CDs or DVDs as backup media, give some consideration to an attractive and readable labeling system. Given the prevalence of CDs and DVDs as backups, easy-to-read and attractive disc labeling might may be worth the time for many digital photographers. Many recent-model Epson printers print directly to special CDs and DVDs with printable surfaces.

The Stylus Photo ships with a CD/DVD tray and Epson Print CD software that designs CD or DVD covers using your photo plus text. Figure S6-1 shows a printable CD designed in the Epson Print CD software. Similar print-to-CD software is available with Roxio CD burner software.

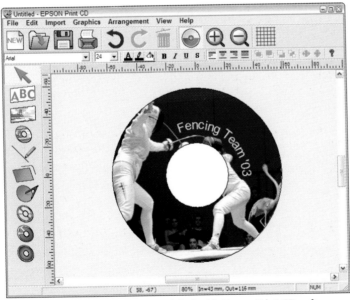

Figure S6-1: Creating a CD/DVD label with Epson Print CD software

Caution Copy photos (or music, or other files) to your CD or DVD before you print the CD/DVD. Printing first can make writing data more error-prone.

If you don't have one of the Epson printers that supports printable CDs and DVDs, you can easily print peel-off stickers to label CDs and DVDs. Roxio Easy CD and DVD Creator (that which is included with Roxio burner software) includes a label-creator component that designs CD and DVD labels that print on a variety of labels. Figure S6-2 shows a label being designed for a CD.

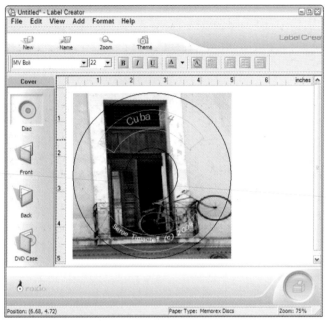

Figure S6-2: Designing a CD label for a backup CD with Roxio Easy CD and DVD Creator

Many CD-label packages include additional features for designing jewel-case covers, inside covers, and even liner-note booklets. Use them to create an attractive, professional set of archived CDs and DVDs for long-term photo safe-keeping and easy access.

Hard drives

If you will be storing thousands of high quality digital photo files, consider integrating one hard drive or a bank of external (and thus removable) hard drives. Joining the storage revolution, 120 GB and larger hard drives are plummeting in price, and becoming more highly reliable as backup devices. External (USB connected) hard drives cost more than internal drives, which are installed directly into a bay in your desktop computer, and cannot be removed. But the extra cost is generally worthwhile. External drives can be taken on the road with you, or stashed in a safe-deposit box or a safe outside your studio for reliable safekeeping.

As this book goes to press, 120 GB external hard drives were selling online for close to $100. Internal hard drives are less expensive, but provide less flexibility as backup devices, and obviously cannot be removed and stored in a safe place to protect them from damage that occurs to your computer.

Newer laptops and desktop systems with USB 2.0 allow for rapid data transfer to a backup external hard drive. The problem is that, with everything from your digital camera to your printers using up valuable

USB slots, piling on a few removable hard drives can cramp your USB availability. One solution is to rotate external hard drives as needed — using the Safely Remove Hardware feature in Windows XP, as shown in Figure S6-3. Another option that's relatively inexpensive is to purchase a USB hub to connect multiple devices; however, make sure that your hub supports USB 2.0 if that's what your devices and computer support.

Figure S6-3: Safely removing a backup hard drive to open up a USB slot

One solution that I find very clean, reliable, and simple is to use stackable external hard drives. The AcomData RocketPod (www.acomdata.com), for example, is a high-speed hard drive (120GB or 160GB giga-byte sizes are available) that you can stack with other similar drives using a proprietary docking port on the top and bottom of the drive. You only have to use one USB or FireWire connection and one power cord for one to five drives, or you can use them individually on different computers. I find this useful because I normally have one RocketPod drive connected to my laptop when I'm in the studio that I use for storing and backups. When I travel, I simply disconnect it from the USB cable and power cord and dock it to the other RocketPod on our main studio desktop, where it appears as another drive. I don't have to fuss with cords or cables, and it remains connected to the studio network (albeit in a different drive location).

Note Portable, pocket external drives, such as the ImageTank or the PicturePad, are extremely convenient and provide a quick way to stash thousands of photos in the field. But their relatively small capacity and fragility makes them unsuitable as backup media.

Remote backup

A plethora of online storage sites offer reliable backup space. The upside is that your digital photos are backed up far from your studio and computer, and you can access them from anywhere. The downside is that, for any significant amount of online backup space, you'll pay money. Also, uploading photos to a remote site over a DSL line is more like an overnight job than the five minutes or so that you'll spend backing up to a local hard drive.

Online backup services charge roughly a dollar a year per megabyte. For example, @Backup (www.backup.com) provides 50 MB of storage space for $50 a year. Online backup services provide down-loadable software that facilitates selecting files for online storage, and scheduling backup for selected folders. Figure S6-4 shows the @Backup interface, with several wedding pictures selected for safe backup.

Did I mention remote backup is slow? Figure something on the order of a minute per gigabyte to upload to a remote server from a DSL or cable connection. You can reduce the size of files before uploading by using a compression utility like Winzip or StuffIt, and that will also reduce the upload time.

Tip These online backup services provide free trials to test their service for 30 days or so:
@Backup (www.atbackup.com)
Easiestfilesystem.com (www.easiestfilesystemfilesanywhere.com)
FilesAnywhere (www.filesanywhere.com)
IBackup (www.ibackup.org)
X:drive (www.xdrive.com)
Give them a spin. Check out their downloadable software for uploading files, and see if you find the wait acceptable. Scheduling overnight backup can make remote backup servers a very reliable and viable option.

Figure S6-4: Selecting files for online backup

Most remote backup systems allow you to restore the backed-up files to any computer — given, however, that you have installed the system's downloadable software on the computer you download to. Figure S6-5 shows corrupted photo files being restored from a remote site.

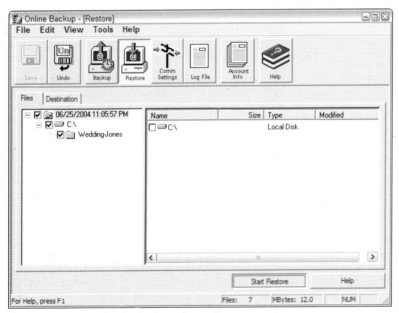

Figure S6-5: Restoring backed-up photos from a remote server.

Backup Systems

Backup systems can be highly complex. If you're managing a huge database of thousands of frequently updated photos, you might need special backup software from providers like Veritas (www.veritas.com), or Retrospect (www.dantz.com). Such systems automatically update a set of backup files and allow you to quickly restore any files lost due to a breakdown of your system.

That's more than most professional digital photographers need. Most of the time simply archiving a shoot, a client's folder, a large project, or your entire portfolio at the end of the day, or once a week, should provide sufficient backup. Landscape photographer Dave Taylor (http://portfolio. intuitive.com) tells me "My 'backup system' is more like 'burn a CD-ROM of originals' than anything more sophisticated."

For a somewhat more robust and reliable backup system that is still manageable, you can purchase two, external, USB 2.0 hard drives. And the end of each day, simply select and copy photo file folders you want to back up to the hard drive. On alternate days (or alternate weeks, depending on how high your risk tolerance is), copy the photos to the second USB external hard disk drive. For more security, take the most recently backed-up files out of your studio each night.

To send a backup copy of any folder (including subfolders) to an external storage device or a CD or DVD, simply right-click in the Windows Explorer and chose an option from the Send To context menu. If you are backing up to a CD or DVD, your CD or DVD burner software will prompt you to take any additional necessary steps. On a Mac, with OSX, click and drag the file to the hard drive or CD. OSX will prompt you to burn the disk.

Alternative Backups: The Relevance of RAID

In 1998, a group of researchers at the University of California wrote a paper called "A Case for Redundant Arrays of Inexpensive Disks (RAID)." The paper addressed the dangers of disk failure in the era of extremely rapid handling of large amounts of critical information. The RAID system essentially minimizes the damage caused by disk failure by rapidly rotating data storage between multiple disks (as opposed to relying on a single disk); it's designed to provide not only a backup file system, but automatic redundancy with multiple drives storing data recorded one time. RAID methodology has been incorporated in systems of widely divergent scale — ranging from home computers to huge corporate systems.

The pace, scale, and price of RAID backups is overkill for digital photographers. But the system of multiple backups can be applied on a smaller scale and with less frequency by rotating backup devices, and backing up backups. For instance, frequent backups to an external hard drive protect all but the most recent photo editing against hard-disk failure, and redundant backups on DVDs or CDs, stored off-site, ensure "fail-safe" photo retrieval in the case of catastrophe.

Another backup alternative is a tape drive, a device common in computing environments since the 1960s. These are quite commonly available, and high-end asset-management companies use them frequently. They are somewhat pricey, ranging from $500 to more than $1,000 for a unit, and individual tape cartridges typically store between 20GB and 100GB gigabytes, depending upon the unit. This is a very reliable and secure, but slow, way to store data. Most units store data at about 10GB or 20GB an hour.

Using the Backup utility in Windows XP

Although simply copying a folder of photos to a storage device is often sufficient, the automated backup software included with Windows XP can automate the process.

Note

An equivalent backup software option for Macs is called, simply enough, Backup. You can find more information about it at www.mac.com/1/iTour/tour_backup.html. Programs such as Retrospect are available for OS X as well. Many external hard drives ship with backup software — LaCie hard drives include backup software for Macs only.

Oddly enough, the Windows XP Backup utility is not part of the default installation of Windows XP Home Edition. The Backup icon is not present on the Start menu in Windows XP Home Edition, nor is Backup listed in Add/ Remove Programs for Windows XP Home Edition. To install the XP backup program, navigate to \Valueadd\Msft\Ntbackup on your Windows install CD. Double-click the Ntbackup.msi file to launch the install wizard for the Windows Backup utility.

With Backup installed, you can launch the program from the Accessories\System Tools folder in the Start menu. This launches a wizard that lets you chose what folders to back up, as shown in Figure S6-6.

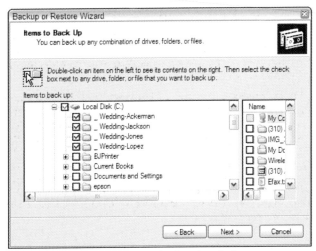

Figure S6-6: Selecting files for backup in Windows XP

The Windows Backup utility provides several backup options (available by clicking on the Advanced button in the backup wizard). Because these backup options are common to many backup programs, they are listed in Table S6-1.

Table S6-1: **Backup Options**	
Option	*Description*
Normal	Backs up selected files and marks files to document backup.
Copy	Backs up selected files without documenting backup.
Incremental	Backs up and documents only files that have been changed since the last backup.
Differential	Backs up only changed files, and does not document backup.
Daily	Backs up only files created on the day of backup.

Note Even a simple backup utility like the Windows version might be overkill for simply archiving photo files. But for backing up your system files or significant and changing data along with photo files, a utility like this comes in handy.

Protecting images with copyrights and watermarks

Safely saving digital photos involves both protecting the integrity of the image file itself, and also protecting the image from unauthorized use. This second issue (protecting against unauthorized use) is especially challenging for images stored or displayed at online servers. Those images need to be protected against being downloaded and printed without payment or your approval.

Your images are, technically and in legal terms considered intellectual property, and they need to be protected. In Stage 4, I discussed metadata and how you can add copyright and personal authorship information to an individual images or group of images. When you create an image, you automatically own the copyright and you can take it even further by registering it with the government. Additionally, photographs can be "watermarked" with your copyright information using a variety of methods. At a simple level, professional online photography services such as Printroom.com allow you to watermark an image when it is displayed. If someone were to use a screen-capture program to copy the image, as long as it's watermarked it will would be difficult to use because the word "proof" is printed on the image, and removing it using an image-editing package like Photoshop would be very difficult. Figure S6-7 demonstrates a proof watermark in Printroom.com.

Backing Up on the Road

When I'm doing shoots on the road, I try as much as possible to create duplicate backups of images stored in separate places for travel. For big international fencing championships and the Olympic Games, for example, I back up images every night and then copy them onto a backup hard drive that is transported by another person traveling to another country flying on different flights. The remote backup options, discussed earlier, can be handy on the road provided you have access to a high-speed internet connection.

Figure S6-7: A proof watermark in Printroom.com

Cross-Reference For more information on applying for a formal copyright, see Stage 10.

Another method for adding a watermark to an image is by embedding invisible or semi-visible information to the file with specialized software. Photoshop offers a plug-in located at the bottom of the Filters menu that lets you embed watermarks into files using Digimarc's technology (www.digimarc.com), and a variety of other watermarking software is commercially available (check www.download.com for a selection).

However, I'm not convinced that watermarking methods are that important or effective for the average semipro and or professional photographer producing many day-to-day, typical images for individuals and companies. The watermark you visibly place on an image is most often sufficient, along with placing copyright information into the metadata. The embedding-type watermark technology potentially increases file size, and some photographers and technologists believe that it can actually degrade the quality of your image because of what it does to rearrange the physical pixel patterns to integrate a watermark.

Backup and Storage Strategies

Having surveyed the available array of technology for backing up your photos, let's look more closely at systems, strategies, and routines that are both doable and secure.

Table S6-1: **Backup Options**	
Option	*Description*
Normal	Backs up selected files and marks files to document backup.
Copy	Backs up selected files without documenting backup.
Incremental	Backs up and documents only files that have been changed since the last backup.
Differential	Backs up only changed files, and does not document backup.
Daily	Backs up only files created on the day of backup.

Note Even a simple backup utility like the Windows version might be overkill for simply archiving photo files. But for backing up your system files or significant and changing data along with photo files, a utility like this comes in handy.

Protecting images with copyrights and watermarks

Safely saving digital photos involves both protecting the integrity of the image file itself, and also protecting the image from unauthorized use. This second issue (protecting against unauthorized use) is especially challenging for images stored or displayed at online servers. Those images need to be protected against being downloaded and printed without payment or your approval.

Your images are, technically and in legal terms considered intellectual property, and they need to be protected. In Stage 4, I discussed metadata and how you can add copyright and personal authorship information to an individual images or group of images. When you create an image, you automatically own the copyright and you can take it even further by registering it with the government. Additionally, photographs can be "watermarked" with your copyright information using a variety of methods. At a simple level, professional online photography services such as Printroom.com allow you to watermark an image when it is displayed. If someone were to use a screen-capture program to copy the image, as long as it's watermarked it will would be difficult to use because the word "proof" is printed on the image, and removing it using an image-editing package like Photoshop would be very difficult. Figure S6-7 demonstrates a proof watermark in Printroom.com.

Backing Up on the Road

When I'm doing shoots on the road, I try as much as possible to create duplicate backups of images stored in separate places for travel. For big international fencing championships and the Olympic Games, for example, I back up images every night and then copy them onto a backup hard drive that is transported by another person traveling to another country flying on different flights. The remote backup options, discussed earlier, can be handy on the road provided you have access to a high-speed internet connection.

Figure S6-7: A proof watermark in Printroom.com

Cross-Reference
For more information on applying for a formal copyright, see Stage 10.

Another method for adding a watermark to an image is by embedding invisible or semi-visible information to the file with specialized software. Photoshop offers a plug-in located at the bottom of the Filters menu that lets you embed watermarks into files using Digimarc's technology (www.digimarc.com), and a variety of other watermarking software is commercially available (check www.download.com for a selection).

However, I'm not convinced that watermarking methods are that important or effective for the average semipro and or professional photographer producing many day-to-day, typical images for individuals and companies. The watermark you visibly place on an image is most often sufficient, along with placing copyright information into the metadata. The embedding-type watermark technology potentially increases file size, and some photographers and technologists believe that it can actually degrade the quality of your image because of what it does to rearrange the physical pixel patterns to integrate a watermark.

Backup and Storage Strategies

Having surveyed the available array of technology for backing up your photos, let's look more closely at systems, strategies, and routines that are both doable and secure.

Digitizing for the Film Photographer

For film photographers — specifically those who have millions of images to back up — the best solution is to prioritize what you want to digitize (what you're most likely to use or need) and have them professionally scanned. Scan the rest on an as-needed basis. Scanning everything is overkill, probably — especially if you're storing your negatives and slides in acid-free, as-airtight-as-possible containers where they're unlikely to be affected by moisture or other factors.

Backup strategies involve figuring out:

- ✦ What to back up
- ✦ How often to back up
- ✦ What media to back up to

Backup challenges of different scales require significantly different backup strategies. Companies that handle huge volumes of extremely critical digital data need highly sophisticated systems that back up very frequently, keep several versions of backup files, and are set up to switch to alternate storage devices with mirrored data instantly. Even the most high-powered professional digital photographer probably doesn't need a system this complex.

For much smaller companies, you can back up folders of digital files periodically, without any special software, onto backup (I prefer external) hard drives, optical media (CDs or DVDs), or remote servers. Between complex, automated, instantly switchable mirroring systems, and manually copying files onto a CD, lies a wide range of backup approaches.

In the software industry, a number of attempts have been made to develop utilities that allow users to create catalogs and databases of their images. These range from relatively simple tools to very sophisticated packages that are suited more to a large organization with an IT department ready to deploy the application over a large network.

Tip By making all the folders you want to back up subfolders of a single backed-up folder, you can easily send them all to your backup storage device.

Create a workflow structure to facilitate backup

The more orderly and organized your file-management system, the easier it is to back up your photo files. You might follow these steps:

1. **Define specific folders and subfolders in which you store photos on your current hard drive system to form a structure.** For example, you might have a dedicated hard drive you use for all commercial digital photos. That hard drive can be divided into folders for various clients, by year, or some other system. Figure S6-8, for example, shows a simple file folder structure I use for a general variety of photos. I segment the subfolders by the type of photo shoot — sports, for instance — and then by more specific categories within each (soccer, football, fencing, and so on).

2. **Use this same structure everywhere in your workflow.** Figure S6-8 shows the structure of my photo archives for original files; everyone in my studio knows these are not to be altered in any way. I also use a similar structure for working files. This way, anyone in the studio can quickly and easily access the files they need, yet the images remain secure. Note that all the photo folders in Figure S6-8 are subfolders of my original photos folder, making it easy to back up all my original photos without searching around my hard drives.

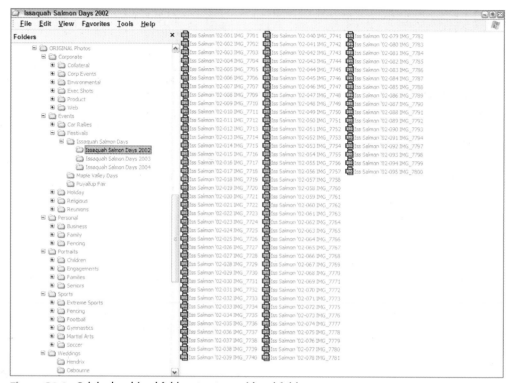

Figure S6-8: Original archived folder structure with subfolders

Caution When you organize images, it's important to note that some applications, such as iView MediaPro, aren't really creating folder with actual images in it. Instead, they are cataloging images. This means they have a file name and often a thumbnail that *points* to an image actually located in another place on your computer or network. The actual files might be dispersed across many folders or drives. Don't rely on a catalog as a way of backing up files.

Determine your storage capacity needs

The type of storage strategy you use is dependent on the amount of digital space you need, and what kind of schedule is appropriate for your backup process. The space your digital images occupies depends upon several factors:

✦ The number of shoots

✦ The types of shoots (weddings, portraits, sports)

✦ What image format(s) you're using (RAW, TIFF, JPEG)

✦ The size of the images you're shooting (JPEG large, medium, small)

✦ The megapixel capabilities of your camera

✦ Your backup system (how many files you're generating from the original)

Data Backup versus Photo Backup

Many of the backup systems available, and much of the available documentation, as well as print and online discussion of backups, are focused on *data* backup. Many environments require constant, automated, and total backing up of files, and near instantaneous restoration of compromised files. Imagine, for example, the levels of file backup required by your bank or the folks who process your credit-card use.

In general, the demands of digital photographers are quite different. Instead of automated, comprehensive file backup systems, it's more useful to make frequent but not necessarily scheduled or automated backups of photo files as needed. This chapter's emphasis is on that.

At the same time, you *should* implement some kind of restoration system for your computer's basic data and system files. System crashes, and corrupt software, is no less disruptive for digital photographers than it is for anyone else. If you download software like Photoshop, make sure you keep a safe set of the install files on a storage device (storage-device options are detailed later in this chapter). Most computer systems come with CDs that restore original software and settings, and in many cases this is sufficient.

Each of these factors weighs against your available storage space. If you're shooting portraits, you're probably going to want to use RAW files, which means larger images; however, portraits tend to produce fewer files overall than, say, sporting events or weddings.

The more you back up, the more storage space you use. The short answer to that contradiction: Get more storage space. Storage space is cheap—while preserving your work, reducing your stress level, and removing the potential danger of losing important work is, as they say in the credit-card ads, priceless.

A more serious constraint in deciding how obsessive you need to be in backing up versions of photos should not be the cost of storage space, but the fact that the more you back up, the more cluttered your backup system becomes and the more work it takes to catalog and manage it.

The tradeoff is between spending inordinate time backing up several versions of a file (tedious, but ultra-safe), and simply storing safe versions of an original RAW or JPEG file that can be re-edited as necessary.

Determine a backup scheme

Convenient and prudent backup strategies often involve combining different forms of storage media. For example, you can create a CD or DVD to archive a single shoot, project, or account, and at the same time periodically back up all your photos onto external hard drives. This provides easy accessibility to specific accounts, along with external hard drives that provide centralized backup locations of all your photos. Rotating two sets of removable external hard drives between your studio and a safe storage space ensures that you can back up your entire set of photo files should disaster strike.

A backup scheme includes what you back up and when you perform the backup. I suggest that you consider the following:

1. **As soon as possible after any shoot, back up your original files.** Make a working copy of each, and store the originals somewhere safe. This might be on a dedicated-original hard drive, on CD, or on DVD; however, the original files must be kept in a location where they're not likely to be inter-mingled with working files.

2. **Next, create a copy of the original files.** These are clean copies of your true original, archived images. They're the photos that you will edit or treat creatively. With these, it's a good idea to store a new *edited* original after you've completed work on each; if they're taking multiple days to

complete, then store at the end of each working session. You'll want to store your edited images with the other originals, or in a specific location you'll be able to identify as protected, edited originals.

3. **Determine how often you want to back up.** Some photographers choose to have periodic backups, where they copy everything they've produced, including originals, to a permanent location. Typically, these backups are done monthly and include everything new produced that month. For some, this can be many gigabytes of images and can be rather time-consuming depending upon the backup system being used. DVD storage, for example, is reliable and you can store a lot on one disc, but it's notoriously slow because the write times on DVDs are much less than that of a CD.

How far should you go in maintaining backups of photo files? A minimalist approach is to back up original photo files (in JPEG or RAW format). For important projects that involve significant editing in Photoshop, you'll want to back up both the original, unedited file as well as your new work in a way that it can be edited later. If the project involves significant editing that will require future reworking, save it as a Photoshop PSD file with layers preserved. For example, if you've put days of work into creating a multiple-layer Photoshop file for a photo to be used in a magazine ad, saving the full PSD file will ensure you can make changes later — as opposed to flattening the layers and saving it as a TIFF or JPEG file. On the other extreme, in Stage 4, I describe shooting up to 1,500 photos a day for some projects. In that case, safely backing up these original JPEG and RAW files on a CD, hard drive, or DVD should suffice.

 Cross-Reference For more tips on organizing the digital photo workflow to prepare to back up photo files, see Stage 4.

Summary

A quick and simple method for saving safe backups of your digital photos is to systematically create CDs or DVDs of different photo shoots, projects, or sets of photos. The backup files should be created from the original, uncompressed files straight from your camera.

While hundreds of high-resolution digital photos can be stored on a CD and a thousand on a DVD, additional backup capacity is available from increasingly cheap and convenient external hard drives. USB 2.0 or FireWire connections facilitate rapid backup.

Remote backup servers have the advantage of being far from your site and quite reliable. You can back up to other computers (as long as you install the backup and restore software provided by the server site). Because remote backup takes much more time than copying files to a local hard drive, schedule remote backups overnight.

Redundancy + Consistency = Security. A reliable backup system need not be complex or high-tech. Routinely backing up projects to a CD or DVD, and frequently backing up all photos on your hard drive to an external hard drive (or set of hard drives) saved out of your studio, provides several layers of safety.

✦ ✦ ✦

7 Creative Image Editing and Optimization

Shot in RAW file format, this early morning shot taken in the Old Town historic district of Plovdiv, Bulgaria, is bursting with color and detail. Shot with a Canon 10D at ISO 200, f/8.0, 1/250 second, and 150mm focal length.

Every photographer is an artist. A part of you is in every photo you take, if only because it shows how you saw the world at that moment. When you share that image with others, it's the same as a writer sharing his ideas or a musician sharing her feelings. When you create good photographs, people often say you "have a good eye."

This talent, just like having a good ear for music or a flair for writing, is as much training, practice, and acquired skill as it is anything else. A passion for photography results in a persistence to overcome most of the challenges you might encounter either at the pre- or post-pixel levels.

In digital photography, creativity can be exercised at both stages. Using all the tools of tried-and-true conventional photography such as composition, light, and exposure, the pre-pixel limits are as boundless as when using film. Once an image passes through the camera's sensor to become digital, the post-pixel creative power far exceeds what has ever been created in a film lab with chemicals and light. Computers present a virtually infinite universe of limitless creative energy and power.

Image editing and optimization includes both touching up images to fix any lighting or composition problems and to address any undesirable elements present during the shoot, as well as using creative elements — including using Photoshop filters to transform photos into works of art that push the border between photos and other forms of art.

The Potential and Challenges of Digital Editing

There is good and bad news about effects. The good news is that many basic, creative tools come pre-packaged in image-editing applications, such as Photoshop. This news is especially good to hear with the myriad of plug-ins available to augment native filters and digital image controls. Even the basic tools can provide tremendous enhancement to your photography without too much work.

The bad news for many photographers is that doing anything really involved at the post-pixel, artistic level takes a lot of practice, training, and skill. It's one thing to apply a watercolor filter or smudge-brush to an image and have it turn out cool; it's another to make a truly unique, composite image containing a complex series of adjustments and filters, and to be able to replicate the work on other images.

This is a book on digital-photography workflow, not an in-depth tutorial on how to touch up photos, or how to achieve creative effects with Photoshop or Corel Painter or other programs like Paint Shop Pro. If you're interested in becoming a master artist with the tools available in these packages, more than enough information and classes are out there to keep you busy. However, if you're a working photographer, even part-time, you'll want to know how to integrate creative and optimization tools into your workflow so that they can effectively help you accomplish your work instead of keeping you distracted or, even worse, struggling to be something you don't have the training or practice to be. And you'll want to know how to keep track of what you've done; methodology in creating abstract effects is key to being able to leverage what you've created and learned over a long period.

Tip

When using filters and other image-editing effects to images, it's a good idea to keep some notes of your work. I keep my memo feature open in my Palm software and note the settings of digital effects I've created that I like. For example, I note which filters I used in which sequence to work with an image and what the specific numerical details were for each. That way, I can more easily replicate the effect on other images later.

Often I use a mix of filters and various effects in Photoshop or other programs to edit images. Sometimes, however, you get lucky, and one simple change achieves a dramatic effect. Figure S7-1 is an image of a water lily that I thought would lend itself well to having a filter or two applied. I simply cropped the image and applied the Poster Edges filter in Photoshop, and I was done. The Poster Edges filter automatically applies a graphic design technique known as Posterization, which effectively limits the number of colors in a photo (which can be set), finds obvious edges within the image, and highlights them with black lines. A further result of the filter is that parts of the photo receive a relatively basic type of artistic shading, and dark detail is spread throughout the image. This sometimes causes small dots to appear which can look good or not, depending on the image; I find it works well with natural textures, such as plants, clothing, earthenware, and the like.

Figure S7-1: Sometimes a simple Photoshop filter can work wonders, such as the use of Poster Edges with this water lily.

Photoshop and Other Programs

Throughout this book, I've used Adobe Photoshop as the prime example of a digital photo editor. I've worked several other photo editing programs, including Adobe Photoshop Elements, Jasc Paint Shop Pro, Corel PHOTO-PAINT, and Ulead PhotoImpact. These are all useful programs, all are less expensive than Photoshop, and some of you may find the interface friendlier or the learning curve a bit shorter.

Because Photoshop has the most complete set of filters, support for plug-ins and file formats, and is the industry standard, I've pretty much settled on Photoshop as my photo-editing tool. In that context, I'll include a few examples of photo-editing features in other programs, just to expose you to them and give you a sense of what other programs do. And I think you'll find that if you're using a program like Elements, Paint Shop Pro, PHOTO-PAINT, or PhotoImpact, that when those programs have features that parallel those I'm discussing in Photoshop, you won't have too much trouble hunting them out of the menus in those programs.

Finally, I want to emphasize again that in no way am I attempting to condense a massive Photoshop guide (such as Wiley's *Photoshop Bible*) into this short chapter. If you don't already have one, you'll probably pick up a Photoshop book as you get more serious about digital editing. Magazines, such as *Photoshop User* (available in larger bookstores), are another important resource for Photoshop editing tips and skills.

Here, in the context of walking through the digital photo workflow process, my goal is to give you a sense of what can be done, what can't be done, and what you can do to stretch the envelope of digital photo editing.

Composing and capturing

As a photographer, your greatest asset in competing for attention among an increasingly large mass of computer-based artists and designers is your ability to see, compose, and capture an awesome photograph. Certain tools in your digital, post-pixel arsenal will aid you in enhancing images to some degree, and knowing what they are is a good idea.

But forewarned is forearmed: In the beginning, you're better off, by far, learning how to best apply your photography skills to produce great photographs in a digital format rather than attempting to alter mediocre photographs into works of digital art. Although they might seem to have a wow factor when you create them on your computer, these mediocre photos can easily turn out looking unprofessional and amateurish to the public and clients alike.

Maintaining realistic expectations

When I first opened and tried out Corel Painter, for some reason I had it in my mind that I would be able to open a digital photograph and, with a few clicks and motions, transform it into a wildly creative work of art. A few hours later, after experimenting with some brushes, colors, and a few interesting tools, I had actually created what I thought were some really fun and unusual effects. But, at the same time, I realized I really hadn't learned much of anything practical that could be applied to digital photography production in my studio and that it would take dozens of intense hours to get to a level where someone might pay me for my efforts.

It's frustrating to see the amazing works of art shown in photography magazines and books and think you can do it pretty easily, only to find out it's incredibly difficult. As part of digital-photography workflow, you'll want to know how to quickly and expertly apply certain creative treatments to make great photographs. I consider learning and using in-depth methods for creating highly involved artistic works a departure from standard digital-photography workflow.

That said, as you get proficient with editing photographs using Photoshop's various tools, do set aside some time to learn how to use some of the more creative capabilities of Photoshop and, possibly, Corel Painter. I suggest you look at some of the method and technique books for these products that walk you through different projects to learn interactively while working on your own images.

For this stage, I'm going to start by quickly and in a condensed way introducing you to basic techniques for photo retouching. Then, I'll focus on some of the basic Photoshop filters and tools, as well as a few plug-ins and tools to creatively enhance your images. This comprises 90 percent of what most digital-photography studios use in the course of day-to-day workflow. You'll want to be able to understand and apply some basic creative and optimization treatments to your images:

✦ Retouching Images

✦ Sizing Images

✦ Working with Photoshop filters

✦ Reducing digital noise

Retouching Images

Inevitably, you'll need to retouch digital images. Many images need to be edited for brightness and contrast, and you may have to get more involved to touch up a person's face to remove blemishes or red-eye, take something out of the photo that doesn't belong there, or perhaps add something to the photo.

As I noted in a sidebar earlier in this Stage, Photoshop offers the widest and most profound set of touch-up tools you'll find on the market, but they come at a price: Using them effectively takes skill and practice. High-end image-editing packages such as Corel PHOTO-PAINT also include very powerful touch-up capabilities, including a number of options that you can achieve in Photoshop, but not as easily.

Having earlier made the case that Photoshop is the industry standard, and has the widest set of tools and filters, I'll confess that different editing programs have tools that I draw on from time to time. For example, I find that some of the automated red-eye removal tools in packages such as Corel PHOTO-PAINT and Microsoft Digital Image Pro are a bit easier to use than Photoshop, where nearly everything is manual. Corel PHOTO-PAINT offers several automated touch-up features, such as the Dust and Scratch option, shown in Figure S7-2.

The moral of this story is that if you have already become comfortable with a less expensive photo editor, don't throw it away if and when you evolve to using Photoshop — every program has its specific strong points.

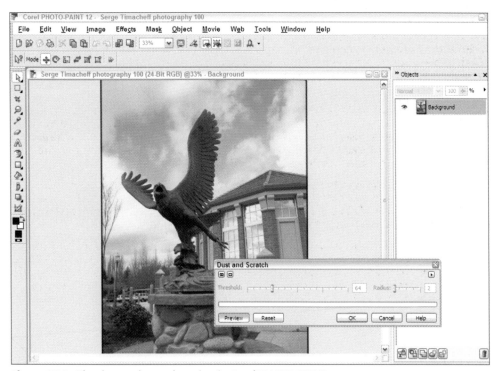

Figure S7-2: The dust-and-scratch option in Corel PHOTO-PAINT

The range of touching up

You'll find that, in terms of digital-studio workflow, image retouching usually falls into several key categories:

✦ Touching up minor facial characteristics such as blemishes, small wrinkles, lipstick on a tooth, spots, moles, whitening teeth, and so on

✦ General auto-level style brightness, color, and contrast adjustments

✦ Removing objects or anything that doesn't belong in a photo

✦ Adjusting shadows and poorly exposed areas to reduce or bring out detail

As I've emphasized throughout the book, whether it's for digital noise, unwanted parts of an image, or other undesirable elements, it's always better to prevent them from getting into the photo at the pre-pixel level than to deal with them when you're image editing. Inevitably, doing post-shoot touch-up is time-consuming and prevents you from getting out to sell and take more photos.

Note A note here on billing and image editing: It's my experience that in general, minor image editing in Photoshop is not a billable item. On the other hand, if you end up doing extensive image editing, you should charge for your time.

The power lines that ended up in the photo shown in Figure S7-3 provide an interesting illustration of the importance of trying to avoid digital editing. If this perspective is the only one you have, you're stuck with the power lines and you'll need to try and edit them out later. However, given their prominence in the image, the best bet would be to attempt to reposition your vantage point and take the photo elsewhere. You'll end up spending less time taking the photo without the power lines than working to edit them out later — clearly a pre-pixel/post-pixel judgment call!

Figure S7-3: Removing power lines can be a challenging task.

Minimizing touch up

Be sure to compose your images carefully — if there's a power line behind the person's head, try to move the person instead of assuming you can just edit the power line out of the image later. Keep basic makeup items in the studio — if the person's nose is shiny or she needs to cover up a blemish, doing it before, not after, you take the photo is better. When you look through the viewfinder, check shadows, lighting, and props. Where is the light falling? Are props in the way? Is the person twisting his neck in a way that's causing the skin to wrinkle? Are any wires exposed from lights? You have to be relentless in looking for anything that might be easier to fix at the time of the shoot instead of having to touch it up later.

You also want to keep your equipment clean. Dirty lenses and spots on a CMOS or CCD are two of the biggest blemishes photographers have to fix in the digital studio. If you shoot a wedding with 1,500 photographs, and each one of them has a spot on it from dust being on your camera's sensor, fixing those images is a lot more trouble than simply cleaning the camera before the wedding begins.

In reality, however, you'll always have your fair share of touch-up work to do. Fortunately, Photoshop's three most commonly used touch-up tools — the Clone Stamp tool, the Patch tool, and the Healing Brush — are nearly magical in what they can do. I'm convinced that these three tools alone are worth the money you pay for Photoshop because they're so easy to use, as well as superior to anything else available on the market. Few people have as perfect a complexion as the model in Figure S7-4, and extreme facial close-ups often reveal the most blemishes. Photoshop to the rescue!

Figure S7-4: Close-ups can reveal even the tiniest flaws.

Typical touch-up work

This section discusses a couple of samples of some typical, minor touch-ups I go through using Photoshop. Some photographers experienced with Photoshop may choose to do this slightly differently—there are a variety of ways to achieve the effects you want.

The wedding photo in Figure S7-5 turned out pretty well. The exposure is good, the catch-lights (the bright little reflections in someone's pupil from a flash or other light) in the couple's eyes aren't overdone, the colors look nice, and the skin tone is good. But a couple of little things need to be fixed before this image is ready to print.

First, the bride's chin, nose, and cheek are a little too shiny; so, in Figure S7-6 I used a combination of the Healing Brush, Patch tool, and Clone Stamp tool to make those spots look a little more like the surrounding skin. You have to be cautious with these tools, however, and work at getting the skin texture just right. If done poorly, the skin will take on a scar-tissue look, or, worse yet, look bruised (and bruised bride photos don't sell very well!).

Figure S7-5: The happy couple, ready to roll to the reception. The exposure is good, the smiles are great, and the moment has been captured, but I can still make some post-production edits to improve it further.

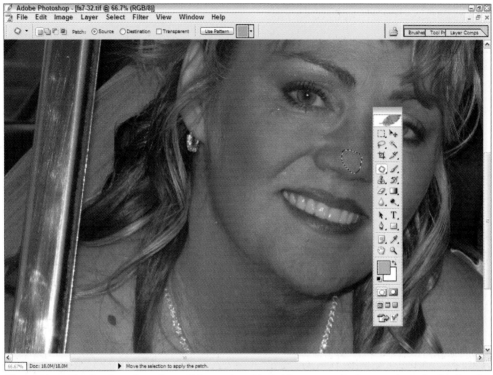

Figure S7-6: The Patch tool works well for getting rid of shiny areas of a face, such as the forehead or tip of the nose.

Next is a simple fix: Get rid of the little bright spot on the bride's cheek, which is probably some glitter from someone who gave her a hug after the ceremony. It's merely one click with the Healing Brush, and it's gone. Be careful, however. Using it for larger areas can be tricky and create new unwanted tones and shades in the tool's shape.

Finally, I remove the beauty mark from her shoulder using the same tool; a couple of clicks and you can't tell anything was ever there. My final image is then ready to go, as shown in Figure S7-7).

Could there have been more I could have done to the photo? For sure. Would I? Probably not, unless the image is destined for enlargement beyond 11-x-14. The problem is that touch-up work tends to have a bit of a domino effect: One fix leads to another issue, and pretty soon you've spent a couple of hours doing some very minor work. Perfection is a noble pursuit, but sometimes it gets in the way of the revenue-driven photographer!

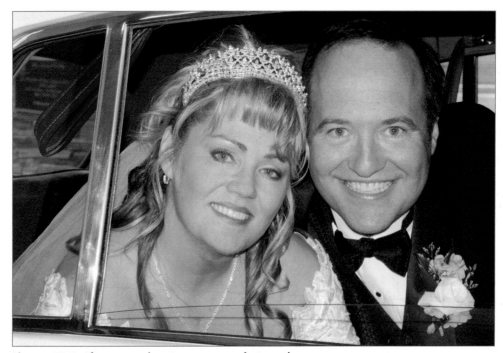

Figures S7-7: After some minor touc-ups, a perfect couple

Using these three touch-up tools can fix many problems, ranging from getting rid of an exit sign on a wall to virtual cosmetic surgery making someone look years younger. However, they take time and you'll need to practice with them to understand which ones to use and when, and with a variety of other Photoshop tools. Knowing how to select areas or objects, feathering them, and then adjusting them are just a few practices that accompany using touch-up tools you'll want to understand before doing anything too involved.

Automated touch up

Photoshop can perform a variety of automatic level adjustments as well as manual ones to improve an image's brightness, contrast, and overall tonality. Figure S7-8 is a baby sea lion napping on San Francisco's Pier 39; I took it with a 400mm lens. It's a little dark, however, so I decided to try using Photoshop's Auto Levels to see if it would fix the problem. Doing so, I see that it helps the image overall, but it overexposes a key part of the image on the little guy's head.

Figure S7-8: Insufficient lighting produced a photo almost devoid of color.

I have a couple of options: I can play with the more specific auto-adjustments, such as color or contrast. I can use the manual levels option, or I can use a plug-in such as nik Dfine (which may, in fact, be my most versatile option). However, I choose Image ➪ Adjustments ➪ Variations, which allows me to see a number of fine to coarse adjustments of darkness/lightness and color (shown in Figure S7-9). This yields exactly what I want, and the result is shown in Figure S7-10.

Adjusting image contrast and brightness is common practice, as is working with shadows or specific parts of an image to bring out or suppress detail. A number of tools in Photoshop (and some other image-editing software) will let you accomplish this, including selecting and feathering areas of an image using the Magic Wand and creating masking layers to provide all sorts of detail changes.

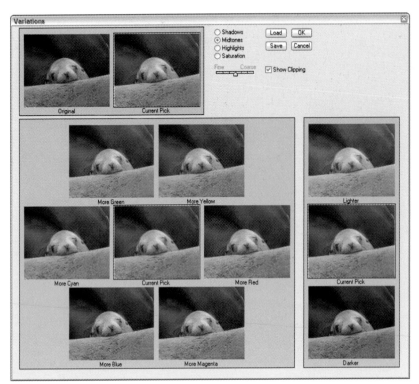

Figure S7-9: The Variations window presents a variety of alternate lighting adjustments.

For black-and-white images, especially, being cognizant of shadows and tones is important; being too heavy-handed with contrast and brightness adjustments can result in overblown or underexposed areas that can ruin an image. Black-and-white images with a wide tonal range are especially susceptible to contrast and brightness adjustments. The photograph in Figure S7-11 of Snoqualmie Falls, near Seattle, has a wide range of grayscale tones, and only the deeply shadowed area behind the falls could be acceptable without too much gradation. While this image required relatively little editing, in its original form it lacked sufficient detail in the brightest part of the waterfall. To bring out the detail, I used the lasso tool to outline the over-exposed region, applied a Feather setting to it (so that any changes wouldn't look too much different at the edges of the area I had lassoed), and then used a combination of the shadow/highlight tool and the histogram levels to bring out the detail of the water. I then noticed just a few places that looked like they had been altered, so I used the healing brush to smooth them over.

Figures S7-10: A happy, well-adjusted sea lion

Figure S7-11: This black-and-white image of Snoqualmie Falls, Washington, has a wide range of tonality that required some area-specific adjustments.

Sizing Images

Digital images must be sized for a variety of purposes: to go onto the Web, to be printed, or to be used in a layout of multiple photographs. Whatever the intended use, to resize images, you'll have to address three key issues:

✦ What part(s) of the photo should be removed to enhance composition?

✦ What size does it need to be?

✦ What resolution does it need to be?

Virtually any image-editing package will let you crop a photograph, but that's only part of the equation. For example, you may need to make the photo a specific size, or you may want to reduce its resolution so that it can appear on the Web in a format that's physically large enough to be viewed, but with a dpi low enough that various speeds of computers and Internet connections will be able to display it. I'm going to use Photoshop for some examples, because it has the most versatility for cropping images.

For Figure S7-12, I wanted to trim the image to close in on the model's face a little, and not have so much of the glove showing. There are a couple of ways to do this.

At this point I didn't know for what purposes the image would be used, much less what size(s) it would ultimately become. So I made another working copy of the file I simply chose the area I wanted to crop without regard to size or resolution. To do so, in Photoshop I used the Rectangular Marquee tool (the dotted rectangle in the upper-left section of the Tools palette) to outline the area I wanted to crop. Then, I chose Image ➪ Crop on the Image menu. In this way, I reduced the image to what I wanted, and retained the original size as it came from the RAW file, to be saved as a TIFF or whatever I wanted.

The method mentioned here is the quick-and-dirty way to crop an image and most frequently you'll probably want to default first to using the Photoshop Crop tool, which offers more features and is ready-made for the job. You can specify the size and resolution you want the photo to be — if you know it in advance — and a new feature in Photoshop CS lets you press one button to jump the dimensions between crop width and height (it used to be a pain in previous versions to have re-enter the data just to change height/width). You can use the Crop tool to perform automated features, such as placing a color or shade around the cropped area of your image. Other crop advantages include being able to simply double-click to invoke the crop, the ability to rotate the crop to fix a crooked image or for artistic treatment, and a robust set of preset tools that can be applied to many images identically — including aspect ratios/sizes as well as several other effects.

Later, to change the actual size of the image for printing, I have a couple of options. If I want to merely reduce or change the size of the pixel dimensions (let's say I know it needs to be 10 inches tall, but I don't care about the width), I can choose Image ➪ Image Size to change the image.

By selecting the Constrain Proportions checkbox in the Image Size dialog box in Photoshop, I can also lock the dimensions, as you see in Figure S7-13, to prevent the image from resampling to a pixel dimension where it would be enlarged more than the original (which could cause image degradation).

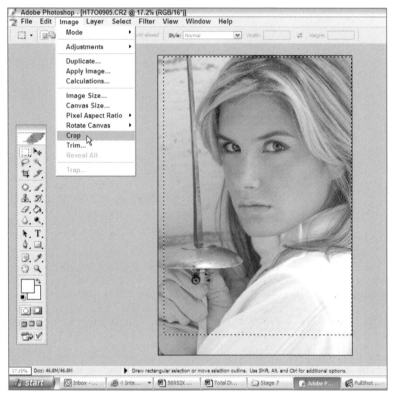

Figure S7-12: Cropping to the selected marquee helps refocus the image on the model's face.

However, if I want to make the image a specific size, for example 5-x-7 at 300 dpi, then I can choose the Crop tool on the Tools palette. At the specific 5-x-7 aspect ratio, I'll have to cut out a little bit of my image out, as you can see in Figure S7-14. If I want it to be that specific size, I have no choice—something's got to go!

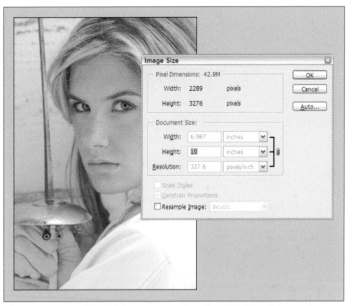

Figures S7-13: The Link icon connecting the Width, Height, and Resolution fields indicates Constrain Proportions is selected.

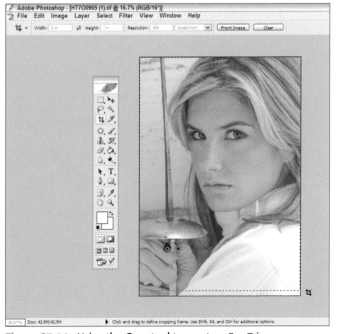

Figure S7-14: Using the Crop tool to create a 5-x-7 image

In Figure S7-15, you can see three popular U.S. photo sizes compared with each other: 4-x-6, 5-x-7, and 8-x-10. Each of these sizes represents a different size ratio, which, by remembering a bit of high-school math, you can compare by reducing ratio to its minimal size:

4-x-6	equals a ratio of	2-x-3
5-x-7	equals a ratio of	5-x-7 (cannot be reduced further)
8-x-10	equals a ratio of	4-x-5

Or, to take one example of enlargement,

8-x-10	equals a ratio of	16-x-20

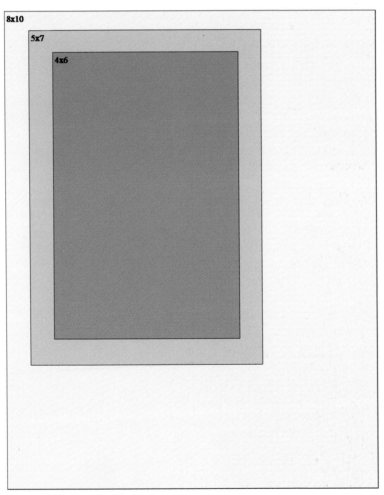

Figure 7-15: Popular photo sizes

If you were to resize an 8-x-10 photo, for example, to 4-x-5, no information would be lost. However, to resize it to 4-x-6 means it will need to be a little higher than wide, so you'll have to trim something to fit it to that size. By the same token, a 16-x-20 image, which is another standard enlargement size, is a perfect enlargement for an 8-x-10.

If you specifically need one size and you absolutely do not want to eliminate any part of the photo, one option is to create a canvas that is your image size (you can specify a canvas size by choosing Image ⇨ Canvas Size in Photoshop). This way, you can place your image on the canvas. However, you should be aware that you might have canvas borders on one side that are larger than borders on another side. Framers deal with this by making custom-size mats to fit odd-shaped photos.

Tip The Canvas Size dialog box in Photoshop always places the image in one of the nine squares. You almost always use the center square to center your image horizontally and vertically on the page (canvas). But the dialog box also provides options for placing an image in a corner or side location on a larger canvas.

Sizing images is an issue for placing photos in online fulfillment services such as Pictage and Printroom.com, because you typically upload one image that must be fulfilled at a variety of sizes. As a result, most of the pro online services allow you to do online cropping, or to print a full-size image with white borders to allow for an odd size to be fully displayed.

Yet another option for resizing is to do so by a percentage, which is especially useful when reducing a large series of images. This option is available in ACDSee, as you can see in the resize window shown in Figure S7-16. The image can be changed by pixel size, actual print size, or as a percentage of the original based on width, height, or both.

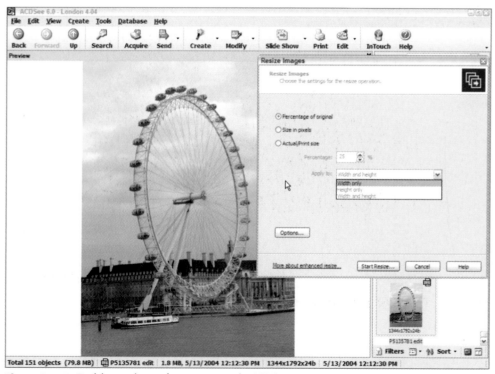

Figure S7-16: Resizing an image by percentage in ACDSee.

This sizing can also be an issue when creating an automatic picture package using an image-editing tool such as Photoshop or ACD FotoSlate, which is the most powerful stand-alone printing utility I've found. It is better than the picture-package option in Photoshop or other image-editing packages. FotoSlate provides an easy way for you to automate high-quality photo printing into photo packages, calendars, greeting cards, and contact sheets with a huge variety of print layouts.

Note For more information on FotoSlate, see ACDSee's Web site (www.acdsystems.com).

For Figure S7-17, which was taken in London, England, I chose a layout that let me print two 4-x-6s onto an 8-x-10 sheet. FotoSlate lets me choose from a number of different sizes (or create my own) on a wide variety of paper sizes. You simply drag one or more photos into the FotoSlate image window, and then do the same with one or more paper layouts. Further, you can choose to rotate images to make them fit into the image sizes, and then, optionally, choose a shrink-to-fit capability if your aspect ratio doesn't fit the image size (but you have to be careful you don't distort your images by doing so). It includes a simple image editor that allows you to crop images and do a few other things as well.

Figure S7-17: A two-print photo layout ready for printing in FotoSlate.

Working with Photoshop Filters

A Photoshop filter is a digital effect you apply to an image that essentially distorts or fundamentally alters the image. It's not to be confused with a pre-pixel filter, such as color-correction or diffraction (such as a starburst) lens-mounted filters. Instead, these are selectable options in Photoshop under the Filter menu. All image-editing packages contain filters of one type or another that can be applied to photos to create various artistic effects, such as watercolor, black-and-white sketch, glass, neon glow, and many others. Photoshop's abilities are the most robust without using an elaborate art package (such as Corel Painter) for advanced and highly manual filtering. Some other programs, such as ACDSee and ACD FotoCanvas, Microsoft Digital Image Pro, and Corel PHOTO-PAINT have filters too, but none has any as elaborate or adjustable as Photoshop's.

Tip Whenever performing image-editing and especially creative work in Photoshop, it's a good idea to work in the Photoshop PSD format. Using Save As, create a working copy of your original in PSD format. This is the most compatible format for all of Photoshop's features, as well as those of other Adobe applications that you might use such as Adobe Illustrator.

Photoshop CS has a generous selection of creative and utilitarian filters, and many more are available as plug-ins that can be purchased or even found on the Web for free or as shareware at sites such as Download.com. However, the real power of Photoshop's filters lies in how they can be adjusted with slider-type controls to specific numerical values; this means you can replicate what you've done to one image with the same preciseness to other images.

It's important to know that not all filters work in all modes. Although all the filters are available when working with 8-bit images, such as JPEG images, only a subset is available for the 16-bit mode; this is an issue when working with RAW and TIFF files. Similarly, some only work in RGB mode. If a particular filter you want to use isn't available, you should check your image's settings to see if that's the problem. Obviously, if you're working with an image in black and white, various filter effects optimized for color may only have very limited, if any, effects.

Tip If you're working with RAW camera files and saving them to TIFF, but you want to do some creative work on an image, create a new file by saving it as a Photoshop PSD file where all the filters will be at your disposal. This is your best and most native format for working in Photoshop. You can also work in TIFF, but to have all the Photoshop filters available in TIFF or PSD you'll need to be in 8-bit mode. Do your creative treatment there and then save it into any other file format the job requires.

Further, many filters require lots of RAM to process an image. If you're processing a large image with a complex filter, and you lack sufficient memory, Photoshop may generate an error message and possibly even terminate. Especially if you're working with large images, you'll want to have enough memory to process images in this manner, both for application stability and just so that they'll process quickly enough. Save your work frequently!

Photoshop CS has an optional filter gallery, which, if you choose to use it, provides an easy way to jump among various filters and preview how they'll affect images. I find it very handy and use it frequently. To use the Filter Gallery, choose Filter ➪ Gallery from the Photoshop menu. An expandable list of filter categories appears.

Managing layers and filters

Sophisticated Photoshop users rely on *layers*, which are invisible overlays that can superimpose editing and effects on a photo. The advantage of working with layers is that they leave the underlying photo

untouched. Filters can be applied through layers, but this technique requires a little more expertise with Photoshop that I can explore in this book.

However, a relatively easy and very effective use of layers is to create a duplicate layer, essentially creating a copy of your basic photo to which you can apply filters or other effects. Layers can be easily displayed or hidden. In Photoshop (and very similar features are available in other image editors), you view the Layers panel by choosing Window ➪ Layer from the menu. The Layers panel lists all layers. By clicking the Layers Visibility icon (it looks like an eyeball) in the Layers window, you can hide or view any layer.

In this way, by showing or hiding the duplicate layer, you can easily turn the effect off and on by simply doing the same to that layer. This is a great way to mix filters, as well, and then when you're ready to complete your image, you simply flatten it into a final JPEG or TIFF. To mix layers, you'll need to play with each one's opacity (an adjustment on the layer's properties).

Using Photoshop filters, you can do some very simple things to photographs that can have a relatively dramatic effect; you can also use filters to only affect specifically defined parts of an image. Which filters are useful for what purposes? Take a look at the photograph in Figure S7-18. I took this image in Cuba of some old pillars in the center of Havana. I like the photo, but it's not especially great, so I'm hoping that by using Photoshop filters I can make it more dramatic and/or unusual. Using this photo and a couple of others along the way, I won't show you every filter, but I'll go down the list of major Photoshop filter categories and apply some different example effects to see how they can work, especially in the context of digital photography workflow.

Having introduced some basic concepts involved in using filters, including using filters in layers, let's have some fun experimenting with filters, starting with Artistic filters.

Figure S7-18: The original, working copy of the photo, saved as a JPEG

Using Artistic filters

All filters are available from Photoshop's Filter menu. They are divided into thirteen rather randomly organized categories. While somewhere, someone has produced technical specs on what these filters do and how, the way photographers use them is to try them on.

Note The Digimarc filter category located on the Filter menu in Photoshop is not used for artistic editing, but to embed watermarks in photos.

In Figure S7-19, I've used the Cutout filter from Photoshop's Artistic filter selection. This filter cuts out elements of the photograph to create an artistic, less defined image. It's a nice effect that's quite useful in creating some interesting treatments in a variety of photos.

Figure S7-19: Photoshop's Cutout filter

Figure S7-20 shows the Fresco filter, also found in the Artistic category of filters. The Fresco filter is one of several filters that make the image look like it was painted.

Another Artistic filter is the Poster Edges filter, shown in Figure S7-21. I like this filter very much because it enhances various textures, especially natural ones such as textiles, plants, and stone.

The Neon Glow filter in the Artistic Filters menu can have a very dramatic or subtle effect on an image. You can choose the color you want to apply as the glow; as you can see in Figure S7-22, it essentially makes the image monochromatic with that chosen color. This would be a great background screen for a Web site or presentation.

Figure S7-20: Photoshop's Fresco filter

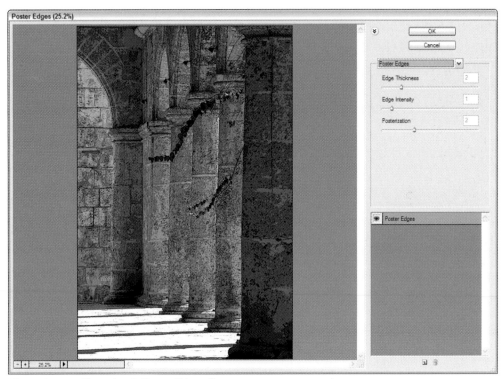

Figure S7-21: Photoshop's Poster Edges filter

Blurs and brush strokes

Both the Blur and Brushstroke categories of filters convert detailed photos into blurred or non-realistic images. Photoshop's Blur filters allow you to make parts of an image look out of focus, and there are a variety of ways to do this. Why would you ever want to make a perfectly good image blurry? One example is if you were to take a photo where you want to emphasize the subject, but the photograph has a deep depth of field — in other words, you can see everything in the background.

Many times Blur effects are applied only to selected areas of an image. The Marquee and Lasso tools in the toolbox can be used to draw freehand ovals, rectangles, or freeform shapes to select a section of a photo. Whole books could be written on Photoshop selection techniques, but that's the essence of it.

Figure S7-22: Photoshop's Neon Glow filter

You can select and blur the background, but keep the subject focused. To do this, first use any of the selection tools (in the Photoshop toolbox) to select the background, and then apply blurring to that selected area. This way, you can fake a shallow depth-of-field image. You could even import another photo into a blurry background.

The Brush Strokes category of filters includes filters that apply various paintbrush-style strokes to your image. I find these somewhat difficult to use on portraits—it tends to look very unnatural and not very painting-like. Further, these filters require tremendous system resources and will slow down any computer with less than a gigabyte of RAM. But sometimes brush stroke filters are worth the price—on an image such as the one in Figure S7-23, it works quite well.

Figure S7-23: Photoshop Brush Strokes using the Ink Outlines filter

Distortion filters

The Distort category of filters work just like they sound: They provide often-profound levels of distortion to an image. In Figure S7-24, I've used the Shear distortion tool to make stone pillars look curved.

As with many filters that apply significant distortion or changes to photos, the filters in the Distortion category require a lot of computer memory and create rather drastic changes to your images. When you select a filter from the Distortion category (or other categories), the Filter Gallery is opened, allowing you to experiment with, compare, and pick an effect.

Distortion filters aren't the most practical filters in common digital photography workflow, and you probably won't find a good reason to use them too often, but they can be fun.

Adding noise and pixelation

The Noise filters can blur or add noise to an image; they're also a way to clean up dust and scratches from a photo. This is useful sometimes for scanned digital images that are dirty, but its effectiveness in common digital photography workflow is limited. You have to be very careful with the Noise and Scratches filter as it softens the image considerably.

Similarly, the Pixelate filter isn't all that useful in a workflow context; it emphasizes turning photos into pixilation patterns that create various effects such as pointillism or crystallized looks. Figure S7-25 shows an image featuring a classic car driving along Havana's waterfront. Figure S7-26 shows the same image with a Pixelate filter (in this case, Crystallize) applied. The Pixelate filter groups like-colored sets of pixels together to create an artistic effect.

Figure S7-24: The Distort filter's Shear tool used to bend pillars

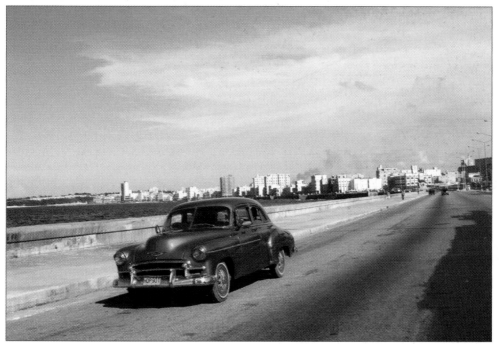

Figure S7-25: This scene, with its dramatic concentration of blue in the car and the sky, is a good candidate for artistic treatment.

Figure S7-26: Pixelation adds a crystallizing effect—note the impact on the skyline in the background.

Using Render filters

Next on my workflow's list is the set of Render filters, which I find quite useful. Although they can provide some rather dramatic effects, for example creating clouds in an otherwise plain blue sky, the best features in the Render filters for workflow on this list are lighting effects. Take a look at Figure S7-27. It's a photograph of a Seattle church steeple against office buildings and sky. This church needed to document images of their building following severe earthquake damage. However, the typical winter overcast sky in Seattle wasn't very appealing.

By selecting the sky using Photoshop's Magic Wand tool and selecting a light blue color on the color palette, I then applied the Clouds option under the Render filters to create the effect seen in Figure S7-28. It was simple, only took a few steps, and it make the image much nicer. You have to be careful with this filter, however. If you make the color too dark or if you overuse the cloud pattern, it can look artificial.

Figures S7-27: A dreary sky can be altered easily with one of the Render filters and the Magic Wand tool.

S7-28: Using Photoshop to improve Seattle weather

Another Render filter I like to use on occasion, and one that can add dramatic effect to a simple image, is Lens Flare. This effect mimics what happens when extraneous light such as from the sun or a bright spotlight enters your camera lens when you don't shield it using a lens hood or something similar. It creates a reflection within your lens of the various optical components. Sometimes this effect is rather interesting, and Photoshop lets you re-create it in a variety of ways. Look at the photo shown in Figure S7-29. Used on the cover of *American Fencing* magazine, I took the photograph of a fencer waiting to compete in a semifinal match at the world championships in Cuba.

First, as shown in Figure S7-30, I've centered the effect cursor onto the source of the brightest reflection in the image — in this case, the fencer's bell on her epee (sword). By selecting a type of lens, and then adjusting the intensity of the effect, I've changed the photo to look like the bell is reflecting much more dramatically, as shown in Figure S7-31. You can have a lot of fun with this filter in a variety of ways, giving interesting emphasis to many types of images.

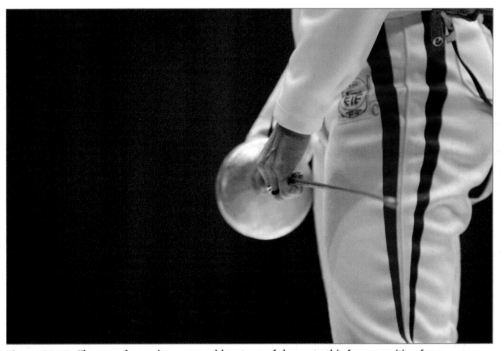

Figure S7-29: The use of negative space adds a tone of drama to this fencer waiting for a championship to begin.

Figures S7-30: Choosing the location and brightness level for the Lens Flare effect's center

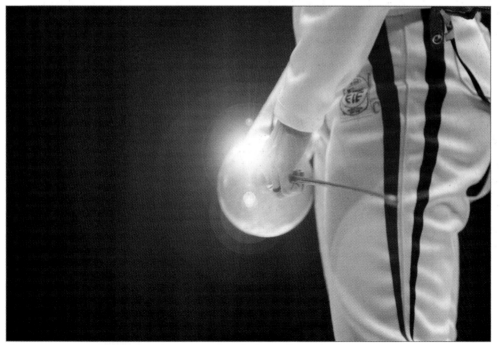

Figure S7-31: A Lens Flare can increase a photo's dramatic emphasis.

A wide variety of effects can be achieved using Photoshop's Lighting Effects filters, also found under the Render filters. This powerful selection contains a tremendous variety of ways to change how light is cast on an image. In Figure S7-32, you can see how just one of the many lighting effects can be adjusted to change how the image is illuminated. Of each effect, there are multiple ways of changing the lighting according to textures, colors, exposure, and other factors.

Figure S7-32: Changing how an image is illuminated with a Lighting Effects filter

I discuss sharpening just a bit in other chapters, but it's worth mentioning again here because, technically, sharpening is a filter that is distorting the image. Using the automated Sharpen feature, you can quickly achieve simple sharpening effects that may or may not help your image sufficiently (or too much). The Unsharp Mask is a better choice for most sharpening tasks and can be adjusted and fine-tuned, unlike the other options.

Transforming images with Sketch filters

The Sketch filters are, for the most part, just what they sound like: They transform your image into a black-and-white photograph that looks like someone sketched it with a pencil, charcoal, or other drawing tool.

A few of the tools, such as Chrome, create some rather wild effects, but my favorite, which works well for creating a simple but artistic rendering of a bride or other portrait, is the Stamp Filter; this practically converts the image to line art, removing much of the detail. In Figure S7-33, you can see how I've applied it to the Cuban pillars.

Exploring Stylize filters

The Stylize filters are perhaps the most wide-ranging artistic filters Photoshop CS offers, including Emboss, Solarization, Glowing Edges, and many other effects. The Diffuse filter (shown in Figure S7-34) is the most subtle of this group, but it's useful in enhancing images with a dash of diffused light, giving images that little edge that sometimes can make the photo all the more dramatic.

Figure S7-33: The Stamp filter creates a very simple image by removing information and detail.

Figure S7-34: Using Diffuse, not to be confused with Diffuse Glow, allows some subtle defocusing effects to soften and enhance an image by shuffling the pixels. In fact, they will often look more pronounced in the editing dialog box than on the ultimate image itself.

Other filters in Photoshop include a selection of textures and filters optimized for video display and presentation of images captured in video. At the bottom of the filter menu is where you'll find any plug-in filters you may have installed into Photoshop.

Digital Noise and Workflow

Adding grain to images, making them look more like film, can be a desirable artistic effect. However, digital noise, which occurs more noticeably when you take photos with a higher ISO setting on your digital camera, rarely looks attractive. I discussed digital noise a little in Chapter 2, and here I want to talk about how to prevent and treat it. There are some specific ways to deal with it after the fact, but the best way to prevent digital noise is at the pre-pixel level by taking an exposure that doesn't, if possible, require a high ISO setting.

Some cameras handle noise better than others; sometimes processing images internally to optimize noise reduction is even an optional setting in the camera. Basically, digital noise is a post-pixel error that comes from the camera's sensor, making up for light it can't see; it's guessing at a light value based on surrounding pixels and on a lack of light on the pixel that ends up being rendered incorrectly. This incorrect rendering results in the little pixel-sized spots you see in a high-ISO image, often featuring colors that you wish weren't there. Digital noise can be affected by a variety of factors, including the type of exposure you set and white-balance settings/color temperature, for example.

Another type of noise is an artificial patterning you see in images, known as a *moiré* pattern. This pattern is typical when you take a photo of a TV screen (not the scan line, but the strange pattern you see) or when you photograph a person with a patterned shirt. The patterns on the screen or the garment are actually interfering with the pattern of pixels in your camera, and the conflict results in the moiré pattern.

For digital-photography workflow, the best plan is to do everything you can to avoid noise at the pre-pixel level, because removing digital noise is seldom completely effective, and removing moiré patterns is very difficult. Shoot images, especially darker ones, with as low an ISO as possible without compromising your focus (if it means using a tripod, do so!). You should also instruct subjects not to wear patterned clothing to a shoot. However, if you do have noise or a moiré pattern in your image, you can work on correcting it at the post-pixel stage.

Post-pixel, there are tools that can be employed to reduce noise in an image. If you're shooting in RAW, Photoshop's RAW converter plug-in offers a noise-reduction feature, although I haven't found it to be nearly as effective as Dfine, the third-party product from nik multimedia Inc. (www.nikmultimedia.com). This product, which is a Photoshop plug-in, gives you a number of options for eliminating noise from your image and can even be set to an optimal state matched specifically to your digital camera (this is an additional-cost feature not available for all types of cameras). Dfine reduces two types of common digital noise. *Chrominance* noise, which they define as "small, off-colored spots or specks in the image," and *luminance* noise, which they define as "small, dark spots that often look like film grain."

Converting Images to Black and White

Typically, the most objectionable digital noise is those little random color dots that seem to be all too visible in an image. One way to overcome this is by converting an image from color to black and white. As described in Chapter 1, there are several ways, some better, some easier, to achieve this conversion in Photoshop:

✦ You can simply use the grayscale mode converter under the Image menu.

✦ You can add a new Adjustment Layer, select Hue/Saturation, and use the sliders to remove color.

✦ You can choose various artistic and effect filters such as those found in the Sketch selections that will turn an image into a monochrome photo, but with various treatments.

✦ You can use Photoshop's Channel Mixer, which is a good method. It is easy, powerful, and I think it yields stronger contrast and a better overall photograph.

This final method is the one I use most often. For example, in the foggy shot of the Golden Gate Bridge shown in Figure S7-35, color was primarily visible only in the ship below the bridge, and it became almost a distraction. Instead of a distraction, I wanted to emphasize the dramatic contrast between the black-and-white shades in the clouds above the bridge. The trick was to change the image to discard the ship's color but to avoid eliminating the contrast in the sky.

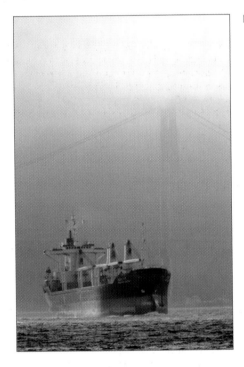

Figure S7-35: The color in this shot was distracting.

Here are a few basics about what I did in Photoshop to get this look:

✦ To the color image, I added a New Adjustment Layer and selected Channel Mixer. I then clicked Monochrome in the Channel Mixer window.

✦ Using the different sliders in the Channel Mixer, I made different adjustments to the image until I arrived at the best-quality black-and-white image, as shown in Figure S7-36.

✦ After I got the image to black and white, I decided to give the image a little overall color for effect. By adding another adjustment layer, but this time using the Color Balance option, I was able to use the different colors to add a sepia-like tone to the image, as shown in Figure S7-37.

Figure S7-36: Adjusting elements in the Channel Mixer

Figures S7-37: Using Color Balance settings to convert a color image to a sepia tone

Thinking in Black and White

Black-and-white photographs are far more than pictures without color. They're dramatically different images that emphasize contrast, scales of gray, light, and shadow in a far more pronounced and visible manner than a color image.

Most photographers experienced in film-based black-and-white photography realize that, when they shoot black-and-white images, they're actually thinking in black and white, even though what they're seeing through the viewfinder is in color. This is primarily because they know they're shooting black-and-white film, and it's the only possible outcome of their photographic efforts. The photographer attempts to discard color information intellectually, focusing instead on the elements of an image without color. The same process takes place when shooting digital images; digital photography may display color through the viewfinder and in the LCD review screen on the camera (a few cameras offer black-and-white or sepia review options, also), but the photographer must still think in black and white.

Although the film photographer sees the black-and-white images on the negatives or proof sheets when they come back from the lab, the digital photographer is able to choose whether the image is to be rendered in color or black and white—and can look at a black-and-white image on a large screen mere moments after it has been shot. In Photoshop, there are several ways to create a black-and-white image from color, such as by creating an adjustment layer (Choose Layer ⇨ New Adjustment Layer ⇨ Hue and Saturation) and use the sliders for hue and saturation to achieve the best-rendered grayscale image. The kind of result you can expect is shown here.

However, let's say you'd like to quickly and easily look at an image as it will appear in grayscale, but you'll work with the final image in detail at a later time. Choose Image ⇨ Mode ⇨ Grayscale. The image is then converted to grayscale, and, although lacking the depth of a grayscale image created with more detail, it's a fast way to discard color, see how the image will look, and then make alterations on-the-fly, as shown in the following image.

Of course, you also have the option of keeping the original image in color (as shown in the next figure) and being able to use it that way if creativity calls for it. However, it's imperative that you continue to use your photography skills of thinking in black and white, even though you're seeing color and you know that a color image — unlike with film — is an option for the photo.

Summary

In this quick overview of how Photoshop is used to touch up and creatively edit photos, my examples only scratch the surface of Photoshop's myriad and robust feature set and tremendous capabilities. But, as a working photographer, what I'd like to emphasize is the following for the aspiring photographer who is new to Photoshop and perhaps digital photography in general: Don't go overboard. Learn the basic tools, and learn them well. Build your skill set slowly, and don't try to promise things you can't do.

Photoshop isn't easy; it's a difficult program to master no matter how adept you are at computing, photography, or even design. The more you learn, the more you'll realize how much you don't know, and that may be frustrating. However, for every situation where you get stuck, there's one where what you've created will delight you and your clients or audience, and that will keep you going.

I'm not a Photoshop expert. But I work with it extensively, and every day I learn something new. I share what I learn in my studio, and we, as photographers, all absorb as much information as we can from other photographers and designers, in workshops, in magazines and books, and on the Web. You'll find that you'll be producing things you never thought you could, and you'll be able to tackle new challenges with confidence that you'll be able to produce amazing effects and beautiful results.

In this chapter, I've tried to share with you some of the perspective I have for how to use Photoshop in everyday digital-studio workflow, and to extol some of its inherent capabilities and how they might relate to your work. Effectively using filters and touch-up tools, as well as understanding how to reduce noise, optimize image sizes, and adjust a wide variety of images, will ultimately yield the best photographs.

✦ ✦ ✦

8

Printing Photos in the Studio or at Service Bureaus

This salmon weather vane, which sits atop the Issaquah Salmon Hatchery in Issaquah, Washington, was taken as a JPEG file, saved in Genuine Fractals, enlarged, and then saved as at TIFF file. It was taken with a Canon 10D at ISO 400, f/5.6, 1/250 second, and 140mm focal length.

The explosion of digital-photography options has been accompanied by rapidly developing options for high-quality digital photo printing. The controversy will likely rage for some time over the relative quality of digital photo printing versus traditional photo printing, but the very fact that there *is* such a controversy is a testament to the impressive quality achievable from a variety of digital print options.

Expect a bit of positive tension in this chapter as Serge and I (David) wax on about the amazing quality you can get from studio desktop photo printers, as well as the need for serious photographers to produce professional-quality photos with professional service bureaus. Both perspectives are valid and useful to the digital photographer. You can achieve high-quality prints from a home inkjet or dye sublimation printer, although tones like the skin color in Figure S8-1 will pose a challenge to any digital printer.

Figure S8-1: The light flesh-tone color in this photo poses challenges to digital printing.

In spite of the remarkable output capabilities of in-studio photo printers, the best output comes from professional fulfillment services dedicated to producing high-quality prints. In this chapter, you'll explore when it makes sense to print either way, and how to get the best prints from printers and professional print shops.

Digital Output versus Photo Printing

Discussions in this chapter focus on three photo-printing options:

✦ Inkjet printing

✦ Dye sublimation printing

✦ Options provided by professional photo-printing labs and service bureaus

Inkjet and dye sublimation printing are practical, affordable, in-studio print options. Properly configured, with high-quality photo paper and six, seven, or even eight color jets, inkjet printers can produce very-high-quality photos. Inkjet printing creates prints by highly concentrated, extremely small dots of ink. Imperceptibly small dots of cyan, magenta, yellow, black, and often other shades, are combined to generate a full spectrum of printable colors. Dye-sublimation (often just called *dye sub*) printing, combines cyan, magenta, and yellow ink in gaseous form, where "gasified" droplets of ink combine to form the color range.

Inkjet and dye sub printing not only differ considerably from each other, they also differ considerably from traditional photo printing. In traditional photo printing, photo paper interacts with photo-printing

chemicals to generate colors on a *molecular* level, qualitatively smaller than even the tiniest inkjet droplet. I'll explore the pros and cons of each of these processes in this chapter.

Printing in the Studio

Studio prints can be a way to generate a quick preview of a photo, an image of archival quality, a sellable image, a frameable print, or anything in between. Studio printers can cost over $100,000 and take up a large corner of your studio, or they can run on batteries and generate decent-quality prints in the trunk of your car.

There are three widely used digital print technologies available for studio printing: inkjet, dye sublimation, and laser printers. Inkjet printing provides the widest scope of size, quality, and print media, and dominates studio printing. Epson, for example, sells the Stylus Pro 10600 Series that prints 44-inch-wide sheets of photo paper and uses special dyes that are guaranteed to last two years outdoors. At the other end of the scale, the lunchbox-sized PictureMate shoots out 4-x-6 prints that last decades.

Dye sublimation printing produces very-good-quality color. Photo labs at copy shops, drug stores, and consumer-level online print shops use dye-sub printers. But what kind of dye-sub equipment is available for your studio? Figure S8-2 shows a small, desktop dye sub—cousin to expensive commercial dye subs that produce larger-size prints. Desktop dye subs are generally limited to small printers that produce 4-x-6 prints but are useful to serious photographers for generating high-quality color proof prints.

Finally, laser printers are an option for high-volume, low-cost color printing. However, the resolution of laser printers does not support photo-quality output.

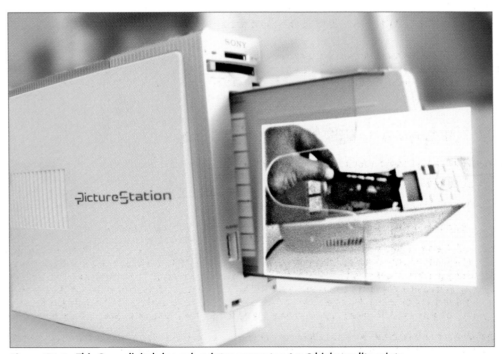

Figure S8-2: This Sony digital dye-sub printer generates 4-x-6 high-quality prints.

Printing high-quality inkjet photos

Inkjet printing is the most versatile way to print digital photos, capable of printing to a wide variety of media, from plastic sheets to CD covers. The achievement of high-quality photo inkjet printing is a product of parallel developments in paper, ink, and the inking process. These three processes need to mesh on a finely tuned level to produce digital prints with photo-printing quality color. As opposed to the virtually limitless color generation that takes place when photo chemicals interact with photo paper, inkjet photo printing is constrained to colors that can be generated by mixing four, six, or eight colors of ink.

How, then, can these printers produce *millions* of colors required for decent, let alone great-quality photo prints? The answer, in a word, is *dithering*. Inkjet printers combine as many as 20 different ink droplets to generate a composite color. These droplets are too small to be distinguished by a human eye, even with a magnifying glass. They blur together to produce colors.

The math of all this is expressed in the discrepancy you'll note between the resolution at which you need to save your photo image file, and the resolution advertised by your photo printer. For example, you can produce fine prints from a photo saved at 180 dpi (dots per inch) in Photoshop. But the Epson Stylus Photo R800, to use a good-quality desktop studio printer as an example, prints with a horizontal resolution of 5,760 dpi. A quick trip to the calculator reveals that, for every dot/pixel (they're the same thing) in the image file, the printer will print 32 dots. Each of those dots can be a shade of any of the eight ink colors available, and these 32 dots will *dither* to produce the color represented by a single dot of image data.

Demystifying inkjet resolution

The calculation in the previous section illustrates the purpose of the very high resolution offered by photo-quality inkjets. You don't need all those pixels per inch to get *resolution;* you need them to get accurate *color.*

All those dots require a paper surface that can accurately absorb the ink, without running, smearing, or penetrating too deep or too shallow into the paper. Printer manufacturers put a lot of research into carefully matching ink and paper so that the extremely fine jets of ink that come shooting out of a modern inkjet printer are absorbed with precision by paper.

Note The emphasis here on the significance of high-resolution printers is only relevant to inkjet printing. Dye sublimation printers, which are also used commonly by semipro and professional photographers, use a very different process to produce accurate colors — instead of dithering many dots to create colors, they are able to more accurately combine colors in a single, larger dot.

Ink droplets are measured in picoliters. There are a thousand picoliters in a liter — which is roughly a quart. Interestingly, ink droplets are measured in *volume* not diameter. So, the correspondence between picoliter volume and dot-per-inch resolution is not mechanical or fixed but depends on how finely the process of spitting ink onto paper is, and how accurately the paper absorbs the ink. But, in general the lower the quantity of ink in picoliters, the higher the resolution and the resulting color accuracy.

The Epson Stylus Photo R800, for instance, produces 5,760 dpi resolution (although, as noted earlier, the real resolution is constrained by the dpi resolution of the image file). That high resolution is a product of the fact that each inkjet burst is of extremely small picoliter volume — in this case, they are 1.5-picoliter droplets.

Matching inkjet paper and ink

Companies like MediaStreet, Pictorico, Hahnemuhle, Moab, Lyson, Crane, and others make wide varieties of paper surfaces, textures, and coatings that are used to print professional-quality photos. Available

paper surfaces include rag, silk, canvas, velvet, and watercolor paper. You'll find these specialty photo papers online from sources like www.inkjetgoodies.com. There is also a wide variety of quality special photo paper products, such as folding greeting cards.

It's essential that ink, inkjet processes, and the paper you choose all work together correctly to generate the best-possible images. So, how do you make sure your paper works well with your inkjet printer? Manufacturers of photo paper provide either ICC profiles or compatibility charts to tell you what settings to use on your printer to match their paper.

Cross-Reference For more on ICC profiles, including for specialty papers, see Stage 5.

Rely on ICC profiles to connect your image-editing software and your printer. ICC profiles are at least as important for your paper and ink as they are for your printer itself. A mismatch between your print software setting and your paper, in particular, produces unpleasant results.

Six-, seven-, and eight-color printing

Even extremely high-resolution color dithering fails to do a good job producing some colors that are very common in photos, including the skin tone of lighter-skinned humans, sometimes referred to as *flesh color*. This color is found frequently in photos. Another challenge to inkjets is reproducing a smooth, unbanded continuum of colors, like those in Figure S8-3.

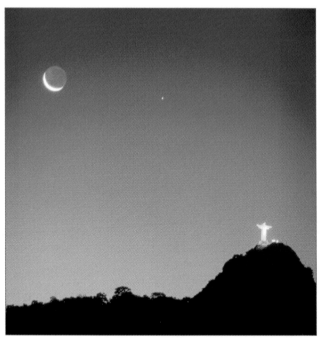

Figure S8-3: This moonlit photo of Rio de Janeiro can tend to band with four-color inkjet printing.

To augment the range of printable colors, high-quality photo printers include additional print cartridges. In addition to the basic cyan, magenta, yellow, and black cartridges, they add light black, photo black, light magenta, and/or light cyan. The light cyan and light magenta help solve the flesh-tone issue, while the special photo blacks allow a more subtle gradation of black and gray than is achievable from standard black ink.

Printers that provide six colors of ink include the HP 3650, HP 5150, Lexmark P707, Lexmark Z705, Lexmark Z715, Lexmark Z815, Canon I900D, Canon I960, Epson Photo R300, HP 5650, HP Photo 7660, HP Photo 7760, Canon I9100, Epson Photo 1280, HP 9650, HP 9670, HP 9680, Lexmark 45, Lexmark 45N, and Lexmark 45N Solaris. Printers that provide eight colors of ink include the Epson Photo 2200, Epson Photo Stylus R800, and HP Photo 7960.

These six-, seven-, and eight-color printers do provide a wider and truer range of colors and will enhance the printing of photos of people. But many four-color printers also produce excellent prints.

Matching ink with photo paper

The famous Rorschach inkblot test used by generations of psychiatrists to find out what a patient sees in a random ink splotch has its origins in the fact that a drop of traditional ink on a piece of traditional paper produces a mess. Given what I've explained about the extremely high resolution of inkjet droplets, it's obviously critical that these drops are accurately absorbed by photo paper.

Photo paper manages the absorption process through multiple layers. You sometimes hear people talk about four-, five-, even ten-layer or more paper. These layers serve the process of absorbing not only the ink shot at the paper, but excess water in the water-based inks. Although there are many varieties of photo paper, the layers that comprise the paper fill four general roles:

✦ The surface layer retains ink — this is the critical surface that displays the absorbed inkjet droplets.

✦ An underlying layer absorbs water, pulling it away from the surface to prevent blurring.

✦ A second underlying layer is the final absorption sheet. Additional underlying layers further facilitate the dissipation of liquid to avoid smearing.

✦ The backing of the paper helps manage feed into and out of the printer.

Glossy versus matte

Glossy paper reflects more light than matte (textured) paper. Therefore, glossy produces brighter colors than matte. At the same time, modern matte paper reproduces extremely bright and sharp color, without the glare associated with the surface of glossy paper. Matte surfaces have the advantage of resisting fingerprints and stand up better to wear and tear. If you're using your studio printer to proof output that is ultimately destined for a professional print shop, you'll obviously want to test your print on the type of paper that will be used for the final print.

Glossy paper works particularly well with the inkjet processes because of the special challenges of absorbing so much ink. Photo matte paper comes close to glossy paper in producing color photos, and the soft, flat (non-reflective) surface can often lend realism to a photo print.

Inkjets also support a wide array of special photo papers with surfaces that run from highly textured to super-glossy. Fabric and woven photo paper can yield interesting textured output. Specialty photo paper is available in textures ranging from satin to canvas. Telling what a print will look like on textured paper is difficult — particularly on special-effect papers like watercolor or canvas. The photo will look less realistic, but the additional texture may give the photo a distinctive look.

Inkjet archival prints

Inkjet manufacturers now routinely promise print life in the decades — 60 years, 70 years, and more. These advances are due to improvements in paper, ink, and the interaction between the two. In particular, Epson's ultra-gloss inks are highly acid-free, and deteriorate very slowly.

Obviously, how you care for your digital prints affects fading. Keeping prints away from direct light prolongs digital photo prints. Framing photos behind glass helps protect them as well. And, for prints you really want to preserve, you can turn to professional printing services that use printing processes close to traditional photo printing — which I explore at the end of this chapter.

Of course, many argue that the ultimate backup of a studio print is the digital original that can be reprinted as necessary. Still, if you're producing high-quality prints for gifts, for display, or for sale, you should check out recent developments in archival-quality prints that last for decades without noticeable fading.

Archival-quality prints depend on a proper combination of ink, inkjet technology, and durable paper. Special inks are developed that last a long time. High-end photo printers use processes that incorporate drying and sometimes coating to protect photos. And the ink and inking processes must fit together tightly with the absorption properties of archival-quality paper.

Printing dye-sublimation photos

Dye sublimation is a distinct digital printing process that in many ways is more similar to traditional photo printing than inkjet printing. Dye-sub printers produce superb color — but at a price. The process of converting ink to a gaseous form, and then condensing (sublimating) the ink onto photo paper can be price-competitive with photo processing or inkjet printing only in two formats — very large, expensive, commercial printers, and very small desktop dye subs.

To appreciate dye-sub technology, it's helpful to return to the discussion in Stage 5 on the difference between how colors are generated on a monitor and how colors are generated in a printer. Computer monitors generate colors by adding red, blue, and green in each pixel (one of the tiny dots that compose your screen). Inkjet printers generate millions of color by dithering cyan, magenta, and red — subtracting colors as the ink is stacked onto the page.

Note Traditional photo printing, in contrast to dye sublimation, is a more flexible process for generating color. Photo chemicals used to process photo paper interact with the paper on a molecular level – in bits far smaller than even the finest inkjet blast. For this reason, traditional chemical photo printing is often considered superior in producing natural, fluid, blending color in photos.

Dye-sub printing does overcome some of the limitations of digital printing. *Dye* refers to the ink that is transferred to paper. But the ink is not shot onto the photo paper in dithered dots to create (the illusion of) many colors. Instead, dye-sublimation printers use a heater element to heat up an ink-permeated film, releasing cyan, magenta, and yellow dye in a gaseous form. Molecules of cyan, magenta, and yellow are mixed before drying, producing very subtle coloration.

Dye-sub quality

There is a clear difference between the look of a dye sub photo and the look of an inkjet print. Using the same settings, my Sony dye sub consistently produces softer, smoother, more natural color than four-color inkjet printing, and sometimes even better than six- or eight-color inkjet prints. This difference is most noticeable for prints with light skin tones, which often appear blotchier and more flushed in inkjet prints than with dye-sub prints.

The higher resolution available with inkjets, however, does better displaying detail. Dye subs, remember, do not rely on high-resolution dithering to produce color, so the dpi is much lower than with inkjets. Resolution for dye subs is increasing—dye-sub printers are now available that print at a resolution of 400 dpi and higher. But that is still only a fraction of the dpi available from high-quality photo inkjets.

Dye-sub paper and ink

The sensitive contact between dye and paper in dye-sub printing makes it essential that you use matching paper and ink sets. You won't shop around for different paper suppliers for your dye-sub printer. Dye-sub manufacturers sell dye cartridges and paper together.

Paper is loaded into dye-sub printers in cartridges, similar to those used in small inkjets. The *dye ribbons* (wide strips of acetate imbued with dye) are dropped into the printer. Paper options tend to run from 4-x-6 postcard-sized prints to even smaller 3-x-5s. You won't be framing a lot of prints from your desktop dye-sub printer, but you may find them helpful for quick proofing, especially for quality color proofing of prints that are destined for a professional print shop.

The economics of dye subs

Dye-sub ink and paper are sold together in kits. That makes it possible to calculate a price per print fairly easily, as opposed to all the variables in inkjet printing (where resolution, colors in a photo, coverage, and other factors affect the longevity of ink cartridges). A pack with dye-sub paper and ink for 75 postcard-sized prints is currently going for about $40, which comes to a little more than 50¢ a print.

Note Printer manufacturers have experimented gingerly with studio-quality dye subs that print 8-x-10s. At this stage, larger prints are generally only possible on professional-quality dye subs.

Dye-sub prints are a bit more costly than inkjet prints. Because of the limitations on print size and the overall cost, the investment to improve the technology is very limited in comparison to inkjets. Key features such as the user interface, imaging pipeline technology, auto image adjustments, and overall ease of use are not going to be on par with what inkjet solutions can offer consumers. At the same time, the improvements to and lower pricing for the latest generation of small dye subs is producing fun, competitive printers that have certain advantages in color quality.

Caution One hassle you'll encounter with dye-sub printing is that you can't easily switch between printing postcard (4-x-6) prints, and smaller 3-x-5 prints. Dye ribbons are matched to paper size, so swapping paper size means you also have to pull a fragile, half-used dye film out of your printer. You can do this by safely storing the partially used dye ribbon in a sealed, shaded plastic bag.

Using Service Bureaus

The term *service bureau* essentially refers to any photo-processing lab that takes your digital images and prints them. The lab may be around the corner from your studio, downtown, in some other city, or online. There are many varieties available, with equally diverse services, features, complications, and quality. Most pro photographers use a mix of service bureaus along with printing in-studio or on-location, depending upon the nature of the job. There's an old adage about the service business that "you can have what you want done fast, cheap, or with high quality—pick two," and that certainly applies to photo service bureaus. There are a number of issues to consider in printing photos in this manner:

Service Bureau Printing for Long-Lasting Prints

Many service bureaus have standardized on high-end, photographic-type printers such as the Fujifilm Frontier-series printer. This expensive device takes your digital image and projects it onto photographic paper, where it is then printed using conventional photography chemicals. This produces consistent, high-quality prints. However, high-end printer manufacturers such as Epson are targeting this market and are doing their utmost to convince service bureaus to convert to inkjet printers. Epson, for example, promises the same, if not better, quality, including assuring clients that the prints will last for 100 years or more—because fading and sensitivity to ambient light is a very real concern. Some prints may look absolutely wonderful when they come out of the printer, but hang them in a frame near a window and after five years they begin to fade. Another method commonly used for smaller prints, such as with the Fujifilm Printpix system, involves no ink or chemicals, just a special thermally sensitive paper coated with yellow, magenta, and cyan colors—making it very easy for the service bureau to operate and maintain the printer, and ensuring it is environmentally friendly. Check the process your service bureau uses, and ask for samples. Check the paper and the image quality, and ask them to give you specific information about the fade factor of their materials for any image intended for framing or keeping for many years. If they don't know, don't use them!

✦ What kind of quality does the project demand?

✦ Are there any special printing needs, such as printing on canvas, significant touch-up, or a very large print?

✦ How quickly do you need your work done?

✦ How limited is your budget?

✦ Are the image files very large?

✦ Do you have a large number of images or just a few?

✦ Is this a proofing stage with your client, or a final print for framing?

✦ Is the service bureau printing digital images using a high-end, large-format inkjet-type printer, or a photographic printer?

The answers to these questions may very well dictate how and where your images are printed. You need to know how and when to use the various services.

Using local service bureaus

A local service bureau may be your local drugstore one-hour processing center, or it may be a pro lab in a nearby city. In any case, it's easy to get to and your project won't be delayed or have costs increase due to shipping or mailing—or be exposed to the risk of having it damaged or lost. If you're lucky enough to live in a city where there's a high-end pro lab, you have the best of all worlds.

For fast proofing, to get a client a mini-album of 100 prints, for example, you may want to just use your local drugstore—when quality isn't a primary concern, but speed and price are important. The only problem with this is that you'll find results from various one-hour-type operations that range from terrible to surprisingly good, so you'll want to check out how they perform before running in with a last-minute job.

Further, they may have problems working with digital files, and you may get the deer-in-the-headlights look from the clerk if you're handing him a disk that needs to be serviced quickly. One thing to confirm is that they do, in fact, do the work locally — some smaller one-hour businesses will send out a CD because they're unable to do it on-site.

Using Costco or Wal-Mart is perhaps the best way of using the fast local method — they have the best-quality printers, service, and prices. Costco, for example, uses the same printers as many high-end labs, and they're very diligent about monitoring ink and chemical quality; plus, if you have a problem with your prints Costco is very good about redoing the job at no cost to you. Their enlargements are actually quite good, and I've even used them for the occasional 8-x-10 wedding print.

For example, a Fjifilm Printpix DigiCam Picture Center 1000 might be used by local service bureaus to print high-volume, low-cost 4-x-6 and 6-x-8 photographs. It requires no consumables other than paper, can print up to 330 4-x-6 images per hour, and directly accepts digital-camera media such as CompactFlash cards — eliminating the need for photographers to burn images onto a CD or other media first.

Larger urban areas feature a wide variety of service bureaus, including hybrid photography service bureaus that offer relatively high-end services and larger prints as well as consumer one-hour prints. Most of the stores that also sell camera equipment, typically offer nothing more than what you'll get at Costco — which may have better-quality printers. Most often, however, you want to look for high quality at labs that are large businesses servicing pro photographers. These aren't typically located in shopping malls or retail centers, but rather are located in industrial corridors where they have the full benefits of setting up their labs with environmental and industrial-grade construction and waste-disposal capabilities.

High-end photographic imaging service bureaus such as these use only state-of-the-art equipment and offer images of all sizes to all types of photographers — from consumer to pro. Consumers will find their prices very high, but pro photographers will not find (locally, at least) anywhere else to have high-quality prints produced. These firms also print on other materials, such as Duratrans, which is the plastic sheet material you typically see illuminated in airports with photo-type ads. These, as well as high-end paper prints, are produced photographically, often with a special laser process using red, green, and blue individual lasers that render precise images without any visible pixel dots.

This kind of service is essential if you're an advertising photographer or if you're creating images for display at a high-end exhibit. These bureaus offer all types of photographic services — including vast support for film — in addition to other photography-management offerings such as digital-asset management. They'll actually store all your images in a safe, RAID-protected system that is backed up daily and accessible via the Internet. For an example of these types of services, visit Ivey Imaging at www.ivey.com; Ivey Imaging is a Seattle-based service bureau with very-high-end capabilities.

Note　RAID systems provide an automatic "redundant" backup, so that if one hard drive fails you still have the other.

Other local service bureaus may specialize in one type of photography or another, such as advertising or weddings. Most of these bureaus provide delivery to individual studios for a nominal price (or even free, with an account), a highly accessible and knowledgeable staff, and many other niceties making pro photographers' lives easier — almost always, however, at a price.

High-end local service bureaus are accustomed to receiving images in all types of formats, both in person and online. Photographers send CDs to them, e-mail images, and, quite commonly, upload them to the service bureau using an FTP site to which the photographer has been given access.

Using remote service bureaus

Remote service bureaus aren't that much different from a local bureau except that they're not set up for you to walk in and do business — they provide photography fulfillment to you over the Web, on the phone, and through the mail. Although some larger local bureaus often do remote business nationwide, it's not typically their bread and butter. Major remote service bureaus are scattered across the country and often specialize in specific types of photography:

✦ High-volume printing, such as several hundred copies of an 8-x-10 for a model to distribute

✦ Fine-art prints

✦ Giclée prints, which are the highest quality of digital photo printing with excellent archival ratings (up to 200 years). However, Giclée (gee-clay) prints are very expensive.

✦ Postcard printers who print high-quality promotional cards for photographers

✦ Wedding and portrait prints, including canvas and other higher-end, archival-quality prints

✦ Black-and-white prints

✦ School and sports picture processing (These services often offer a complete system providing photographers with envelopes, pricing/printing options, and other features oriented toward helping them sell students and athletes picture packages.)

The pricing these remote bureaus offer is almost always exceptional for the quality and turnaround, and most of them pride themselves on their telephone support, because that's the customer's primary way of communicating with them. Often, you can find these printers listed in the back of pro photography magazines under "lab services" or similar categories.

Using online service bureaus

There are a number of popular online service bureaus for consumers, representing the Web-based version of a one-hour developer. These services allow customers to post and share their photos online and have them printed. Kodak's www.ofoto.com is perhaps the best known; however, there are other popular sites such as www.snapfish.com, www.dotphoto.com, and www.shutterfly.com. These bureaus print photos onto paper and gift items such as T-shirts or coffee mugs, and friends and family members can view and purchase the images online from anywhere.

There are professional sites, however, that service pro photographers in a similar manner but are oriented towards higher-end features and quality. They also often provide an online storefront where images can be presented and sold. Tiger Mountain Photo uses www.printroom.com, which has more than 2,000 photographers using its service to display tens of thousands of images to thousands of clients.

Other services for pro photographers include Pictage (www.pictage.com), which serves the wedding photographer market, especially www.collages.net, www.proshots.com, www.eventpix.com, and www.photoaccess.com. These services require a registration/sign-up fee and allow photographers to display multiple galleries online in various arrangements and designs, and for clients to be able to see the galleries online and purchase images. Photographers set the prices themselves, and the service bureau receives a percentage of the sale and processes the images, mailing the finished product to the client. Figure S8-4 shows a page of galleries at an online professional print service.

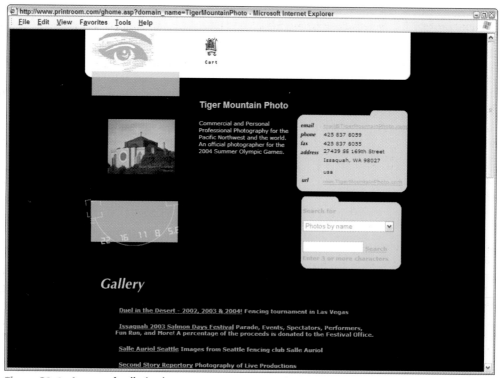

Figure S8-4: A page of galleries by `www.printroom.com` for Tiger Mountain Photo

Placing your business online with these companies is a commitment, more so than merely having a service bureau process your photos. You should check to see what is available for your needs before you sign up, because these services may offer a wide variety of features and capabilities, including

✦ Online storefront fulfillment (meaning the service bureau processes credit cards and ships the product, and you don't have to deal with it)

✦ Customizable storefronts that look like your Web site or even integrate completely with it by using HTML code that you provide

✦ Marketing programs to help you sell images faster, such as volume discounts, on-site coupons you can sell at an event, or e-mail promotions to your existing/previous customers

✦ High-end wedding-album services, ranging from online design using templates to connecting with actual designers to create original custom books

✦ Automated proof-book ordering

✦ Image enhancement, both manual and automatic

✦ Multiple ways of delivering images to the service, such as via FTP, e-mail, CD, or other means

Try out an online service before paying a registration fee, if at all possible, to ensure their quality, service, and responsiveness meets the standards of you and your clients. Look at how they ship the products. Is it done professionally? If you were paying a lot of money for a nice print, is it what you would expect?

Professional online photography services really become an integrated part of your business, unlike local service bureaus. This is because you'll be spending time working with your online galleries, the service will most likely be tightly integrated with your Web site (to the point that many customers may not know the difference between your own Web site and your storefront galleries), and the online business will be a big part of how customers rate you as a business — meaning how the online service performs is a direct reflection on your studio. For these reasons, choose carefully; it's difficult to back out of an online service bureau commitment after you've uploaded thousands of images in multiple galleries, and incorporated the service bureau into your Web site.

Another way to work with online service bureaus involves complete customization, and you do almost all the up-front work. Sites like www.ezprints.com provide the fulfillment capabilities, but often you must create a Web-based gallery that they service. Ultimately, you have a lot of control over how your work is presented, but you also end up doing a lot of the work in terms of customer service and there may be a relatively steep learning curve. These services may also offer less in the way of marketing promotions.

The Total Cost of Printing

In digital photography workflow, understanding how much your work costs is an important factor in ensuring you're running an efficient, successful business. You may have invested a considerable amount of money into capital equipment, such as cameras and computer hardware, software, backgrounds, lights, and other high-ticket items. This is typically the equipment that you will depreciate over time. But what about the consumable of digital photography?

In the film world, consumables were certainly more pronounced, especially if you were processing and developing your own film and exposing your own photographs in a darkroom. You had the cost of the various chemicals, as well as paper and film.

In digital-photography workflow, the consumables don't come at the front end of the process, but rather at the back end. Obviously, there's no film and you can put virtually as many photos as you want on a flash card depending upon the card's capacity and other factors, such as the image size you're shooting. The cost comes in printing your images, which, unless everything you do only goes onto the Web, is bound to be an ongoing expense.

Whether you print your own photos or you use any type of service bureau, it's important to understand the concept of the *total cost of printing* (TCOP). This is a way of calculating what it costs to make prints, including paper, ink, and, if appropriate, any lab surcharges. The term *total* may be a bit misleading, because it

Calculating Hardware Costs

You can calculate hardware costs using a comparative pricing formula. However, to arrive at a realistic and accurate number, you should only include the amount of money purchasing a printer would cost *above and beyond* what you would have in the studio even if you were not creating your own prints.

For example, the computer you use to edit photos, the storage devices you use to store photos, the networking equipment and connections in your studio, your workspace, and so on are all necessary even if you aren't managing a digital photo studio. At the same time, a digital photo setup requires *more* computer processing, *more* storage, and faster bandwidth connections than a configuration that may be sufficient to handle the business end of your photography work.

Further, you'll want to spread the hardware cost over the reasonable and expected lifespan of the hardware — which is another reason I don't normally include hardware costs in TCOP calculations.

does *not* take into account the cost of purchasing a computer or printer if you're doing it yourself. It also doesn't consider travel costs if you're driving to and from a lab to drop off and pick up your prints.

What does TCOP take into consideration?

✦ The cost of making prints at a lab, at a per-print basis, which can be calculated either by print size (4-x-6, 5-x-7, 8-x-10, and so on) or by square foot of paper used

✦ The cost of shipping to and from a remote lab, if you're incurring that cost (in the case of professional online fulfillment services, the customer pays shipping, not you, unless you're ordering the prints shipped to you directly)

✦ If you're printing your own images, the cost of inkjet ink/cartridges, paper, or dye sublimation printer ribbons

Realistically, you'll probably find that you use different printing solutions for different projects, depending upon the quality you want, the amount of time you have, where the clients (or potential image-purchasers) are located, and other factors. Few photographers print their images just one way!

In addition to knowing which service or printing method works best in terms of quality and delivery time, it's also, then, important to know the relative cost differences between printing methods, which is the crux of the TCOP concept. For a lab, it's easy to calculate costs, because you know how much it will cost, specifically, for a print and you can easily track that.

When you print yourself, however, calculating costs is a little tougher. For example, an 8½-x-11-inch sheet of high-quality Ilford, Canon, or Epson inkjet paper may cost about 50¢ a sheet. To that, you must add the cost of ink (see the section following this one, discussing aftermarket inkjet cartridges). — which can be tricky, considering that in higher-end inkjet printers there are multiple tanks of ink with different colors, and each runs out at a different time. To further complicate matters, if you make a mistake and print an image at the wrong size, the printer prints poorly (for example, if the nozzles need to be cleaned), or if you happen to print an image and find that you don't like how it turned out and you want to print it again, you've just doubled the costs for that specific print.

Most printer manufacturers state a per-print cost for various models, which isn't that different from an auto manufacturer stating the miles-per-gallon (MPG) a car is expected to have in the city and on the highway. Of course, MPG varies depending on how and where you drive, and, likewise, TCOP for a printer varies depending on the type of images you're printing, if you make a mistake, and so on. The printer manufacturer cost ratings are often based on a very limited *ink load,* meaning that, realistically, you'll probably be printing images with lots more ink per page than the amount they used to rate the printer.

I called a number of printer retailers who gave estimations of somewhere between $1.60 and $1.80 for 8-x-10 prints produced by two of the current best-selling pro photo printers. This included ink and paper costs using manufacturer-recommended consumables.

However, my recommendation is that you multiply these costs by at least 40 to 50 percent to guesstimate a reasonable cost—making it well over $2 a page for an 8-x-10 and something you must realistically consider when shopping for a new printer. You should compare these prices to a lab. For example, www.ofoto.com, as of this writing, charges $3.99 for an 8-x-10 while Costco charges $1.99.

A good way to track your own paper and ink costs is to record the following information over a period of about three months:

✦ The amount you spend on ink cartridges.

✦ The amount of paper you use, including rejects, and the amount it costs you per page. Simply divide the number of sheets in a box by what the full box of paper cost.

✦ The number of prints you produce, and their specific sizes. If you print two 5-x-7s on one 8-x-10 page, then count it as an 8-x-10.

Based on the numbers you get from this information, you can calculate your per-page cost. For example:

Consumables over three months:

25 Inkjet cartridges	$10 each	$250
220 sheets of 8-x-10 paper	$0.50 each	$110
Total consumable cost		$360

Number of finished prints completed:

150	8-x-10s
60	5-x-7s (or 30 8-x-10s — counting two 5-x-7s per page)
Total consumable cost	$360
Divided by total 8-x-10s	180
Equals	$2 per 8-x-10 page

Over the same time period, you then combine your cost for your own printing with that of the lab(s) you're using to give you a cumulative TCOP. In this way, you can at least generally (and, if you're very methodical, very specifically) understand how much you're spending.

There are several ways to optimize your in-studio TCOP:

✦ Make sure to calibrate your digital-studio color to ensure your monitors, software, cameras, and printers are producing consistent output.

✦ Use good-quality photo paper, and try to limit mixing papers — they'll produce different results.

✦ Clean your nozzles and print heads using the software utility that comes with the printer on a regular basis — more frequently if you're printing often.

✦ Print as many images onto a page as possible. Adobe Photoshop, ACD FotoSlate, and other packages offer ways to optimize prints per page.

✦ When printing test images, use lower-quality settings because high-quality settings consume more ink.

✦ If you're purchasing cartridges and paper from a local photo store, and you're selling the prints to clients, you may be eligible, as a business, to claim these products as "for resale," and therefore not subject to tax. Ask your retailer and they'll provide you with a form to fill out to request this status.

Aftermarket Inkjet Ink Cartridges

A quick visit to a search engine and typing *inkjet cartridges* yields a plethora of companies offering tremendous and enticing savings on ink for virtually any brand and model of printer sold. However, buyer beware: You may be causing yourself more problems — and incurring more expense — than you ever expected.

Not all inks are the same. Most manufacturers pride themselves on producing inks supposedly optimized for the printer, and with the best-possible archival quality. After-market cartridges may be using cheaper

chemicals that present a couple of notable potential perils: They may fade much faster than better ink and they may not render colors as accurately as manufacturer-recommended inks.

Note When working with inkjet printers, you're dealing with a nearly infinite amount of colors mixed from the combination of inks, and controlling the results is tough even under the best circumstances.

There are other potential problems including cartridges that don't fit into the printer very well, which means they are useless; and cartridges that leak ink, both inside the printer and outside onto the desk or studio floor. You may find yourself cleaning nozzles more often than necessary, which means you're using more ink — and it's costing you more than you thought you were saving.

Finally, by using an aftermarket inkjet cartridge, if the printer head becomes faulty or experiences problems, you may have invalidated your warranty (that is, assuming you inform the manufacturer that you're using non-recommended cartridges or they see them in the printer when you return it for repair).

With any of these problems, your TCOP can be negatively affected, and that means your cost savings per cartridge has just lost its value. One option is to use the cheaper inks on one printer for higher-volume, lower-quality prints (such as proofs or in-house review), and use another printer loaded with high-quality ink for final printing.

Before using any aftermarket cartridge, and certainly before purchasing a large quantity of them, test to see how compatible and accurate they are with your computer. Print two pages — one with original inks and one with aftermarket — using exactly the same parameters, and compare the results. Place the prints in direct sunlight, such as in a brightly lit window, for about a week and see what happens. If the images are anything but equal, you'll want to think carefully about whether you can trust your output with the inferior ink.

Of course, this isn't to say that all aftermarket inkjet cartridges are bad — some are made to very exacting and high-quality standards and could potentially even exceed the quality of your manufacturer's ink (for example, Lyson produces superior aftermarket ink; you can find them at www.lyson.com). However, testing what you're buying and making sure it's of the best-possible quality for what you're producing is important. This alone ensures your TCOP is optimal.

Summary

Printing digital photos can be a tricky business. Photographers have the option of printing in-studio or at a lab, and for either solution multiple options, cost implications, and quality considerations require significant decisions to be made.

In-studio inkjet and dye-submlimation printers produce self-printed photographs of extremely high quality, but they can be expensive and are required to be color-correct, matched with the right paper, and managed to ensure ink is ready and flowing. Service bureaus — including online image fulfillment — provide superior quality and color management, but images must be in a final ready-state to be printed and printing takes more time.

Every photographer will doubtlessly use a mix of in-house and remote printing solutions to match the prints needed for various jobs to the services required, the quality needed, and the economics involved. Learning how to manage these multiple options takes practice and experimentation as well as an understanding of how to match the service to the situation. Once that is achieved, outstanding quality can be attained for virtually any printing need.

✦ ✦ ✦

Digital Image Display and Distribution

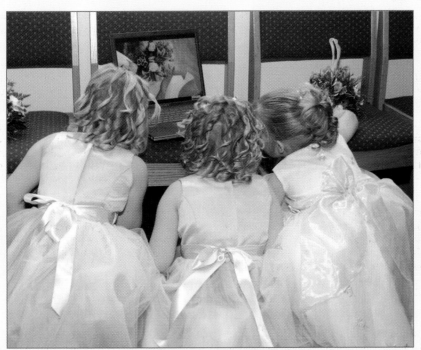

With digital images and a laptop, photos of a wedding ceremony can be viewed in a slide-show format even as soon as the reception. Taken with a Canon D60 at ISO 400, f/4.0, 1/60 second (with flash), and 24mm focal length.
Photo courtesy of Amy Timacheff

Since I was a child, I've loved looking at photographs. *Life, Look,* Germany's *der Spiegel, Paris Match,* and *National Geographic* were all wonderful sources of images of the world and its wonders — of humanity, nature, events, beauty, art, exotic locations, and even unknown frontiers like space and the ocean. Growing up in Europe and the U.S. in the '60s and '70s, magazines were my primary format for viewing amazing photographs and images.

In college, I spent hours putting together a slide show using two projectors I synchronized with a cassette player that had music as well as embedded signals causing the slides to change automatically. Having two projectors allowed the slides to transition and fade in and out at different rates. Really high-tech stuff. And really fun!

Understanding how to put your photographs on display and get them distributed is, at least in part, what photography is all about. Digital photography workflow, as it relates to display and distribution, means knowing how to process images so they can be shown and most effectively reach their intended audience and recipients. Who hasn't been annoyed by a slow-loading Web site filled with oversized images, frustrated by trying to work with a digital photo with impossibly poor quality, or struggled to determine how to best place their photos on display?

Photographers love to show their work—wherever, however, and to whomever they can. Art and photography are about seeing the world in a unique way, rendering it into a format suitable for someone else to enjoy, and then showing it off. Even something simple and relatively unnoticed by the world passing by, such as an old nail hammered into a tree, can be made into an artistic image for others to enjoy if captured and displayed correctly (see Figure S9-1). That said, who hasn't endured a boring slide show of mundane, poorly composed images some enthusiastic shutterbug trapped you into viewing at some point in your life? At the same time, textbooks, the Web, and magazines would all be pretty dull without photos to punctuate the articles, stories, and information.

Figure S9-1: I'm no different from any other photographer—I love to show my work! This old nail caught my eye in Plovdiv, Bulgaria.

Displaying Your Digital Images

Commercial and pro photographers must show their photos to clients in some manner. Being able to present images in the best and biggest manner possible means optimal sales and revenue. Although the slide show has long been the mainstay of film and pre-Web presentations, today most slide projectors are either stored away in a closet or up for sale on eBay. Even for film photographers, converting film to digital and storing images on a CD makes for easier presentation.

Today, more photos than ever before are shown to the world, thanks to the technological advance in hardware, the Web, software, and cameras. Some cameras have the ability to directly display images on a TV, for example, and with the proliferation of DVD players, it's relatively easy to provide clients with a disk they can play on their home theater systems without any special equipment beyond what they'd use to watch a movie.

Being digitally prolific is cheap and easy, and, in spite of the doomsayers predicting the demise of paper, more photos are being printed on more paper today than ever before in history. But that doesn't mean all the images are good ones. Without a doubt, good photography on the Web or anywhere else is actually becoming more rare, only because so much of it is diluted by images we'd rather not bother seeing. Good photos or bad, you've never had more ways to display and distribute photography, and it's never been easier. For most photographers, it's a dream come true.

For displaying photography, you'll want to think through several key questions; some of which are subjective, artistic considerations while others are merely addressing the technical and logistical demands of digital photography:

✦ What images do you need to display, and why?

✦ How can they be shown to your target audience(s) in the most efficient, best manner possible?

✦ Will the images be displayed as prints, on the Web, or in a digital slide show?

✦ What is needed to display the images, in terms of hardware, software, and the Web?

✦ How much time, cost, skill, and effort will it take to display your images?

The necessary images

Deciding upon images to display is one of the most subjective challenges the photographer faces, especially in an era where it's so easy to produce so many photographs with relative ease and little or no cost.

When displaying images, in whatever format, early on you'll want to become adept at grouping and ranking your photographs in order to pare them down to a manageable number. Whether you're shooting weddings, nature, sporting events, or anything else, nobody wants to endure lots of mediocre photographs just to be able to enjoy a few good ones. Software programs such as Photoshop and ACDSee offer systems for ranking and rating images, and it's a good idea to make use of these frequently.

To choose your best images, ask yourself these questions when deciding on images to display:

✦ Is the image truly important to the project, whatever that may be?

✦ Is the photo redundant? If so, which of the redundant images is truly the best?

✦ Is having too many or too few images doing the audience or client a disservice, or something other than what they expect?

✦ Is the photograph going to pose more questions than it answers? For example, taking a wedding photo that didn't turn out well, such as one that's soft, and treating it artistically might look nice. However, what do you do when the client asks for the original?

✦ Is the image part of the story you're telling for a given photography endeavor? Sometimes you might see an interesting artistic angle or shot, but if it really doesn't pertain to the topic, then showing it might not be prudent.

As you take more and more digital images, you'll learn to make very fast decisions about images and these questions will become second nature. At the beginning, however, it's to be expected that you're going to have a very hard time making decisions about which are your very best images, but that is ultimately what will help people truly appreciate your work the most.

The necessary equipment

I've developed a three-part format for my photography workshops — which I present to amateurs, enthusiasts, and pros — that spans a variety of topics. During the workshop, I begin with a combination discussion and lecture that includes a presentation of my own images, related to the topic or location. This is followed by a practical exercise, where the workshop attendees go out and shoot a specific assignment. The third component of my workshops involves having participants display the photos that have been taken during the workshop. The group then critiques and reviews the displayed images.

This workshop format would be impossible without the innovations in both digital hardware and software commercially available today. Here's what I generally need to accomplish the display portion of my workshops:

✦ An LCD projector

✦ A portable screen

✦ A powerful laptop with plenty of memory

✦ Portable speakers

✦ A multifunction flash-card reader (attendees often have a wide variety of flash cards with their digital cameras, especially the point-and-shoot kinds)

✦ Extra USB cables (preferably USB 2.0) with various types of connectors

✦ Image-management software

✦ Image-editing software (Photoshop CS, Corel PHOTO-PAINT, or ACD FotoCanvas)

✦ Display software (ACDSee, ACD FotoAngelo, or iView MediaPro)

You may choose to show images on a TV using a direct connection from your computer or camera, and you may decide to put the presentation on DVD or CD; you may even want to show images on a computer screen. Each of these options has specific considerations for software and hardware, and some options are easier and more accessible than others.

Putting a slide show together

While it seems like a lot of equipment, displaying digital images is actually quite easy when compared to the old-fashioned slide show with multiple projectors cluttered with little gadgets to help with sound, fades, and the like. Given that your computer can handle both sound and images, that alone lowers the

hassle-factor of setting up a show tremendously. Here are ten tips to consider for putting an effective a slide show together using the equipment I've described (obviously, there are multiple ways to do this):

1. Prepare your slide show using a software program that can handle sound and image fades, and run automatically or manually (you may wish to forward slides, for example, by clicking the mouse or have them advance automatically every few seconds). See the "software" section below for more information.

2. You may want to put your slide show onto a CD or DVD, depending upon how it will be displayed or if it needs to run on another computer (or, in the case of DVD, on a TV set with a DVD player).

Note You'll want to determine if your slide show program integrates the images, or if the images need to be copied along with the slideshow onto the CD or DVD; otherwise, you might have a slide show missing the photos! Integrating the images into the slide show in a self-running format is usually a option in slide show software.

3. Check to see how your computer will operate an LCD projector or a different display screen with your images. It may be that if your computer is running in a screen resolution that's higher than what the display device can handle you'll need to downsize your screen resolution if you want the images to be displayed fully on the screen.

4. Connect your PC to your screen or LCD projector using the appropriate cables, and position it so that your audience can best see it. Computer screens, especially the LCD flat screen types, often cannot be seen well from any vantage point except directly in front. If you have an audience of more than just a few people, you'll want to use a wide screen or project the images.

5. Ensure your display environment is dark enough that images can be seen well. This is especially important for LCD projectors.

6. If you're looking at images that have just been shot, such as reviewing images in a workshop, it's better to download the images to your hard drive first; this way, they'll run much more quickly than if kept on a flash card and accessed through a card reader.

7. Don't go overboard in using slide show fades. These can become obnoxious and tiring for the audience. Better to use just one or two that work well, complement your images, and don't become distracting.

8. Separate computer speakers are inexpensive, small, and powerful. If you're using sound, make it sound good! Don't just assume that your tinny-sounding laptop speakers will suffice, because sound with images, done well, is extremely powerful.

9. Test your configuration before showing it. Run through the setup, the full slideshow, the sound, fades, and so on. Have an associate or friend view the display and seriously critique the images beforehand.

10. Think carefully about the order of images, depending on what you're showing. While you may need to be chronological, such as if you're showing a wedding, that doesn't mean some of the best shots can't be strategically placed at the beginning or end, or even in a surprising location.

Software

When it comes to software, much of the photo presentation is divided into high-end professional and low-end consumer display—there's very little middle ground. What that means is that you'll find simple

programs that will display your work to family and friends, but it won't be suitable for a large audience paying to watch a show with professional transitions, audio tracks, and the like. For the high-end show, there are authoring applications, often designed more for video but that support still images, such as Adobe Premiere that requires lots of skill and time to work with. Scala Broadcast Media also produces high-end tools that support slide-show production (they also offer an inexpensive slide-show program, iPlay Studio, worth considering for simple use). These programs, often meant for developing integrated multimedia for high-end purposes such as television broadcasting, interactive advertising kiosks, and the like are extensive, challenging to master, and powerful (and usually overkill for most photographers).

At the low end, there are programs that will let you create DVDs to offer family members and maybe even clients, such as Ulead PictureShow or the simple slide-show features that run with Windows XP. However, these programs aren't suitable for anything requiring some customization and certainly not for professional distribution.

One option not to be summarily dismissed is Microsoft PowerPoint (shown in Figure S9-2), which offers the ability to run slide shows of images, and you can integrate music, video, and text of all types. PowerPoint is especially useful if you intend to present text with your slide shows or if you're teaching a workshop. If that's the case, I recommend it highly. However, if a slide show is your sole endeavor — especially the self-running type destined for distribution — PowerPoint will be overkill, and you'll be using and buying something different from what you really need.

Figure S9-2: Using PowerPoint to combine a slide show with a workshop format

A Note about Music

Whether you're displaying your slide show on a projector in front of a group, producing a computer screen saver, or distributing a DVD of images to a client, if you're using music you need to be aware of what's legal and what's not, as well as what you can do with music. Technically, if you record a song off of a commercially produced CD, place it into a DVD slide show of your images, and sell it to a client, you've broken the law. You've violated copyright laws restricting you from using that music without paying for a distribution or performance license.

Of course, people do this all the time, and they might not get into trouble for it, but that doesn't make it right — or legal. If you're giving away a slide show free of charge, it's not a big problem. But if you're selling it or performing it for a reasonably large or public audience without a license, you've become a "pirate." Radio stations, for example, have special licenses to play the music you hear over the airwaves, and even discos have to have permission to play music — it's not the same as playing it on your stereo system for a few friends.

This doesn't mean you need to learn to play an instrument and record yourself. There is free music to be had for public use, and much of it is excellent. MP3.com is a good place to find free music you can download and use in a wide variety of genres, from classical to rap, and you can find other free download sites. Although the better slide-show programs, such as FotoAngelo and iView MediaPro, support multiple types of audio files such as MP3 and WAV, having MP3-to-WAV-conversion software, is useful for the applications that don't support multiple types. If you can use MP3 files for a CD or DVD you'll distribute, all the better because they're much smaller files.

Photoshop offers a simple-slide show option worth mentioning, although you'll probably not find it to be your first choice because it's relatively limited in options and capabilities. Under the File/Automate menu, you can select PDF Presentation, which allows you to create a slide show saved to PDF (Adobe Acrobat) format. This can then be run using Adobe Acrobat or Acrobat Reader (which is a free download from Adobe).

Fortunately, although not a wildly competitive arena, there are three programs in the middle ground that will satisfy much of what you probably need to display photographs without a lot of work, but in a way that looks good and is versatile. The three primary programs worth considering are ACDSee, ACD FotoAngelo, and iView MultiPro. Although not the only ones, I've found these programs are the most professional and the best to quickly and efficiently get a slide show running. They also put digital images into a format that is ready to display and even distribute with minimal effort and maximum power. Because I believe these programs to be the best choice for the majority of semipro and professional photographers who require a midrange slide-show solution, I briefly cover each program in the following sections.

ACDSee

ACDSee, as I discuss in previous chapters, isn't really a slide-show program, but, rather, a powerful image-management package. However, ACD Systems has integrated a surprisingly powerful slide-show feature, complete with transitions, timing, text annotation (such as the filename or anything else), and the ability to play embedded sound. I use ACDSee to quickly download images in workshops, for example, and show them to the group without having to organize much of anything at all. I download the images to one folder (I can include subfolders, if I choose to), make sure the images are rotated properly, make sure that I've gotten rid of any obvious duds, set my transitions and time, and off I go.

Note ACDSee can play WAV files that have been embedded into TIFF or JPEG files. It cannot play music or other sound files that exist separately.

Although the least powerful of these three applications, ACDSee is by far the easiest and fastest way to get a slide show up and running. It just plays everything in the folder and, optionally, the subfolders as well. It can run in random, as well as in forward or reverse mode, and can go continuously or one time through. I've used this program to show images on my laptop immediately after taking them during fencing championships, to display a wedding ceremony immediately afterward at the reception, and at workshops.

Tip You can also use ACDSee to create basic screen savers.

ACD FotoAngelo

ACD FotoAngelo is a true dedicated slide-show program that can also create screen savers. To create the slide show, you select images; place them into a slide-show configuration; add sound, transitions, text, background, and image attributes (such as how each image will appear on the screen); and then build the slide show (see Figure S9-3). FotoAngelo then creates a single file that runs with all the images and settings, and that can be distributed. This way, too, it's secure and essentially impossible for someone to extract the images from the file (simpler slide show features on image management applications, such as ACDSee, don't offer this capability.)

Figure S9-3: With ACD FotoAngelo, you have all your control for a slide show displayed in one window so you can make adjustments on-the-fly.

iView MultiPro

Although iView MultiPro is primarily a dedicated slide-show program, it's billed as a "cross-platform cataloging and asset management" application. It's the most powerful of the group, and also requires the most setup to do anything beyond simple slide shows, although once you're up to speed on how it works, which is unique, you'll be creating slide shows in no time.

iView MediaPro uses a catalog system, which is a concept requiring you to create media catalogs of photos as well as other media objects, such as sounds, text, movies, and so on (see Figure S9-4). In its interface, a thumbnail for each file exists, but this is really only a pointer to the original file, which lives in its original location on your hard drive. The program actually accesses the original files to be able to display them in a slide show or other format, which is how it is able to operate efficiently and with versatility. You can simply drag and drop all the files that you want to be included in the slide show, including sound files.

The program has a deceptively robust set of features. For example, it provides a way to create slide shows that can be exported into HTML and run on the Web, to create cross-platform CDs, add movies and other multimedia features, create contact sheets, and many other features. There's also a free reader for people viewing the slide show. iView MultiPro works interactively with many other programs, including QuickTime, Photoshop CS, and AppleScript (Mac only), and also provides image-editing tools.

Figure S9-4: A slide show featuring the aurora borealis, created with iView MultiPro

The average photographer needs software that's easy to use, fast to set up, and has the power and options she needs to get images displayed and presented efficiently and quickly. Unless you have the technical ability, time, or inclination to develop complex presentations with authoring software, one of these three options will work well for you. That said, there is room for still more development in this area and, hopefully, you'll see even more powerful and feature-rich midrange image-presentation packages come on the market, even as the current ones continue to improve.

The white-sheet syndrome

If you're projecting images using an LCD projector, no matter how top-notch the technology, it'll only look as good as the surface upon which you're projecting it. Although I've used white bed sheets thumb-tacked to any wall I could find with free space, any time you need the images to look really good, there's no substitute for a projection screen.

Projection screens range in price and quality from a simple folding/collapsing model like your parents used to use for home movies, to a high-end home-theater screen that can cost you thousands of dollars to install. You can even get reflective "sheets" you can hang anywhere. However, these screens all share something in common: They use a specialized highly reflective and flat surface to accurately reflect the image as brightly and clearly as possible.

A nice white wall isn't necessarily a bad choice (and certainly better than a sheet!), especially if it's fairly smooth and you can darken the room sufficiently. And, in a pinch, a projector with enough light power can look darned good on it. But that's a key issue — using a projector that's bright enough.

For presentations in different locations, I actually do use the old home-movie-style screen. I found one at a garage sale (eBay's a good place to look, too), and it works perfectly for workshops; I've even used it for a group of 40 or more photographers. When folded up, it's not much bigger than a portable light and stand. It's rugged, it has a remarkably nice screen, and it cost me all of about $50. And I don't have to ask a bride and groom to remove objects from their living-room wall in order to show them photos from their wedding.

 Cross-Reference In Stage 10, I get into some specifics about how digital prints are framed, and how the quality of framing can dramatically affect their longevity.

Online display

Online display of photography seems to be dominated by black screens, which I suppose relates to the black-frame and white-mat print display you often see in art museums and galleries. It seems that the least-visual distraction possible makes for the best and most dramatic display of photos online, as well. If your images are displayed on a busy Web page, especially one with a lot of light colors and design elements, the images will be lost. A busy background also makes enjoying the individual contrast and composition of each image difficult.

LCD Projectors: A Bright Idea!

With LCD projectors, the more brightness and the finer the image, the more expensive — that's the fundamental tenet of LCD projector pricing. If you're going to be using it in a variety of locations, I suggest you buy the brightest you can afford with the best-quality picture you can get as your second (but still very important) priority. If you can completely control where the image will be projected all the time, such as in a dedicated space onto a fixed screen in a darkened studio, then brightness is something you'll be able to fudge a little, and you should go for the very finest resolution you can afford.

There are multiple ways of displaying photographs online, ranging from the consumer galleries such as Ofoto or Yahoo! Photos to your own Web site that you or a Web designer creates. Typically, images for display on the Web are low resolution—commonly 72 dpi—because this is screen resolution. Anything that is a higher resolution than 72 dpi will be wasted on a computer display and will just take longer to load when being viewed.

Tip Photoshop CS includes a Save For Web feature that makes it easy to save photos for the Web in JPEG (or GIF or PNG – options relevant to other artwork but rarely to photos). The Save For Web window is accessed by choosing File ↪ Save For Web.

Large file sizes are especially frustrating for people using a modem—any image too large will stall their computer and their patience with your site. Furthermore, if the image is high-resolution and unprotected (meaning anyone could download it), the full-size image is accessible to anyone to take and use; the 72 dpi, small-dimension files you see on the Web are very limited in their ability to be printed beyond something very small.

Cross-Reference For more on watermarks and copyrights, see Protecting images with copyrights and watermarks, in Stage 6.

Resolving resolution

If you find image resolution confusing, don't feel alone! You're not. Many photographers, especially those new to digital, find it hard to know what the resolution of images should be for most applications, including printing, slide shows, and Web display.

According to Adobe (as referenced in the Photoshop CS Help section), "understanding the relationship between the pixel dimension of an image and its print resolution is key to producing high-quality images." Well, that's all fine and nice, but what does that really mean for those of us who don't claim to be computer geeks?

When working with JPEGs, some cameras will produce a JPEG file that opens up in Photoshop at some specific size, but 72 dpi is good for screen resolution (see Figure S9-5). Creating a high-resolution image only meant to be displayed on a computer screen will only make the image unwieldy and won't improve its display quality.

If you change an image's dimensions manually to make the image a bigger size and/or resolution for print, however, the computer will simply make pixels bigger to accommodate your request, which can result in *pixelation,* that jaggy, low-quality effect that makes your image look like it came out of a computer. Known as *resampling,* this means you've artificially expanded your image's pixels and, resulting, degraded its quality—ultimately at a very noticeable level, depending upon how much you've increased the size.

In the Image Size window in Photoshop, a good practice to prevent images from becoming bigger than they should be is to uncheck the Resample Image box. You'll notice that doing so makes it impossible to alter the pixel dimensions, and creates a lock between the file size dimensions and the dpi. This way, any change to the height, width, or resolution will force the other dimensions and dpi to be altered proportionately up or down, preserving the quality of your image at the specific size you're defining.

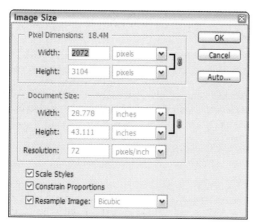

Figure S9-5: Photos display at 72 dpi on monitors, but are saved at higher resolution for printing

If you're going to resize images significantly, and especially if you're going to make them bigger and make high-quality prints, working in a 16-bit mode, such as TIFF, from an original RAW file, is the best bet. You'll drastically limit any negative effects you have in JPEG from compression and data loss, which can occur by doing something as simple as rotating a photo.

For any Web-based or screen applications, you don't need more than 72 dpi at whatever size the image is you're going to use. Most labs, both local and online, will want images at somewhere between 150 and 250 dpi, no matter what the size. In fact, labs using Lambda Durst printers, which are very high-end, large-format printers, will always reset an image to 200 dpi, even for photographs exceeding 50 inches, because 200 dpi is the preset resolution of the printer.

Still confused? Always remember, you cannot make an image bigger than it is when created without some loss of quality. If you need a big image, shoot it at the highest possible quality your camera will produce.

For example, you have a photo that's 8-x-10 inches and 150 dpi. If you unclick the Resample Image box when working in Photoshop, and you change the width from 8 to 12, the 10-inch width changes to 15 and

Resolution and Viewing Distance — A View Worth Considering

Consider how your print will be viewed: In a frame on a wall; Up close; From a distance? Or perhaps it will be viewed by passers-by or by art-show guests who'll get as close as possible to your work. These factors can directly affect the resolution you may want to use in your photo.

According to Seattle's Ivey Imaging, which uses Lambda printers, "it's generally not necessary to exceed 300dpi regardless of print size, because, typically, as print size increases, so does the viewing distance." So, in addition to the various considerations of the original pixel dimensions of your photo, the size at which it's printed, determining its resolution, and so on, you'll also want to think about the ultimate reality of how your photography will be displayed in terms of how to render and print it.

For more information, visit www.ivey.com/pdf/lambda.pdf.

Making Bigger Better

If you still need it bigger, don't despair, there is one other option. It's called Genuine Fractals, made by LizardTech (www.lizardtech.com). A plug-in for Photoshop, Genuine Fractals lets you increase an image's size by up to 600 percent without degradation of quality. Fractals are a form of geometry related to chaos theory and allow images to be resized accurately; for example, fractals can also let you store images accurately at a much smaller size. By using a proprietary method of encoding the image, Genuine Fractals is able to work with your image independently of its native resolution, and, consequently, let you resize it without the normal constraints of image quality being lost as pixel sizes increase. If you work with creating larger images, you'll find Genuine Fractals an indispensable asset to your studio.

the resolution changes to 100 dpi. In this way, you've preserved your image quality. You've not increased the physical, individual pixels, but you've dropped the resolution (meaning made the file larger than when you started), which may adversely affect how it looks when it prints because the pixels will be the same size but spread farther across the page.

Distributing Digital Photography

To get digital photographs to their intended recipients, you have a number of options. You can print them, either yourself or by a lab, and get them to your clients in person or via the mail. You may be a fine-art photographer with an agent or a gallery presenting and selling your work. Or you may be a stock photographer producing images that ad agencies, the media, and others will purchase from a stock agency like Getty Images, Corbis, or Comstock Images. For any of these, your objective is to get your images to the right audience, presented in the right way, and to be compensated properly for your work.

One of the fastest-growing areas of Internet activity and commerce is that of online photography fulfillment, both for professionals and consumers. This market is expected to grow and improve over the next few years, because it makes getting a digital photograph from your computer to a print in someone's hands as easy as it can possibly be. As part of digital photography workflow, it's essential that you at least take this very viable and valuable digital asset into consideration.

For distributing photographs, you'll also need to ponder some issues:

✦ What images do you need to distribute, to whom (family, friends, clients, interested viewers), and why?

✦ Is the distribution to be on paper, in published form, digitally, or on the Web?

✦ Is it being distributed for fun, to build your image, or for profit?

✦ What is the fastest, least-expensive, and highest-quality way to get the images into their intended format?

✦ What will be required in terms of fulfillment (getting the images printed and shipped)?

Because they're quite different, the consumer and the pro sides of the online photography fulfillment market should be considered separately.

Consumer sites for online photography distribution

Although professional online photo printing sites offer services, quality, and pricing options that are essential for professional photographers, consumer online print services provide free galleries. A free gallery is a simple way to store, share, or let people purchase prints. Online galleries (such as Shutterfly or Ofoto) don't charge you to post your images online, but they do, of course, charge for the photos if someone decides they want a print. Unlike professional online galleries, however, these services keep all the money from the prints.

Consumer-level online photo printing services include storage space and display features to share and distribute photos. The number of photos you can upload and save as well as the period of time you're allowed to leave them in a gallery varies depending on the service. Consumer online photo printing services provide differing features for sharing photos. Ofoto (www.ofoto.com) and iPhoto online service (accessible only by Mac users in connection with iPhoto software) — both run by Kodak — and Shutterfly (www.shutterfly.com) provide the best and most reliable sets of online gallery features for no cost.

Note Unlike Shutterfly and Ofoto, Wal-Mart's widely used online print service charges for gallery storage.

Among the features you don't get at Ofoto or Shutterfly online galleries are copyright protection, watermarking, or the ability to make money from selling prints (visitors can purchase prints, but all the money goes to the online service). You also won't be able to send visitors to a professional-looking URL.

Note To see a sample of a professional site hosted by Printroom.com, visit www.printroom.com/pro/tigermountainphoto. You can also link to this site from www.tigermountainphoto.com.

On a free site, you have very little control over quality issues, like ICC compatibility, paper quality, or documentation on the type of printer and print process used. You might use a consumer online photo gallery as a way of dipping your toe into online photo distribution, or as a way to share samples, or make photos available to friends. However, along with not making any money from sales of your online photos, you won't be able to judge the market for your work because you won't get reports on what is selling.

Although consumer online services do not provide the same level of control over photo sharing, they do generally allow you to distinguish between photos you upload to print yourself, and photos you want to let others view or purchase online. So, you can upload photos, assign some to a public gallery, and keep others available for your own access (or online printing). And, because they want you to tell your friends to purchase photos online, many sites have fun features, such as e-mail lists you can use to alert folks to additions to your online gallery. Ofoto provides a simple but effective e-mail list manager. Shutterfly also allows you to send e-mail announcements when you add or change your photo gallery, as shown in Figure S9-6.

Other gallery features at Ofoto and Shutterfly include visitor guest books, calendar-design software, and, of course, plenty of options for printing photos on surfaces ranging from photo paper to coffee mugs and shirts.

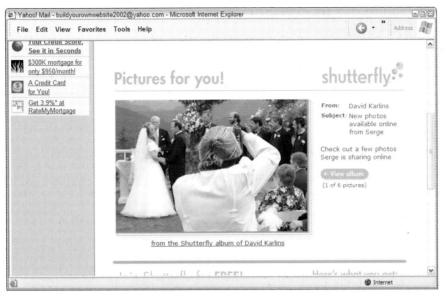

Figure S9-6: This e-mail (with a photo) sent from Shutterfly informs your mailing list of new photos available at your online gallery

Suffice to say that a consumer online gallery is not a secure place for a digital photo archive. You still need to keep your own backup of uploaded photos. Online photo printing services make no promises that their servers will preserve your photo file. But there is another reason to keep a safe backup in your own location: Most online print services alter your photo if you utilize their online editing, cropping, or sizing features as you print. Reverting to an original photo file is usually not an option after you've altered your file during the online print process.

Consumer-oriented online photo printing services provide built-in, online editing options that perform many basic photo-editing features. If friends, family, or clients order prints of photos from online galleries, they can often crop, resize, recolor, and apply simple contrast adjustments to photos as they order prints.

That's obviously rather bad news for a photographer who wants to control how his or her prints end up. Free galleries are not designed to protect your prints from being mangled by someone who wants to order one but wants to subject the print to his own cropping, sizing, and even color editing. Figure S9-7 shows a photo being poorly cropped at Ofoto, resulting in a bad print of a good photo — a serious drawback for an aspiring photographer who wants to use an online gallery for online portfolios or photo distribution.

Figure S9-7: Buyers can crop and edit photos before printing at Ofoto.

Uploading to consumer galleries

Both professional and consumer online photo services require registration. Registration is free at consumer online photo services (although sometimes storage is not). Shutterfly and Ofoto services provide free registration and gallery space, so experiment with both and see which one has features that suit your needs. After you register, online print services issue a password, a login name, and server space to upload photos to. You can provide your friends (or clients) a URL to find your gallery.

Caution IE 5.5 doesn't seem to support all the scripts used to run the slide-show feature at Ofoto. With IE 5.5 and Mac OSX, you may get a script error that prevents you from seeing complete images.

Consumer online print services provide downloadable software that allows you to easily select and upload photo files by dragging them from a folder on your computer to a drag-and-drop zone on the service's Web page. Figure S9-8, for example, shows the drag-and-drop feature at Shutterfly.

Online photo services provide huge, amazingly fast servers for rapid photo uploading. They compete to make it easy for people to send photos to the server for printing, even if you simply want to store and share photos at the site.

Figure S9-8: Using a convenient drop-and-drag upload at Shutterfly

Consumer gallery and display options

Most of the time, online print providers include some kind of online album or gallery feature. Some online services allow you to share your photo gallery, and all provide options to protect your photos from being viewed by visitors without your authorization. These online galleries generally provide a couple of different ways to view your photos. Figure S9-9 shows the online gallery at Shutterfly in slide-show mode.

Tip Shutterfly and Ofoto provide elementary and rather crude color, contrast, and level adjustment online. And, as noted, there's generally no way to disable these features to prevent viewers from doing their own editing on your photos before printing. Online editing tools are slow, and provide less flexibility than even the most basic photo-editing software.

When you register at Ofoto, the first step is to download the drag-and-drop photo uploading program provided. This software installs on your computer for future use and only needs to be downloaded and installed once. This drag-and-drop software makes it easier to upload photos, And, it also includes some tools for managing and editing photos. But these tools are not essential to using Ofoto — you can use the online interface to upload photos as an alternative.

Figure S9-9: Viewing an online slide show at Shutterfly

Shutterfly has a similar drag-and-drop uploading program that you can download to facilitate easy uploading of lots of files. Yahoo! Photos uses the Shutterfly service, but the interface and server experiences are smoother at the Shutterfly site because you don't need to navigate through the Yahoo! page to get to your photo gallery. And I've found that sometimes uploading through the Yahoo server is slower than using the server available if you go directly to the Shutterfly site.

Tip Printing online? If you do consider online printing, Ofoto uses Kodak paper (and is owned by Kodak), while Shutterfly uses Fuji Crystal Archive paper. Before you settle on a service, test each with the same file to compare processing and papers to see which you prefer.

iPhoto for Mac

Apple has teamed with Kodak to allow Mac users to print online directly through iPhoto software on the Mac itself, so there is no need to download special uploading or gallery management software.

Mac users share photos by creating a Smart Album in iPhoto, and sharing it with Apple's Rendezvous photo-sharing technology. You can fairly easily attach music to photo slide shows with iPhoto by combining a photo gallery with music from an iTunes music library.

Kodak's iPhoto site is seamlessly integrated with, and an extension of, iPhoto software and is not accessible any other way on the Web. For more information on iPhoto, see http://www.apple.com/ilife/iphoto.

Professional sites for online photography distribution

You might be surprised, actually, at how few professional photographers today have gone completely digital. With the explosion in digital cameras and the constant buzz about them, it may seem like film is already dead and gone. I haven't expressed any qualms or regrets about referring to film in the past tense. Yet I'm very aware that many pro photographers have been, and continue to be, slow to switch. They have more to lose than a consumer trying out a new digital camera. Professional photographers have invested significantly in their studios and camera equipment; their film-based workflow methods; how they process, develop, and print images; their relationships with labs; and, generally speaking, their focus on how to provide customers with the best-possible product.

Even for photographers who realize the value of digital but haven't made the leap, one of the biggest hurdles is fulfillment — getting photographs printed and delivered to clients. Once you have decided to sell your prints online, and want to get paid for them, you must address several key issues:

✦ Getting photos into a format and location — digital or otherwise — where they can be seen

✦ Allowing customers to select and order images online

✦ Handling the order process, including accepting payment and managing printing, quality control, and shipping

✦ Dealing with follow up if there's a technical problem online or if the customer doesn't understand how to use the software

If you're a film photographer and you're just transitioning to a pro or semipro photography business to digital, these are big, time-consuming issues no matter how much you acknowledge that digital is great and the change is an inevitability. It represents a major transition in workflow mentality, and if you choose the wrong fulfillment service, it can cost a lot.

A number of professional online photography services have appeared on the market in the last few years, ranging from some rather big names to some small ones, all with one concept in mind: providing a way for a photographer to post images so that clients can see them and buy them, yielding a profit for the photographer (and the service, of course). This is where the proverbial rubber meets the road in e-commerce in the photography world.

Some photographers have attempted to create their own Web storefronts using online payment systems like PayPal or by monkey-wrenching their own online galleries or consumer-type galleries into professional services. Most often, this turns into a management nightmare that appears homegrown and unprofessional.

Three of the most visible and well-known pro online photography services on the market today are Printroom.com, Pictage, and Collages.net. Most pro photographers using these services use only one of them, not multiple services, primarily because each becomes an integrated part of workflow, and using more than one would be confusing to the photography studio as well as to clients.

Tip Cafepress.com (www.cafepress.com) is also worth noting; while not a way to display images, per se, they offer a wide variety of products onto which you can have your images printed and offer them for sale.

The Case for eBay

Until I actually sold some of my photography on eBay (www.ebay.com), I thought this was a really dumb idea. But then it began to grow on me. eBay allows people to search for keywords that help them find things, such as works of art—photography included. Thousands of people surf eBay daily, and if my images are interesting enough, eBay is a good central clearinghouse for people to at least see and maybe buy my work.

I've had luck selling some photos on eBay, but the real advantage of the transaction was that several collectors, who otherwise might not have found me, discovered my work and then proceeded to either commission new photos or buy existing work directly from me.

Online storefront galleries don't always feature photo art and aren't as widely known as eBay—certainly not for collectible art. Further, even if someone does find an online professional gallery, they may not find your photos because most of the online pro gallery storefronts are designed to reach an audience directed to them by the photographer who did the shoot. Although the galleries are searchable, it's not likely a listing on them will be hit by a Google search, for example.

If you want to sell photography, especially fine-art images, give eBay a try. List an image with a very low reserve and see what happens. Make sure you describe it clearly in category, title, and details so that someone interested in your subject will find it when he searches using keywords.

Each of the services has features in common with the others as well as unique attributes that will suit different photographers depending upon their needs, experience, and interest. Furthermore, each has different pricing strategies for charging for their services and products, which all relates to bottom-line profitability. All these Web companies include a mix of the following services:

✦ Online storefront galleries you, the photographer, set up to display and sell your photos in thumbnail and enlarged views

✦ Server-hosted storage of thumbnail and full-size images

✦ Fulfillment services, including order processing, enhancement (for example, cropping, image editing, and so on), and shipping to customers

✦ A variety of print sizes and products

✦ Marketing tools and specialty products, such as flush-mounted wedding albums

✦ Security to protect the gallery, the images, or both

Here is a quick overview of these services followed by some general things to consider as you explore this very new and exciting pro photography market.

Tip There are many other services offering online photography storefronts and fulfillment to pro photographers, and you may want to look around at them. However, you'll need to be careful about ensuring that the companies offer the reliability, support, pricing, longevity (these are Web businesses, after all!), and quality you'll want to rely on for your business and clients.

Printroom.com

I've looked around at a number of services and decided on Printroom.com (www.printroom.com), as shown in Figure S9-10, which has worked very well for my studio over the last several years. We fulfill a

substantial portion of our photography through them. Hardly a day passes that I don't create a gallery or upload images, and I'm constantly monitoring the site to see how sales are progressing.

Printroom.com caters to a wide variety of photographers, especially those doing events, sports, and, to a degree, weddings and portraits. Their service is divided into three parts: online hosting and galleries; e-commerce fulfillment of images; and sales and marketing tools. While most photographers set up a hosted gallery that they link to their own Web sites, Printroom.com also provide options for installing an e-commerce feature onto your existing Web site so users can purchase prints directly by clicking a button.

For thumbnails, the better pro services often provide at least a semiautomated method for converting full-size images to a small format. Printroom.com, for example, offers a utility application called Pro Studio Manager (PSM) that installs on the PC and handles gallery and thumbnail creation and uploading of both the small and large files (as shown in Figure S9-11). PSM also has an automated feature that will check for orders at regular intervals and then upload full-size images from your computer to the Printroom.com server automatically—a good option for photographers who aren't sitting at their computers checking orders all the time. You pay a sign-up fee and then a percentage of your image sales with Printroom, and, as with most other services, you set the prices for selling your photos.

Figure S9-10: Printroom.com lets the photographer access multiple types of online storefront controls and options from one centralized point.

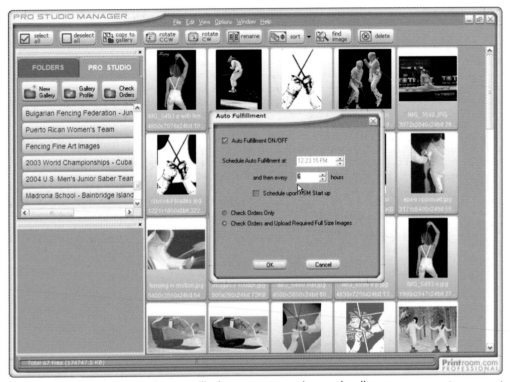

Figure S9-11: Printroom.com's PSM utility lets you manage images locally on your computer, converts them to thumbnails, and handles uploading.

Pictage

Pictage (www.pictage.com) is an online pro photography fulfillment service focused particularly on the wedding photography market, although they also have photographers producing portraiture and event work. Unlike some digital services, they also support film, and will perform high-resolution film scans on developed negatives and post the image for photographers. In keeping with their wedding focus, they produce many types of wedding-specific products such as a variety of albums and art proofs. Pictage requires a monthly fee along with a setup fee.

Collages.net

Like Pictage, Collages.net (www.collages.net) caters especially to wedding photographers and also supports film photographers. They use a variety of labs around the country to fulfill images (Pictage processes in-house) and, like other services, also provide various photo options such as CD/DVD services, slideshows, and proof books. Collages.net also offers a variety of pre-packaged, custom-designed Web sites for clients that include hosting, galleries, and other features.

Considerations for choosing an online fulfillment service

Now that you've read a bit about what each service provides and how each operates, you can start to think about what you need in a fulfillment service. Much of the business all these services support falls in the area of personal portraits and events such as weddings, bar mitzvahs, senior and student portraits, and sports. They're not used as much for fine-art photography, commercial work, or corporate shoots, although there's some of that, and they're definitely not being used for stock photography. The products, services, and business models are all oriented toward photographers serving individuals and families. Collages.net and Pictage, especially, are (self-admittedly) oriented toward weddings.

Although different pricing models exist, essentially you pay for a membership fee and perhaps online storage. You also pay a wholesale rate for products such as prints or coffee mugs, and then set prices your customers pay. There may be other fees as well, and the difference between the money you pay for the service and products and what the customer pays is your profit, which the company pays to you on a regular basis.

When you're evaluating using an online service, you'll want to think seriously about how it will be integrating with your business and day-to-day digital-photography workflow. It's a big commitment, and it has very direct visibility and impact on how your customers perceive your business. The quality of prints, tech support, ease of use, and e-commerce management is all a reflection on you, the photographer, more than that of the service because they're in business to present you to the customer, not the other way around. When you're in the market for this type of service, you'll want to consider a number of options and issues:

✦ What are the total fees and costs?

✦ Is there an annual fee?

✦ Is there a charge or limitation for any certain amount of images being uploaded or stored (by gallery, event, or other factor)?

✦ Is there a way to ensure color profiles are optimized or controlled from when the image is uploaded to when it is printed?

✦ How secure are your images? Can they be downloaded easily? If so, in what size?

✦ Are images watermarked online?

✦ Is *back-printing* (printing your studio, file, and copyright info on the back of the print) provided?

✦ Does the company handle e-commerce? Does it process credit cards and deal with customer service related to returns or declined charges, for example?

✦ Can you monitor how your galleries are performing, in terms of how many people are looking at the images?

✦ What kind of special promotions does it offer? Are there any specialized marketing tools you can use? What are they?

✦ What other photographers are using the service? Are they doing similar photography to yours, or something entirely different? What are their prices like (if you can see them)?

✦ If you shoot both film and digital, does the company process film as well as digital images?

✦ What kind of paper and processing are they using? Ask for samples — not of their images, but yours — to see not only how images are printed, but how they're shipped.

✦ What proofing and editing tools are offered? Are they just for the photographer, or can clients also edit images?

✦ Is color correction and image editing only offered as an automated feature, or can you also opt to have a human do it?

✦ What options are there for digital files (for example, can you provide customers with digital images through the service)?

✦ Is there a proof-book option? How does it work?

✦ Are you limited in how long images can remain online, or is that up to you?

✦ Are you using a Mac or a PC? How does the system work with either?

✦ Can you provide customers with CDs or DVDs?

✦ How easy is it to upload images? Is it done using a Web-based system, by sending the company CDs, using an FTP server, with a local (non-Web-based) utility, or a combination of these?

✦ Are you required to upload full-size images in all cases, or can you just upload thumbnails and then send only the full-size files as needed?

There's a lot to think about and make sure you understand, especially because it will become part of your digital photography workflow. Potentially, these services take care of much of what you don't want to be spending your time doing as a photographer, such as post-shoot administration, fulfillment, proofing, and editing. However, if you commit to a service and, for one reason or another, it requires your constant attention and there are any variety of problems associated with getting your images uploaded, displayed, sold, and fulfilled, it makes you look bad and can take up a tremendous amount of time. So, consider your options carefully.

Another issue to consider with these services is how you get paid. Most of the major services calculate your photo sales on a monthly (or, in rare cases, quarterly) basis, subtract their fees, and send you a check. They also have to send you a year-end tax statement because you're essentially working for them on a contract basis. Issuing you a tax statement allows them to have a way of reporting the income and expense of managing the transaction. Usually, the services offer a way for you to see a detailed view of your sales, the profit, and the amount taken out by them.

One real advantage of having these companies manage print fulfillment for you is that if there's a problem, such as a client not being happy with print quality, they handle the problem. Now, if the problem relates to you not taking the right photo or leaving a critical shot out, that's another story. But normally these services will work directly with the customer to resolve quality issues and you'll not have to get involved. If you've done any pro photography fulfillment on your own, I'm sure you'll immediately understand and see the advantage to this service.

That said, professional online photography services will continue to grow in their importance and involvement in digital workflow. Their ability to help offset the amount of time you, as a photographer, must spend fulfilling business and not getting and creating it is an undeniable asset. In the coming years, you can look to these services to provide increasing functionality and features that will help you market and sell your business.

Submitting Images for Online Distribution

Getting images online — for pros or amateurs — is an aspect of photography workflow typically divided into two parts: small digital photos meant for easy Web display, most commonly known as *thumbnail images,* and large, full-size images suitable for printing.

Getting large photo files online is problematic, if only because they can take a long time to upload, no matter how they are sent. For pros, most services are personalized and offer a variety of upload options, including FTP and e-mail, as well as accepting files via snail mail or a professional delivery service on CD. The consumer photo services generally offer fewer options; they're dealing with a bigger mass audience and so cannot handle labor-intensive services (such as accepting CDs). Although you can usually choose to upload all your big images, normally photographers just upload the ones that have been ordered, to save time, bandwidth, and storage space if the service allows that.

Images will have to be prepared for being uploaded, in terms of prioritizing the ones you want to display, doing some basic image editing (cropping, contrast, brightness, etc.), and placing them in the order you want them displayed. Some of the services will perform basic image editing for you and your clients, including additional cost options for other editing adjustments. However, you shouldn't have to make too many adjustments to your images beforehand, or you're paying for a service that isn't doing as much as it could for you as a client.

Uploading and managing your online distribution can be a time-consuming part of your digital photography workflow, and you'll want to consider carefully how you'll be able to fulfill this part of the business. If you underestimate it, thinking you can do a shoot every day and still handle uploads, think again — you're sailing directly into a big iceberg. If you're producing more than a single shoot a week, you'll most likely need someone to help with this part of the work. It involves several key stages:

1. If you're creating an online gallery as part of your agreement with a client, make sure that, before the shoot, you've written down the fundamental details of what he wants. Some details you need to consider include the following:

 * How long will the gallery remain online?

 * Are you charging for the gallery to be created/posted?

 * Is it to be password-protected or open to the world for viewing?

 * How many images is your client expecting to see in the gallery?

2. Review the images from an event or shoot that will be placed online and prioritize them using ACDSee or Photoshop.

3. Pare down the prioritized images to as few as possible, but enough that clients will see the agreed-upon amount of photos from the shoot.

4. Unless you only have images on your laptop and you're the only one working with your service, make sure that images necessary for uploading to your online distribution service are stored on a permanent computer that can be accessed by anyone in your digital studio. If you're gone on a shoot, you don't want clients to have to wait for their orders to be processed.

5. Do everything possible to streamline the uploading process, and remember that the sooner you get galleries online, the more likely you are to sell photos.

6. Realize that, though you may have all your images online at the gallery and stored as thumbnails, you may need to access and process images yourself locally, as well. You may need to produce an image larger than what the service offers, for example, or you may have a client who wants something printed in your studio on the spot. For that reason, make sure you can cross-reference images. For example, don't name your online gallery images differently from the original ones or you'll end up having to search visually to match images later on.

Stock Photography: A Different Animal

Stock images are photographs that can be purchased and used for commercial purposes, such as in brochures, advertisements, Web sites, and other purposes by advertising agencies, graphic design firms, magazines, and others. They're typically marketed through stock agencies, a market dominated by huge companies such as Getty Images and Corbis. These companies, though once purely involved in stock work, now have broadened significantly into assignment bureaus, where they will ask photographers to shoot for specific and commissioned projects and events.

The stock market is overwhelmingly digital at this point, with stockpiles of hundreds of thousands, if not millions, of images categorized into vast catalogs of searchable categories and keywords. Some photographers make a living shooting only stock images; it is an area of specialization with specific requirements that affect the digital-photography workflow at many levels.

In terms of distribution, stock images are almost always offered through agencies, and if you're inclined to pursue this line of work, you'll need and want to know where your images are headed before you put too much into the endeavor. Like any agency, they have to want and acquire your work.

Individual agencies will give you parameters for stock images, such as the format, size, and resolution in which you'll need to present your images. You'll want to offer a specialized area of images and create a set or sequence of shots, such as kids eating breakfast, baseball players, airplanes landing or taking off, and so on. The list is virtually endless, as are the opportunities to build a stock-image business. But before you run out the door with your camera to shoot random images, you'll need to consider some specifics.

Tip

In the digital age, stock agencies have become overwhelmed by too many photos — photographers submitting hundreds of images of a sporting event, for example, and many of them of only marginal quality. Remember that they are looking for the *crème-de-la-crème* shots, and sending too many photos may only get you blacklisted if the agency ends up doing all the work to find the best images.

Probably the biggest issue is that stock images have to be *clean,* meaning that anyone recognizable in the image has to sign a model release. Brand names cannot be recognizable or visible — you can't show logos or names on clothing, products, or anything else that is copyright-protected.

At a stylistic level, your stock images need to send a specific message, especially a message with metaphoric qualities that will resonate with an ad agency or design firm. Simple messages in your photos, such as success, win, failure, or shopping, and so on, need to be visible, first, and foremost. Study images in advertising, Web sites, and brochures to get a sense of this. It doesn't mean you can't be surreal or creative, but you'll end up with a different clientele for your images than if you create something more literal or descriptive.

You'll need to make sure your photos have accurate metadata keywords describing what they present. The individual agencies will provide, in detail, what you need to do to get them the images they want, and how they work with you as a photographer. Most offer various types of contractual arrangements that cover everything from licensing and copyrights to how you get paid for the work (which can vary from a one-time payment to royalties and usage fees in a predefined split).

Summary

The Web provides tremendous potential for the display and sale of photos. No longer restricted to brick and mortar photo galleries, digital photographers can easily expose potential buyers to their work with online portfolios, sell wedding photos online, or use online galleries to market their work.

Online photo display is restricted to low-resolution images because monitors — and thus Web sites — only display photos at 72 dpi (compared to print resolution of 180 to 300 dpi for quality photo prints). Online galleries generate thumbnail or large display versions of photos, but the print versions are much higher quality.

Free online galleries allow anyone to post photos online. People can order these photos, but the money goes to Ofoto, Shutterfly, or other online photo developer services. Professional online fulfillment services, such as Printroom.com or Pictage, extensive services to protect photos from unauthorized printing, allow photographers to earn revenue from the sale of the photos, edit images, provide marketing tools, and the like.

The online stock photo market distributes photos used for commercial purposes, such as in brochures and advertisements; stock photos are sold through agencies, such as Getty Images and Corbis.

✦　　✦　　✦

10

Fighting Image Mortality

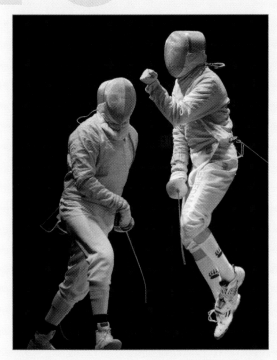

Stop-action shots are challenging in fencing, with low light and fast-moving objects — and no flash allowed. These champion saber fencers are competing for a big casino prize at the Flamingo Las Vegas Hotel's Duel in the Desert tournament. Taken with a Canon 10D at ISO 200, f/4.0, 1/250 second, and 70mm focal length.

There's a subjective aura of impermanence associated with digital photo prints, even as there is a sense of immortality associated with digital photo files. In fact, digital photo print longevity has undergone dramatic improvement in the last few years, and properly printed and framed, digital prints can be expected to last at least 50 years — much longer in many cases.

Further, digital photos — the files themselves — are permanent only in the sense that data securely saved will not go away. Relative to advances in digital photo file capacity, including exponential expansion in the amount of data captured by digital cameras, even digital permanence has to be understood as something more complex than the fact that digital data doesn't degrade. This chapter explores preserving digital images, both in digital and print form.

Optimizing Key Images for Long-Term Survival

The short life of a digital print is not exactly a myth. Several factors in the digital photo print process tend to degrade more quickly than traditional photo printing. For example, the ink used in most inkjet printers fades noticeably after a few years, even when properly protected, and much digital photo paper contains acid that begins to corrupt the photo quality quite quickly — within a year or two. In addition, digital photos are frequently not properly cured after printing, or not properly displayed or stored, which further contributes to their early demise.

However, all these factors can be overcome. Recent studies — and not just those from the makers of digital printers — project decades of life for high-quality digital prints when created and preserved properly. Achieving this kind of endurance requires a high degree of control over printer, ink, paper, and display environment. At the same time, ongoing advances in digital print technology are raising the bottom levels of print permanence as well. Figure S10-1 shows a framed photo of a Moroccan man taken in Marrakech that has been on display in several galleries. It was printed with a Fuji Frontier printer and Fuji Crystal Archive paper, and then mounted professionally using a linen (naturally acid-free) mat with spacers (to keep the photo from touching the glass) and UV-screened glass. The back of the frame is sealed.

Figure S10-1: An archival, gallery-quality print framed and on display

What is archival quality?

Photographers promise clients photos on archival-quality paper as a general practice. Printer manufacturers advertise archival inks. Digital printers pledge archival prints. You're likely to wonder if these claims are legitimate and what they mean.

References to *archival quality* usually mean a print that will last between 60 and 80 years. The Wilhelm Imaging Research project (www.wilhelm-research.com) produces and shares highly documented research into digital print (and other image) preservation.

Elements that go into creating archival quality prints include paper type and quality, ink type, and storage (including framing). For a professional digital photographer creating or ordering prints for clients, combinations of archival quality paper and ink will produce long-lasting photos.

Inkjet printers can now produce archival quality prints. A recent Wilhelm study, for example, projects a life of up to 200 years for photos printed on an Epson Stylus Pro 4000 before visible fading or changes in color balance. But we live in a big after-market world, with lots of cheap alternatives to big-name manufacturers' consumable products, such as ink and paper. In the long run, this may turn out to be penny-wise and pound-foolish. In 2003, *Consumer Reports* conducted research of printer ink fading, comparing bargain paper against brand-name papers from HP and Kodak. They concluded that "scrimping on paper is a false economy."

 Note The *Consumer Reports* study was titled "The Paper Chase: Printer Ink Fading Tests" and can be found in the May 2003 issue of Consumer Reports magazine. The article is also available at www.consumer reports.org.

Digital with Chemicals?

Prints from big-volume digital photo processors—including consumer companies like Costco as well as professional online photography services like Printroom.com—aren't commonly printed with inkjet printers, but rather using photographic paper and a silver-halide process. For example, Printroom.com prints are projected and exposed onto Fuji Crystal Archive paper using Fuji Frontier printers, which claim to "last for generations." This photographic process is a chemical one; however, the big inkjet manufacturers are working hard to convert the photography industry to large-format, high-volume inkjet printers that they claim are at least equivalent to, if not better than, silver-halide prints in quality, longevity, and cost. Suffice it to say both these services are providing quality that may very well outlast anything you produce at home with mainstream inks and paper.

Comparing professional inkjet and photographic printing, there is, in general, "a huge archival difference," according to Carlton Osborne, CEO of Printroom.com: "Silver-halide prints are rated to last 75 years under normal conditions. The 'archival' inkjet prints require special inks that cost more and supposedly last 100 years but under very limited (framed, matted under glass), gallery-like conditions. So... in terms of quality and archival I think silver halide wins, hands down."

Some of the mini-labs, such as those at drugstore one-hour processing centers, use "consumable-free" systems that don't require ink or chemicals. Rather, they use a special photo paper that reacts to a laser to expose several layers of color to produce an image. These high-volume, small-size printers—many of which can print directly from flash cards—are what many consumers are having their family-vacation photos printed on today. The longevity of those prints depends on the paper, ink, and processing used to create them and will vary.

Most tests are conducted scientifically, and claims of print longevity are honest and as accurate as can be expected given that they are, of course, based on simulations of the aging process and not actual aging. Truly long-lasting digital prints are the product of many synchronized elements of a digital photo print. The only way to assess and project print permanence is to look at the entire process — the printer, ink, paper, display, and storage. In this context, although there are some particularities to preserving digital photo prints, in fact overall the process of long-term preservation of a digital photo print is subject to the same basic laws as preserving any artwork.

Ink, chemicals, and paper degrade with time, and external factors such as exposure to direct sunlight, atmospheric pollution (a major enemy of digital photo prints), or obvious damage such as exposure to water, will hasten the process. Although colors tend to fade, one goal of archival-quality photo prints is to maintain a consistent color balance (the relationship between colors in the photo) even if there is minor fading.

Even if most of your digital photo prints won't need to be of archival quality, understanding the factors that govern the lifespan of a digital print can help squeeze the best quality out of any print.

Archival ink

High-quality photo inkjets use either dye- or pigment-based inks. Each of these inks has different ways of interacting with paper and a different dynamic in relation to color permanence.

Dye-based inks are dissolved in the inkjet spray process, and mist in the form of tiny droplets onto photo paper where they are absorbed into and combine with the layers of photo paper to produce color. Traditional (film) photo printing relies on dye-based inks and their ability to react to paper on a molecular level.

Pigment-based ink is sprayed onto the page in larger droplets. When Epson introduced pigment-based ink for photo inkjets, like the UltraChrome inks, those pigment-based inks represented a significant development in ink stability. However, with new advances in paper technology, dye-based inks can be highly stable as well. Epson has continued to develop the UltraChrome and other pigment-based inks, while HP has poured significant resources into developing archival quality dye-based inks.

Dye versus Pigment Inks

Dye-based inks are almost always created using vegetable sources, which is a common way color has been turned into ink for centuries. These inks are more compatible, not surprisingly, with the natural effects of aging, such as light, humidity, and temperature. They can often last, fade-free, for as much as 100 years if prevented reasonably from the elements.

Pigment inks are solvent-based and created from a man-made, chemical source. These can withstand extreme conditions, especially if covered with a clear laminate and are a good choice for photos that will be exposed to the elements, such as harsh sunlight, temperatures fluctuations, humidity, etc. Don't expect them, however, to last for 100 years if they're really being weathered — a few years is about all you can hope for.

The kind of ink that comes with your inkjet printer is determined by the manufacturer and is usually available in their specifications or by asking them directly. If you want to use a different type, you'll have to turn to after-market ink suppliers, but you'll want to be sure the inks are of good quality and won't damage your hardware. Alternatively, for really important work, you'll probably want to have a pro lab print your images; you can tell them about the environment for which the print is intended and have them print it accordingly.

Although inks are a significant factor in the life of a digital photo print, the interaction of paper, ink, and inking process far overrides any one particular element of the process. So, for example, Epson archival UltraChrome inks used with non-compatible photo paper will likely produce photos that will show noticeable and substantial degradation of color in as little as two years, even if it is a high-quality paper. Always make sure that the ink you use and the paper you use are compatible.

The acid factor

In arts-and-crafts or photography stores, you'll find acid-free plastic sheets for storing photographs. A critical element in reducing the rate of deterioration of a photo is to maintain an acid-free environment. Although not the only factor in preserving photo quality—air, light, and other obvious factors like exposure to water or damage (like tearing or bending of the photo) also affect the life of a photo—an acid-free environment is an extremely important factor to photo preservation. However, avoiding acidic products in printing and presenting photos is a constant that applies to all situations where the longevity of a photo print is important.

Wood-based products are acidic. Because many photos are printed on wood-based paper, mounted in wooden frames, and mounted with wood-based paper matting, all these elements tend to attack the photo paper. Photos placed directly next to a wood frame or a wood-based paper matte frequently show staining within months, or just a few years.

A variety of treatments are available to de-acidify wood and wood-based paper. These treatment processes have their own drawbacks in terms of imbuing paper with potentially harmful chemicals. On the other hand, museum quality acid-free paper is made from cotton rag or other non-wood material. Acid-free paper is becoming more accessible as professional photographers begin to demand longer lasting photo paper. Cotton-based acid-free paper is expensive, but it provides the ultimate in acid-free protection for photos.

All major printer manufacturers market acid-free matte and semi-gloss paper, and other acid-free products. Third-party manufacturers offer large lines of acid-free paper, ranging from under $2 a sheet to upwards of $20 per sheet. InkJetArt (www.inkjetart.com) provides a very wide range of acid-free photo paper, along with research and longevity ratings.

Along with InkJetArt, there are several high-quality online resources for acid-free paper. The Inkjet Mall (www.inkjetmall.com) also lists and recommends a variety of archival-quality photo papers.

Paper surface and coating

Glossy and matte papers interact with ink in different ways, and present different challenges for long-term print archiving. High-gloss prints, which some clients or photographers prefer, are very durable in resisting water and other elements but inks do not always mesh well with high-gloss paper, and are highly susceptible to environmental air pollutants.

That problem is easily solved if a client prefers or will be happy with prints on matte or semigloss paper. These papers mesh well with pigment-based inks such as those available for Epson printers. Generally speaking, glossy surfaces are less stable for image preservation and longevity.

Dye-based ink produces higher-quality prints on glossy paper, but it's also highly variable in its longevity. To provide archival-quality inkjet prints on glossy paper with dye-based ink, consulting longevity studies for specific ink and paper combinations is necessary. Some, as mentioned earlier, are every bit as long-lasting as pigment-based ink, while other dye-based ink and photo paper combinations are quite unstable and deteriorate in a year or two.

Take Your Time and Handle with Care

Along with grease and sweat, contact with human hands can expose photo paper to acid. Shield valuable photos from exposure to acid and other contaminants by handling them with cotton gloves.

If you want long-lasting prints, avoid deterioration produced by how you handle photos minutes after printing. Care in handling of digital photo prints for their first, fragile, 24 hours of life is essential. And, of course, you want to guard against smudging photos with fingerprints. Cotton gloves will protect prints from acid and grease commonly found on human skin.

Photos must cure properly, which is why the first 24 hours are so important. But you should always avoid contact with your hands. Digital prints should not be framed or put under any glass or plastic covering for *at least* 24 hours after printing, allowing the ink time to dry, cure, and become stable. You may be wondering about various forms of fast-drying inks or ink and paper combinations. These are generally a bad idea if you want any kind of color stability over more than a year. Fast-drying (microporous) paper absorbs ink more quickly, but the process sacrifices color stability and is particularly vulnerable to airborne pollutants like ozone.

Lamination and coating are options for preserving unframed digital photo prints, but the cost is often equal to the cost of printing. Most dye-sub printers apply UV coating to generally extend the life of a print and to prevent moisture, fingerprints, and wear and tear from degrading the color and surface of the photo.

I prefer Ilford (www.ilford.com) paper—it's probably the best of all the papers I've used for my own photography. Long known, especially for its superior black-and-white film, today Ilford is a leader in producing some of the best-quality, honest-claim-to-longevity products available. They tend to be a bit more expensive, but when the image needs to last, it's worth it. Their pearl paper creates especially beautiful prints, in my experience. Ilford claims their paper has "similar resistance to air pollutants as conventional photographic print media," won't suffer from gas fading issues, and can be stored in light or dark storage without laminate, sleeve, or glass protection. Images printed on Ilford paper are expected to last up to 20 years when displayed indoors when the correct ink types are used.

Note The details of the Ilford study are available at www.ilford.com. You can find Ilford paper online from photography suppliers, and most pro photography shops stock it, as well.

Epson, Kodak, and Canon also all produce good-quality papers that are generally available at office-supply and computer stores, as well as camera outlets. For proofing and relatively short-lasting purposes, these are to be regarded as consumer—not professional—papers unless they specifically state they are of archival quality. Canon's papers, especially the Photo Paper Pro, in my opinion provide some of the best quality prints I've seen and have withstood years of display without sign of fading.

If you really want high-end papers, it's worth taking a look at those produced by the German company Hahnemühle. Sold by pro photography and art stores, you can even select papers with matched certificates of authenticity using Hahnemüle's digital artist registry service, myartregistry.com.

Framing and displaying photos

Framing is both an aesthetic and protective element of displaying digital photos. The aesthetics of framing and matting range from very neutral shades of white, beige, and gray to more audacious color schemes that highlight or draw out colors from a photo.

Photo framing is, of course, an art itself. Although few photographers will frame their own prints, having some knowledge of the science and art of photo framing is helpful. Expert framing involves backing paper, matting, and glass. Backing paper preserves the photo by insulating it from acid in a wood frame. If acidic framing material like wood is used, the backing paper separates the frame from contact with the photo. Matting not only has an important aesthetic role, but also protects the photo from direct contact with glass.

For archival display, UV-protected glass can help prevent ink and paper from degrading. Perfectly clear framing glass is available with up to 98 percent UV protection. Non-shattering, high-quality plastic (the type used in eyeglass lenses) is also an option for framing.

Framing a photo too soon can trap gas that is produced as inkjet ink cures. This trapped gas can cloud the inside of the photo frame glass. Photos should air out for at least 48 hours before covering them with glass or plastic.

Direct exposure to glass damages digital photo prints. After a few years, or sometimes only a few months, ink from the photo will leach into the glass, and it's not uncommon to remove glass that has been in contact with a photo and see the photo etched into the glass. Matting provides that necessary spacing between glass and photo.

One other essential element in the archival framing process are non-acidic clips made from cotton-based or other non-acidic paper that are used to hold photos in place in a frame. Adhesive material leaches into photo paper, and is not used in quality framing. Instead, small corners shielded behind matting are constructed to position the photo in the frame without adhering to the paper.

Thinking about frames

Photographs are not like paintings in terms of display: An ornate frame, for example, can detract from a photograph where it can complement art. Becoming enamored with fancy frames and mats is easy, but in many cases they can only have the effect of detracting from what you've worked so hard to create. In most museums and galleries, you'll find, photographs are often simply displayed with white or off-white mats and plain black frames. Why? Because anything more ornate draws the viewer's eye away from the subject of the image, which is very real, and conflicts with and causes visual dissonance against something abstract. Choosing the proper frame is important to presentation—some images present special framing challenges.

That said, some of the more sedate and yet creative frames can look nice with certain photographs, which becomes an extremely subjective issue and judgment call on the part of the photographer, or the consumer of a photographic print, whether from film or digital.

Family portraits can look very nice in a semi-ornate frame as long as it complements the image well and doesn't distract from the image. Unlike a fine-art photograph, family images enhanced by high-quality sculpted and decorative wood framing and a linen mat can look wonderful and will serve to make the image look even better.

With certain types of photography—for example, boudoir, family portraits, and images that have been significantly artistically edited in Photoshop or Corel Painter—ornate and abstract framing has a distinct place, and all bets are off in terms of being sedate. A large family portrait printed on canvas, for example, will look absolutely lovely in a well-appointed gilded and sculpted frame with a hand-wrapped, Asian silk mat.

According to Larry Yocom, owner of Seattle's Gallery Frames (www.galleryframes.com), a high-end framing company that provides all types of framing to consumers and professionals in the Pacific Northwest's art, museum, and collector community, it's essential that a framed photograph have several qualities:

✦ Photos should be framed with a "non-buffered" mat free of buffering materials used in many paper-based, common mats to bleach and de-acidify them. Products that say "acid-free" may, in fact, have added chemicals such as baking soda that can damage the print.

✦ The backing of the photo should be of the same acid-free, non-buffered quality as the mat.

✦ Cotton rag mats are some of the best, with a very neutral natural acidity.

✦ To optimize longevity, especially for inkjet images (because this type of ink is thin, like a watercolor), it should be covered with UV-protection glass or Plexiglas.

✦ The photo should *never* come into direct contact with the Plexiglas or glass (glass is technically a liquid and will move over time as well as absorb ink).

✦ If possible, the back of the frame should be sealed to prevent humidity or insects from damaging the photo.

Illinois-based Crescent Cardboard (www.crescentcardboard.com) is known by framing professionals for providing the best non-buffered mat boards available on the market. You can find distributors of their mats on their Web site, and you can request your framer use their mats as well.

Meshing paper and ink

There is a widely known economic model in the digital printer industry, often referred to as the *razor model* — an analogy to the fact that razor manufacturers make much more selling replacement blade cartridges than they do on the razor itself, and in fact razors are often sold at a loss to hook a customer on a lifetime supply of blades.

How then, to look at manufacturer's claims that it's essential that you use Canon papers with Canon inkjets, HP papers with HP inkjets, Epson paper with Epson pigment-based inks, and so on? Research by print-archival guru Henry Wilhelm and others, such as in the *Consumer Reports* test cited earlier, indicate that, in some cases, there is a lot to these claims. HP's four- and six-color photo ink cartridges produce prints with dramatically longer life when used in combination with HP's highest-quality photo paper.

Trimming Photo Paper

Photos that will be framed should be printed with extensive borders, and then trimmed to fit framing materials. Borderless prints do not allow for matting, proper clipping, or protection from exposure to glass. There are techniques available for sealing borderless photos to preserve them. Dry mounting requires a dry mount press, which is a significant investment. Plastic sleeves can be used to protect borderless photos in a portfolio. Wilhelm- Research has a comprehensive survey of options for preserving photos in sleeves and envelopes at www.wilhelm-research.com/pdf/HW_Book_14_of_20_HiRes_v1a.pdf.

If you'll be doing your own framing, get a high-quality paper cutter. You can't add paper around a photo after it's been printed, so trim carefully! Craft and photo stores usually have these types of paper cutters, and you can also find them online or at big photography trade shows; they typically operate using a roller-type cutter and have guides on the cutter for standard photo sizes such as 5-x-7 and 8-x-10.

Dithering and Colors

Photo-quality inkjets produce millions of colors using only cyan, magenta, yellow, and black ink (plus additional, in-between colors in six-, seven-, or eight-color printers). They do this by *dithering* (mixing) invisibly small droplets of four, six, or eight colors that the human eye merges into a composite color.

The extremely high-resolution printers available enable a large number of droplets to be dithered, resulting in finely tuned colors (measure in dpi, or dots per inch). This process demands a high level of sensitivity in how photo paper absorbs tiny ink droplets.

The ink dispensing processes used in high-resolution inkjet printers is extremely refined and fragile. Successfully connecting a picoliter (1/1000th of a liter) to a specific spot on a page of photo paper so that it fits perfectly into a dithering pattern to produce a highly nuanced color tone is a precarious process. Maintaining that tone is yet another challenge, as different types of colors are produced with different kinds of patterns of ink droplets.

The physical process of connecting ink droplets with specific photo paper is governed by ICC profiles. Printer manufacturers provide ICC profiles (which install with printer drivers) that govern just how much ink is shot out of an inkjet for the selected paper. Figure S10-2 shows an ICC profile being selected in Photoshop for premium glossy photo paper. The way ink is projected onto this paper will be quite different from the process used to spit ink onto matte paper.

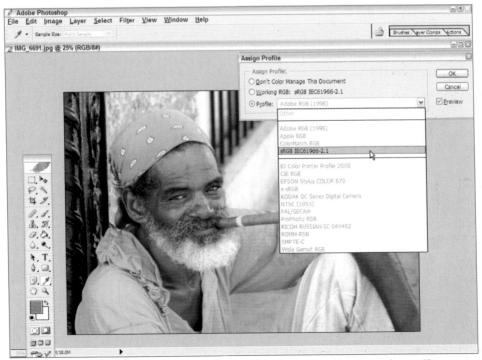

Figure S10-2: Photoshop allows you to use a variety of custom and preset color profiles on an image-by-image basis.

Ideally, ICC profiles provide the bridge that enables any kind of paper to work in any kind of printer. In reality, the availability of cross-product-line ICC profiles varies widely. Expensive, professional-quality, acid-free paper manufacturers provide ICC profiles for high-quality photo printers. Such profiles are often not available for decent-quality photo paper available in computer stores or even digital photo shops.

For all these reasons, even though a sheet of "works-with-all-printers" photo paper may produce a print that is indistinguishable from a print on manufacturer-compatible photo paper, the long-term results are likely to be much worse with the non-matched paper.

Note Canon, Epson, and HP all print (selective) research results at their Web sites evaluating the projected longevity of their paper and ink combinations.

Copyrighting

One of the biggest issues for photographers who want to present their images to the public is that they also want to protect those same works from being used without permission. Placing large images onto the Web without any form of protection is a bad idea — you can assume that, no matter what threatening statements you make, your images will end up being downloaded and used by someone else.

Metadata tags allow you to enter copyright information into a photo, but this information doesn't appear on an image. And, as any software manufacturer will tell you, copyrighting in the litigation-happy U.S. is one thing; protecting and proving your own works in foreign countries is entirely another. Once on the Web, whatever you present is worldwide.

Figure S10-3 shows a Photoshop image and its associated copyright information, which I've entered into the file along with other image information, such as the name of the photo and keywords describing it (especially useful for stock images). Adding this information, you'll notice in the figure, automatically adds the © symbol in the image heading displayed on the screen. Placing this notice or the word *copyright* along with pertinent ownership information (your name, for example) is what you need to do to identify that the image is, in fact, a copyrighted work. The image technically is copyrighted the moment it is created, but its ability to be protected over time may wane if the image doesn't bear a copyright statement and (and this is the tough part) if it hasn't been registered with the U.S. Federal Copyright Office.

Resorting to government copyrighting is an exceptional endeavor, however, reserved for the images that are being distributed widely or prominently as fine art. It definitely provides a foundation for proving an image's source and ownership, but for the vast majority of photographs taken by the vast majority of photographers, it's overkill.

Note Registering with the U.S. Federal Copyright Office involves filling out and mailing a government form (Form VA), a $30 fee, and a non-returnable copy of the image. Even if you submit photos on contact sheets, a $30 fee for every sheet of photos you want to copyright gets very, very pricey!

Most images online are set at screen resolution and relatively small (usually 72 dpi) so they aren't much good for printing anything beyond a very small print, and even that won't look very good. Although, that's not much solace if your images end up on someone else's Web site.

Figure S10-3: Adding copyright information to images in Photoshop may deter unauthorized use of a photo.

As a commercial photographer, you own your images unless your client specifically has purchased not only your time and talent, but also the right to own the image. Legally, there are different ways of going about this. For example, a client may not want to purchase an image from you permanently if you set a price that's beyond his means. However, he may want to be able to use the photograph — in a limited or unlimited sense — for a period of time, or maybe permanently. You can assign usage rights to that person or entity with a letter of agreement or contract, for which he may pay you a one-time fee, an annual fee, or whatever you mutually decide.

In general, photographers don't like to give up their rights to ownership of an image unless a hefty fee is involved. In some cases, it's not an option for large projects that have been bid out to the photography community — the company offering the job states clearly that it is a "work for hire" job, and that they intend to own the images the winning bidder will produce.

For images displayed on the Web, some of the online photography services offer customizable copyright statements as well as protection of images that prevents someone from right-clicking to copy the image. That's no protection, of course, against someone using a screen capture program, but it does prevent a lot of garden-variety downloaders from taking your photos.

Figure S10-4 shows the Printroom.com Copyright Screen Statement. In the Tiger Mountain Photo store-front gallery, a copyright statement appears when attempting to right-click on an image.

Figure S10-4: The Printroom.com copyright screen statement

When you create an image, consider using the following copyright protections:

✦ Add copyright metadata to your images, including date, copyright, and author (photographer).

✦ Keep backup copies of your images archived.

✦ Use copyright statements with online galleries and images.

✦ Provide polite but firm copyright statements when you give customers their orders.

Tip You can obtain some generic copyright statements from the PPA (Professional Photographers of America).

✦ Be clear about ownership and usage rights, especially with commercial clients.

✦ If someone does use your photo without permission, don't assume a lawsuit is your first course of action. Consider negotiating a fee or a credit, or even access to a mailing list, in lieu of litigation. Most people don't know they're violating the law.

Digital Never Dies — Or Does It?

I have several hundred record albums from the '60s and '70s to which, occasionally, I still listen (yes, I still have a turntable, too). When I do so, I'm always surprised at how they're in remarkably good quality with very good sound, even at 30 years old. Nonetheless, something tells me I should do something more to preserve the music, such as copying them to CD.

I realize that it's not the information but rather the *medium* onto which something is recorded that experiences the most significant deterioration. Even CDs deteriorate over time, and what is recorded onto them will suffer accordingly.

According to the Colorado Preservation Alliance, a nonprofit consortium of libraries, government organizations, museums, and historical societies, CDs are "complex laminate structures vulnerable to damage by light, humidity, temperature mishandling, and pressure." They state that most CDs fail because of "physical stress, dirt- or grit-induced scratches, yellowing of the plastic or light-recording layer, low reflectivity due to oxidation of the aluminum layer (laser rot), and natural aging." Their Web site also has a tremendous list of what to do and not to do to preserve archival CDs, such as how to store, house, handle, clean, and format them in various environments.

Note The Colorado Preservation Alliance Web site study can be found at www.colorado.gov/dpa/doit/archives/cpa/index.html.

The effect of time

Just like an image in a frame, time can negatively affect what's holding your precious visual property. Plus, CD players in 30 years may not play your archived information in the same way, or at all (think of how hard it would be to find an 8-track player today!). Likewise, if you're counting on hard drives to hold your data, over time they can fail or become technologically obsolete. Anything with lots of moving parts, in my opinion, probably isn't the best bet for long-term reliability (meaning more than ten years).

A digital image, which, after all, is nothing more than a complex and voluminous series of 1s and 0s organized to be read by a computer, can be copied precisely and, therefore, maintain its ability to be replicated over time. By copying it into different file formats or compressing it, however, you may be causing it to render less than perfectly. The only real way to keep it is to preserve the original digital file, untouched.

As tedious as this sounds, a good practice for the digital studio, once a year, is to recopy all images over five years in storage onto new media — whether that's onto a DVD, RAID backup system, CD, or whatever. Develop a maintenance schedule that won't destroy a week of work when you need to do the backup, but plan on doing it on some regular timeline.

Note You might want to place a set of archived CDs or DVDs in a safe location off site, even a safe-deposit box for valuable photo files.

Archival-quality CDs are available, although they're a little hard to find locally. These CDs are made with materials and to standards intended to allow them to stand up to well over 100 to 150 years without degradation of quality. I'm not sure what the technological standards will be in 100 years, much less 150, but if you really want to be secure in what you're storing you may want to consider these. Several years ago, Kodak offered an "archival gold standard CD-R," which they have since abandoned. You can still find them, but they aren't cheap. Take a look at Pictureline (www.pictureline.com) as a source for learning more about and purchasing gold-standard CD-R media, among other archival-quality products.

Long-term image management on the Web

Many people store their images on the Web by uploading digital files to online services. However, this is not usually a long-term proposition. For example, at Tiger Mountain Photo, with only a few exceptions for fine-art images, most photos that are uploaded are removed from the Printroom.com server within three to six months.

Tip Mac or Windows users can join .Mac, available at www.mac.com, for a small annual fee and own storage space that can be accessed on the Web.

In fact, putting your images online can be disastrous without backup. Although some companies providing online image storage, such a Kodak's Ofoto, are solid, some online photography service companies have gone the way of other Internet startups — shutting the doors and giving photographers no opportunity to retrieve their images. If you don't fully trust the longevity of your online photography solution, make sure to keep a local copy of your images!

Uploading to Web photo galleries is relatively inexpensive, but not reliable enough to archive valuable digital photos. The more reliable but more expensive way to solve this problem, when dealing with thousands of high-resolution images, is outsourcing with companies specializing, at least in part, in image-storage services. There are companies that will store images professionally and be responsible for them, but you'll pay a storage fee and you'll have the potential hassle of accessing those images elsewhere. Known as *asset management*, you pay for and receive multiple services such as searchable image archives, change tracking, Web-based thumbnails of your images, and other benefits. Ivey Imaging (www.ivey.com), for example, is a full-service professional lab handling all types of digital and film-based image services, including asset management. They use a UNIX-based RAID system with a highly secure server and access control, as well as a daily tape backup of their entire system.

This is a very high-end, technical area of computing, and it requires companies that are well-funded and managed, and prepared to do whatever is necessary to protect your images like a bank protects money. Check with your local pro lab to see what services they offer, but realize you may need to go to a service in a major technological or business hub to find what you want.

The Future and Longevity of Digital File Formats

File formats will change over time — that's a given. It's the nature of technology to change, and for its file formats, connections, and other secondary components to change along with it. In the past few years, the RAW format has come a long way in terms of support from photographers, although it's technically not really a format at all. But the advancement of camera and software technology has enabled photographers to get at the best possible image rendering, and RAW is as close to what the camera is really seeing as anything else we can get today.

Note Unfortunately there is a lot of literature and information referring to RAW as a format. For more information on the nature of RAW photos, see www.rawformat.com.

JPEG files are the most versatile and standardized images today. The format and term, which stands for Joint Photographic Experts Group, has been around for some time and is best because of good quality, size, and general support. However, there are better-quality formats, such as TIFF (Tagged Image File Format)

and GIF (Graphic Interchange Format) that are good for limited applications. For example, GIF files are primarily a good format for non-photo illustrations such as drawings, logos, icons, and graphical text.

File formats are often proprietary standards that are owned worldwide by organizations. TIFF, for example, originally developed by Aldus Corporation and Microsoft, is now owned by Adobe. The Joint Photographic Experts Group has an official Web site, www.jpeg.org, where you can find out lots of information about where the JPEG standard is going and what the future holds for it and related new formats.

Figure S10-5 shows the Save As file format drop-down menu from Photoshop. Photoshop and other image-editing programs offer a number of file formats to which images can be saved.

Figure S10-5: Photoshop offers a number of file formats to which images can be saved.

A number of factors affect file formats and their potential for long-term survival:

✦ **Standardization:** How likely are they to be adopted and used by major software and hardware manufacturers and users? How likely are they to still be worthwhile file types in ten or more years?

✦ **Reliability:** How good are they at working consistently as intended, and with a wide variety of platforms and systems?

✦ **Quality:** How well do they support increased file and image size and bit depth? How do they render colors?

✦ **Compressibility:** How do they handle being compressed for portability with minimal degradation of quality?

✦ **Innovation:** What do they offer that the others don't?

Summary

We live in a channel-surfing, moment-to-moment world, and thinking about how images will survive time isn't the first thing most of us think about. However, pro photographers like to believe their images will remain fade-free for a foreseeable future — but most would be hard-pressed to provide any guarantees for clients if questioned.

It's a good idea to understand the effects of aging on ink, paper, and how a photograph is preserved in terms of framing and display. There are a lot of options as to how photos are created today, ranging from photographic printing of digital images at big labs, to simple in-studio inkjet prints. All have different results in terms of how they last when subjected to sunlight, humidity, varying temperatures, and other factors.

Planning for the digital future is part technology, part crystal ball. There's no good way to predict the technology that might affect digitally stored images in the future — either to view and access it more easily or to find that a format or storage medium is no longer available. Floppy diskettes, for example, are quickly becoming obsolete and will one day be tough to find.

Another issue in protecting images is considering copyrights: How can you as a photographer ensure your work won't be claimed as someone else's, and what do you do if it happens?

Image mortality means understanding how to protect images from the effects of time, whether that has to do with the environment, how widely the photos are distributed or how they'll be accessed for archival purposes. Prudent photographers and studios will put into place conventions intended to guard against these inevitable considerations, at least for critical and important work. They will also develop a way to guide and work with clients concerned about image mortality as it relates to work being sold for long-term display.

✦ ✦ ✦

Appendixes

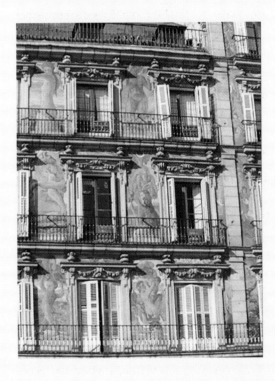

Appendix
References and Resources

Glossary

References and Resources

In this appendix, I list manufacturers, Web sites, and sources of information referenced and mentioned in the book. This appendix also contains a few that may just be of interest to you in general.

Note Web sites and companies are always changing, and this list contains information that was current at the time of publishing, but may change in the future.

ACD Systems (www.acdsystems.com)
Maker of ACDSee, FotoSlate, FotoAngelo, and other products designed to help digital photographers.

Adobe (www.adobe.com)
Maker of Photoshop, Photoshop Album, Photoshop Elements, and other products for image editing.

Canon (www.canon.com)
Maker of cameras and photography equipment, as well as printers.

The Colorado Preservation Alliance (www.colorado.gov/dpa/doit/archives/cpa/index.html)
Home to lots of great information on how to preserve digital images.

CompactFlash Association (www.compactflash.org)
Memory card organization technical specs, user alerts, advice, peripherals and other resources for CompactFlash cards and readers.

Corel (www.corel.com)
Maker of PHOTO-PAINT, Painter, and other illustration, graphics, and imaging software tools.

Crescent Cardboard (www.crescentcardboard.com)
Great source of acid-free, non-buffered mat board for photography display and preservation.

Digital Photography Review (www.dpreview.com)
Online magazine news and reviews, forums for users of a wide range of printers and cameras, and digital photography tutorials. Detailed reviews and sample photos are available for over a hundred digital cameras.

Delkin (www.delkin.com)
Maker of the e-Film PicturePAD. Shop for digital photo accessories, adaptors, memory cards and other essentials.

DotPhoto (www.dotphoto.com)
Online photo-sharing and fulfillment service.

Dyna-Lite (www.dynalite.com)
Photography lighting equipment.

Epson (www.epson.com)
Maker of photographic printers and paper.

EZ Prints (www.ezprints.com)
Provides fulfillment capabilities, but requires a Web-based gallery that they service, or that you send them photos on a CD or zip disk.

Ilford (www.ilford.com)
Maker of photographic paper and source of information on paper quality and longevity.

ImageFolio (www.imagefolio.com)
Digital asset-management software and storefront for sale of web-based images.

ImageTank (www.jobodigital.com)
Image storage and backup devices manufactured by Grand-Level Technology Corporation (`www.grand-level.com.tw`) and distributed in the U.S. by Jobo Fototechnic, Inc.

Ivey Digital (www.ivey.com)
High-end Seattle photo-processing lab and digital-asset management.

The Joint Photographic Experts Group (JPEG) (www.jpeg.org)
Standards, news, and advice for the most widely used digital photo format, including developments with lossless JPEG 2000 format (supported by Photoshop CS).

Lexar Media (www.lexar.com)
Information and sales of CompactFlash, Memory Stick, MultiMediaCards, Secure Digital Cards, SmartMedia, and other portable digital photo storage cards and devices.

LizardTech (www.lizardtech.com)
Maker of GenuineFractals.

NPPA (www.lizardtech.com)
Home of the National Press Photographers Association, a professional organization.

nik multimedia (www.nikmultimedia.com)
Makers of nik Dfine, Color Efex Pro, Sharpener Pro, and other great digital-photography utility software.

Nikon (www.nikon.com)
Maker of cameras and photography equipment.

Ofoto (www.ofoto.com)
Kodak-owned online photo-sharing and fulfillment service for consumers.

Olympus (www.olympus.com)
Maker of cameras and digital-photography equipment.

Pelican (www.pelican.com)
Maker of waterproof cases for photography equipment.

PhotoMedia (www.photomediagroup.com)
West coast online (and print) publication for photographers.

PhotoFlex (www.photoflex.com)
Maker of all types of photography lighting accessories for the studio and location.

Pictage (www.pictage.com)
Online professional photography fulfillment services, especially for wedding photographers.

Pictureline (www.pictureline.com)
Source for learning more about and purchasing gold-standard CD-R media, among other products.

Printroom.com (www.printroom.com)
Professional online photography services, including lab services, e-commerce, and marketing/workflow tools.

Professional Photographers of America (www.ppa.com)
Home of the professional organization for American photographers. A membership and advocacy organization for professional photographers with news, resources, and benefits.

Profotos (www.profotos.com)
Online photography galleries and pro-shooter information.

Professional Marketing Services (www.promarketinc.com)
Great source for new and used pro equipment.

Quail Electronics (www.quail.com)
Maker of international power strips and other supplies.

SanDisk (www.sandisk.com)
Maker of CompactFlash cards and other memory products.

Sekonic (www.sekonic.com)
Sales on information on high quality light meters.

Shutterfly (www.shutterfly.com)
Online photo-sharing and fulfillment service.

Sportsshooter (www.sportsshooter.com)
Membership-based information source for professional photographers.

StudioDynamics (www.studiodynamics.com)
Sales of hand-painted muslin backdrops and other studio props.

SuccessWare (www.successware.net)
Software dedicated to operating a photography studio business.

VirtualBackgrounds (www.virtualbackgrounds.net)

Distributors of virtual photographic backgrounds projected in your studio.

Wetpixel (www.wetpixel.com)

An information source for scuba-diving photographers, but with lots of other great information as well.

Wilhelm Imaging Research (www.wilhelm-research.com)

Extensive resource for information on imaging technology.

✦ ✦ ✦

Glossary

additive color: Monitors add colors together to project light and can produce a larger spectrum of color than is possible to create by mixing colors on a printed page.

archival quality: References to archival quality usually mean a print that will last between 60 and 80 years.

archival quality CDs: Archival quality CDs are made with materials and to standards intended to allow them to last well over 100 to 150 years without degradation of quality.

ASA: Film sensitivity was rated with ASA or, in Europe and some other places, with a DIN rating (DIN stands for Deutsche Industrie Norm, a German standards organization). ASA stands for the American Standards Association, which, like DIN, was replaced by the ISO rating.

backup media: Backup media includes readable and read-write CDs, as well as writable DVDs that store six or seven times the amount of data as a CD. Other backup media include internal or external hard drives, removable media such as Zip disks, and even portable media such as the iPod.

barn doors: An attachment to the front of the modeling light consisting of multiple doors that can be moved to control where light is being cast on a scene.

batch processing: Applies the same types of changes or modifications to all images in a folder (or drive).

calibration: Monitor calibration corrects color display to established (ICC) standards.

card reader: A card reader is a device that reads photo-storage cards and transfers data to a computer.

chrominance noise: Very small, off-colored specks in an image.

CMYK color: Printers create colors by mixing inks — cyan, magenta, yellow, and black — collectively referred to as CMYK (K is used to represent black, to prevent confusion with blue). Current inkjet photo printers enhance the set of printable colors by adding other cartridges like light cyan, light magenta, or red, green, and blue.

colorimeter: A device used to measure a given lighting scene and then adjust your camera's Kelvin degree setting accordingly.

copyright: Your photos are intellectual property, and they need to be protected. When you create an image, you automatically own the copyright and you can take it even further by registering it with the government.

CRT monitors: Cathode ray tube monitors favored for soft-proofing by serious digital photographers because of traditionally better calibration results.

digital noise: Refers to grain in images, making them look film-like. Digital noise, which occurs more noticeably when you take photos with a higher ISO setting on your camera, rarely looks attractive.

digital photo processing: Taking the untouched, original digital image from when it first is transferred to the computer and processing it to be stored, archived, optimized, prepared for client needs, edited and enhanced, displayed, and printed.

digital viewfinder: Digital viewfinders, common in less-expensive, point-and-shoot, consumer digital cameras, rely on some form of liquid crystal display (LCD). LCDs have many advantages over optical viewfinders in film cameras — they allow you to view other photos, and they provide a sharp, accurate image. LCD viewfinders, however, require substantial battery power, particularly when it's necessary to generate an image bright enough to see in bright light.

DIN: Deutsche Industrie Norm, a German standards organization for film speed. ISO (International Standardization Organization) is now used worldwide as the prefix to film speed and to refer to speed settings on digital cameras.

dithering: Combining many different ink droplets (in a printer) or pixels (on a monitor) to generate a composite color. These droplets are too small to be distinguished by a human eye, even with a magnifying glass. They blur together to produce colors.

dye-sublimation (dye sub) printing: Dye-sublimation printing combines cyan, magenta, and yellow ink in gaseous form, where gasified droplets of ink combine to form the color range.

dye-based inks: Dye-based inks are dissolved in the inkjet spray process, and mist in the form of tiny droplets onto photo paper where they are absorbed into and combine with the layers of photo paper to produce color. Traditional (film) photo printing relies on dye-based inks and their ability to react to paper on a molecular level.

EXIF: "Exchangeable Image File," which is an internal file format commonly used by many digital cameras to manage JPEG- and TIFF-processed images. This allows images to be "understood" in various formats and applications. Even when a camera records a JPEG file, for example, it is storing the file in EXIF format and using a JPEG compression algorithm to process the image.

FireWire: A simple (and safe) form of file transfer uses a FireWire cable to connect your camera directly to your computer.

fixed-lens camera: Typically a less expensive digital camera without the option of interchanging different types of lenses. Fixed-lens cameras have a single lens permanently attached to the camera; many of them can zoom in-or-out, both digitally and optically. Images are presented to the photographer via a video LCD or through a mini-viewfinder that approximates where the lens is pointing.

flagging images: Flagging is a technique for selecting, prioritizing, and sorting images.

flash bracket-mount: A flash bracket-mount, often with cable, that allows you to raise the flash higher than if it's just on the hot shoe of the camera (to avoid red-eye and be able to rotate the flash for vertical shots).

flash card: Small storage devices (such as CompactFlash, SmartMedia, and Memory Stick) that store and move or copy photos to a computer using a flash card reading device. Flash cards hold image files that have been transferred from the camera.

gels: Colored transparent sheets of plastic that add spot color to a scene; these are mounted onto a light.

GIF: A graphics format supported by the Web. The GIF format is a lossless compression technique that supports 256 colors. GIF is better than JPG for images with only a few distinct colors, such as line drawings, black-and-white images and small text that is only a few pixels high. GIF supports animation and transparency.

glossy paper: Glossy paper reflects more light than matte or textured paper and, therefore, produces brighter colors. Glossy paper works particularly well with the inkjet processes because of the special challenges of absorbing so much ink.

grid lighting: Grid lighting disks can be mounted in a light and are available in varying percentages. The percentages refer to the amount of light allowed through.

grid: A honeycombed disk that snaps into the hood in front of the light to control light on a subject and provide lighting depth without highly defined edges. These also come in large soft styles as a combination of a soft-box light with the grid effect.

ICC profiles. The International Color Consortium is an organization that manages the standardization and information about how digital cameras, monitors, printers, and scanners process and manage color. When devices are equipped with ICC profiles, image-editing software, such as Adobe Photoshop, can preview your photo based on your printer and paper using the ICC profile of your printer. Most major printer and scanner manufacturers include ICC profiling information with the printer drivers and software that come with your printer.

image-capture device: Usually a digital camera, but it could also be a scanner or other equipment.

inkjet printing: Inkjet printing provides the widest scope of size, quality, and print media, and dominates studio printing.

ISO: International Standardization Organization. ISO is now used worldwide as the prefix to film speed and to refer to speed settings on digital cameras.

ISO settings: When you set the ISO on your camera, you're determining how much light you want the camera to allow the CCD or CMOS to absorb for the image. For lower light, you want a more sensitive, or higher, ISO setting. This setting ranges from as low as 50 (for very bright light) to as sensitive as 3200 (for very low light). Higher ISO settings typically generate more digital noise.

JPEG: JPEG files are the most versatile and standardized images today. The format and term, which stands for Joint Photographic Experts Group, has been around for some time and is a good choice — especially for Web photos — because of quality, size, and general support. However, there are better-quality formats, such as TIFF and GIF.

LCD monitors: Liquid crystal display monitors with convenient flat screens for desktops and all notebook monitor screens.

light temperature: Different types of light have different temperatures that result in the light having different colors. A candle flame, for example, has different colors at its top, middle, and bottom, due to the fire being a different intensity and, therefore, a different temperature in those different areas. Likewise, the light outside in sunlight, inside a room with normal household lamps, inside an office with fluorescent lights, or in a studio with flashes all cast different physical temperatures and, therefore, appear in different colors when photographed the same way.

lighting kits: Lighting kits are typically more dedicated than stand-alone units and work with specific power supplies and connectors.

lossless formats: Formats like TIFF, RAW, or JPEG 2000 that do not compress photo files or reduce data during saving.

lossy format: Image file formats like JPEG, PNG, and GIF that compress digital data to reduce file size. Repeated resaving to lossy formats degrades quality.

loupe: A magnifying lens used specifically to view slides and negatives.

luminance noise: Tiny, dark specs that look like film grain in a digital photo.

mat spacing: Buffer between framed photo and glass.

matte paper: Non-glossy paper. Matte surfaces have the advantage of resisting fingerprints and stand up better to wear and tear.

metadata/metadata tags: The unique subfile of data about an image recorded by the digital camera. It tells when the image was created, by what type of camera, the exposure and focal settings, and even information such as if the flash fired or not. Metadata is an easy way for a photographer to embed copyright, authorship, and image title information in a file.

mini slave strobe light: A mini strobe light is a very portable, inexpensive, and handy light that fires when your flash goes off.

model releases: A legal contract that gives you permission to use the image of the individual being photographed. If nudity — whether actual or implied — is involved, make sure the agreement stipulates the model is over the age of 18.

nanometers: Color tones are measured in wavelength nanometers (nm), which is a billionth of a meter. The spectrum of visible light runs from about 400 nm (purple) to around 700 nm (red).

online storefronts: Online storefronts are essentially Web-based galleries where another company hosts your images in a format optimized for others to view them. You create the gallery, upload images to specific galleries, and set prices and other features such as image optimization, copy protection, and so forth. Customers can go online, see the images, select them, and purchase them. The capabilities of storefronts differ from site to site.

PCMIA card: A PC card adapter that fits into a laptop PC card slot. Can be used for card readers that accept CompactFlash cards for downloading images to the computer.

picoliter: Ink droplets are measured in picoliters. There are 1,000 picoliters in 1 liter, which is roughly a quart.

pigment-based ink: Pigment-based ink is sprayed onto the page in larger droplets. When Epson introduced pigment-based ink for photo inkjets, like the UltraChrome inks, those pigment-based inks represented a significant development in ink stability.

pixel: The smallest digital dot used to record image data. On-screen resolution is often referred to as ppi, or dots per inch, while print resolution is usually referred to as dpi, or pixels per inch.

PNG: PNG is a graphics standard supported by the Web (though not supported by all browsers). PNG images are more compressible by 5 to 25 percent than GIF files of a comparable size. PNG also allows control over the degree of transparency. Repeated saves of a PNG image do degrade its quality. Animation is not supported.

pocket drives: Portable, pocket external drives are extremely convenient and provide a quick way to stash photos in the field. But their small capacity and relative fragility make them unsuitable as backup media.

profiles: Files that store information that synchronizes the output of color in various devices. Profile standards are set by the Internal Color Consortium (ICC).

proof books: One of the easier ways to show your work to a client or friend for whom you've shot a large number of photos is the tried-and-true film-photographer method of a proof book — with a digital twist. You can take the digital images to any lab to be processed as 4-x-6 or 5-x-7 images, and then place your best shots in a presentation flip-style album. With it, you can include a CD of the images in low resolution that the client can see on a PC, or you can even include a simple slide show in a self-running mode.

RAID system: A RAID (redundant array of independent discs) system is a set of drives that work together to create a large amount of storage. The drives automatically back each other up so that they are swappable and work together for optimal efficiency, scalability, and access. RAID systems are very reliable and perhaps the best way to store lots of vital information. They usually require a board that's inserted in your computer, the RAID hardware shell that holds the drives, and the drives themselves. Although a bit pricey for the entire configuration, your images are very secure stored in this manner.

ranking images: Image-management tools offer features that allow you to rank images, prioritizing the best shots. Rate the images that are obvious best shots, as well as those that are good possibilities, and so on. Although not every image needs to be rated, ranking down to second- or third-best can be accomplished quickly.

Photoshop RAW format: The Photoshop RAW format is a flexible file format for transferring images between applications and computer platforms. This format supports CMYK, RGB, and grayscale images with alpha channels, and multichannel and lab images without alpha channels. Documents saved in the Photoshop RAW format can be any pixel or file size, but cannot contain layers. Photoshop RAW is not the same file format as a RAW image file from a digital camera.

RAW format: A digital camera's RAW image file is a camera-specific proprietary format that provides the photographer with a digital negative, an image free of any filtering, white-balance adjustments, and other in-camera processing. RAW format provides instantaneous control of the image as the camera and photographer saw it, without any distortion, chemical intervention, or digital alteration. And this is all before images have been filtered in Photoshop or otherwise manipulated.

resolution: The concentration of data recorded by a digital camera, displayed on a monitor, or printed on a page.

RGB color: Monitors mix channels of red, blue, and green to produce millions of different colors. Each pixel on your monitor contains a combination of red, blue, and green. Those combinations are quantified with the RGB color system. For instance, an RGB setting of red = 0, blue = 225, green = 0 produces blue.

rule of thirds: A very important, traditional, and yet simple concept for composing a good photograph is the rule of thirds, which involves positioning your subject within something similar to a tic-tac-toe grid.

sharpen: Virtually all image-editing packages offer a sharpen feature of one ilk or another that allows you to simulate the appearance of detail in a photo or section of a photo. Usually the feature allows you to use a slider tool to dynamically change the sharpness of an image, or perhaps you progressively press a button to increase sharpness incrementally.

silver-halide prints: Prints produced by traditional chemical photo development and printing.

sketch filters: Image-editing filters that transform your image into a black-and-white photograph that looks like someone sketched it with a pencil, charcoal, or other instrument.

SLR: A single lens reflex camera that captures an image through a lens that reflects light through a prism and onto the viewfinder. Therefore, the viewfinder shows the real pre-pixel (non-digital) image that will be captured by the camera. Different from a fixed-lens camera, most SLRs support interchangeable lenses.

snoots: Cone-like attachments to a light that provide a focused spotlight on a scene or subject.

soft-proofing: Viewing a pre-print proof in photo-editing software. Unlike traditional photo developing, it's possible to preview and soft-proof to see a close approximation of your final print output. Soft-proofing is useful for printing on your own photo-quality inkjet or dye-sub printer and for previewing photos that will be printed by a service bureau.

stock photos: Stock images are photographs that can be purchased and used for commercial purposes, such as in brochures, advertisements, Web sites, and other purposes by advertising agencies, graphic-design firms, magazines, and individuals. They are typically marketed through stock agencies, a market dominated by huge companies such as Getty Images and Corbis. Photographers can also sell their images to these houses.

stylize filters: Perhaps the most wide-ranging artistic filters Photoshop CS offers, including embossing, solarization, glowing edges, and other effects.

subtractive color: Printers layer inks on top of each other to produce a spectrum of colors. This process is referred to as subtractive because, for instance, when cyan is applied on top of yellow, the result is less yellow.

The Total Cost of Printing (TCOP): A system for calculating what it costs to make prints, including paper, ink, and, if appropriate, any lab surcharges. The word *total* may be a bit misleading, because it doesn't take into account the cost of purchasing a computer or printer if you're doing it yourself. It also doesn't consider travel costs if you're driving to and from a lab to drop off and pick up your prints.

TIFF (Tagged Image File Format): A lossless photo file format. Some digital cameras offer TIFF as a file format in addition to RAW, but this has become less prevalent.

unsharpen: A seemingly counterintuitive term for sharpening an image. The term comes from a dark-room technique used in traditional film-based photography to enhance or blur detail.

USB: The simplest (and safest) form of transferring data between components like a digital camera or card reader and computer. Drives with USB 2.0 support, providing your computer supports 2.0, is significantly faster than USB 1.1. However, note that flash cards themselves don't download at full USB 2.0 speeds (but they're usually faster than USB 1.1).

UV-protected glass: UV stands for ultraviolet. Ultraviolet-protected glass can help prevent ink and paper from degrading. Perfectly clear framing glass is available with up to 98 percent UV protection.

virtual backdrop: Using a virtual backdrop allows you to green-screen subjects onto virtually any background imaginable. Virtual backdrops combine an in-studio subject with a scene of anything you can photograph and create as a background. The result is a photo that looks like the subject was physically part of the background.

watermark: Text imposed on or embedded within an image to protect it against unauthorized use. Photographs can be watermarked with your copyright information using a variety of methods. At a simple level, professional online photography services allow you to watermark an image when it is displayed. If someone used a screen-capture program to copy the image, as long as it's watermarked it will be difficult to use because the word *proof* is printed on the image, and removing it using an image-editing package like Photoshop would be very difficult.

white-balance: A measure of how the camera sees and records color based on light that's being reflected into the lens or sensor. White is actually a misnomer because cameras are actually calibrated against an 18 percent gray shade, not white. Gray is considered a mid-tone and, thus, a better determinant of what the camera is likely to see. You can purchase perfectly colored, 18 percent gray cards from photographic supply stores, take photographs of them in the light where you intend to shoot, and adjust your camera to that color to obtain a perfect exposure.

XMP: Photoshop uses the XMP (extensible metadata platform) to carry information among various Adobe applications and to manage publishing workflows. The information you append to a file's metadata, such as copyright information or a document name, will then appear as metadata in other applications.

Index

Continued

Continued